OLD MASTER
DRAWINGS
FROM
THE
LBERTINA

National Gallery of Art, Washington, D.C.
October 28, 1984 – January 13, 1985

The Pierpont Morgan Library, New York, N.Y.
March 8 – May 26, 1985

Organized and circulated by the
International Exhibitions Foundation, Washington, D.C.

Made possible by a grant from United Technologies Corporation

OLD MASTER DRAWINGS FROM THE ALBERTINA

This exhibition and catalogue have been made possible by
a generous grant from United Technologies Corporation.
Additional assistance has been received in the form of an
indemnity from the Federal Council on the Arts and the
Humanities.

©1984 by the International Exhibitions Foundation,
Washington, D.C.
Library of Congress Catalogue No. 84 81063
ISBN: 0 88397 079 1

Designed and produced by Derek Birdsall R.D.I.

Typeset in Monophoto Van Dijck 203
and printed on Parilux matt cream in England
by Balding + Mansell Limited using Inmont Inks.

Cover Illustration:
Albrecht Dürer, *Praying Hands (Study for an Apostle)*, 1508.
The Albertina Collection, Vienna, Austria.
Catalogue no. 7.

This corporation has enthusiastically sponsored many major exhibitions over the past half dozen years, but perhaps none as visually exciting nor as important to art history as this show of drawings from the Albertina. We are immensely proud of our role in support of *Old Master Drawings from the Albertina.*

HARRY J. GRAY
Chairman
United Technologies Corporation

ACKNOWLEDGMENTS

It is a great distinction and honor for the International Exhibitions Foundation to present to museum audiences in Washington, D.C., and New York this breathtaking assemblage of drawings from the collection of the world-renowned Albertina in Vienna. Spanning four centuries of Western European art, the seventy-five masterpieces seen here include works by the greatest draughtsmen of all time and comprise an exhibition of incomparable richness.

The first loan exhibition from the Albertina ever to travel to the United States, *Old Master Drawings from the Albertina* is the culmination of nearly two decades of negotiation and preparation. Beginning in 1968 when I first approached Dr. Walter Koschatzky, Director of the Albertina, about the possibility of such a loan, discussions between the Albertina and the IEF have continued over the course of the intervening years and have grown to include representatives of the Austrian government as well as our colleagues at the National Gallery of Art and The Pierpont Morgan Library. We see here the results of this collaboration — an exhibition and tour that would not have been possible without the goodwill and cooperation of all of these parties, and an international cultural event of the highest order.

First and foremost, I should like to express our deep gratitude to both the Austrian government and the Albertina for making these rare and beautiful drawings available to us. Their generosity in lending the works will enrich the experience of countless American museumgoers. To Dr. Koschatzky and his excellent staff at the Albertina, we owe a very special measure of thanks. In addition to working tirelessly on the selection of the works and overseeing the numerous details involved in their loan, Dr. Koschatzky has remained enthusiastic and supportive of this project from its inception and we are deeply in his debt. Dr. Fritz Koreny, Dr. Alice Strobl and Dr. Veronika Birke also have been unfailingly helpful throughout the organization of the exhibition, responding promptly and patiently to our many queries.

At the National Gallery of Art, interest in the project was first expressed by former Director John Walker and continued to build under the leadership of his successor, J. Carter Brown. Their efforts, as well as those of Senior Curator Andrew Robison, have helped ensure the success of the project and deserve our gratitude. Dr. Robison especially must be singled out for his invaluable assistance with the selection, as well as for his many helpful suggestions at every stage.

Our colleagues at The Pierpont Morgan Library have also given us their fullest cooperation and assistance. In particular we wish to acknowledge the contribution of the Library's Director, Dr. Charles Ryskamp, as well as that of Assistant Director Francis Mason and Felice Stampfle, Charles W. Engelhard Curator of Drawings and Prints Emeritus, all of whom gave freely of their advice and expertise throughout the course of the project.

His Excellency Dr. Thomas Klestil, the Ambassador of Austria, has kindly agreed to serve as Honorary Patron of the exhibition during its tour, and we are indeed grateful for his ongoing interest and support. Our warm thanks go also to Wolfgang Waldner, Second Secretary for Cultural Affairs at the Embassy of Austria, who has been a most able and sympathetic liaison, and to his predecessors, Brigitta Blaha and Gabriella Holzer.

An exhibition of this magnitude cannot be realized without financial assistance, and we are pleased to acknowledge those who have made the exhibition and tour possible. Once again we are deeply indebted to United Technologies Corporation for providing a most generous grant in support of the exhibition and for underwriting this splendid catalogue. It has been a pleasure to collaborate with them on the project and to continue our association with both Gordon Bowman, Director of Corporate Creative Programs, and Marie Dalton-Meyer, Manager of Cultural Programs.

Additional assistance for the project has been received in the form of an indemnity from the Federal Council on the Arts and the Humanities, for which we are sincerely grateful. We also wish to thank The Andrew W. Mellon Foundation for their ongoing support of our catalogue program.

The catalogue, beautifully printed by Balding + Mansell Limited, represents the extraordinary design talents of Derek Birdsall. His enthusiasm and creativity have resulted in a publication of exceptional quality and deserve our special thanks. We also wish to express our gratitude to Agnes Mongan for her invaluable comments and suggestions and to Peter Nisbet for his fine translation of the catalogue text.

Lastly, I want to extend heartfelt thanks to the staff of the International Exhibitions Foundation — notably Taffy Swandby, Lynn Kahler Berg, Deborah Shepherd, Migs Grove and Elizabeth Bauer — who have, with their customary efficiency, attended to the numerous practical details of the exhibition and tour.

Annemarie H. Pope
President
International Exhibitions Foundation

PREFACE

The mounting of special exhibitions devoted to old master drawings has become a pleasantly customary activity at the National Gallery of Art and The Pierpont Morgan Library. With the chance to borrow seventy-five splendid sheets from Vienna's Albertina, however, there was a measurable quickening of the pulse in Washington and New York. We happily found ourselves engaged not in routine affairs, but in a most extraordinary and singular project.

The Albertina, a former Austrian palace, houses one of the very finest collections of old master drawings in the world. The history of this nonpareil collection is as compelling as its holdings are beautiful, and we urge our visitors to read Dr. Koschatzky's essay on the growth of the institution which began in 1769 under the joint patronage of Duke Albert von Saxe-Teschen and his wife Marie Christine, the favorite daughter of the Empress Maria Theresa. From these auspicious Hapsburg origins to the present day the Albertina has stood for the best in the graphic arts and this remarkable resource numbers more than 34,000 drawings catalogued in its inventory.

Intentionally small in scale, this exhibition contains drawings by some of the greatest draughtsmen in the history of art including Michelangelo, Raphael, Dürer, Cranach, Bruegel, Rubens, van Dyck, Rembrandt, Poussin, Claude, and Fragonard. Some drawings, such as Dürer's *Praying Hands*, have never before been lent anywhere by the Albertina.

Old Master Drawings from the Albertina has enjoyed the support of many dedicated and talented people. The project, initiated almost two decades ago by Mrs. John A. Pope, President of the International Exhibitions Foundation, has been brought to fruition under the patronage of His Excellency Thomas Klestil, Austrian Ambassador to the United States, together with Dr. Wilhelm Schlag, Ministry of Science and Research. Dr. Walter Koschatzky, Director of the Albertina, made the selection of drawings with Dr. Andrew Robison, Senior Curator of the National Gallery. The organization of the exhibition and tour has been ably administered by Mrs. Pope and her staff.

On this the bicentennial of political and economic relations between Austria and the United States, we are deeply indebted to the Austrian government and our colleagues at the Albertina for their cooperation in making this show possible. We also should like to extend our thanks to United Technologies Corporation for their generosity in support of this show and the Federal Council on the Arts and the Humanities for granting it a federal indemnity.

J. Carter Brown
Director
National Gallery of Art

Charles Ryskamp
Director
The Pierpont Morgan Library

FOREWORD

Exhibitions such as this one are bridges, great arches spanning countries and continents to unite those people who are conscious of the value and meaning of artistic creation and can discern, appreciate and respond to masterpieces of world art, and who know that the sublime message of gifted human beings exists in timeless statements beyond the reality of what concerns us day to day. It is precisely the art of drawing which speaks most immediately of this. For here the artist's hand usually moves at its most spontaneous, often without long deliberation and without any constricting medium which might come between the thought and its execution. Drawing has therefore been called "the soul of all the arts," and it is indeed here that someone's inner essence and unconscious is manifested most strongly. It is, as the Greek word *graphein* indicates (it is no accident that this is the root of the word *graphic* as in graphic art), a kind of writing, which is definitely capable of expressing content and whose ductus can become the writer's innermost statement. The individuality of a person's handwriting is often able to tell us more about someone than long intellectual declarations. Nevertheless, empathy and some knowledge of the handwriting's characteristics are needed, as is reflective contemplation of the whole and the parts. The same applies to a drawing. It must be approached quite differently than other works of art. Sensitive, empathetic listening is a much more exciting prerequisite for this encounter than is necessary, say, in the case of the impressive power of a painting.

It is also common to compare painting to symphonic music and drawing to chamber music. Density and depth are the same, only the scale is different. These advantages of drawings were well known to our founder in the late eighteenth century and they have not changed since then. We may live in a world where the delicate tones of chamber music cannot always be heard over the noise of the big city, the traffic, the machines and the airplanes, but that makes encounters with gentle, beautiful and infinitely valuable things all the more necessary in this world. They are what speak to us of true humanity, of thought and emotion, of glimpsing eternal beauty behind things, of everything, in short, which artists can give us. However, they can only do this when we let them speak, when we want to understand their language and when we accept their message.

All this lies behind the intention to organize such an exhibition. Of course, a different selection of works could have been made, but no more beautiful one. We have given much thought to the question of which works would most clearly represent the size, breadth and stature of our collection for an American audience. The Albertina includes both old master and modern drawings, works of international standing as well as works from the Austrian art world, in addition to anything that may be considered printed art, graphic works (in all processes and media) from the invention of printing to the present day, illustrated books and posters, and also sketchbooks, architectural drawings, playing cards and historical caricatures. Nevertheless, we have decided we would rather confine ourselves concisely to old master drawings from the fifteenth to the eighteenth centuries than present an unfocused selection from all these other categories. The latter would certainly have produced a few sensations, from Dürer's trial proofs to variant states of Rembrandt's prints,

Egon Schiele's masterpieces or drawings from Borromini to Adolf Loos. But the unity of an exhibition, its coherence and the course of cultural history which it allows one to feel, are better messengers than the merely sensational. The restriction in fact offers far more than could a profusion of disparate objects, however large.

Beyond all these considerations, there is a further, unmentioned reason for the decision to allow works of this quality to travel to another continent. We do not forget that we owe it to the convictions and help of the United States that the Albertina, like Vienna's other large museums, suffered no losses at the end of the war. The rescuing of our art treasures during the war, their relocation to the old salt mines, was, of course, itself a cultural feat of a special kind, but the return of these works to Vienna and the opportunity immediately to reestablish culture as an integral part of the new Austria was an accomplishment which shall not be forgotten. It is therefore my wish that this exhibition of masterpieces from our institution should also be an expression of our gratitude.

This exhibition has a long history. The mutual wish to present original masterpieces from the Albertina in the United Sates has existed for many years. It has taken a long time but has in the end turned out to be a highpoint in what we can achieve. If the Albertina is invited to show the significance of its collections at such prominent locations, then the chosen works can only be of equivalent quality.

I should like to express our thanks to those who have shown us sympathy, understanding and patience, which has made the realization of the exhibition possible. We must thank many for a great deal of obliging cooperation. This applies first to Mrs. Annemarie Pope, President of the International Exhibitions Foundation who as the tireless initiator may claim the credit for laying the foundation for this exhibition. Special thanks are due the Director of the National Gallery of Art, J. Carter Brown, for the generous welcome which he gave to the project, and similarly to Felice Stampfle, our longtime friend and colleague, and to Charles Ryskamp, Director of The Pierpont Morgan Library. Their repeatedly demonstrated interest and convictions have played a major role in persuading us to take these treasures from their well-protected boxes and send them on this long journey. We have also been encouraged by our professional respect for Dr. Andrew Robison, Senior Curator of the National Gallery of Art, and by our knowledge of the magnificent achievements so often demonstrated in the special exhibitions of these two famous institutions, the National Gallery and the Morgan Library. My thanks go to the entire staffs of the International Exhibitions Foundation and these two collections. Their skills and efforts are also responsible for making this undertaking possible.

The Austrian ambassador Dr. Thomas Klestil has been able to make necessary connections with great understanding, and the relevant federal ministries in Vienna have been very conscious of their responsibilities when approving our decisions and thereby enabling us to proceed. My respectful thanks in this regard go to Federal Minister Dr. Heinz Fischer, who as the head of the responsible department has at all times proven his willingness to go beyond conventional bounds at the appropriate moment. Without this, we could not have realized our hopes. Our gratitude is due to Dr. Wilhelm Schlag, previously the longtime head of the Austrian Cultural Institute in New York and, during the preparations for the exhibition, the responsible section head in the Federal Ministry for Science and Research in Vienna. This also is no less true of the head of the museums department, Ministerial Councillor Dr. Carl Blaha, who gave this project his interest and support.

In this exhibition we have achieved something which has never happened to us before, even in a scholarly context — all the members of the Albertina's staff have collaborated to bring this project to fruition, beginning with suggestions for the selection of objects to be exhibited, culminating in the many months of work on the production of a critical catalogue that reflects the results of current scholarship and concluding in the careful escorting of the treasures from Vienna to Washington. It is rare to have the opportunity to test professional teamwork and prove its spirit in public by working towards the common goal of a worthy and professionally respectable presentation.

The Albertina is an institution rich in tradition and all those who work here are proud of that. The famous scholars who came before us were able to investigate thoroughly the inheritance passed on to them from a glorious past. Their pioneering accomplishments have won great esteem for the name of our founder and the life's work that bears his name. During the preparation of this exhibition we have always been concerned to do them justice. The Albertina of Duke Albert was a product of the old Austria and its imperial capital Vienna. Cultural preservation, scholarly research and unwavering continuity in today's world are our tasks. I have had the great honor of presiding over this collection as Director for more than two decades, and hardly anything gives me more satisfaction than to see how much all my colleagues share this conviction. Doubtless this also explains the ambition with which the task of organizing this exhibition in the United States has been undertaken. Therefore I must finally also express my special gratitude to my colleagues, who join me in wishing all success for the showings in Washington and New York.

Walter Koschatzky
Director
Albertina Collection

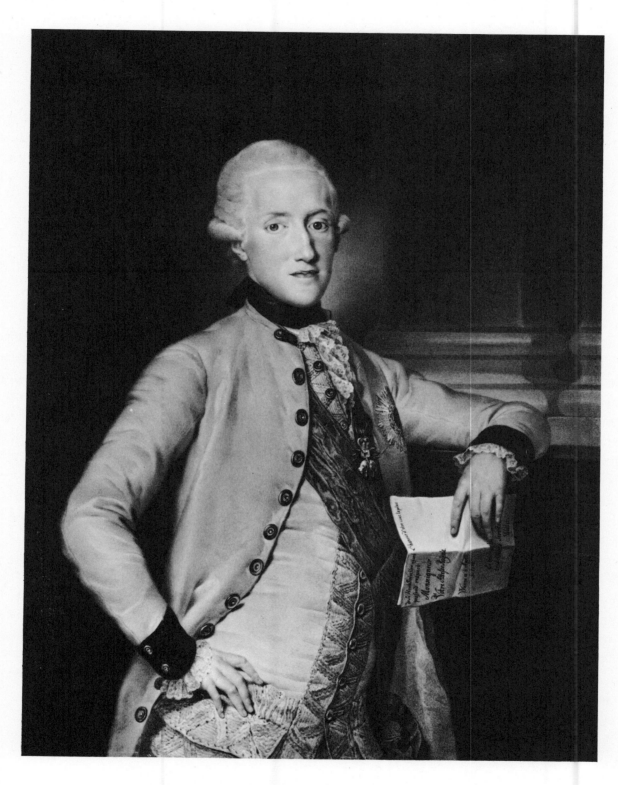

Duke Albert Casimir of Saxe-Teschen (1738–1822),
founder of the Albertina Collection

THE ALBERTINA IN VIENNA

Collecting art is not the same as accumulating art works. Certainly, owning treasures, rarities and the pictorial inventions of geniuses was for centuries characteristic of the powerful, of secular and religious rulers and princes. Much, if not everything, from these earlier epochs was thereby saved from the ravages of time, and much of our awareness of the value of artistic activity and our knowledge about past masters and their achievements has been similarly sustained. Of course, the desire to own such works may later have found other motivations, but the satisfaction in the property itself and in the status its value may confer has remained constant, as has the interest in the depicted subject (landscape, figure or portrait). But, perhaps, the ultimate reason for acquiring art stems from the need to be moved inwardly, the need for an experience of an intellectual or spiritual nature. All this can motivate a collector, but collecting is more than this. As the activity of ordering and discerning, comparing and clarifying, collecting unites us with the multiplicity of the world; in short, it is a fulfillment of what seems to some to be one of the obligations of being truly human.

The collection created by Duke Albert of Saxe-Teschen (1738–1822) was founded on this conviction. The idea that gave meaning to these efforts and expenditures has since lost none of its importance.

The Albertina is a collection of graphic art. The quantity, artistic quality and systematic comprehensiveness of its holdings have given the Albertina a special position in the world. The Albertina is not only renowned for its comprehensive collection but also for its scholarly research and publication programs. The Albertina, founded two centuries ago, has always considered itself a mediator between the artists' creativity and a sensitive, inquiring audience. The clearest expression of this is found in the many exhibitions, which are of especial importance to a graphic collection because its holdings, unlike those of a paintings museum, cannot be on permanent view.

A public collection serves not only as a place of preservation and quiet contemplation, but as a bridge to information and education. Education not so much in the sense of quantitative knowledge, analysis and interpretation but, rather, as a means of touching and cultivating man's emotional side, can most effectively be addressed by great art. To understand art means to gain in openness and sensitivity. The collection's responsibilities, however, go beyond this role. Counteracting the fragility and sensitivity of works on paper, or the preservation of the artists' great achievements, is nothing less than a high ethical demand. In addition, the Albertina has always considered itself a living collection committed to furthering the history of graphic art. Consequently, every generation has placed as much emphasis on acquiring contemporary works as on adding to the older schools. Contact with the present has always been considered a special challenge and allied closely with research and teaching. In this way the three principles — preservation, acquisition and interpretation — were and remain very consciously applied here, even if different circumstances prevail today from those evident when Vienna was the center of an extensive empire. Austria may now be territorially small, but its spiritual energy and the pursuit of its cultural obligations certainly are not, and in this activity the Albertina has played a major role.

On July 11, 1738, Albert Casimir, after whom the Albertina is named, was born in Moritzburg Castle (near Dresden) to August II, Elector of Saxony (1696–1763), and Maria Josepha (1699–1757), an Austrian archduchess, who was a Hapsburg, the daughter of Emperor Joseph I. Although Albert, the eleventh of fourteen children, grew up at the Dresden court, its elegance and artistic tradition cannot have had much influence because his upbringing was determined by the War of the Austrian Succession (1740–48) and the Seven Years' War (1756–63). When the family moved to Prague, he and his brother Clemens stayed behind with their tutor, Baron von Wessenberg, whose strict and extremely religious nature cast a shadow over Albert's childhood. Albert's early devotion to the Enlightenment and Freemasonry, to ideas about new goals and obligations for a duke, to untrammeled encouragement of free human beings and to the "improvement of humanity," in short everything which later formed the intellectual basis for the Albertina, may have had its roots here. Also, the events of the Seven Years' War prejudiced him against Prussia; this in turn, led him to flee and join Empress Maria Theresa's army as Austria's Marschall Daun besieged Dresden during that year of changeable fortunes, 1757.

Albert reached Vienna in the winter of 1757–58 and presented himself to the imperial couple, Maria Theresa and Francis I. He was received in a warm and, no doubt for political reasons, emphatically official manner. From the first moment Maria Theresa showed him great sympathy and later open affection, as if he were her son. This may have resulted from her troubled relations with her own son, Joseph II. She was therefore not displeased (perhaps also because Albert provided a calming, rational and progressive counterbalance to Joseph) when her favorite daughter, Archduchess Marie Christine, showed herself disposed to Albert's enraptured admiration. Because Albert was in no way a match of consequence for the Imperial Court, many difficulties had to be overcome before they could marry. On April 6, 1766, in Schlosshof near Vienna, Albert and Marie Christine were married. On that occasion, Maria Theresa wrote a most beautiful letter to her daughter, which included a touching sentence about having always encouraged her love for Albert because she wanted at least one of her daughters to be able to live according to the dictates of her heart. It was indeed a particularly happy marriage, a close human relationship between two highly cultivated, sensitive, art-loving individuals, who were all the closer because a miscarriage in the first year of their marriage denied them any children.

To keep the couple close to Vienna the Empress named Albert Governor of Hungary. Albert skillfully and assiduously fulfilled his difficult mission of placing Austria in an acceptable position over and against the powerful and extremely independent lords of Hungary. He carried out Maria Theresa's wishes to effect the emancipation of the serfs, introduce agricultural reform, and improve social

conditions. For thus helping the people, Albert is remembered to this day in Hungary.

In 1773 the Austrian ambassador to Venice, Count Giacomo Durazzo, whom Albert had known from Vienna as the director of the Court Opera, visited Albert at Pressburg Castle. Durazzo, who belonged to the same Freemasons' lodge as Albert, believed that a prince should not exploit the opportunities and privileges of his station for selfish pleasure and amusement (as happened in so many foreign courts). Instead the prince should be responsible for the future of mankind, for its culture and education. Durazzo proposed to Albert that mankind's highest achievements, which he saw in art, be collected and recorded in a catalogue raisonné and housed in one place. (The nature of Durazzo's visit and proposal are well documented in notes from this meeting.)

Albert, who had already begun to collect graphic art (albeit exclusively contemporary works, French engravings and English mezzotints), and Marie Christine, herself very talented and particularly interested in drawings, were immediately attracted to Durazzo's proposal and commissioned him to create such a collection in Venice. This moment was indeed epoch-making for it resulted in the founding of the Albertina.

Once back in Venice, Count Durazzo became feverishly active and, within two years, presented the Duke with the biographies and oeuvre catalogues of 1,400 artists and some 30,000 prints, primarily by Italian masters. This material was accompanied by a systematic overview, a *discorso preliminare*, which divided the works into schools and historical chronology, rather than into collections of rarities and thematic groupings as was the prevailing practice. This was the first step toward presenting drawings as art and historical investigation instead of curiosities. If one considers that the idea of the *peintre-graveur* grew from this concept, it is obvious that we still have not grasped the importance this collection had for the "graphic arts" as a field in which the skill, stature and quality of graphic creativity (nothing more than a visual medium for centuries) could manifest themselves.

On July 4, 1776, Albert took possession of the collection in Venice and energetically began to expand its holdings. The Duke faithfully followed the tenets of the *discorso* as he aimed to "cultivate the happiness of all peoples" and preserve for posterity a collection "which serves higher ends than others do." The aristocratic couple set about this task with an enthusiasm increased by what they experienced on their journey in 1776 from Venice, Parma and Turin to Florence, Rome and Naples. Obviously affected by the treasures and beautiful things they had seen, they began to view the world differently, discovering a deep sympathy for older art and the history of culture and the arts.

But another crucial change was needed in the Duke's life before plans could become reality. When Francis I died in 1765, Marie Christine came into a substantial fortune. In addition, Maria Theresa decided that Albert and Marie Christine should assume the position of Governors General

in Brussels — the highest paid post in the Empire — upon the death of Grand Duke Carl of Lorraine, an event which occurred in 1780. Thus the material needs of the young couple were assured. The geographical and cultural position of Brussels also proved invaluable. The spreading revolutionary disturbances in France brought some of the greatest masterpieces onto the market, and because of Brussels' proximity to Paris Albert was able to contact all the dealers and many of the collectors directly. Indeed, France with its strong interest in drawing also proved more and more of a model for his collection. The proximity of art-loving friends, like the young, personable Charles Antoine, Prince de Ligne, also exerted an influence. Prince de Ligne, son of one of the most prominent personalities of the age, had been able to acquire the choicest holdings from French collections such as those of Crozat, Mariette or Julien de Parme. No less important for Albert was neighboring Holland, where Cornelis Ploos van Amstel offered valuable assistance and advice when the Duke purchased drawings of the highest quality. Although London dealers were also very much in evidence, Albert's purchases were concentrated more and more in Paris. We know that Albert acquired works from J. D. Lempereur in 1779 (F. Lugt, *Marques de Collections*, Amsterdam, 1921, no. 1740) and the Chabot auction in 1782 as well as from J. G. Wille (Lugt 2577).

The first large block of Italian drawings, purchased from the Saxon collector W. G. Becker of Dresden who had lived in Italy for a long time, entered the collection in 1784. The following year Albert and Marie Christine visited her younger sister, Marie Antoinette, Queen of France, in Paris. Knowing the couple's passion for collecting, the Queen presented them with a parting gift — a collection of the finest drawings, including outstanding works by Fragonard.

Then came the dramatic end to this period of the Duke's life: the revolutionary upheavals and the murder of Marie Antoinette gave birth to political conflicts that resulted in France's declaration of war. In 1792 the French army clearly took advantage of a propitious moment and attacked Belgium when Emperor Leopold II, probably the most capable of all, died unexpectedly after a two-year reign. The Governors General were forced to flee. Albert and Marie Christine traveled up the Rhine, while three ships, heavily laden with their collection, library and furniture, sailed from Rotterdam to Hamburg. One ship was destroyed in a storm in the English Channel, and Albert was never to recover from this blow. The couple first settled in Dresden because the Duke wanted to distance himself from Austrian policies. In his opinion, the support given to The Netherlands had been more than inadequate, and the indecisiveness among the German states, which prevented a massed response to France, struck Albert as totally flawed. The young Emperor Francis I(II) (Francis II, emperor and king of Hungary and Bohemia, took the title emperor of Austria as Francis I in 1804) can hardly have welcomed such criticism, especially coming from Saxony, for it could have had a serious effect on imperial policy. In any event, Francis invited the

Archduchess, his aunt, and Albert to take up residence in Vienna in 1794. He offered them a small palace with several old houses and part of the dissolved Augustinian monastery, adjacent to the Imperial Hofburg, as a site on which to build a suitable residential palace. This decided the move. In 1801 the important art collection was installed in the new and spacious Albertina Palace, which had been designed by Louis de Montoyer, the Brussels architect responsible for their Belgian residence, Laeken Castle.

During this time Albert bought the collection of his friend Charles Antoine, Prince de Ligne, who was one of the first Austrian officers to be killed in the war against France. His will declared, "My comprehensive collections of prints and original drawings are to be sold to the highest bidder at an auction — they are in fact priceless." The young scholar and official of the Imperial Library, Adam von Bartsch, was commissioned to catalogue and appraise the works, which were stored in Vienna. Bartsch's catalogue is surely a landmark in the development of scholarship. He begins by saying that the collection is definitely "... *une des plus belles, des plus riches, des mieux composée qui ait jamais été faite par un particulier....*" There follows a critical listing which from that moment on became the model for all future scholarship. There was, however, no auction, a circumstance that has never been fully clarified. One thing is certain: the most important pieces entered Albert's collection. It is said that Marie Christine made the purchase possible by giving a substantial sum of money to her husband. Be that as it may, the collectors' marks on the sheets confirm what Adam von Bartsch had said — these were the best pieces from the best collections in the art world.

One last and serious event — the death of the Archduchess — affected the formation of the collection. After only a few years in Vienna Marie Christine became seriously ill and died on June 24, 1798, before the new palace had been completed. Despairing, the Duke withdrew yet more, to the point of total isolation. His wife's deep devotion is recorded in a touching farewell letter: "*Vous étiez le seul objet pour qui je vivais et auquel je désirais être digne de lui appartenir.*" She charged Albert to apply all reason, all philosophy and the knowledge of the inevitable, in order to complete what he had begun, ending with "This your loving wife requests." With absolute fidelity, Albert carried out her wishes and provided for the education of their adopted son, Archduke Carl, the victor over Napoleon at Aspern and Albert's sole heir, financed a home for the blind, constructed a drinking-water system for Vienna and an irrigation canal in Hungary, which transformed 5,700 acres of marsh into productive farming land, and, last but not least, continued building the collection itself. In an endeavor to memorialize his wife, Albert commissioned Antonio Canova, in his estimation the greatest living artist, to erect a tomb of fine Carrara marble in the Augustinian Church next to the Albertina. Napoleon, who numbered it among the three most beautiful works of art, was not alone in his admiration.

Duke Albert ended his official career to lead a solitary

life — *dans une vie moins agitée* — in his fine house with his collections until he died. That this seclusion was to last twenty-four years was the final impulse for the evolution of the Albertina. Later generations described how "the old man spent his days in these sacred rooms, from early morning until late at night, granting himself only as much free time as was necessary for meals and walks. Visiting scholars and artists always found him there, constantly busy with the ordering and expansion of his art treasures." Others described him as a "thin old man in a white Empire wig, blue coat and high boots, with a benevolent face, but with tired, sad eyes, who walked through the rooms alone, followed by a little white dog, when he went to look at his art and drawing treasures."

During this time the annual expenditures on the collection were staggering — wealth on a grand scale was being used for a life goal, for a collection "which serves higher ends." Seen as a whole, the sums are considerable. For example, the Imperial Court's total spending on paintings between 1792 and 1811 was 101,882 florins, an exceptional cultural achievement for an imperial kingdom, especially one in the throes of war. Albert's expenditures as a private collector, on the other hand, were no less than ten times as great; namely, 1,265,992 florins, an exorbitant sum even by today's standards. Albert spent no less than one-quarter of his available means on drawings and prints, a fact that should dispel any illusions that lasting cultural achievements can happen without sacrifice.

In the last decades of his life, the Duke also established a school in Vienna for German artists. Many came, attracted by the opportunity to work under Heinrich Friedrich Fueger and the commissions offered by Vienna's nobility. These artists, in turn, attracted the flourishing printing and lithography shops and artists on their travels to the Alps and Italy.

Albert's extensive connections with the great collectors and dealers of Europe, such as Domenico Artaria (Mannheim and Rotterdam), Frauenholz (Nuremberg) or Zanna (Brussels) proved invaluable for they would continuously present their offerings and search for particular works. As the Duke began buying less for pleasure, his search took on a historical and systematic approach. Albert was known to take the biography of an artist and mark those creative periods from which he owned works and those for which he was still looking. He constantly consulted with his two directors, François Lefèbre and van Boeckhoet, but most often Albert relied on the advice of the curator of the Print Cabinet of the Imperial Court Library, Adam von Bartsch, who was considered the greatest connoisseur of graphic art. Albert chose works very carefully, thoroughly checking the value and the price. What emerged was anything but a chance accumulation; rather, it was a systematic arrangement that eventually formed an overview of the artistic achievements of all eras, all schools and main masters. In the auction catalogues Albert indicated very scrupulously which items would suit him; his written instructions were concise and definite. His collection grew steadily and organically. Then, however, came the fateful years.

In 1796 Emperor Francis I (II) transferred the Imperial Court Library — the nucleus of which was the Dürer sheets from Emperor Rudolf II's time — to Duke Albert. Although the collection from the Imperial Library was "officially" moved for reasons of public interest, and not as a gift, it is generally accepted that the Emperor wanted to compensate Albert, who had been severely affected by the events in Belgium, in a way that would be most valuable to him. The following years brought fortunate acquisitions from Zanna in Brussels, Rogers in London, Ploos von Amstel in Amsterdam, Conte Gelosi in Turin and Saint Ives in Paris; but no acquisition was to enrich the collection as much as the holdings of Count Moriz von Fries, who was forced to sell his treasures when his bank collapsed in 1819. These unceasing efforts to find the works that were most valuable and most important for completing the collection continued to Albert's dying day. In January 1822, a month before his death, Albert spent 3,179 florins for drawings.

For decades he kept all his correspondence, catalogues, *cahiers* (notebooks) and card indices himself. There is no doubt that his great taste and true scholarly attention to detail made the collection what it was at his death (when it was much admired) and what it continues to be today. Duke Albert of Saxe-Teschen died on February 10, 1822, at the age of eighty-four, in his palace on the Augustinerbastei. Although Albert left his entire estate to his adopted son Archduke Carl, he declared his collection to be an entailed estate — a form of ownership that is dissolved by any kind of sale.

Soon after Albert's death, the Emperor ordered a complete inventory and examination of the collection. In an official document, connoisseur Franz Rechberger describes the collection, which was found to be in good condition, as follows:

The number exceeds 13,000 items, kept in 230 portfolios. The collection includes works of the first rank by masters of the four main schools, difficult to find on the market and increasing in rarity with every passing day; in addition a large number of preliminary sketches, often only hasty notations by great artists that bear the stamp of originality and delight artist and connoisseur alike. The authenticity of an equally large number is guaranteed by the presence of the previous owner's mark or name, like those of Crozat, Mariette, Ploos von Amstel, Bianconi, Reynolds [and so forth], names universally revered among connoisseurs, both now and surely for a long time to come. It is a characteristic of most collectors that they strive always to add new names to their lists, which inevitably means that a significant number of weaker works eventually creep in, works whose greatest claim to fame will be to have expanded the inventory. Finally, there is no collection free of dubious pieces and copies, because the greatest masters always have the most imitators. The connoisseur will, however, be amazed at the large number of remarkable, extremely rare and even unique works, and will in the end realize that this collection is not only the result of the money spent on it, but primarily the consequence of a very special and

almost miraculous combination of propitious events, and that it is so to speak the aggregate of various famous collections whose dissolution has been caused by circumstances. It is also the fruit of a long, happy life and an outstanding and immutable love of art.

Rechberger's report of 1822 is still informative after all this time and strikes one as astonishingly modern, for it characterizes the collection as it exists today — the important number of art works of high quality, whose provenance can be traced to famous collections or to the artists themselves (as in the cases of Dürer and Raphael), and the continuing obligation of research and scholarship to work at criticism and better attributions. One thing lies at the heart of this inheritance: the immutable belief in the meaning and value of the arts; the importance of drawing, the most spontaneous and direct of the artistic mediums and the obligation of taking responsibility for the transmission of values. Collecting is indeed more than accumulation; it is central to a humane world.

<p style="text-align:center">* * *</p>

For almost two centuries, Albrecht Dürer's drawings and watercolors have formed the centerpiece of the Albertina, whose history can be counted as one of the most remarkable. This corpus was subjected to every imaginable threat and vicissitude of history, but was constantly attended to by the unremitting efforts of generations to preserve it, admire it and pass it on. I have elsewhere called this a symbolic example of the cultural continuity of old Austria, a cultural achievement that began with an emperor's passion for collecting.

Rudolf II, the son of Maximilian II, ascended to the throne on October 12, 1576. Strictly educated by Jesuits in Spain and highly cultivated, Rudolf II was particularly unfit to cope with a problematic political climate. Because he tended toward melancholy solitude and an almost pathological unsociability, he often withdrew into seclusion and was interested only, but enthusiastically, in the arts and sciences. Although he could not succeed as a ruler (overthrown in 1606), he occupies a unique place in history as a collector and patron of exquisite taste. Rudolf's "Kunstkammer" (treasure house), although now widely dispersed and almost impossible to reconstruct, remains one of the most remarkable cultural achievements. Above all, Rudolf, who lived in Prague, had a predilection for works by Albrecht Dürer, and he directed all his energies toward acquiring whatever was available.

Until his death in 1528 Albrecht Dürer had kept virtually all his drawings in his possession. They were not considered artistic final products like engravings, woodcuts or paintings. Rather, they were a storehouse of forms and images that the artist made for his own use. Contemporaries admired them, and the many inscriptions on them are a confirmation of their importance to Dürer. Dürer's heirs also knew what they possessed. Prospective purchasers appeared, but the group of drawings seems to have re-

mained intact for quite a long time. It is certain, however, that an important part of this Dürer *nachlass* [estate] was in Madrid in 1586, when the aged Cardinal Antoine Perrenot de Granvelle (Granvela), Archbishop of Besançon, died on September 21. His fascinating political career, which included being Minister to Charles V and Philipp II, reached its highpoint after 1547 when he intervened in European politics. He may have acquired Dürer's drawings during this period, but it is possible that this collection had previously been owned by Nicholas Perrenot de Granvela (1486–1550) who, during more than twenty years as an influential Minister to Charles V, would have had ample opportunity to purchase them, even as early as 1530. Much of this is speculation; we do know, however, that Rudolf II very definitely knew of Granvela's holdings.

Upon hearing of Granvela's death, Rudolf II urged Austria's ambassador in Madrid, Count Hans Khevenhueller, to acquire those treasures by Dürer's hand. The ups and downs of these efforts are evident in the letters in the Khevenhueller family archive. Khevenhueller's respectful and devoted loyalty to the Emperor, whose great enthusiasm astonished him, is especially touching. Khevenhueller was finally able to secure the drawings, which arrived in Prague in 1590. In the meantime, Rudolf II had obtained a second group of drawings in 1588 through his painter Hans Hofmann's contact with Willibald Imhoff the Younger. Although the political situation became more precarious, the volumes survived unharmed. Daringly carried to Vienna (1631) across enemy lines, the sheets soon came to rest at the treasury of the Imperial Hofburg, which was a good, relatively secure place.

In 1651 Emperor Ferdinand III (1606–1657) showed the Dürer treasures to the artist and historian Joachim von Sandrart. Sandrart's is virtually the last known reference to the works until 1783 when Adam von Bartsch (1757–1821) had the drawings transferred for educational purposes from the treasury to the print room of the Court Library. An exact description of the volumes was produced which revealed that the Dürer portfolios contained 371 sheets. Admittedly, not all of these could have been by Dürer, and there were some forgeries and copies, such as the *Old Man* with a false date. Still, Bartsch began to classify the drawings. As already stated, the Dürer sheets were acquired by Duke Albert in 1796 and from that moment on they formed the focal point of the collection.

The next century brought more than enough drama. In the first decade of that century the collection was seriously harmed by the actions of a disloyal employee, François Lefèbre. While Albert was away, Lefèbre sold a large portion of the drawings to English and French dealers. One of his best clients probably was Vienna's French governor in 1809, Antoine F. Andreossy, who at his death owned 100 Dürer drawings(!).

Albert's heirs treated the collection with the greatest respect and responsibility, faithfully passing on the entailed trust. Moriz von Thausing (1838–1884), the scholar and director of Albert's collection who coined the term *collectio Albertina*, made the greatest scientific contributions. His large publication of 1876 on Dürer, which is still a fundamental book, was his most important work. The exhibition that he conceived and implemented for the 1873 World Exposition in Vienna laid the basis for the worldwide fame the collection would come to enjoy. The collection's renown was actually propelled forward by the important work of Josef Meder (1857–1934) and the development of the Albertina facsimile. Meder, a distinguished scholar who devoted his life to the study of drawings, was the author of Volume V of Lippmann's corpus, an extraordinary seven-volume work published in Berlin between 1883 and 1928 and devoted to Dürer's drawings, all reproduced in facsimile. Volume V is devoted exclusively to the drawings by Dürer in the Albertina, catalogued by Meder while he was director of that institution.

The phrase Albertina facsimile is not, in fact, a reference to the palace that houses the collection in Vienna, but to the inventor of the process of reproduction used, Josef Albert of Munich. It is a planographic process using multiple plates, later called photo-type and today known as collotype. It was through this publication of superb facsimiles that the Albertina's treasures became firmly fixed in everyone's mind.

Word of the Albertina's Dürer collection rapidly spread through exhibitions and publications. While Thausing's first exhibition in 1873 displayed only twelve sheets, Josef Meder's first comprehensive Dürer exhibition (1899) showed eighty-two drawings that were selected and arranged chronologically to outline the artist's life and work. Attendance, however, was disappointing and can surely be attributed to a lack of information. The reviews, on the other hand, were most enthusiastic. Now began the task of gradually educating the public, whose numbers increased steadily until the outbreak of World War I. The collection was closed; Archduke Frederick went to the Russian front as commander-in-chief; and the Dürer collection was moved into secure bank vaults where it survived the collapse of the monarchy. When the collection returned home, it was to the beginning of a new era.

Never in the previous two centuries had the Albertina come so close to dissolution and destruction as it had in the wake of the collapse of the monarchy in 1918. The danger began with plundering in November 1918. The worst was to be feared, and yet the real danger came from quite another quarter: Article 197 of the Treaty of Saint Germain had deemed Austria's entire art holdings to be security for reparation payments. Although an allied commission did indeed come to the Albertina to take possession of the treasures, a small chance event, namely, the refusal of admission to the bank safe, brought the whole business to light. The public rallied; the Austrian parliament began researching the question; the Viennese newspapers appealed for help and were heard around the world. Their first support came from Marcel Dunan. On April 8, 1920, he

wrote in the Parisian *Le Temps* that it would be a great mistake were the Entente powers to create a desert in Austria. The great Dürer scholar, Hans Tietze, who was an official in the ministry, was perhaps the most important voice:

> *Let no one try to hide from the fact that the Albertina is completely irreplaceable. A paintings collection or other art collection is only a question of unlimited financial resources, but an Albertina can, if destroyed, never again be created. It is not only the pride of Vienna and materially as well as culturally one of the most positive assets in Austria's balance sheet, but it is at the same time one of the greatest treasures in the area of German culture. The whole world has an interest in its preservation, Austria is responsible to the whole world for its preservation.*

Tietze's decisiveness and Duke Albert's stipulation that the collection never leave Austria had their effect on the government, on parliament and on those negotiating the victorious allies' claims; soon all plans that would have caused irreparable damage were abandoned.

In 1920 the Austrian government decided to unite its two major graphic collections — the one at the Imperial Court Library built by Adam von Bartsch and the other, of course, the Albertina. The Imperial Print Cabinet had always been a part of the Court Library, which itself goes back to the first half of the fifteenth century. Its core was formed by the very special collection of Prince Eugen von Savoyen (1663–1736), who had been richly rewarded for his victory over the Turks. Possessing excellent artistic taste and interest, Eugen had brought the very talented Pierre Jean Mariette (1694–1774) from Paris in 1717 to build a rich collection systematically. This was the origin of those much admired 290 volumes bound in red morocco leather with gold-tooled crests. Eugen died intestate, so the Emperor had the final decision about the fate of the print collection. Anna Vittoria von Savoyen received the inheritance and squandered it without delay. Charles VI acted as decisively as he could by purchasing Belvedere Castle, the famous library, the palace in town and also the print collection. The importance of Mariette's preparatory work and its further development by Bartsch needs no explanation: the basis for an entire scholarly discipline was created here. The idea of the *peintre-graveur*, the notion that graphic work can indeed be original and not merely a reproduction, finds its origins here. This is not the place to review Bartsch's importance, but it must be stressed that his Print Cabinet made, in Frits Lugt's words, *une marriage fantastique* when united with the Albertina.

In 1935 a very strange situation arose. The last trustee of the entailed estate, Archduke Frederick, had a son who lived in Hungary and South America. In a veritable coup, this man, Albrecht von Hapsburg-Lothringen attempted to entrust the sale of the Albertina to the London art dealer Gustav Meyer, who was acting in good faith. (For a full account, see Henry P. Rossiter's article, "The Albertina for Boston?", *Apollo*, no. 96, p. 135–47.) In the interim we have found the confidential file on the Austrian side, which confirms the extraordinary behind-the-scenes activity. Be that as it may, the Albertina was fortunately saved and even began to thrive in an unprecedented fashion.

During the difficult years of the 1920s, 1930s and 1940s, the directors and their industrious and efficient colleagues continued to carry out scholarly work in spite of the innumerable external circumstances associated with a depressed economy and war. During World War II they successfully completed a salvage operation of great magnitude — the successful relocation of 1.5 million works of art on paper from the Albertina to the salt mines near Hallein. Everything was saved. Duke Albert's palace was, however, largely destroyed on March 13, 1945, by several bombs during the worst destruction of Vienna's inner city. Fortunately there were no works of art inside at the time. Reconstruction work began immediately after the end of the war, but the division of the country into four zones created grave problems for the collection. The safe return by the American troops of all the art treasures will forever remain a remarkable and unforgotten contribution to culture. When Otto Benesch returned in 1947 from the United States, where he had lived and taught during the war, the massive task of reconstruction began, leading to the Albertina's present position.

Over the past decades an institute has been formed — I myself have been director since 1962 — that consciously assumes the traditional obligation of uniting the preservation of treasures in our care with scholarship and publication. We believe that there is a meaning in the fortunate history of this collection, fortunate that so much misfortune was avoided and that many auspicious contributions led to successful achievements, to greatly increased interest and to an esteemed position in cultural life. One of the finest collections in the world, in its noble setting at the center of Vienna, has been passed on to our generation so that that meaning may be fulfilled in our time and in our way. The Albertina will again be handed on in the effort to perpetuate its essential idea by planting it in the minds of as many people as possible. Art, we believe, is part of life, a central one in fact. It is the concentrating and deepening of life, but it is this only when it is alive, sought after, loved and used, . . . only when there is a bridge between the work and viewer — in short, when there is a collection that fulfills its living function.

Walter Koschatzky
Director

GERMAN SCHOOL

I

UPPER GERMAN (RHENISH?) MASTER (active c. 1430–1440)
St. George and the Dragon

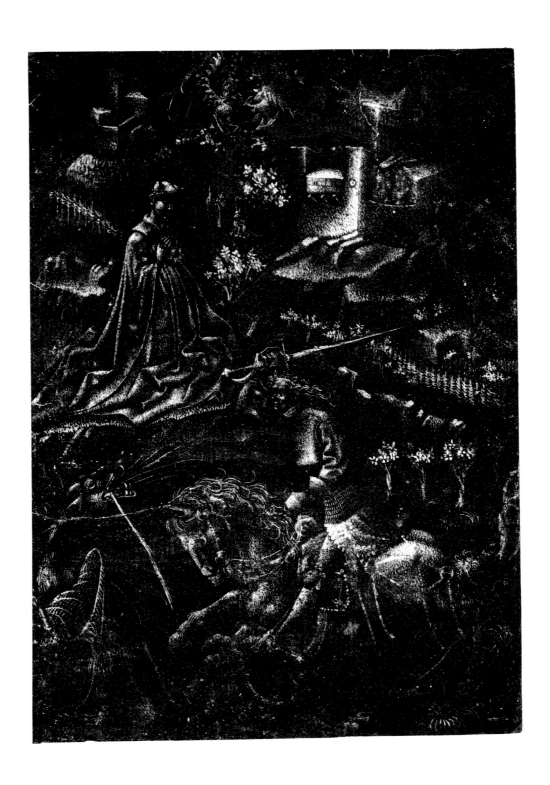

2

UNKNOWN GERMAN MASTER (active end of 15th C.)
Portrait of a Man

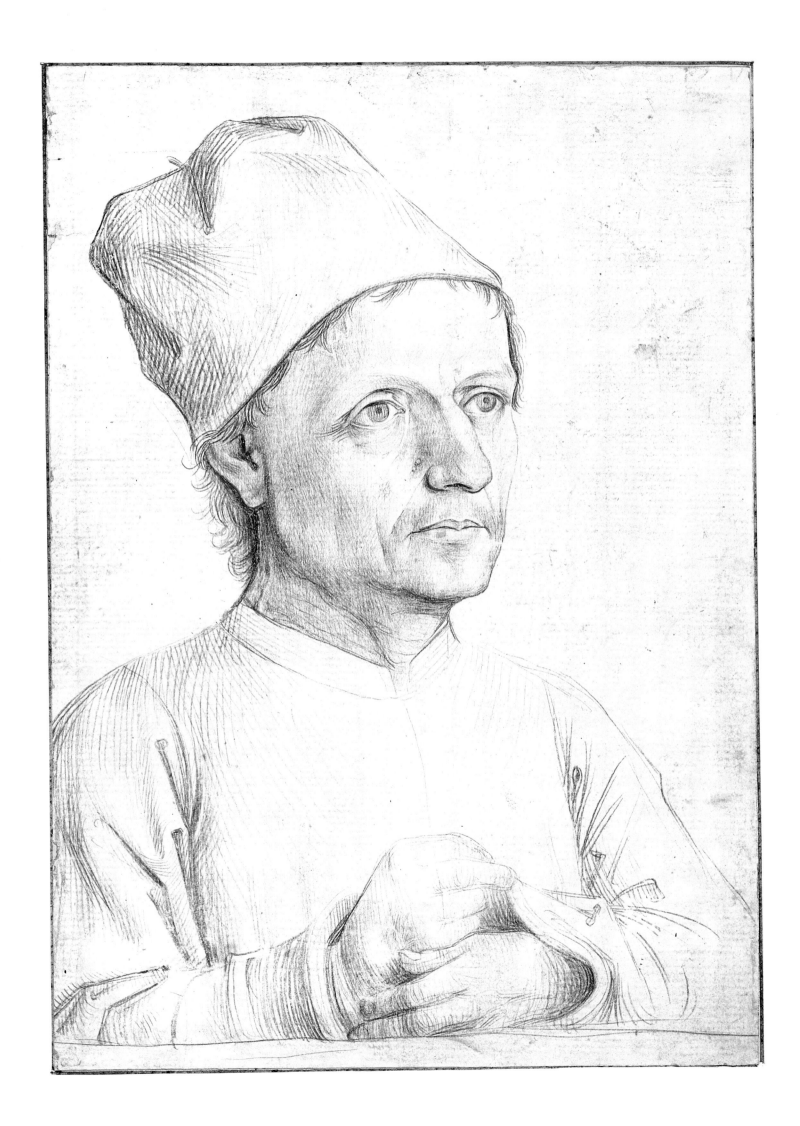

3
ALBRECHT DÜRER (1471–1528)
Studies of Hands

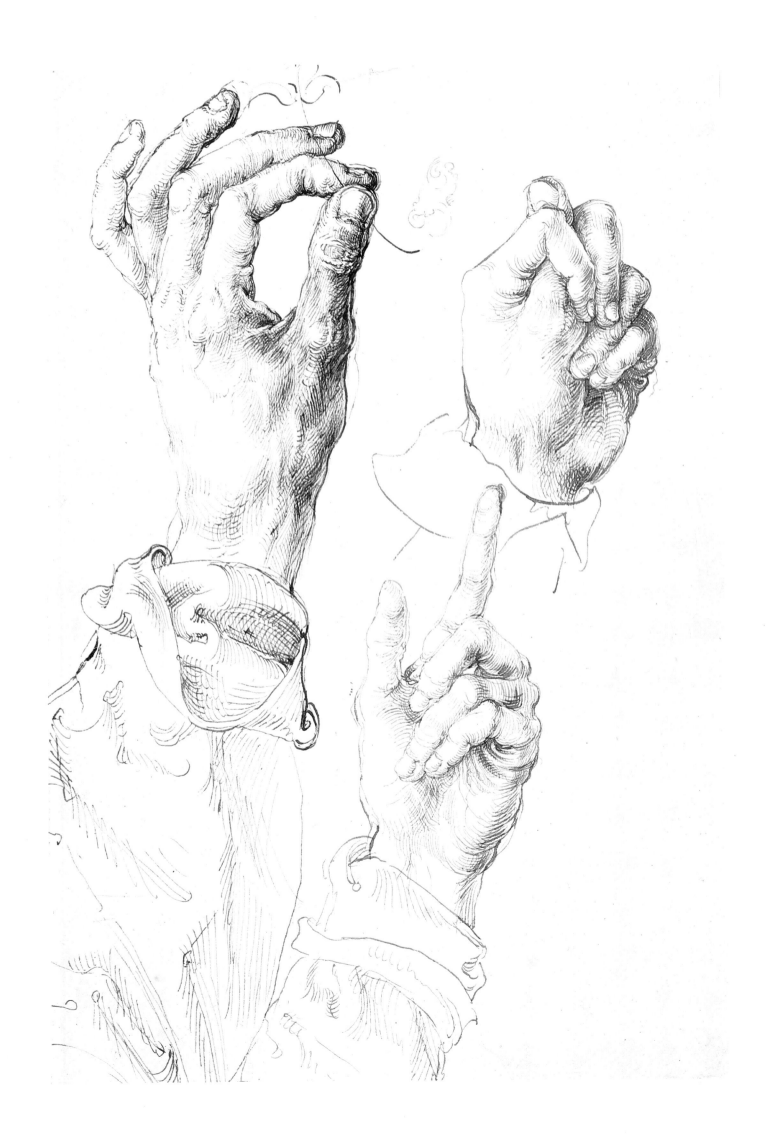

4

ALBRECHT DÜRER (1471–1528)
Knight on Horseback

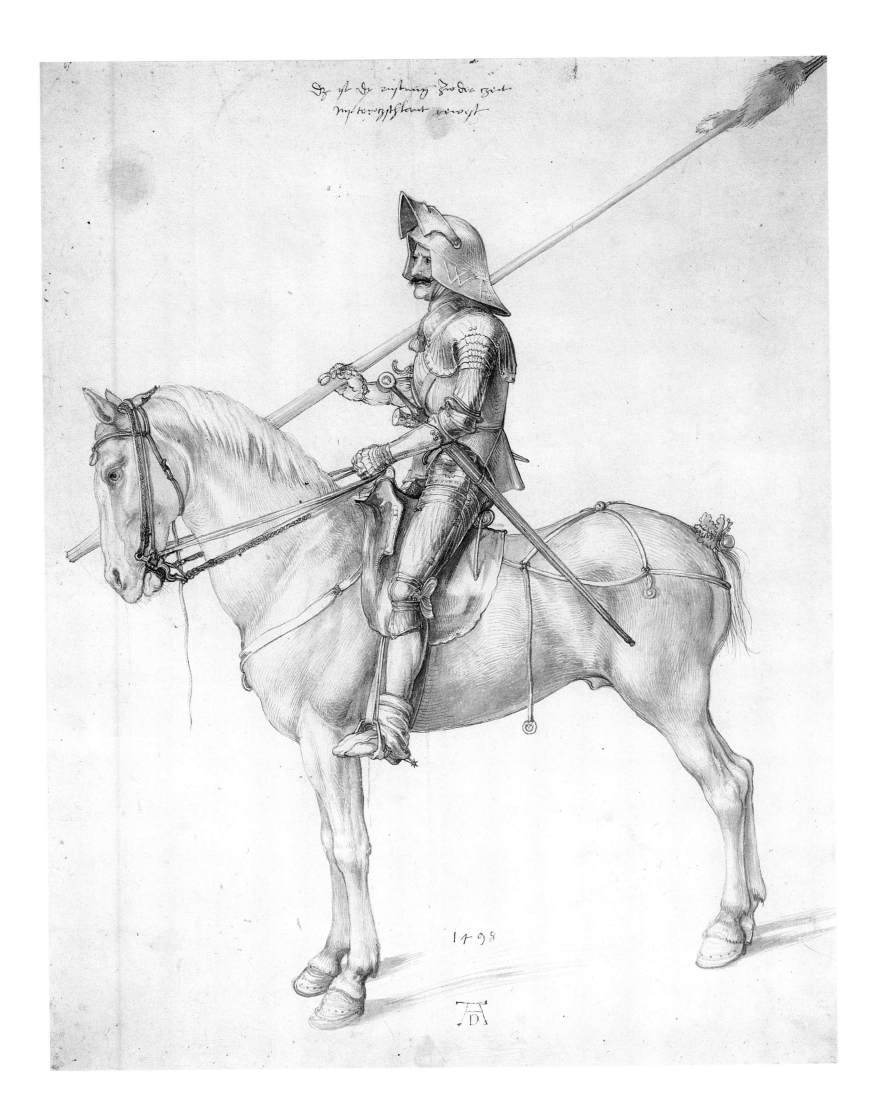

5

Albrecht Dürer (1471–1528)
Head of an Apostle

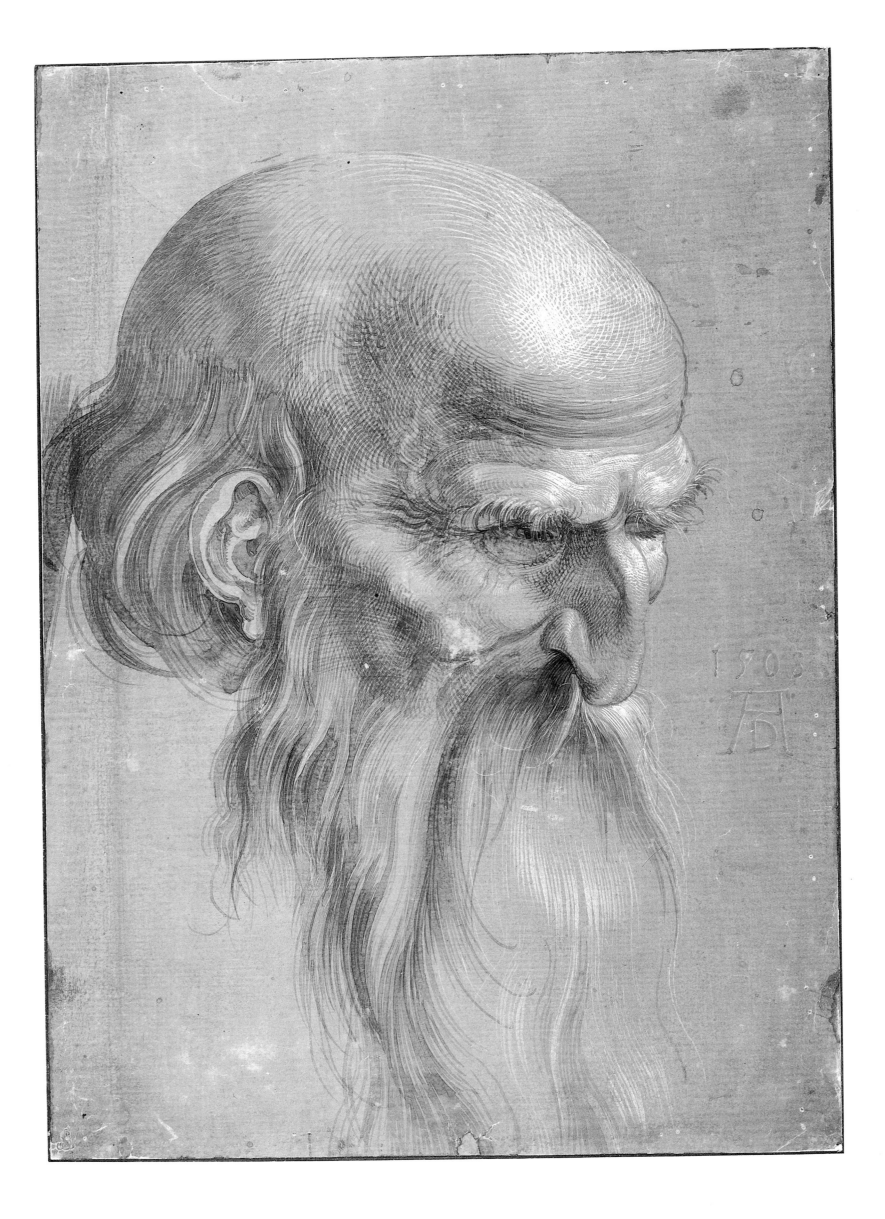

6

ALBRECHT DÜRER (1471–1528)
Drapery Study

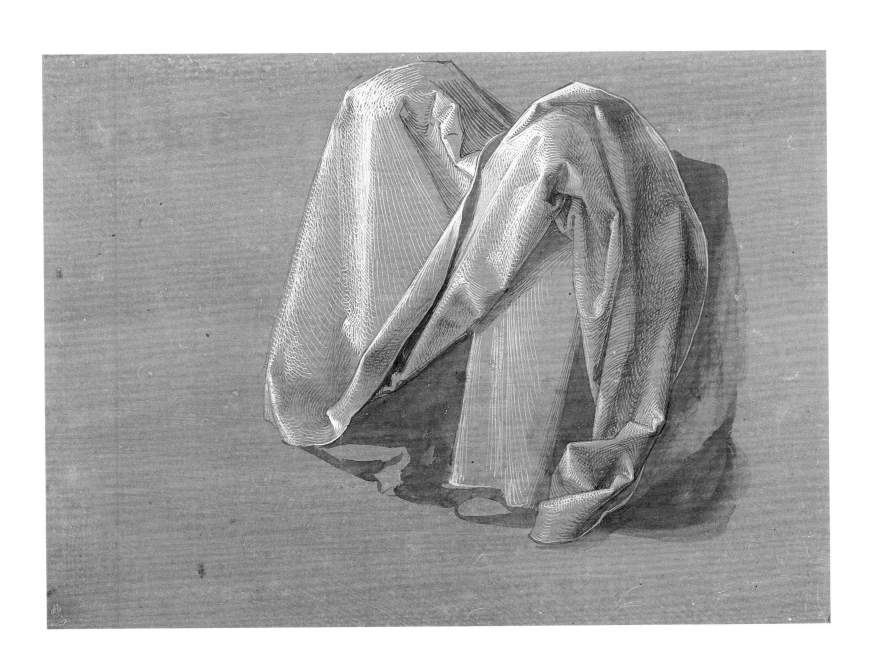

7

ALBRECHT DÜRER (1471–1528)
Praying Hands (Study for an Apostle)

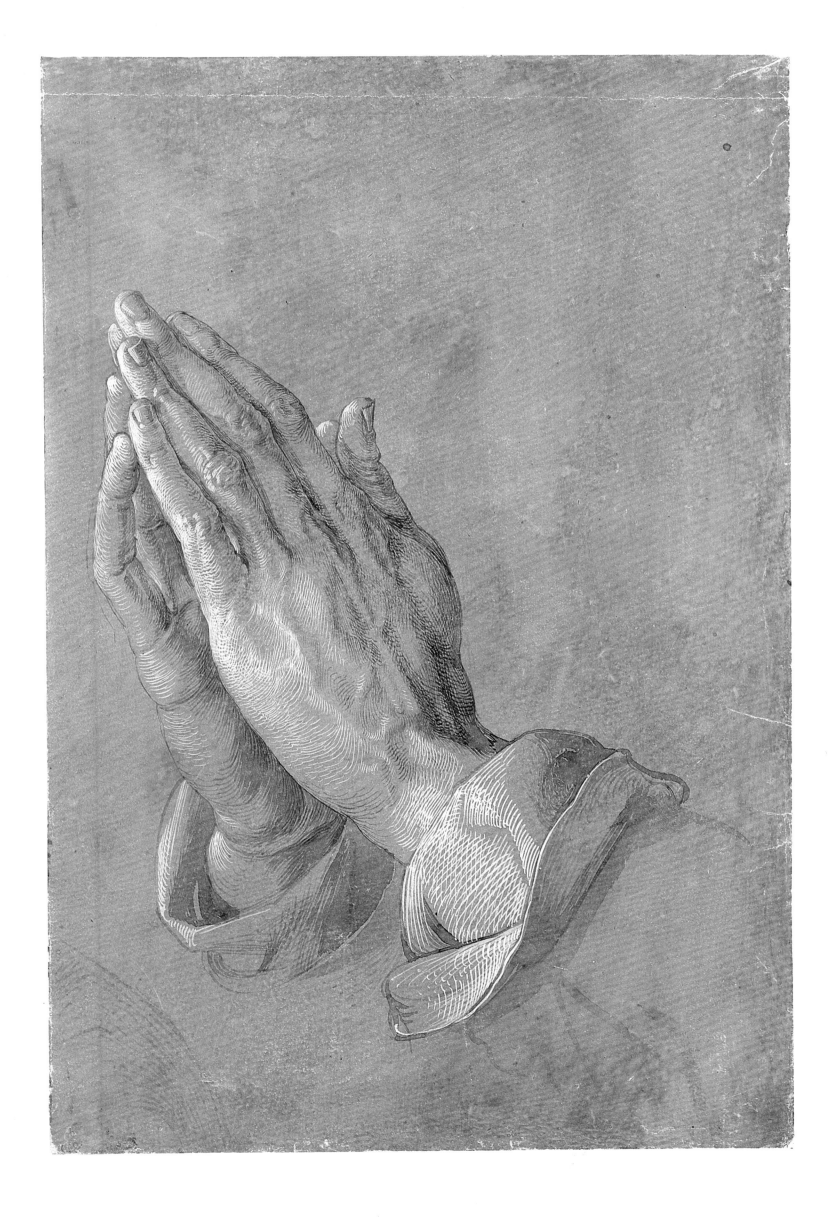

8

Albrecht Dürer (1471–1528)

The Virgin and Child with Saints

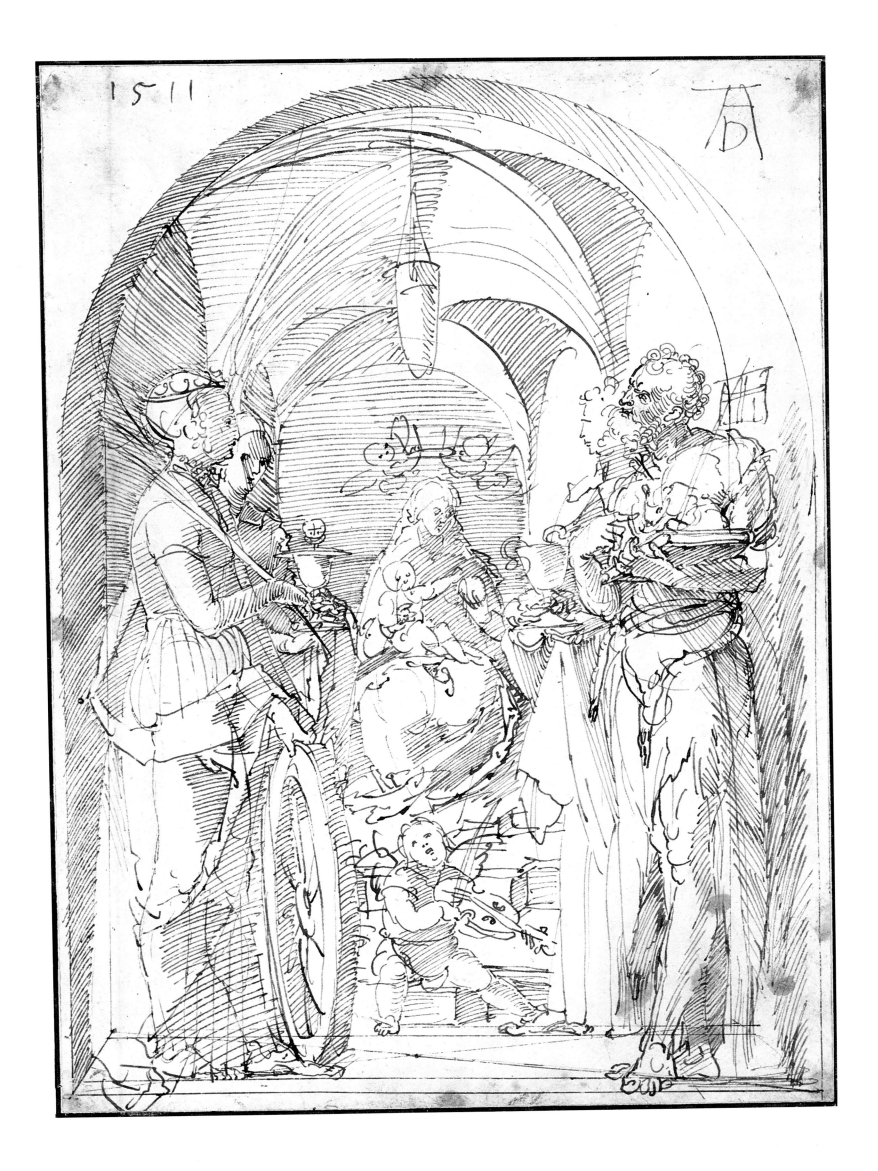

9

ALBRECHT DÜRER (1471–1528)
The Virgin Nursing the Child

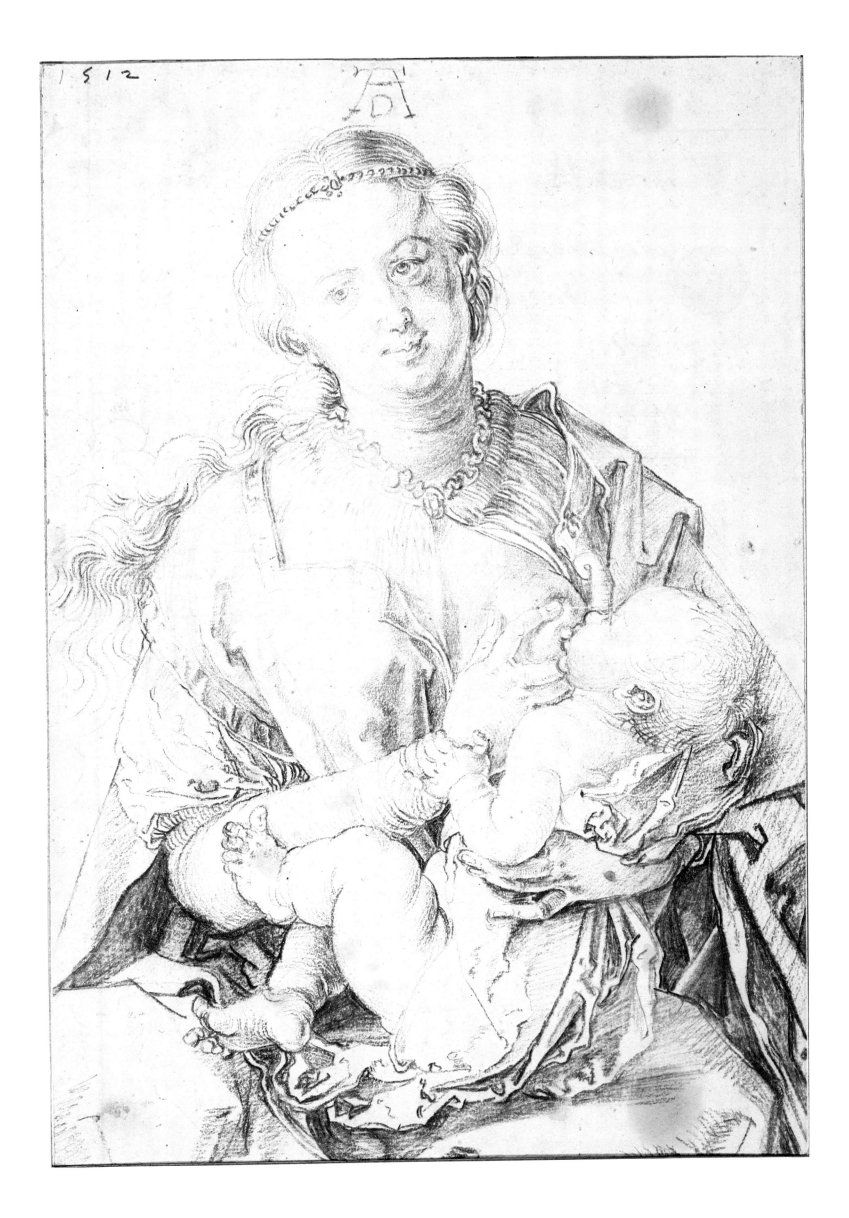

10

ALBRECHT DÜRER (1471–1528)
Head of a Black Man

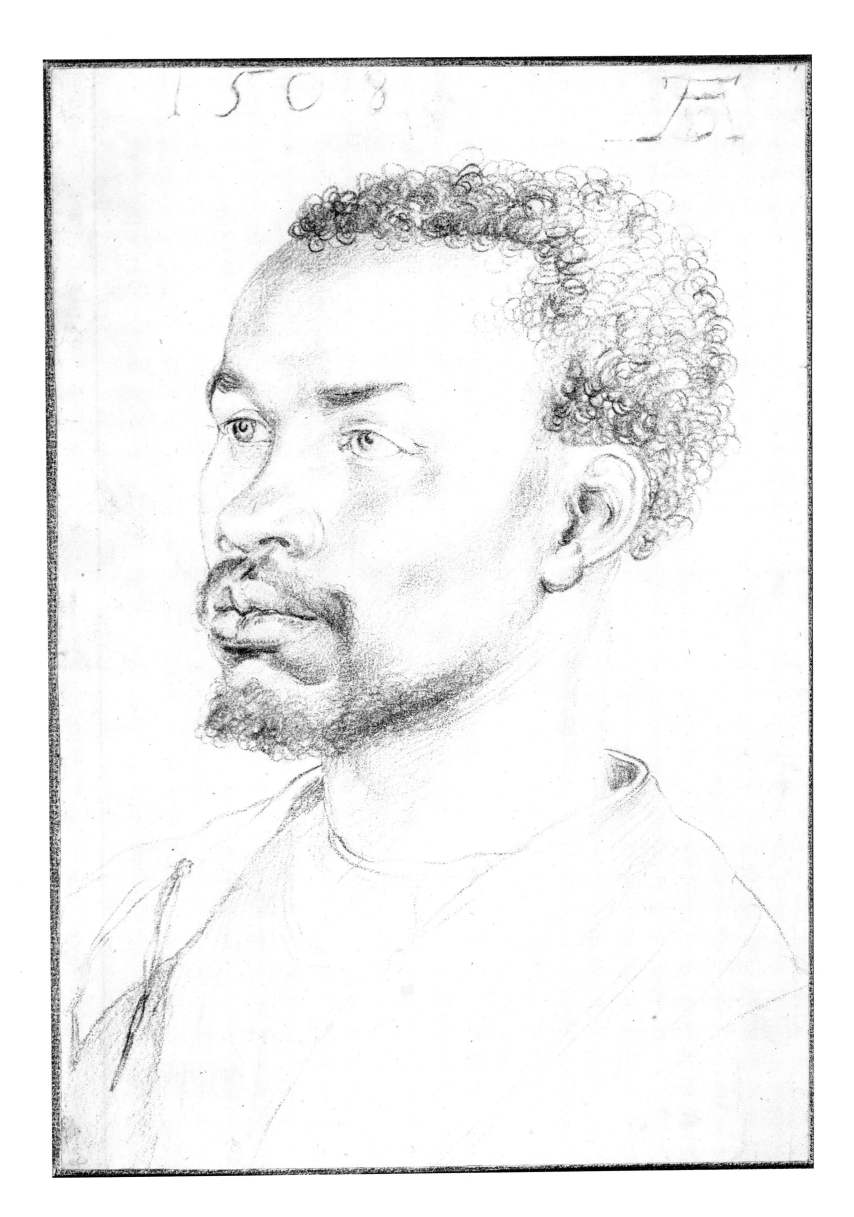

11

ALBRECHT DÜRER (1471–1528)
The Italian Trophies

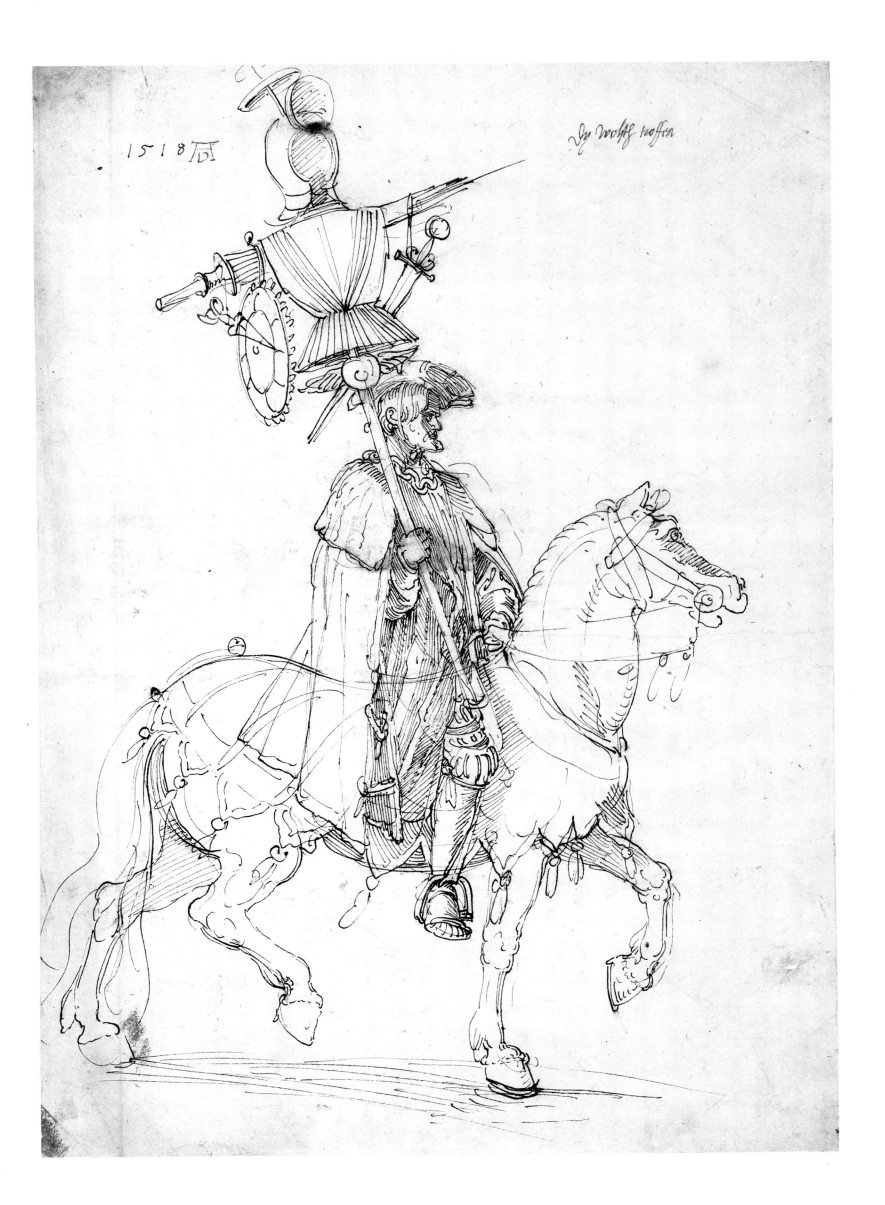

12

ALBRECHT DÜRER (1471–1528)
View of Antwerp Harbor

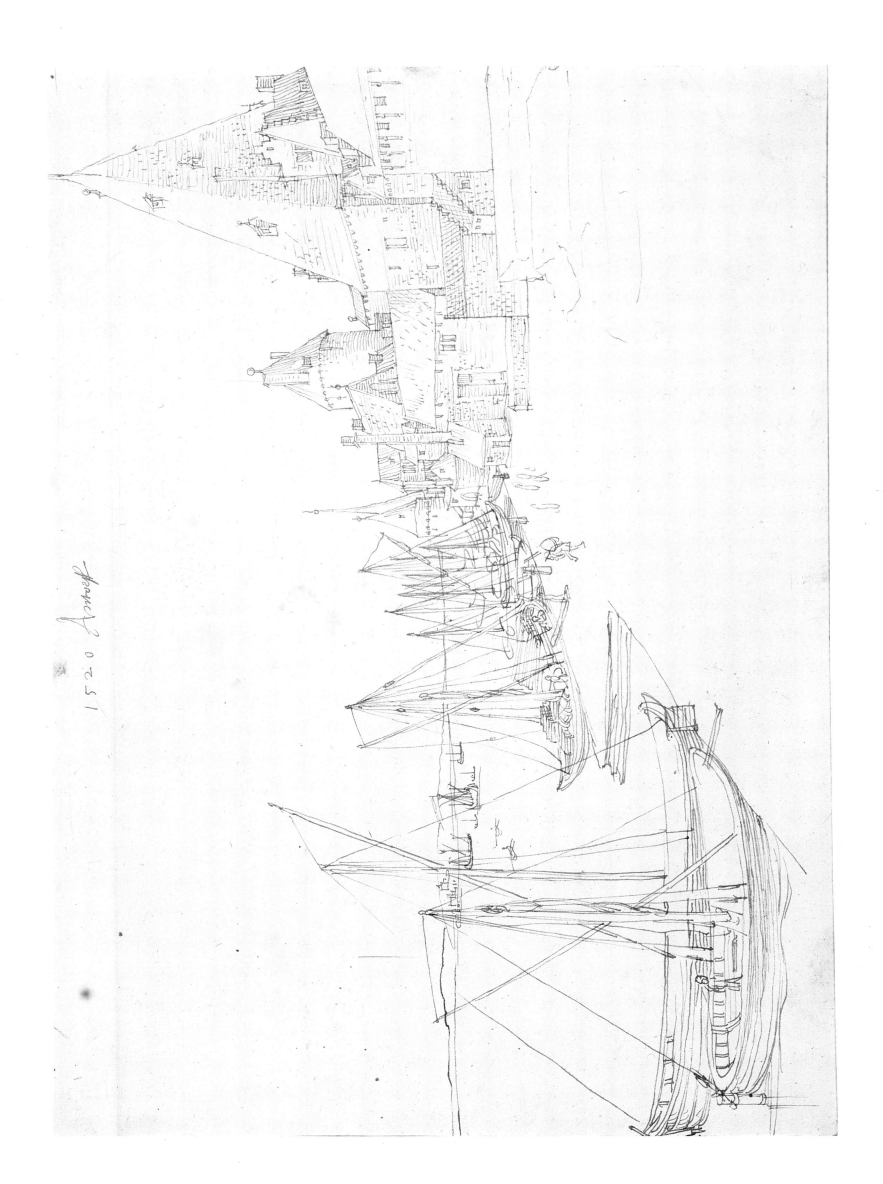

1520 Antwerp

13

Hans Süss von Kulmbach (c.1480–1522)

The Adoration of the Child with St. John the Baptist and St. John the Evangelist

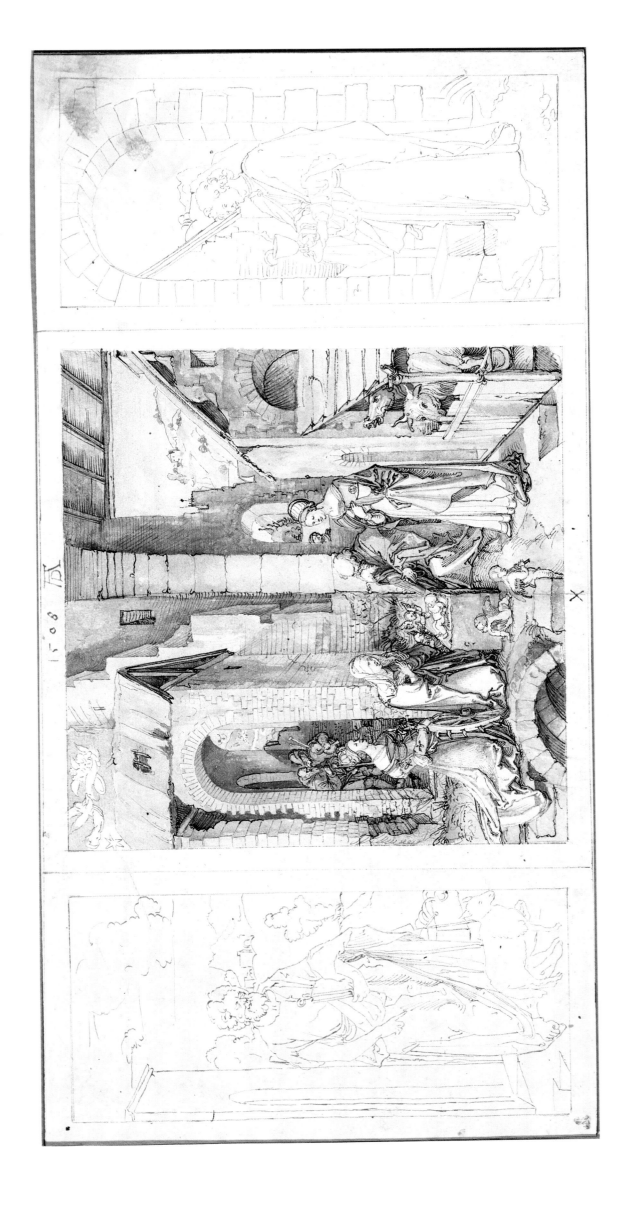

14

ALBRECHT ALTDORFER (c.1480–1538)
The Sacrifice of Isaac

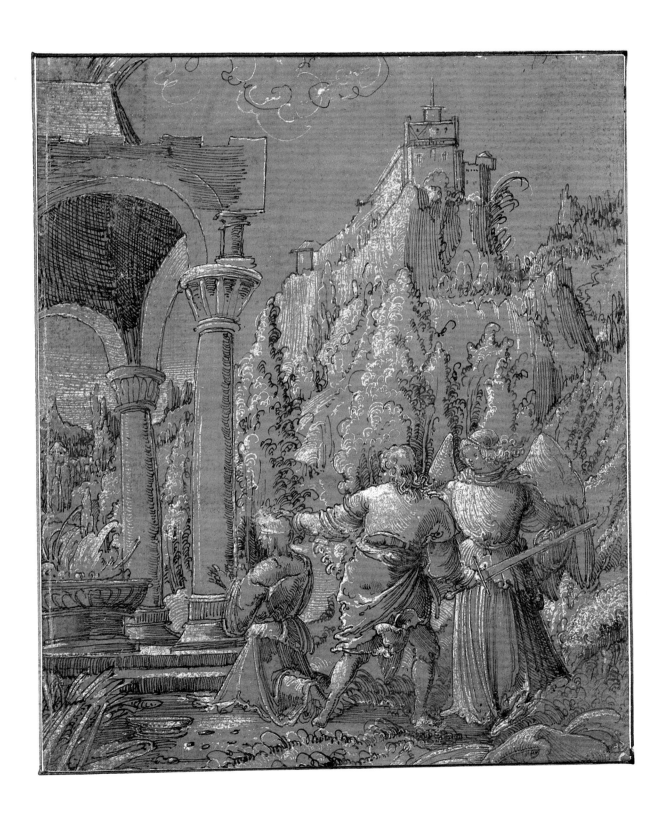

15

Hans Baldung, called Grien (1484/85)
Witches' Sabbath II

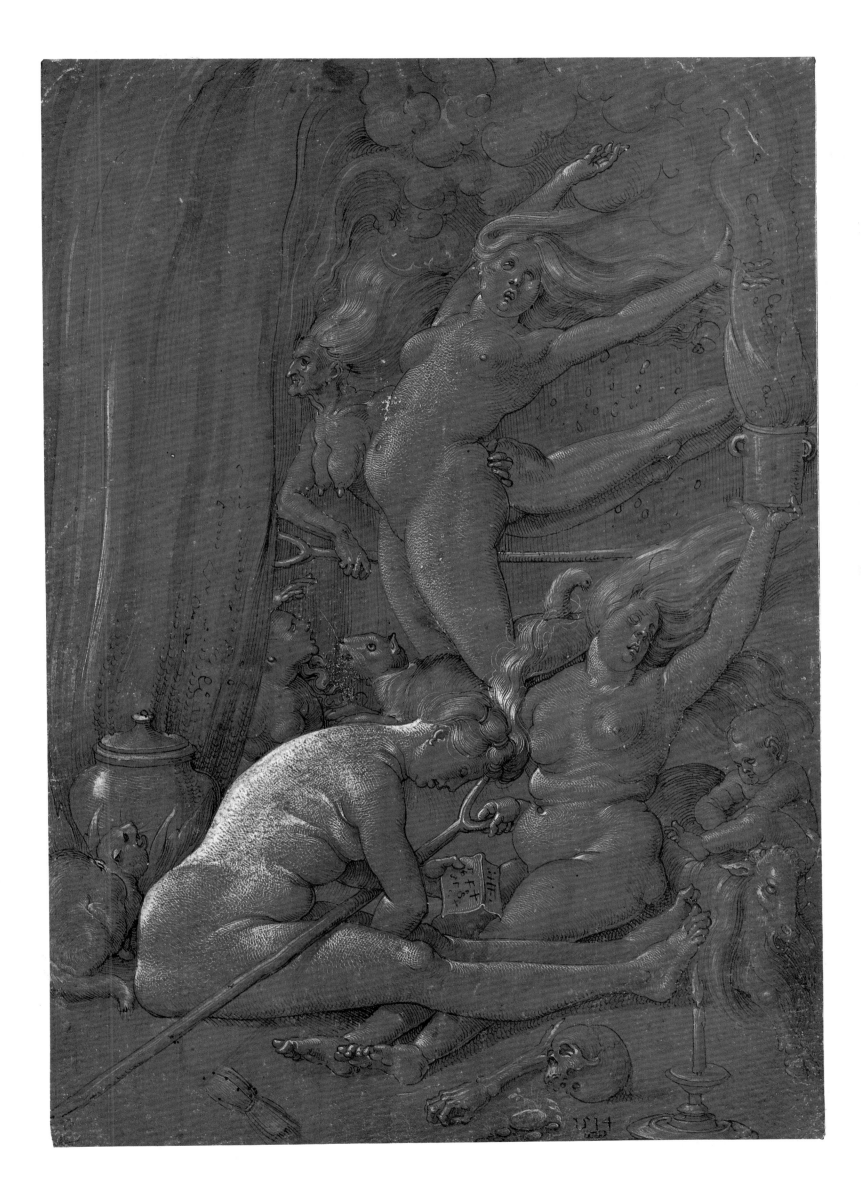

16

HANS BALDUNG, called GRIEN (1484/85)
Head of Saturn

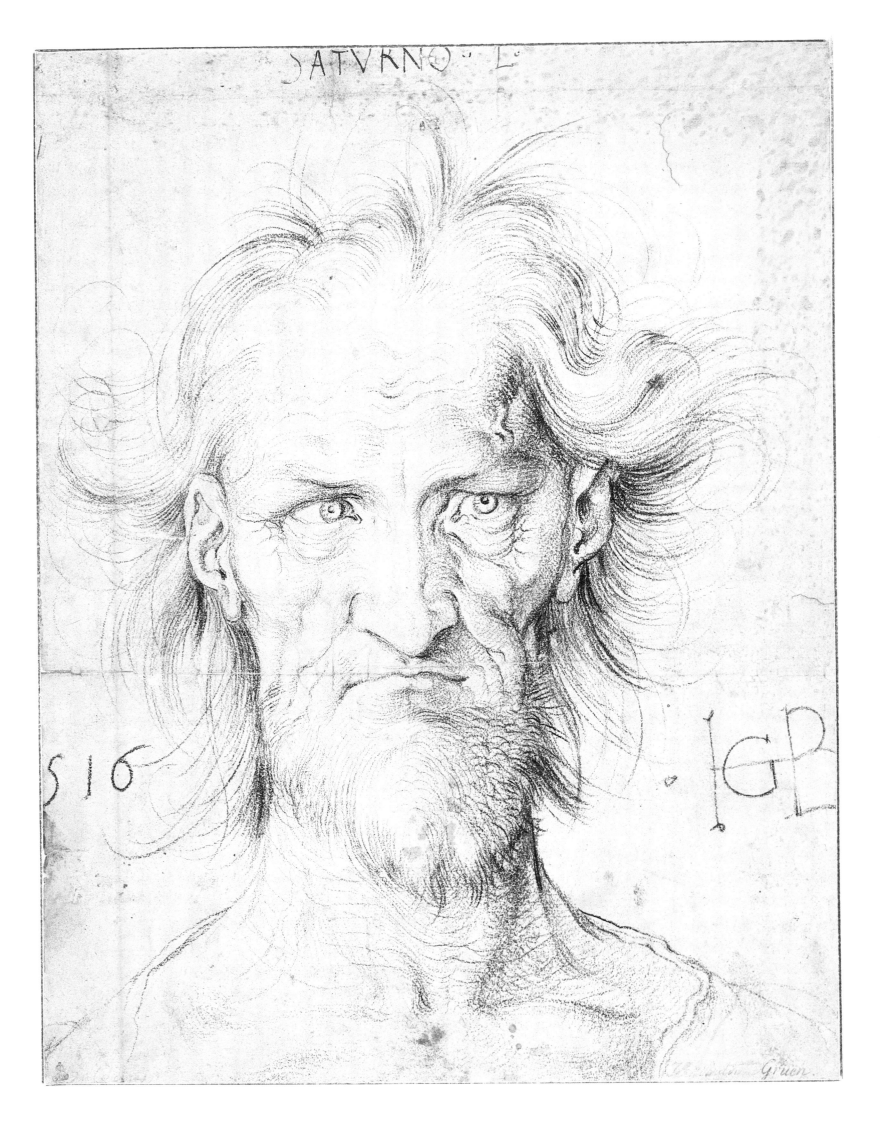

17

URS GRAF (c.1485–1527/29)
Woman Wading a Stream

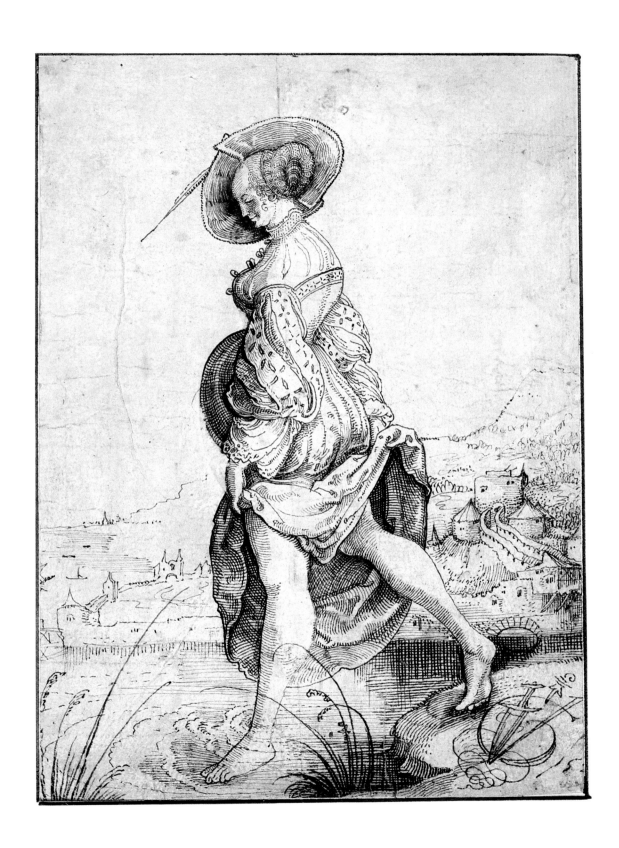

18

HANS HOLBEIN THE YOUNGER (1497/98–1543)
Two Angels Holding an Escutcheon

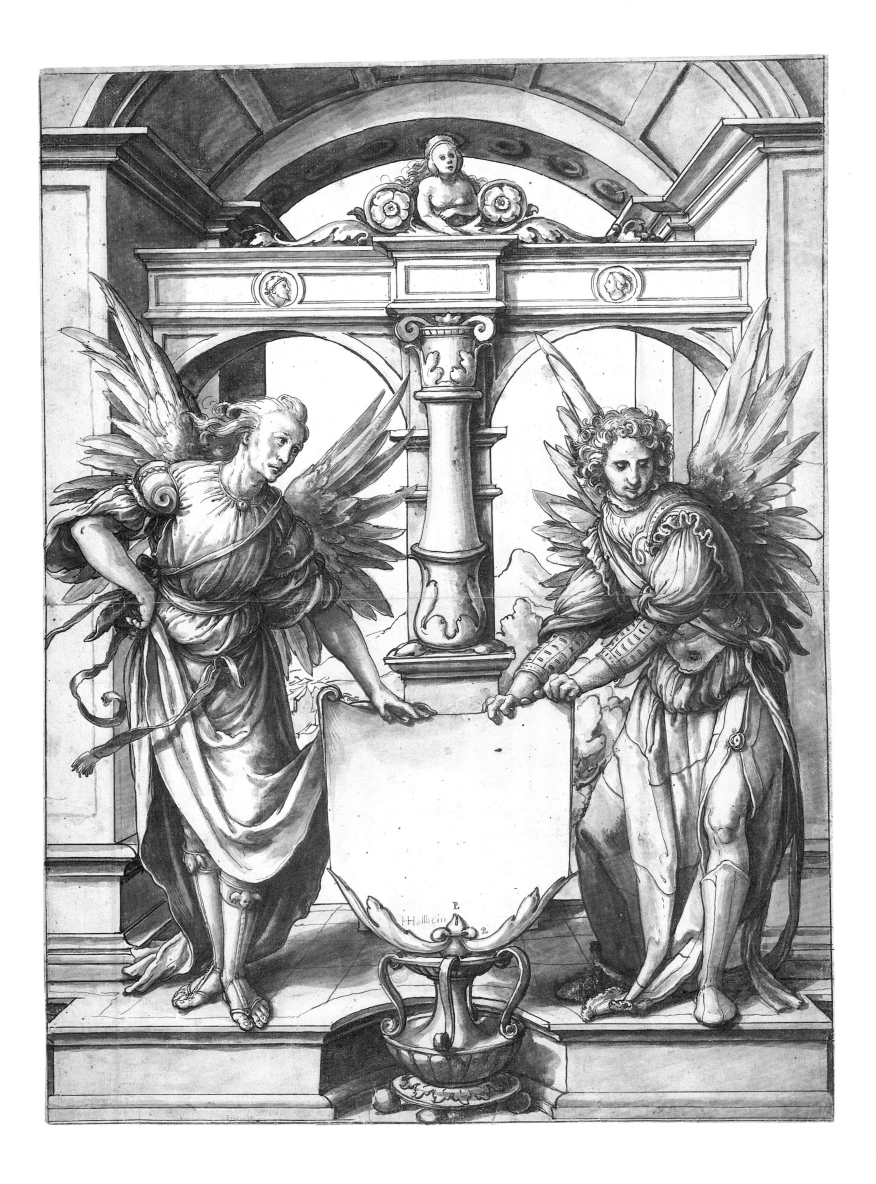

19

ERHARD ALTDORFER (attributed to) (c.1480–1561/62)
Panoramic Coastal Landscape

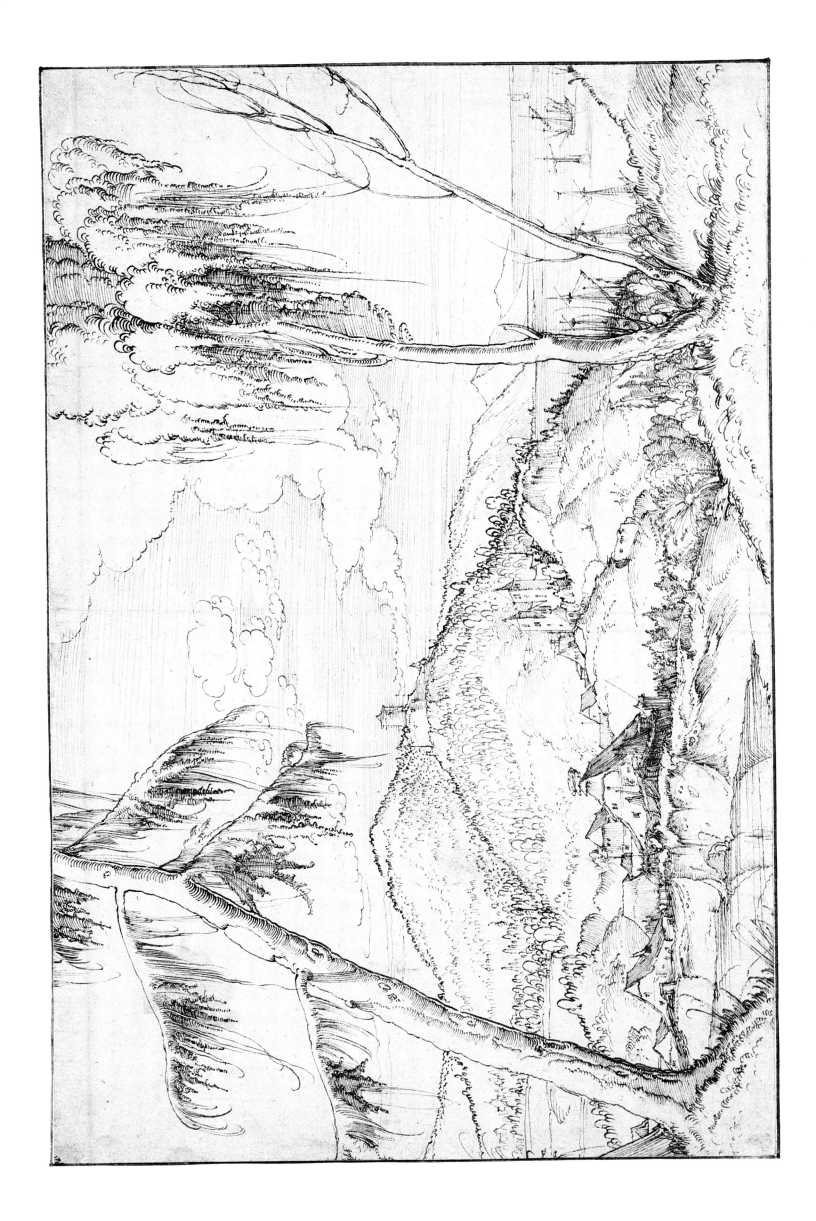

20

WOLF HUBER (1480/85–1553)
Bust of a Woman

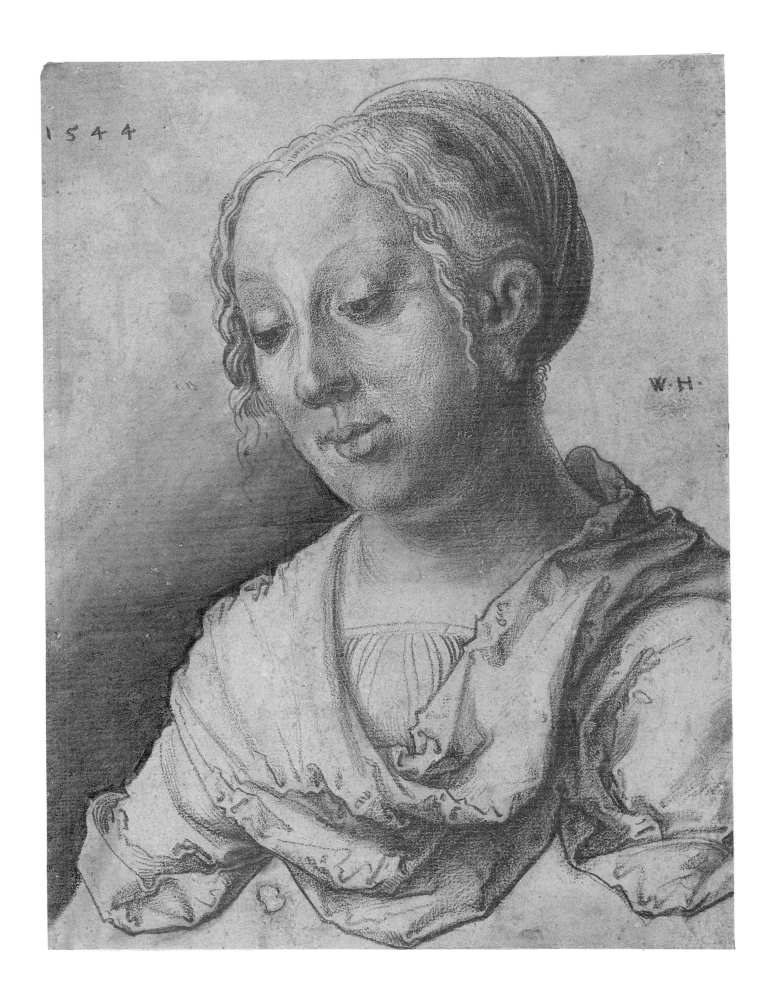

21

LUCAS CRANACH THE YOUNGER (1515–1586)
Portrait of Prince Alexander of Saxony

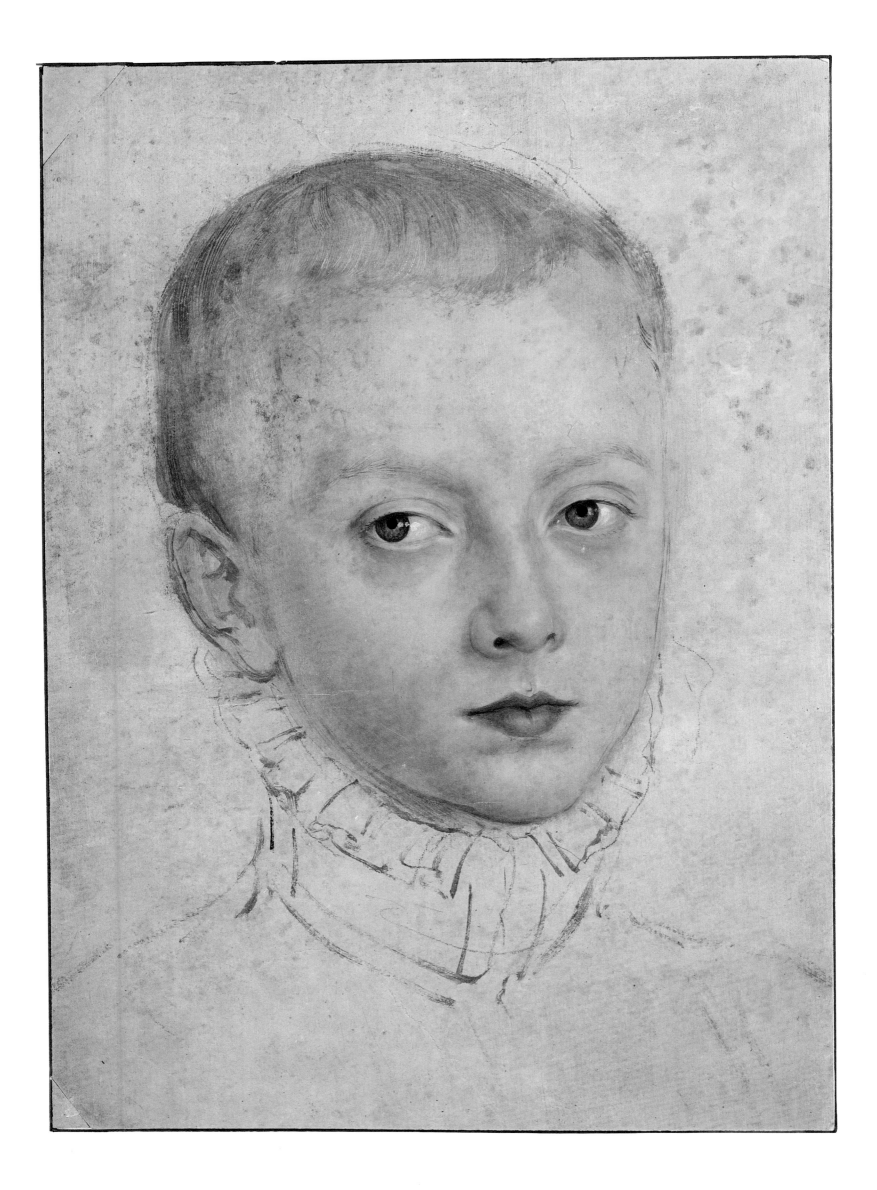

NETHERLANDISH SCHOOL

22

NETHERLANDISH MASTER (Fourth quarter of the 15th C.)

The Carrying of the Cross

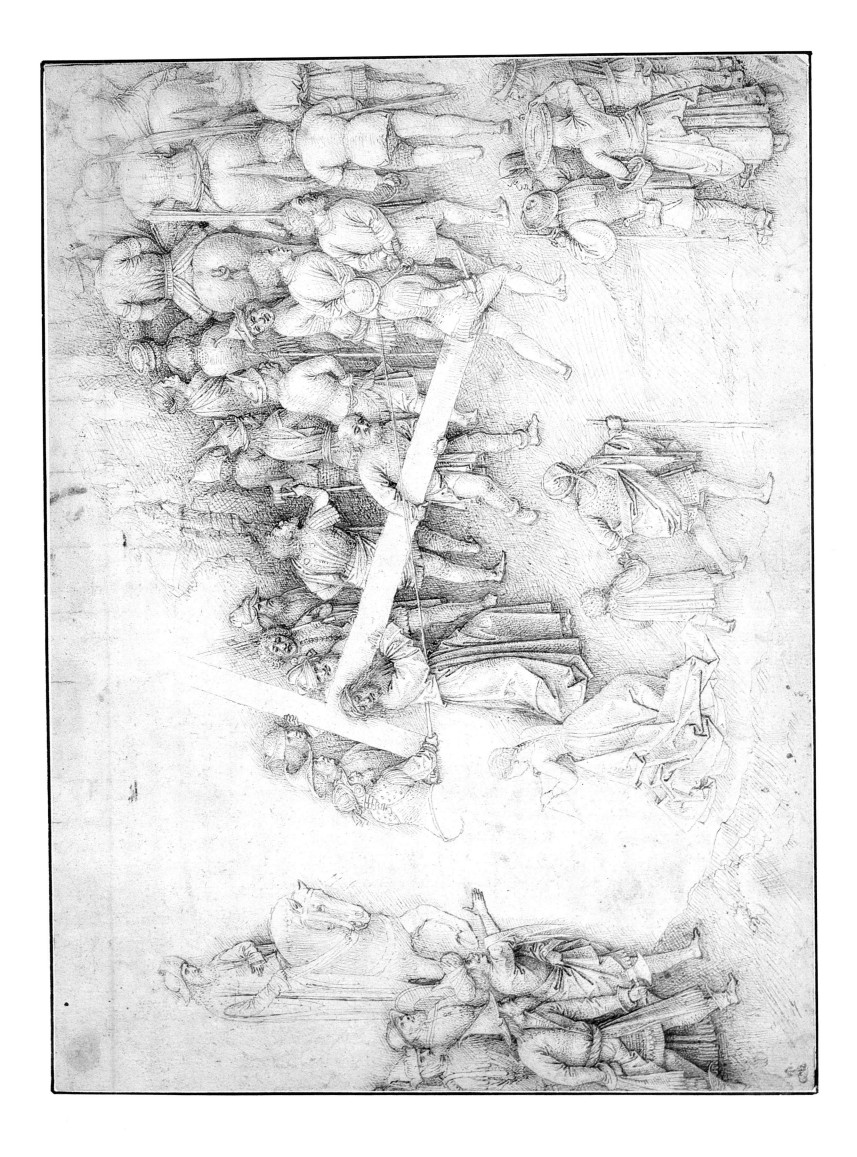

23

JAN GOSSAERT, called MABUSE (1478/88–1532)
The Fall of Man

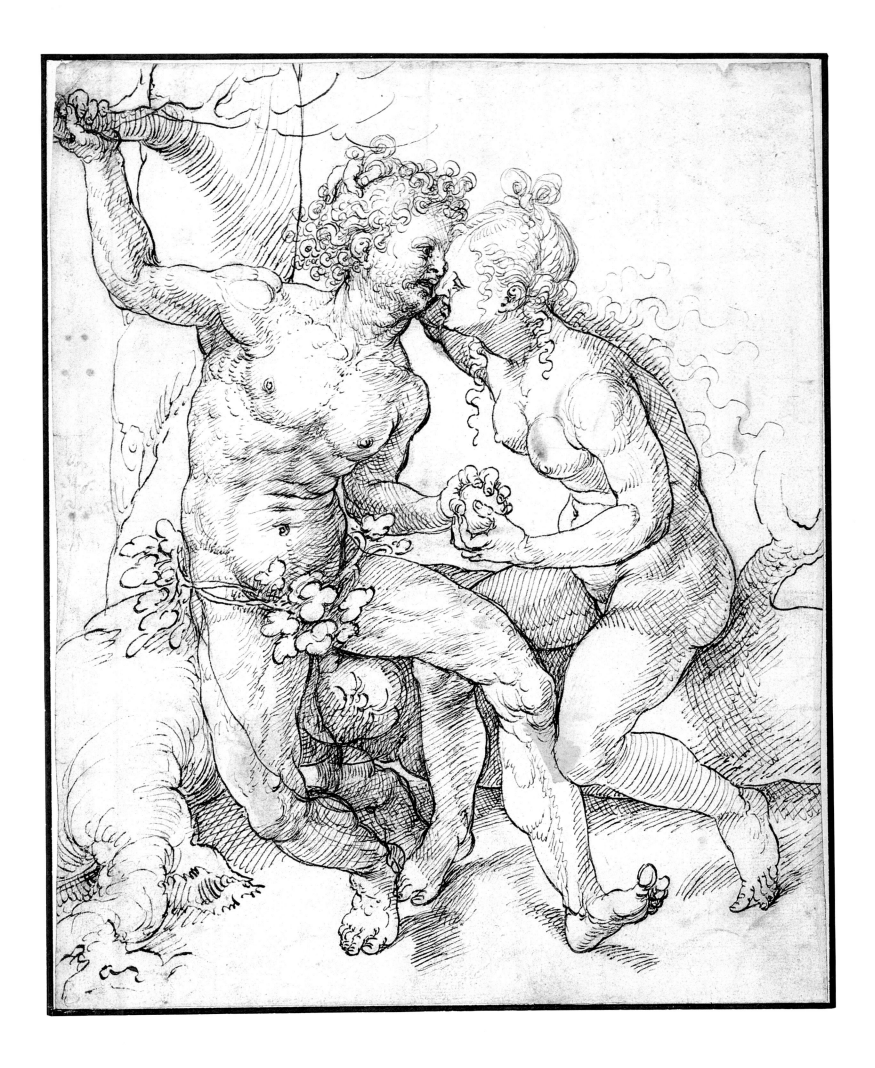

24

Pieter Bruegel the Elder (1525/30–1569)

Spring

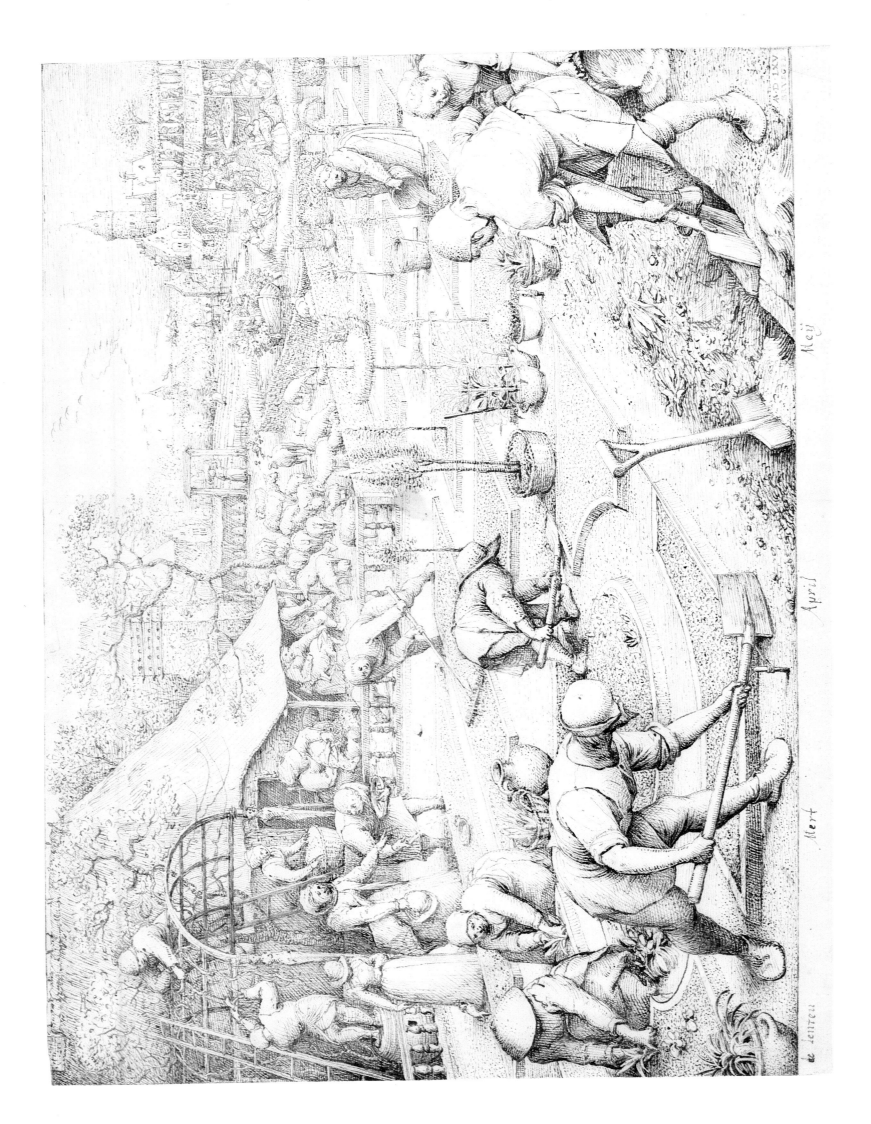

de Lenten Mert April Mey

25

PIETER BRUEGEL THE ELDER (1525/30–1569)
Painter and Connoisseur

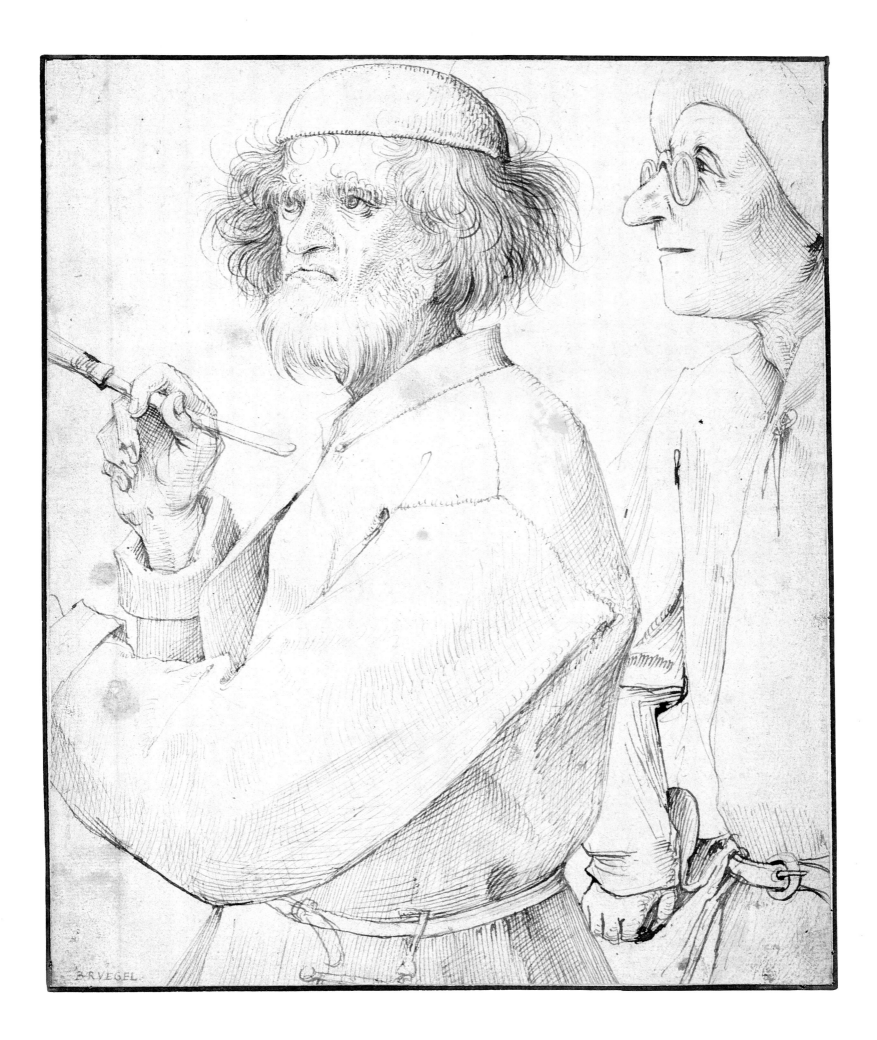

26

HENDRICK GOLTZIUS (1558–1617)
Self-portrait

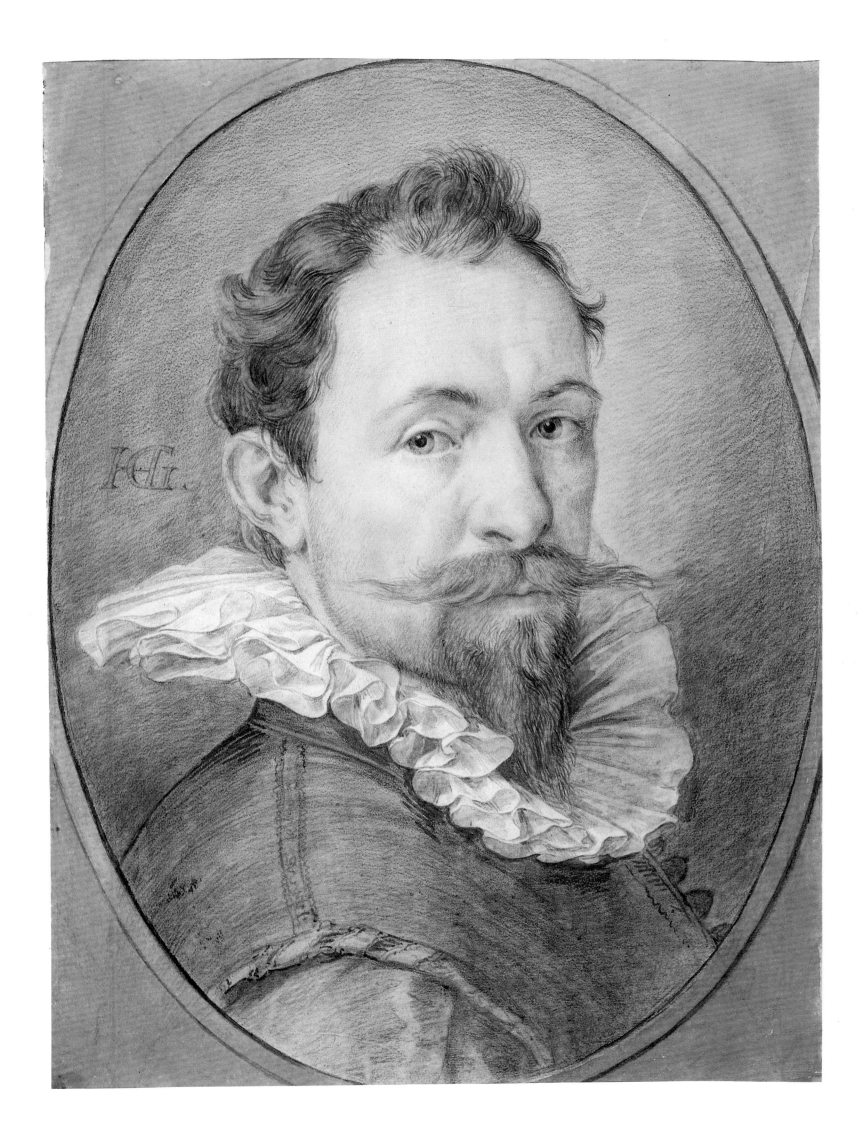

27

JOACHIM A. UYTEWAEL (1566–1638)

The Reception of the Princess

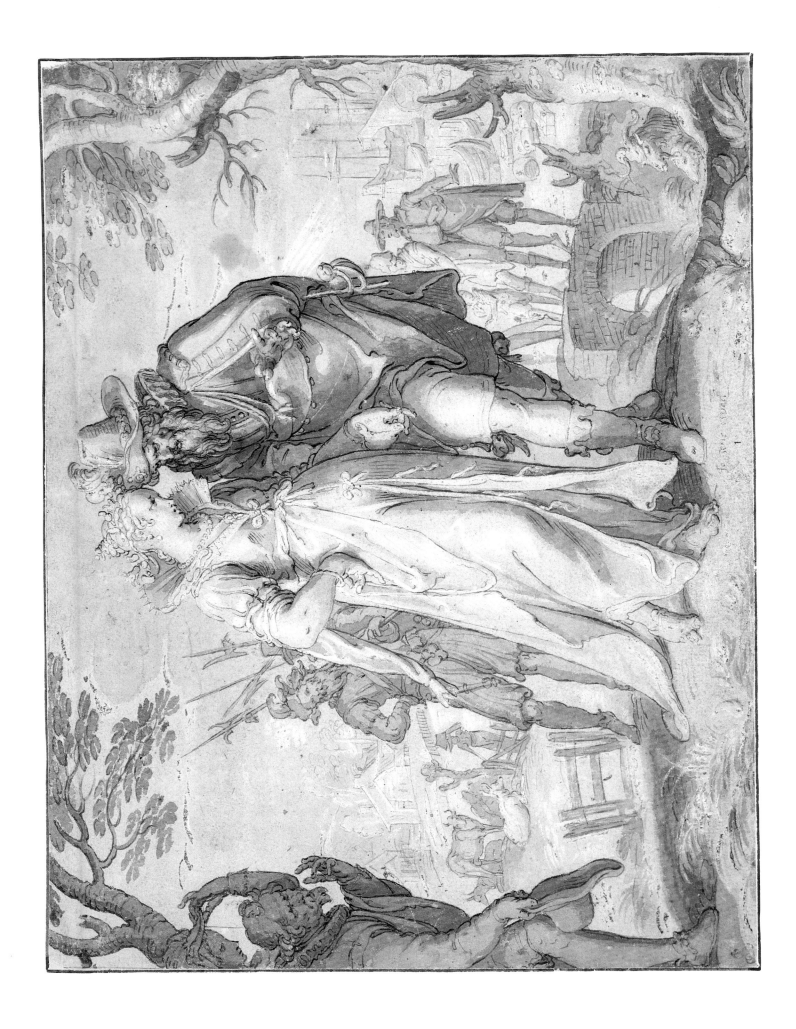

28

REMBRANDT VAN RIJN (1606–1669)
An Elephant

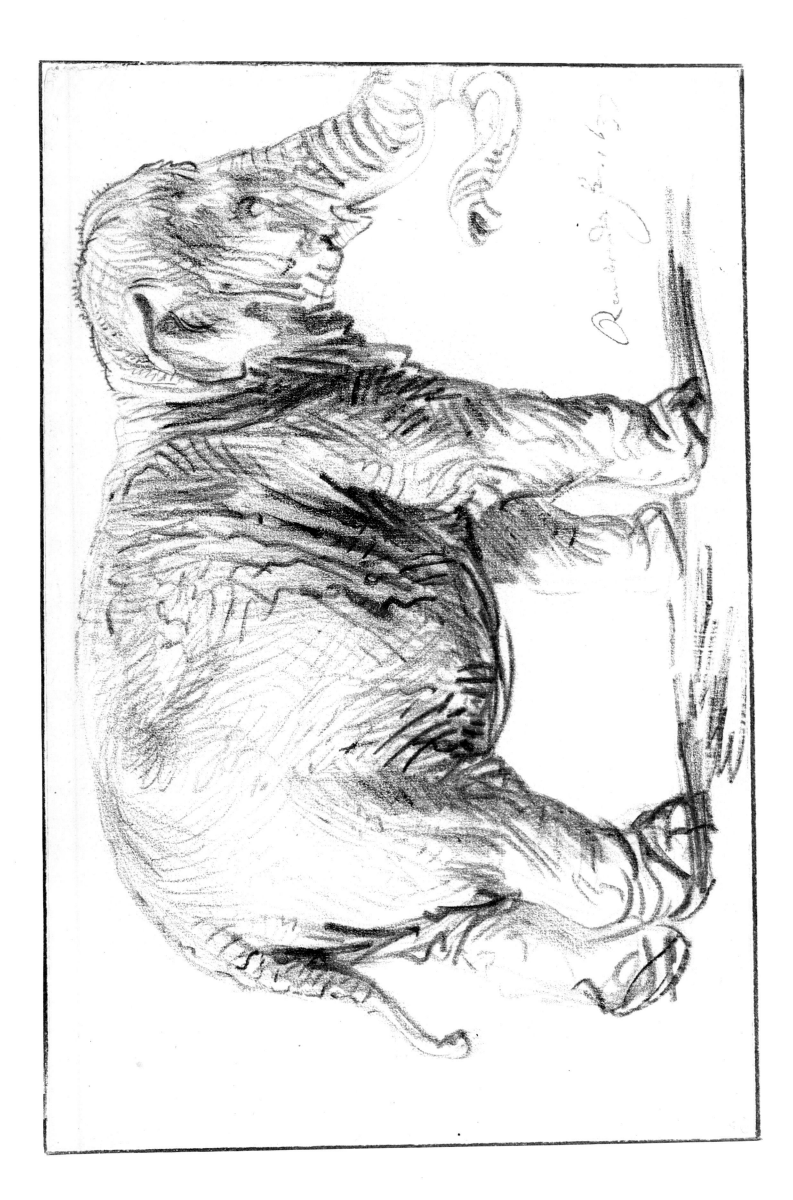

29

Rembrandt van Rijn (1606–1669)

The Parable of the Unworthy Wedding Guest

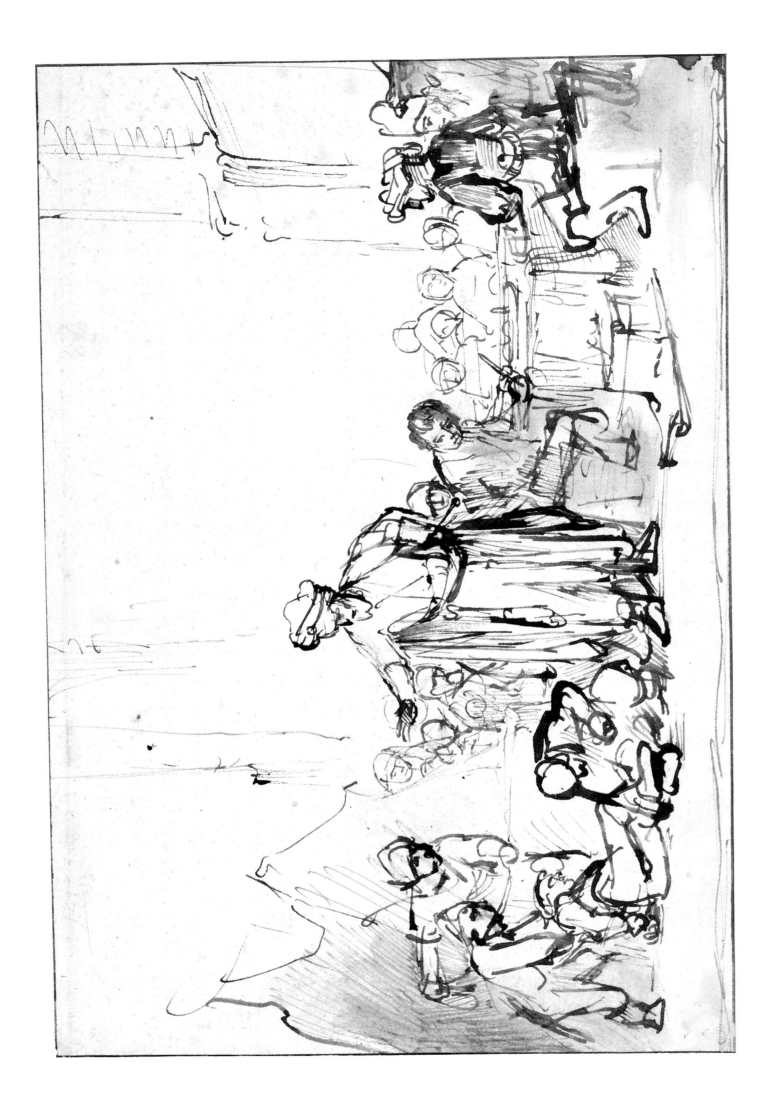

30

REMBRANDT VAN RIJN (1606–1669)

Landscape with a Drawbridge

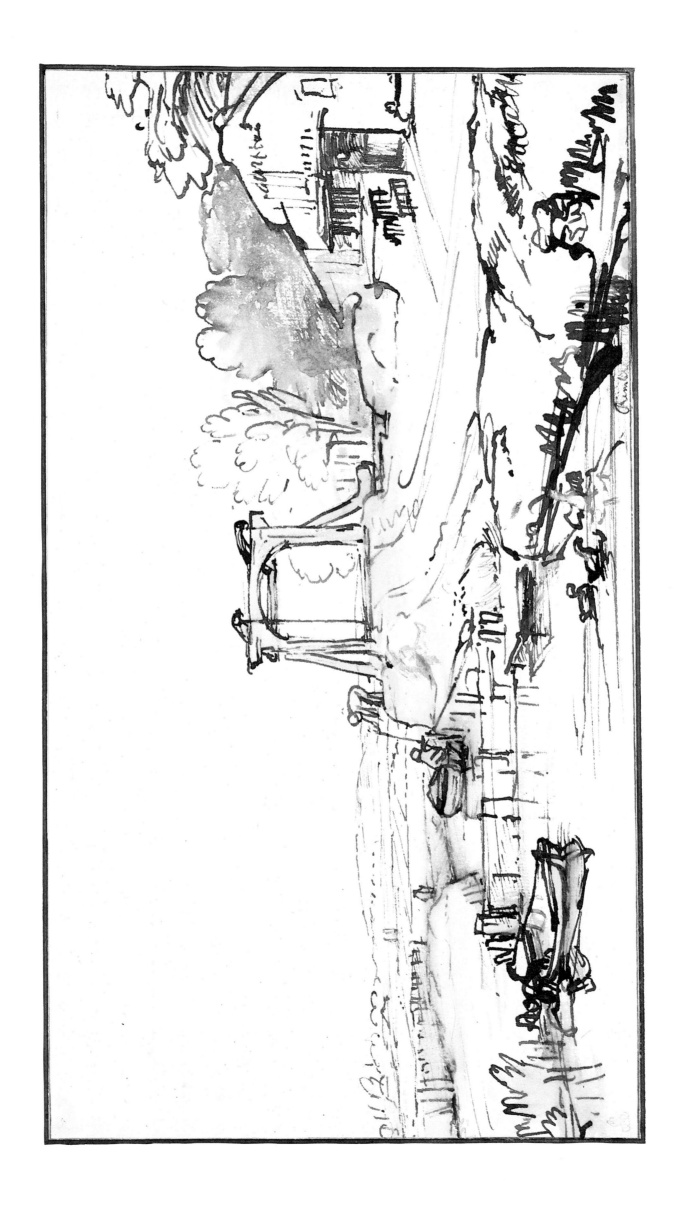

31

Gerbrand van den Eeckhout (1621–1674)
Boy Leaning on a Chair

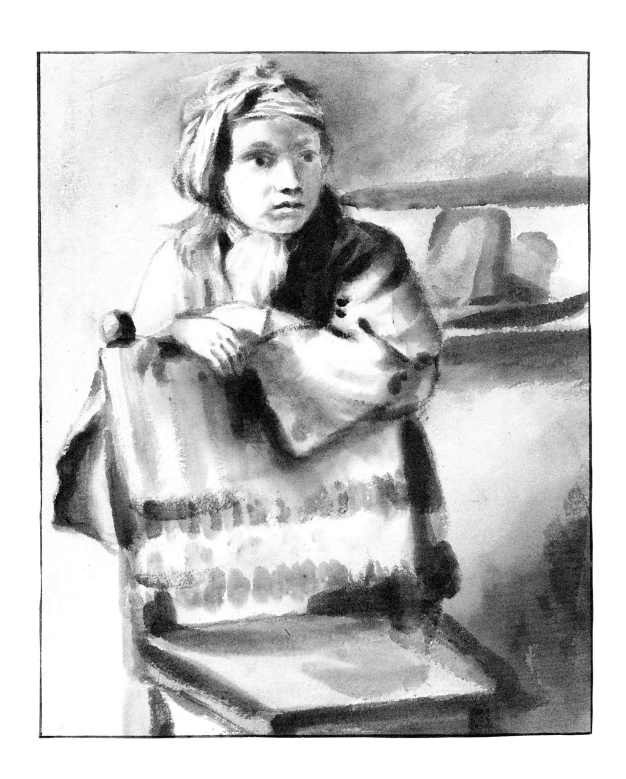

32

AELBERT CUYP (1620–1691)

Landscape with a Distant Town (Arnhem)

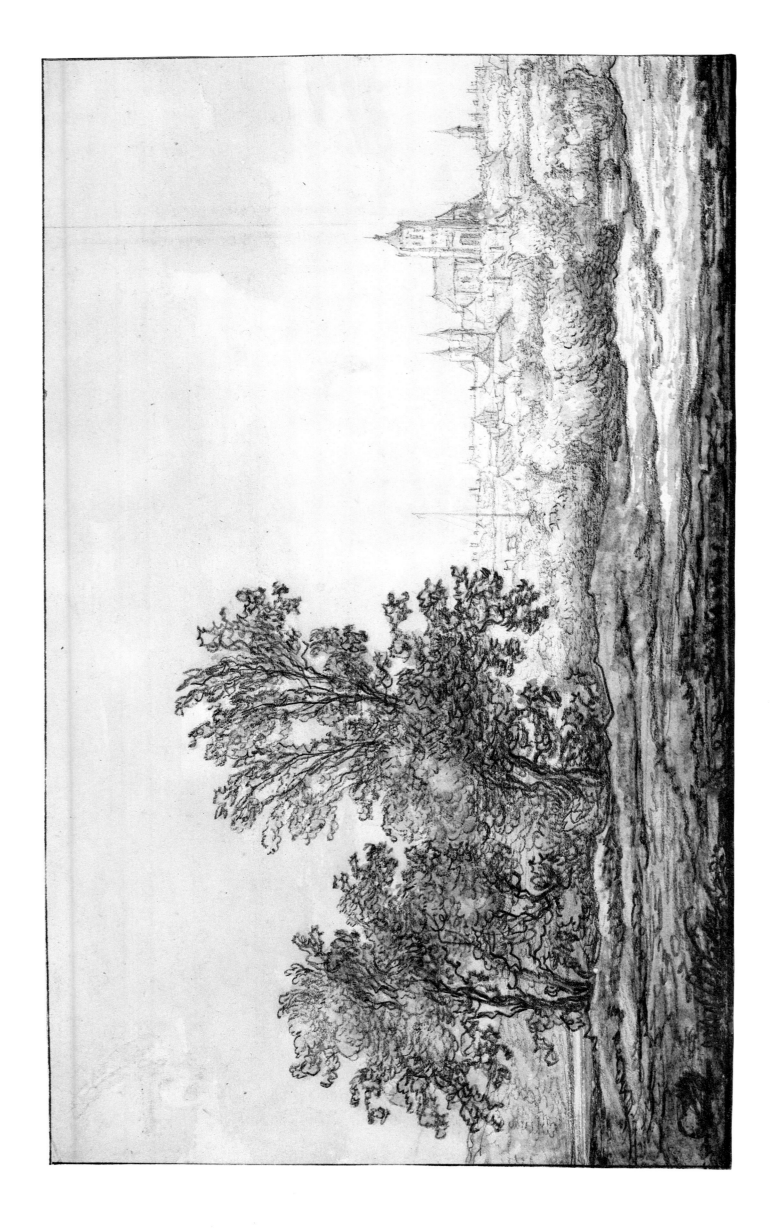

33

PIETER JANSZ SAENREDAM (1597–1665)

Interior of the Groote Kerk at Alkmaar

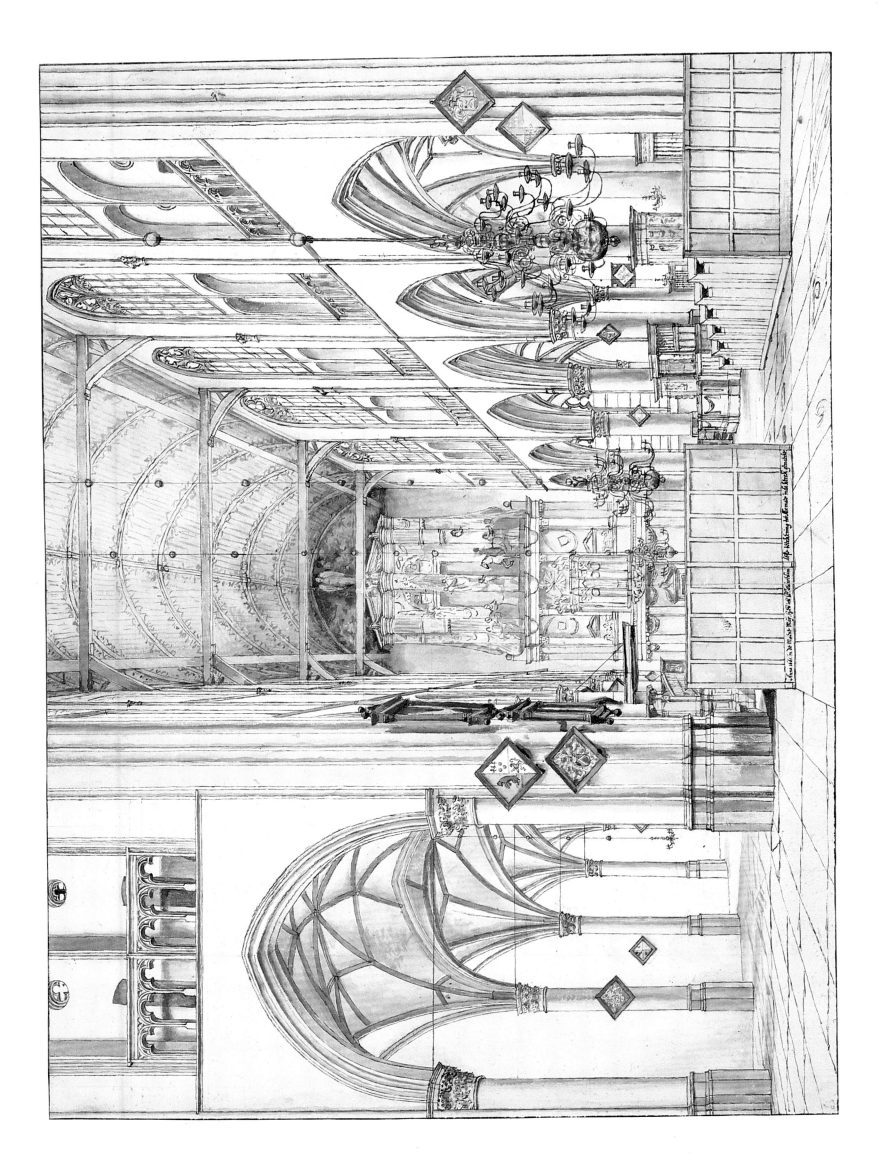

34

PETER PAUL RUBENS (1577–1640)

Studies of Heads and Hands

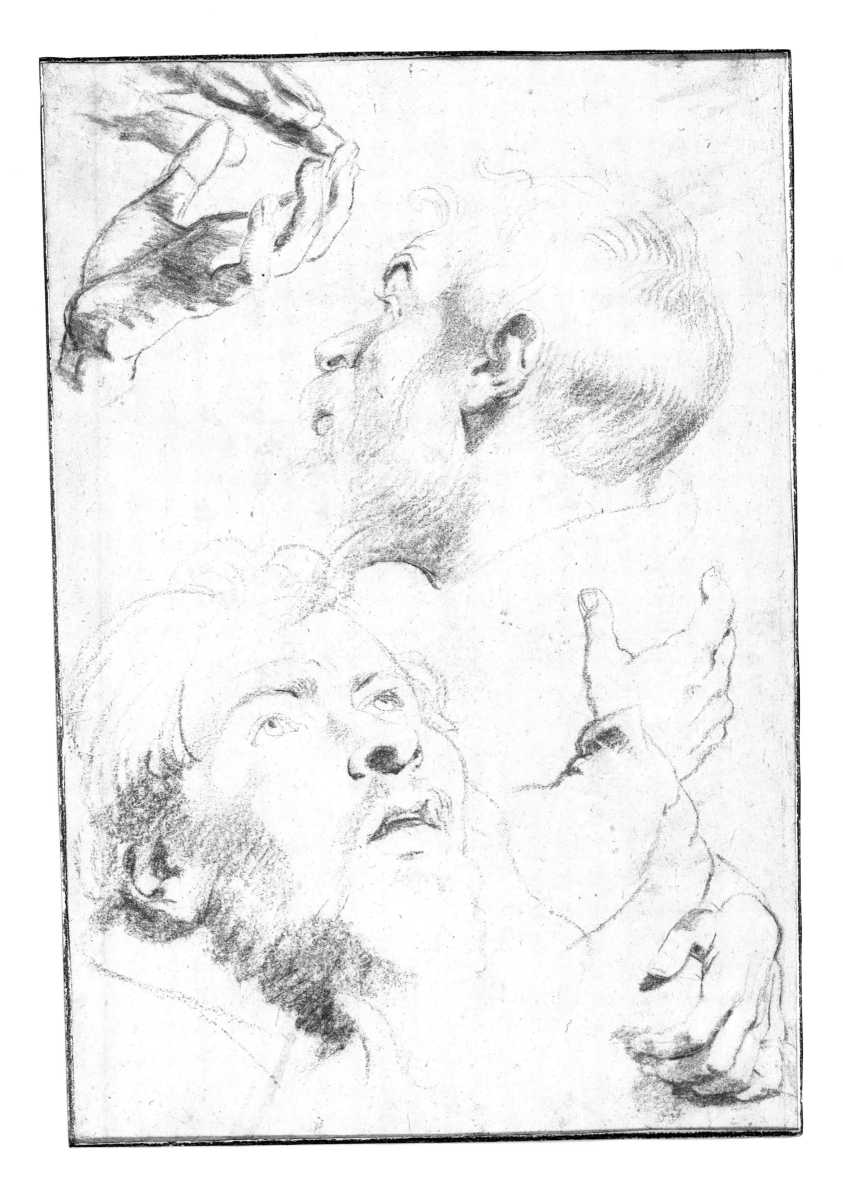

35

PETER PAUL RUBENS (1577–1640)

The Assumption of the Virgin

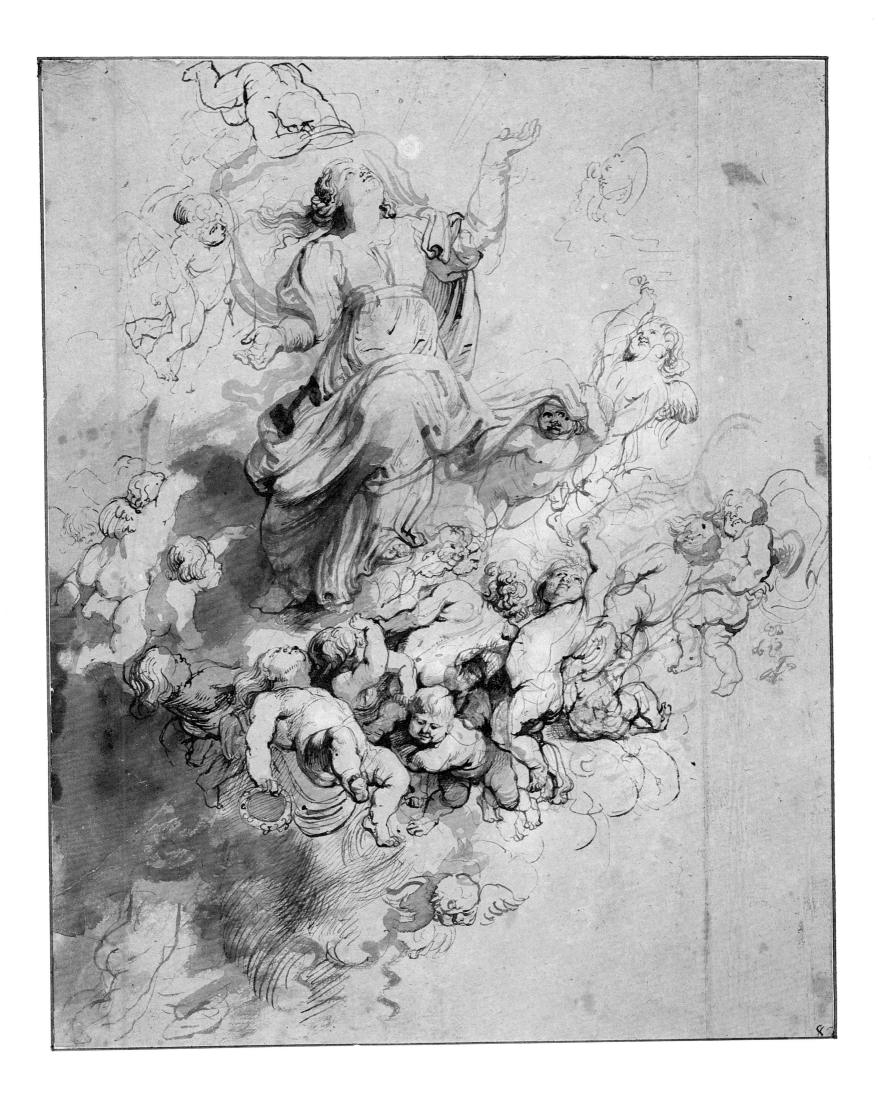

36

PETER PAUL RUBENS (1577–1640)

St. Catherine

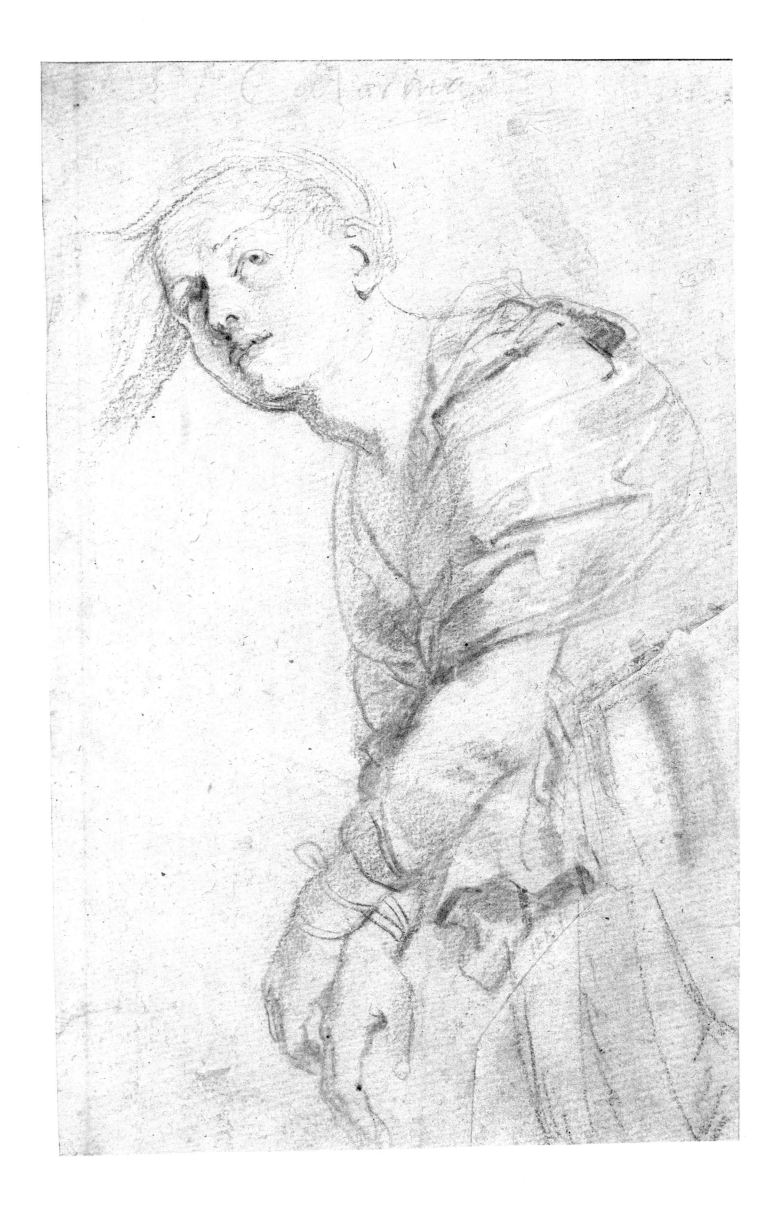

37

Peter Paul Rubens (1577–1640)

Portrait of Susanna Fourment

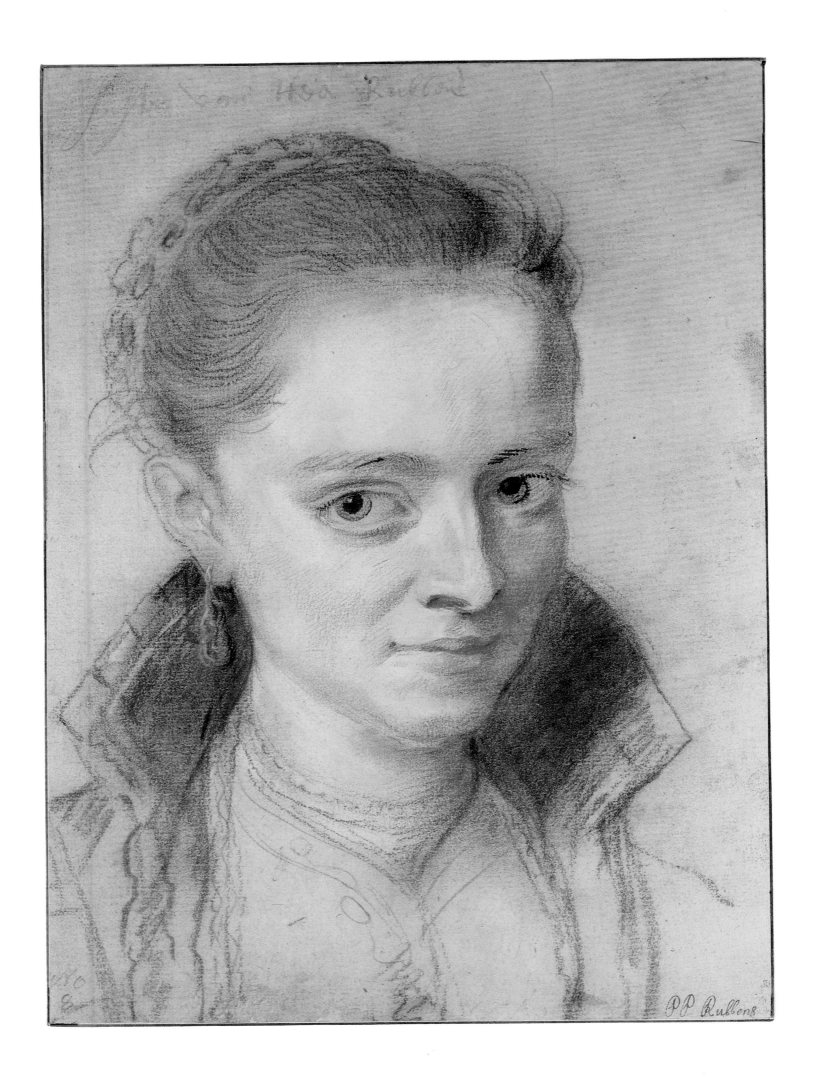

38

SIR ANTHONY VAN DYCK (1599–1641)
The Arrest of Christ

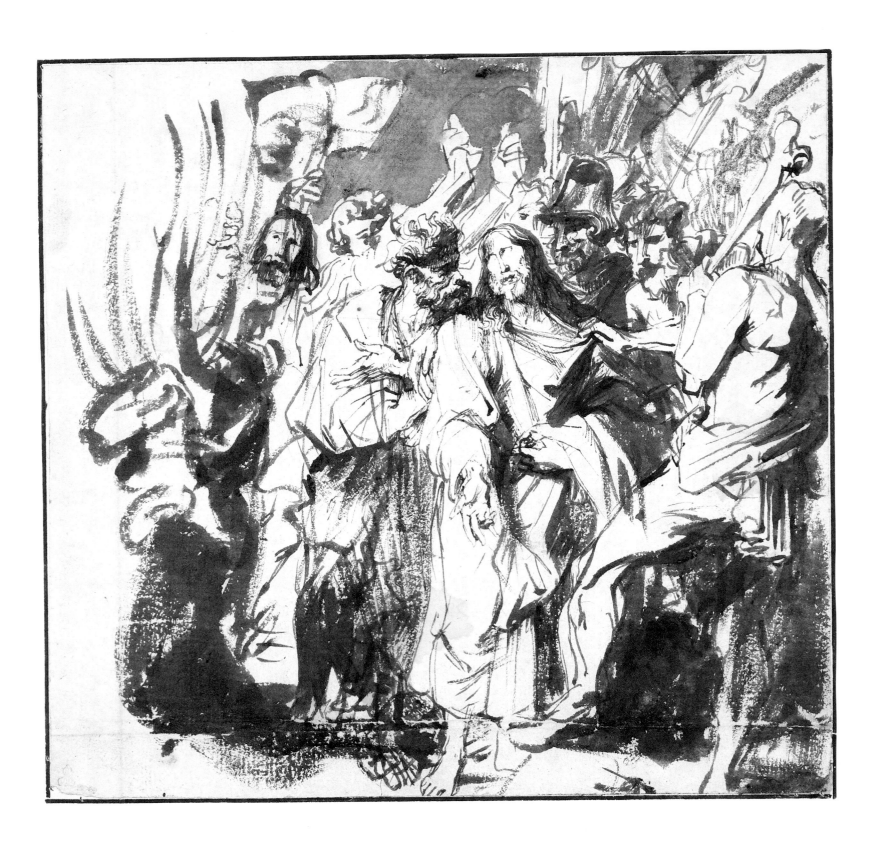

39

SIR ANTHONY VAN DYCK (1599–1641)
Portrait of Artus Wolfaert

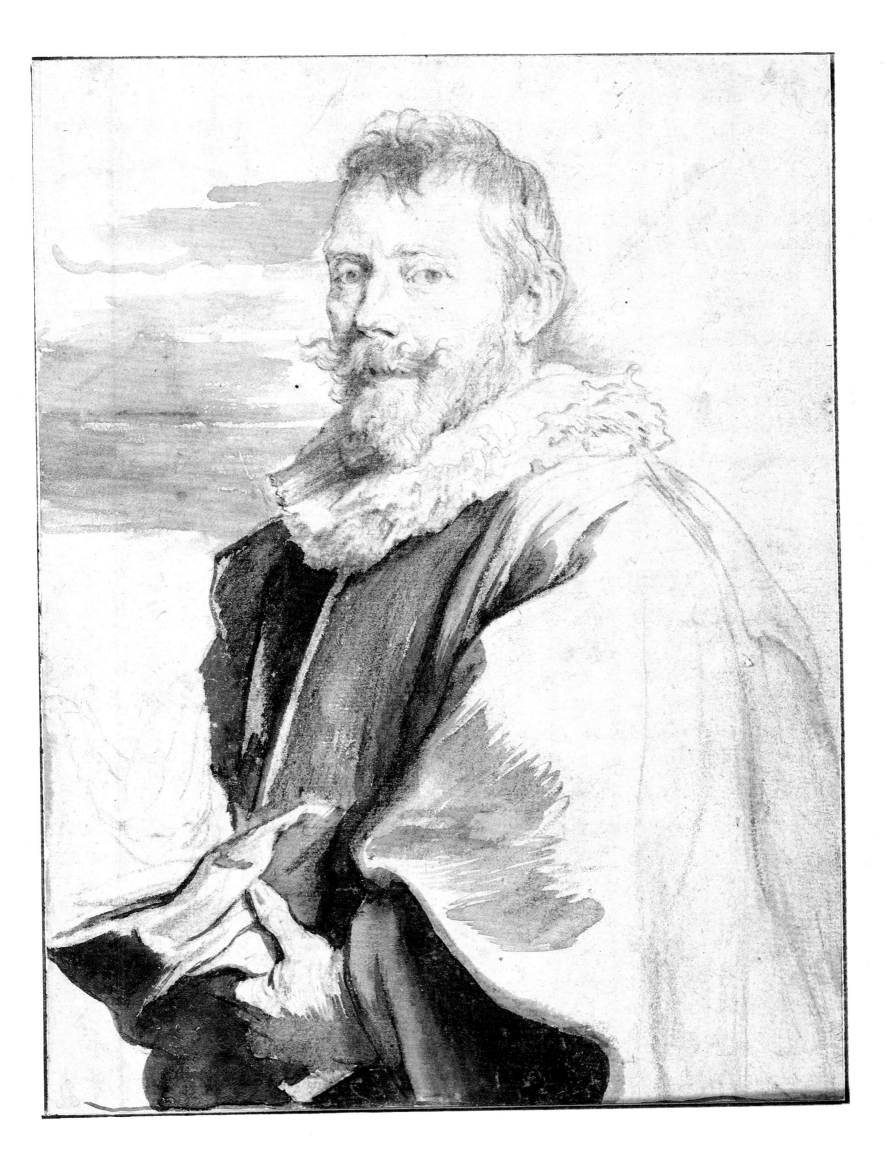

40

SIR PETER LELY (1618–1680)
Two Heralds

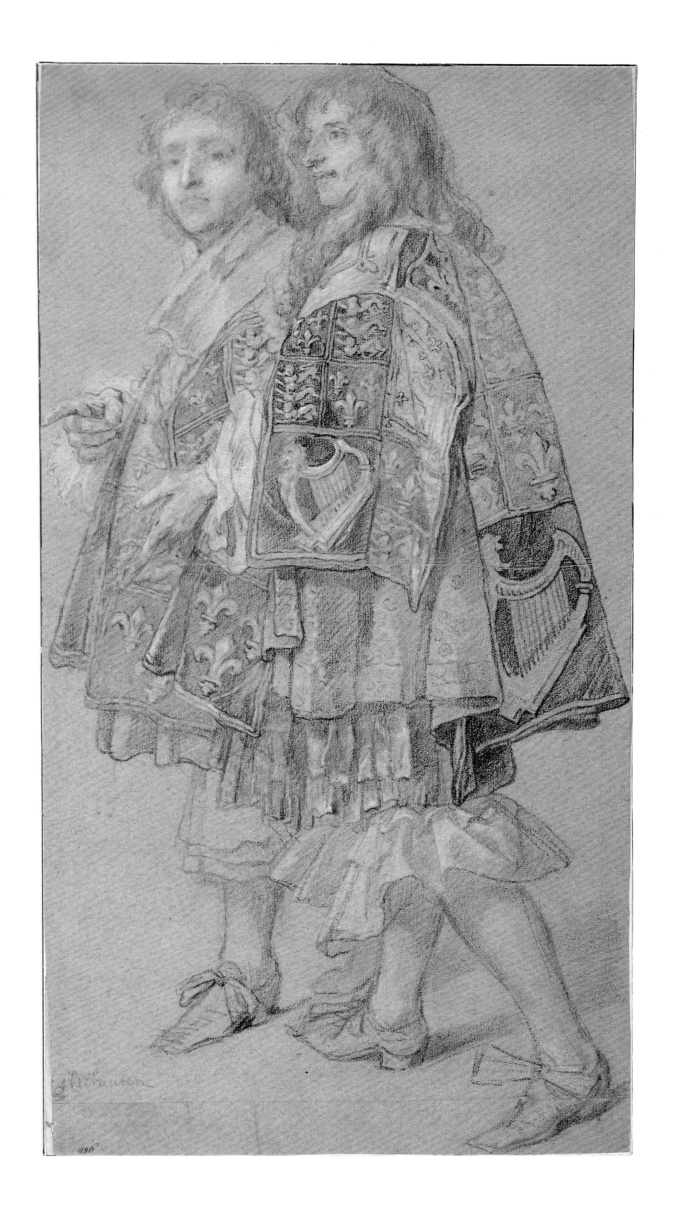

ITALIAN SCHOOL

41

STEFANO DA ZEVIO (c.1375-post 1438)
Three Studies of Prophets with Banderoles

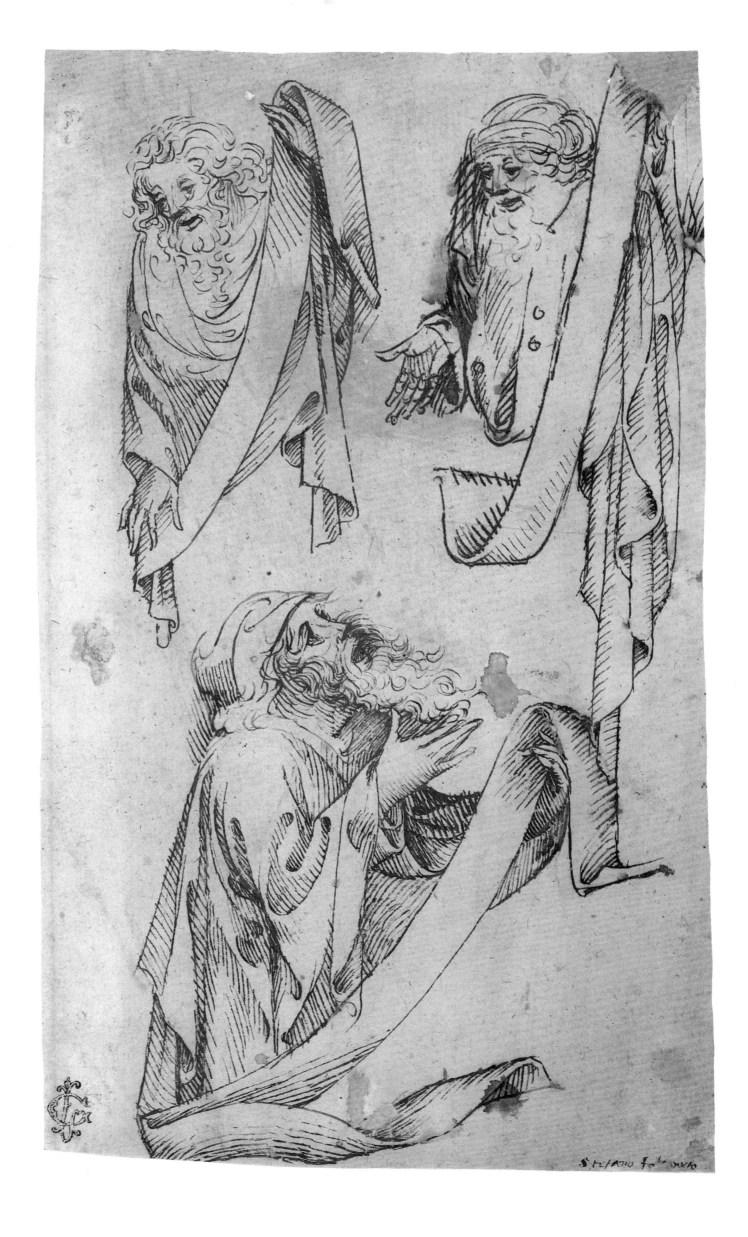

42

LIBERALE DA VERONA (C.1445–1526/29)

Two Studies of a Sleeping Woman with a Child at Her Breast

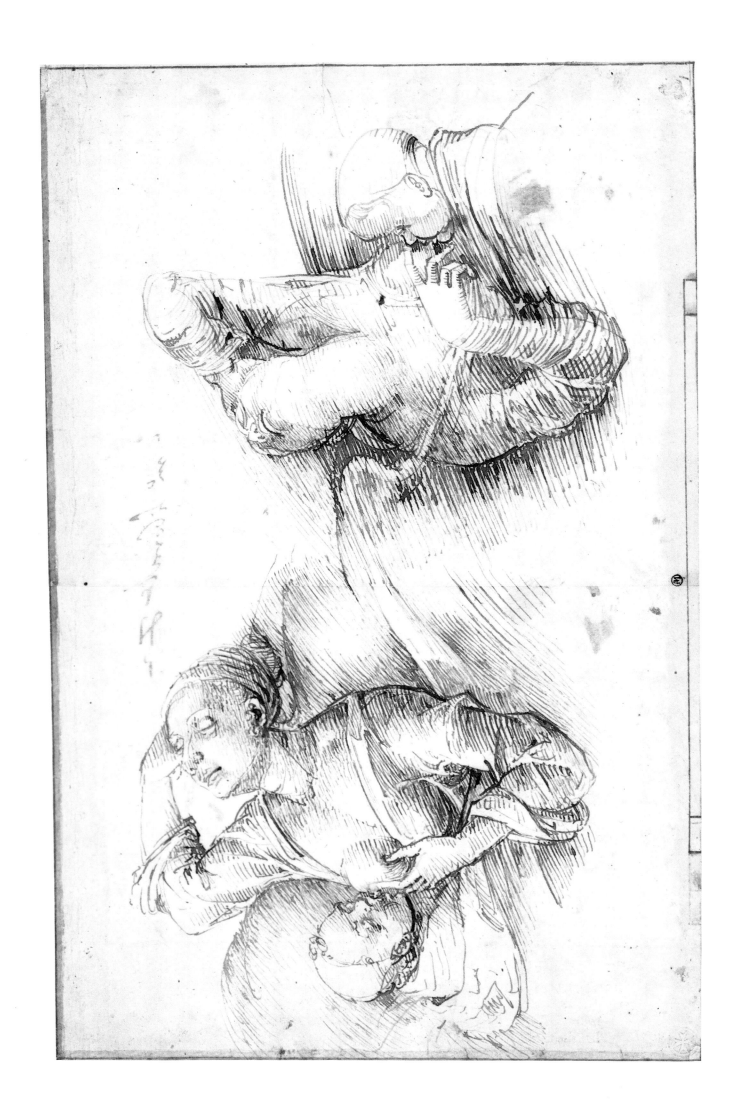

43

LORENZO DI CREDI (c.1459–1537)
Bearded Saint

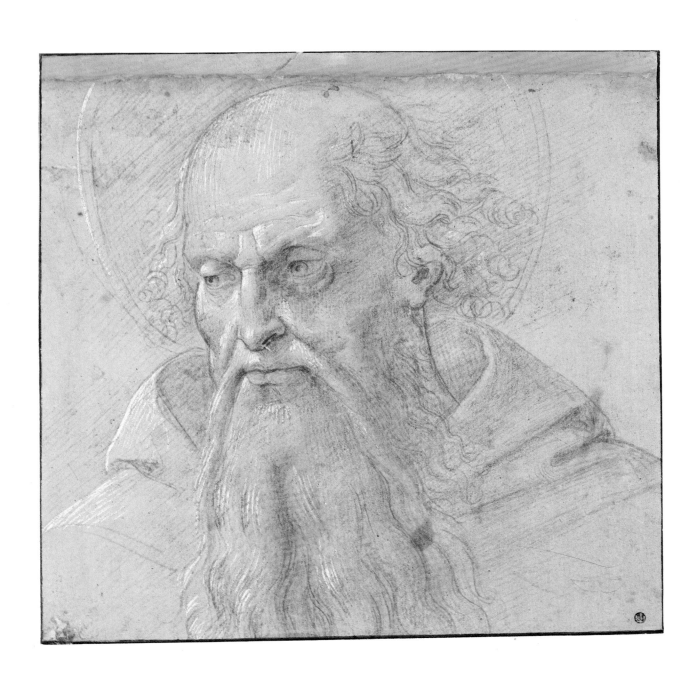

44

LORENZO DI CREDI (C.1459–1537)

Bust of a Youth with Long Hair

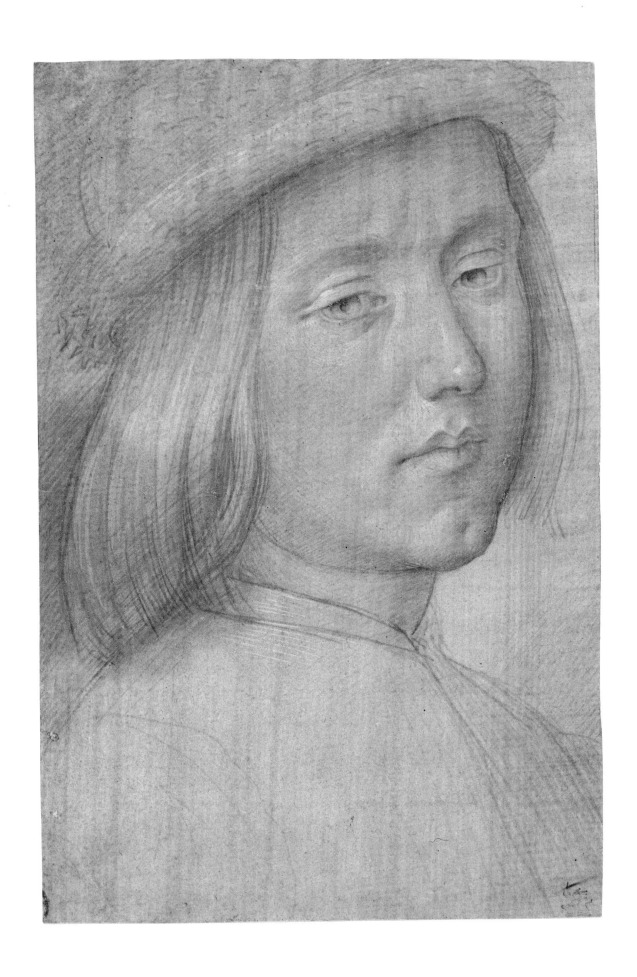

45

DOMENICO GHIRLANDAIO (1449–1494)
The Angel Appearing to Zacharias

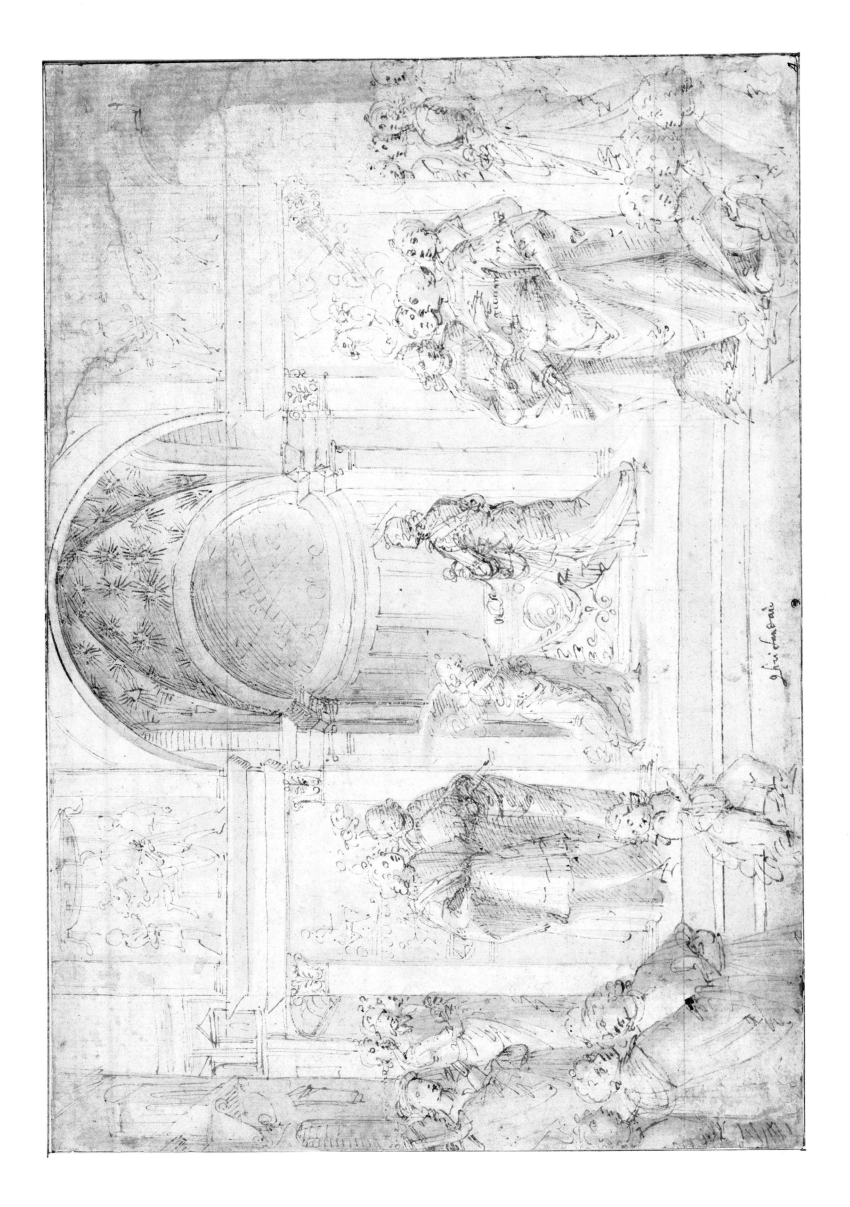

46

FRA BARTOLOMEO DELLA PORTA (1472–1517)

Buildings at the Foot of a Cliff

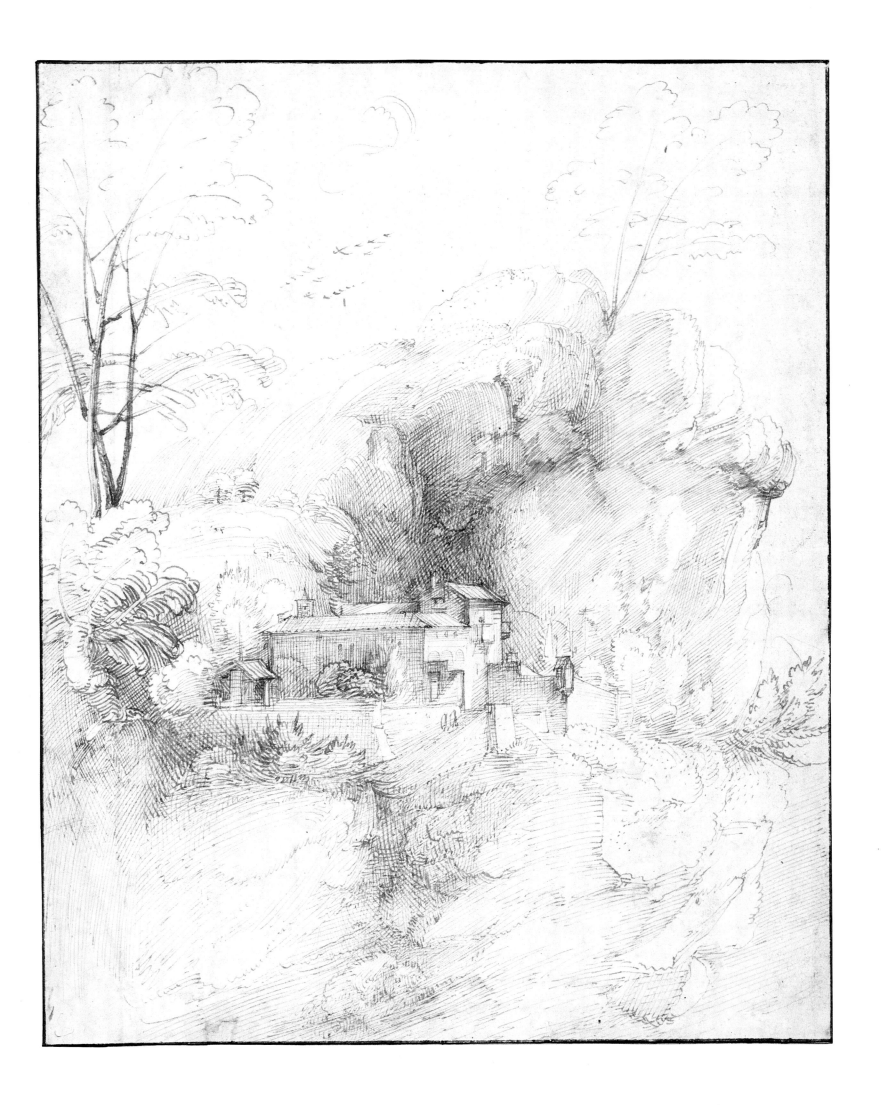

47

FRANCESCO BONSIGNORI (c.1460–1519)

Bust of a Young Man

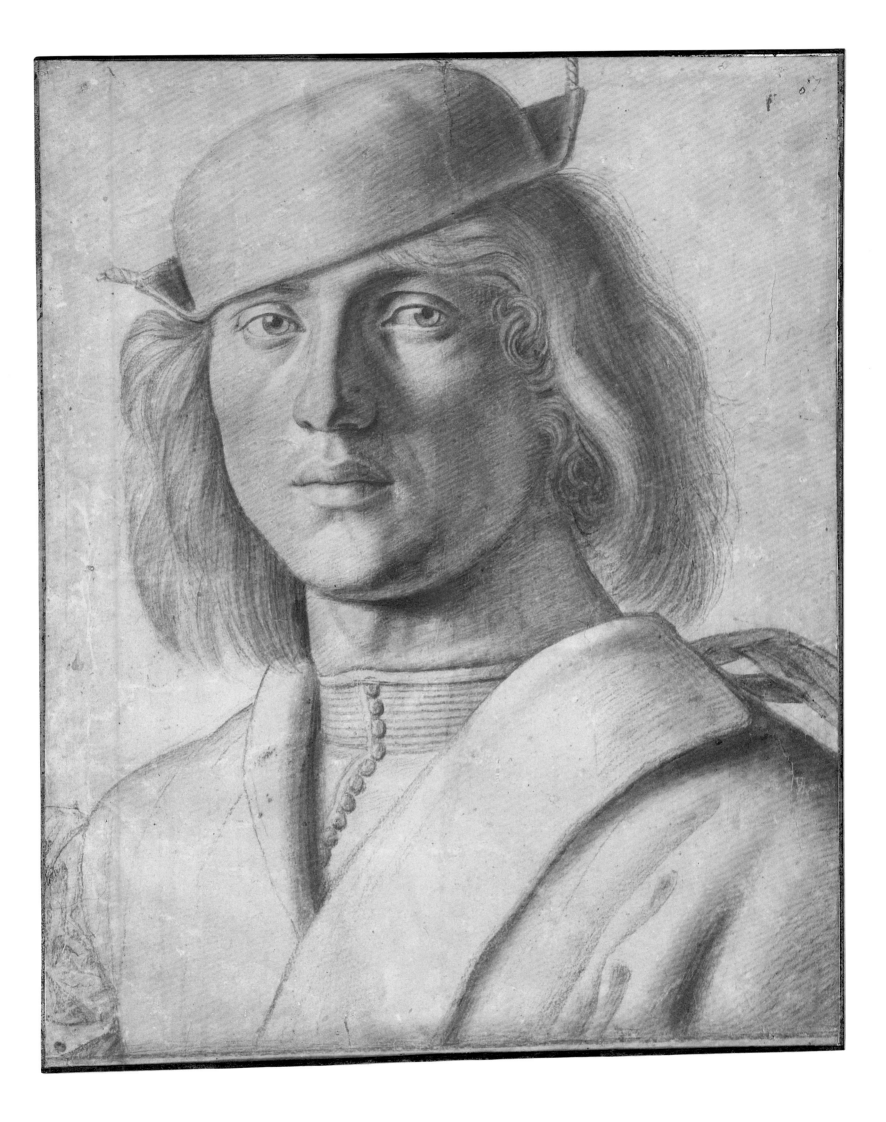

48

MICHELANGELO BUONARROTI (1475–1564)
Seated Male Nude
VERSO: *Study sheet with a Torso and Folded Hands*

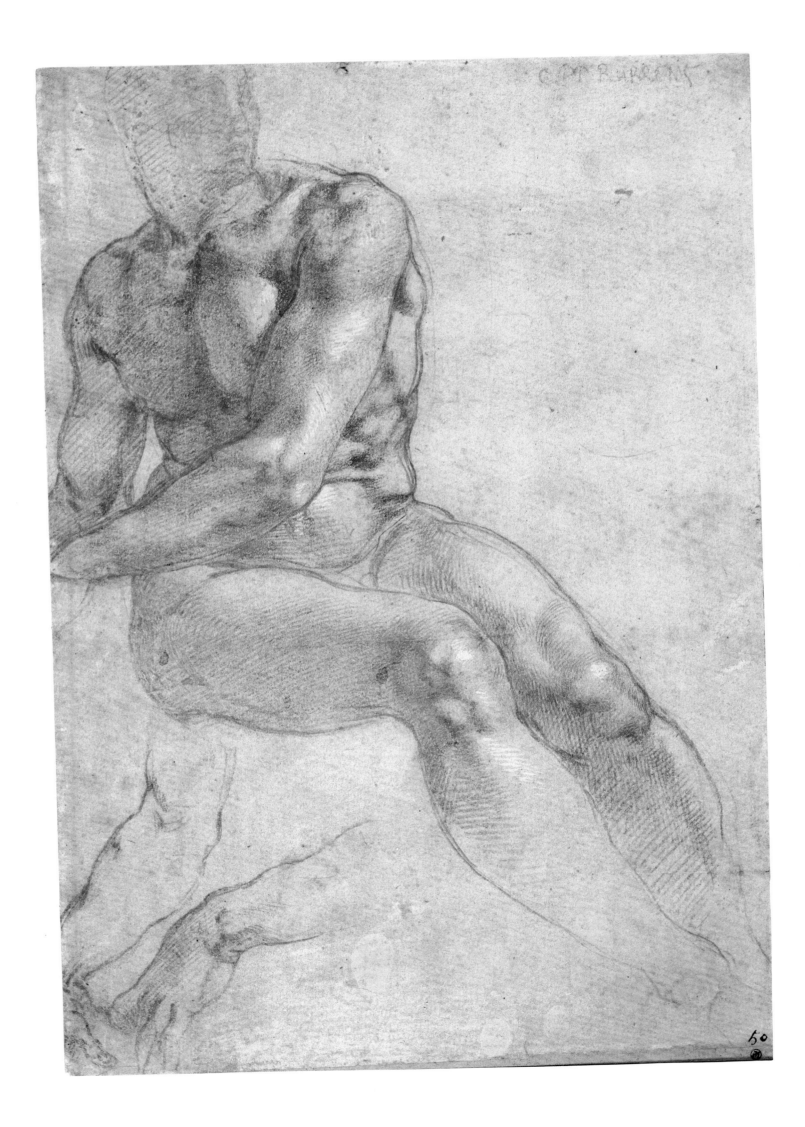

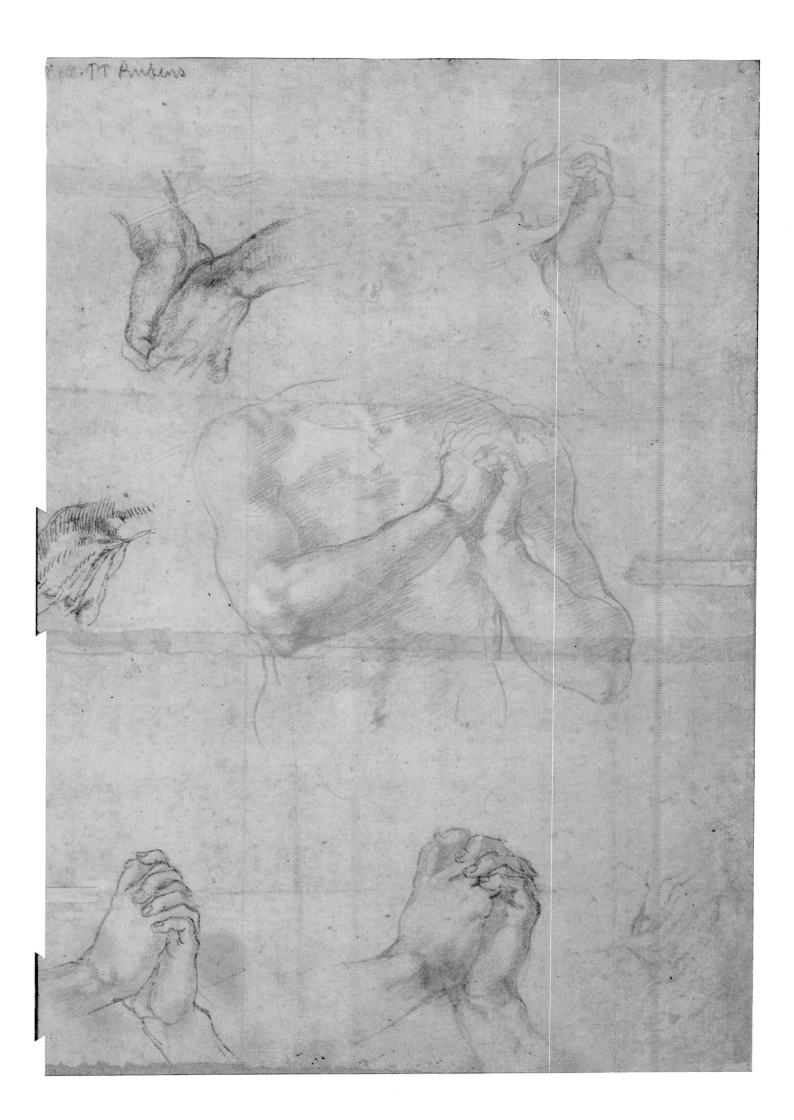

LEFT: *Verso of number* 48

49

RAPHAELLO SANTI (1483–1520)

Madonna of the Baldacchino

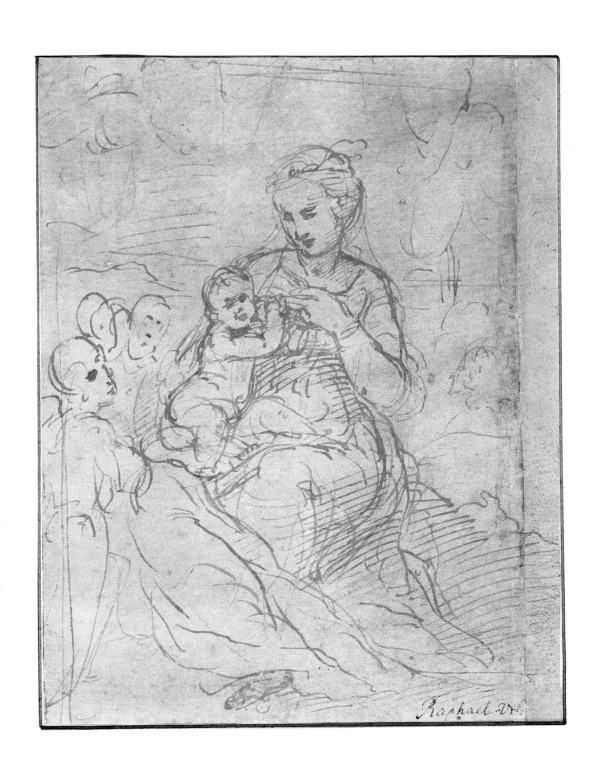

Raphael Urb.

50

RAPHAELLO SANTI (1483–1520)
Seated Muse (Terpsichore)

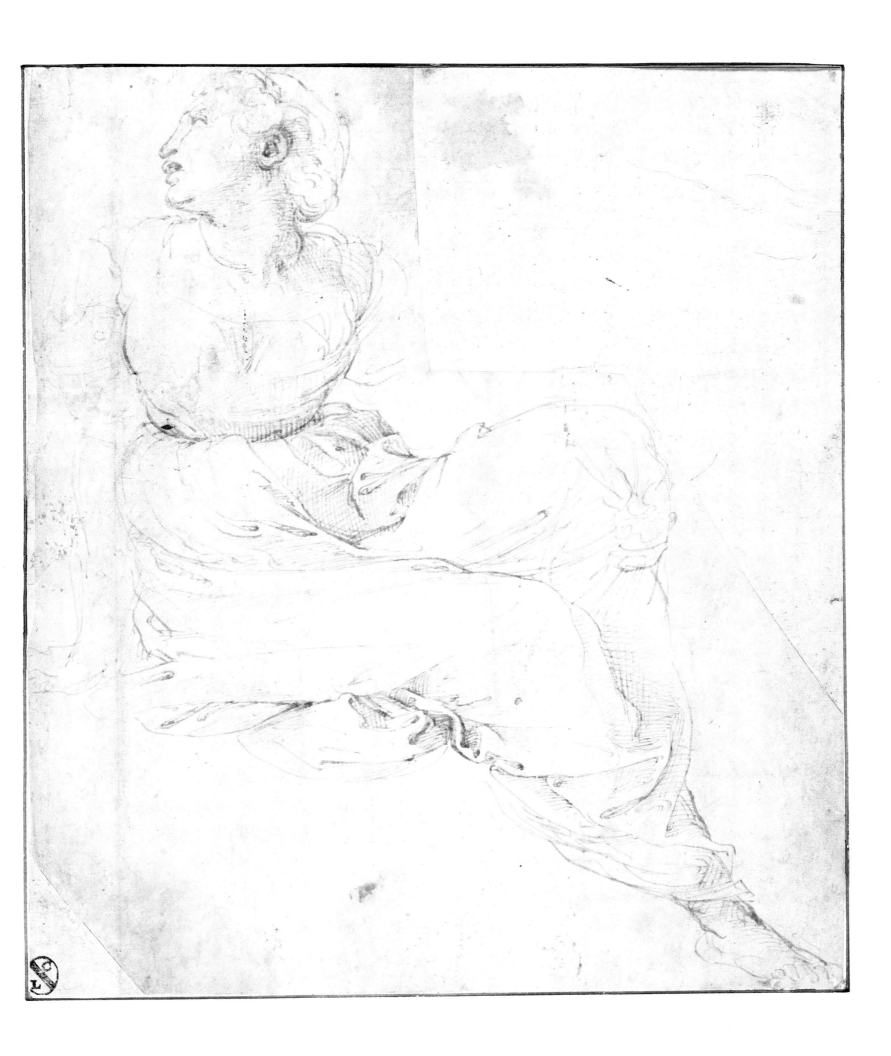

51

RAPHAELLO SANTI (1483–1520)
Two Studies of Male Nudes

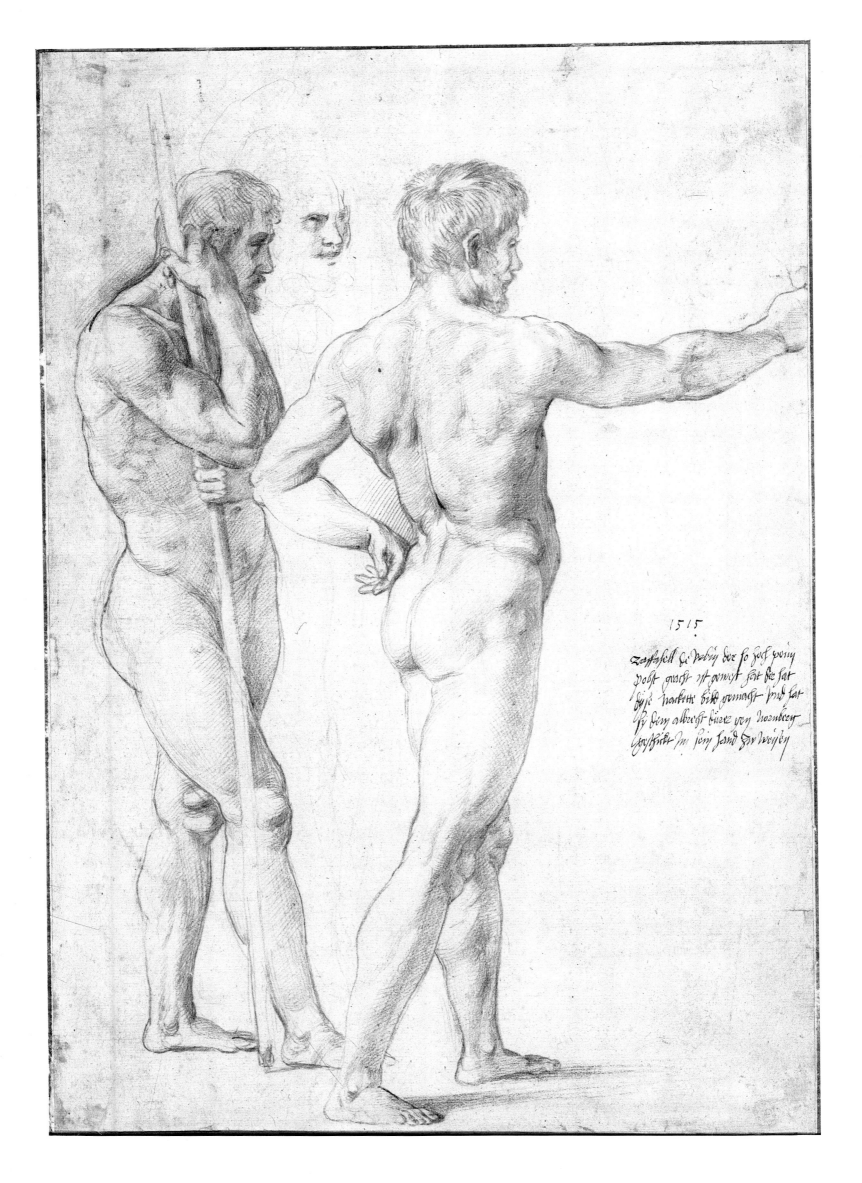

1515

Raffahell de Vrbÿ der so hoch peÿ
pobst gracht ist gewest hat die sak
hÿse narkette bild gemacht vnd hat
sÿ dem albrecht dürer von nornberg
gyschickt Im sein hand Zu weÿsin

52

GIOVANNI ANTONIO DE SACCHI, called PORDENONE (1484–1529)
Man with a Plumed Hat

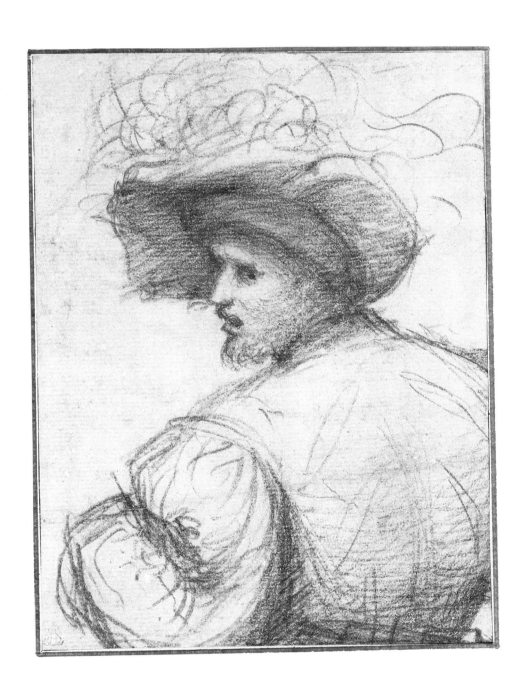

53

BERNARDINO LUINI (1480–1532)
Portrait of a Noblewoman with a Fan

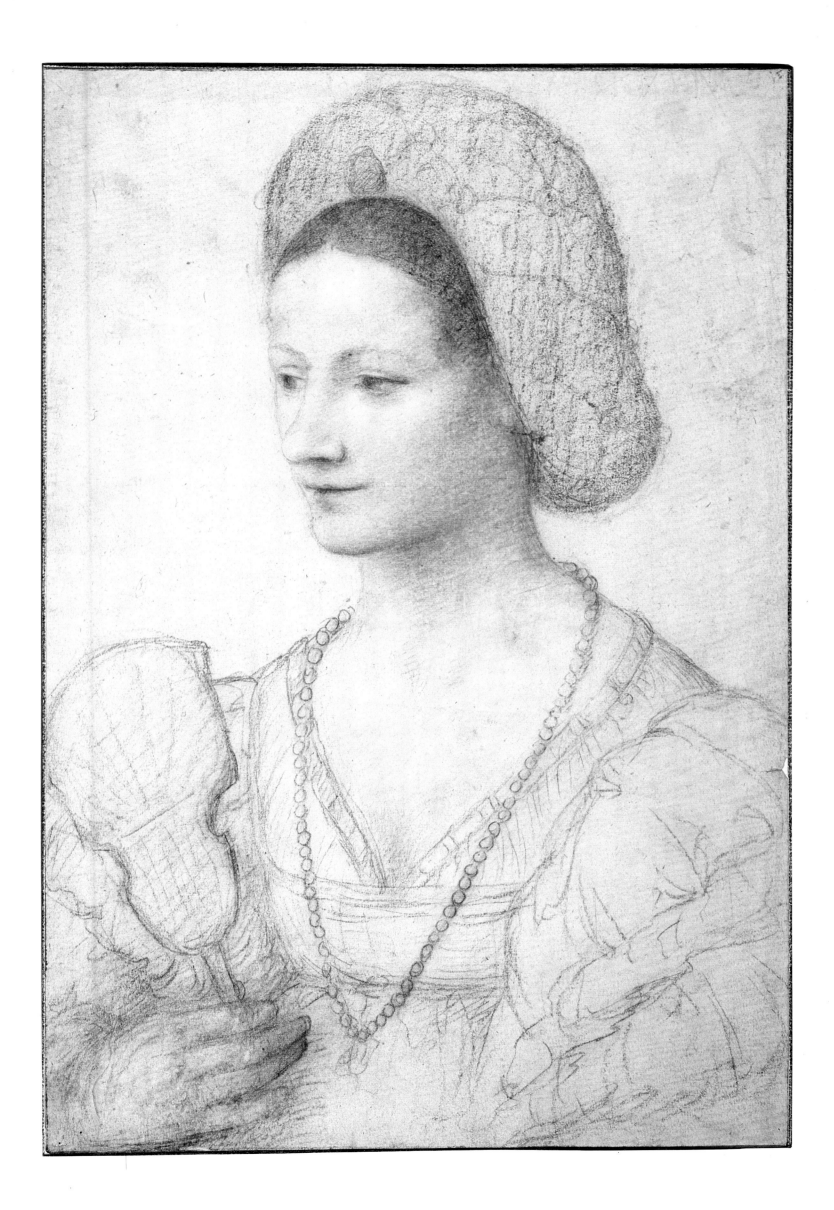

54

PERINO DEL VAGA (1501–1547)
The Martyrdom of the Ten Thousand

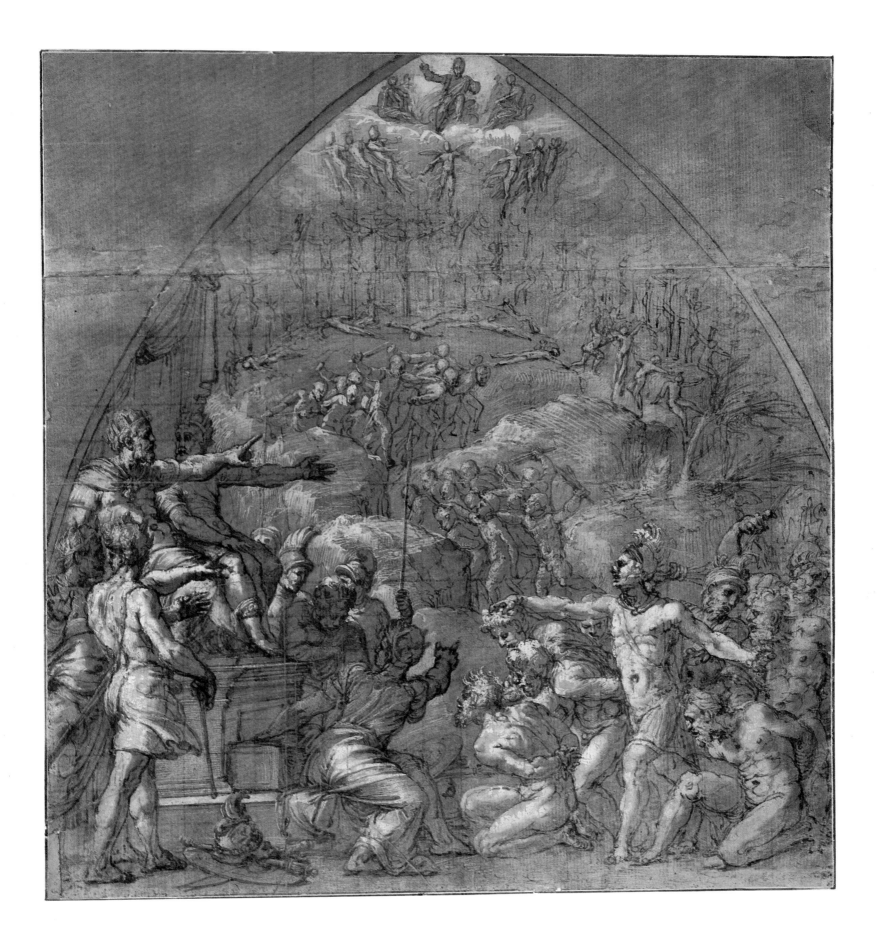

55

FRANCESCO PARMIGIANINO (1503–1540)

Study of a Caryatid

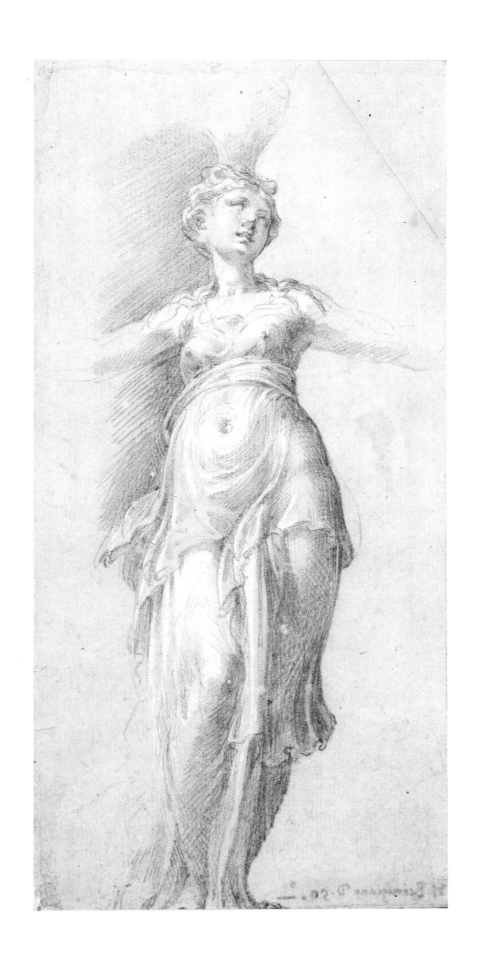

56

PAOLO CALIARI, called VERONESE (1528–1588)
Sheet of Studies

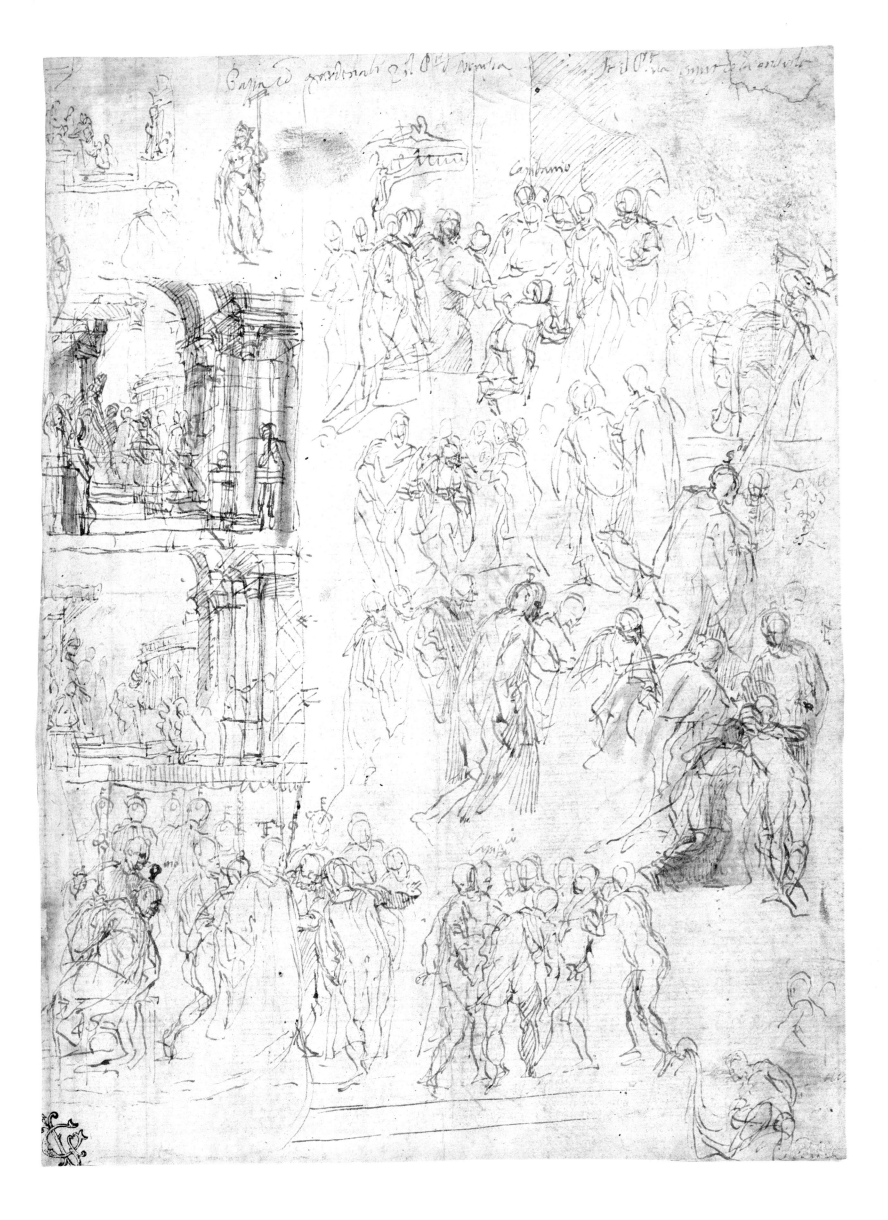

57

ANNIBALE CARRACCI (1560–1609)
Portrait of a Member of the Mascheroni Family

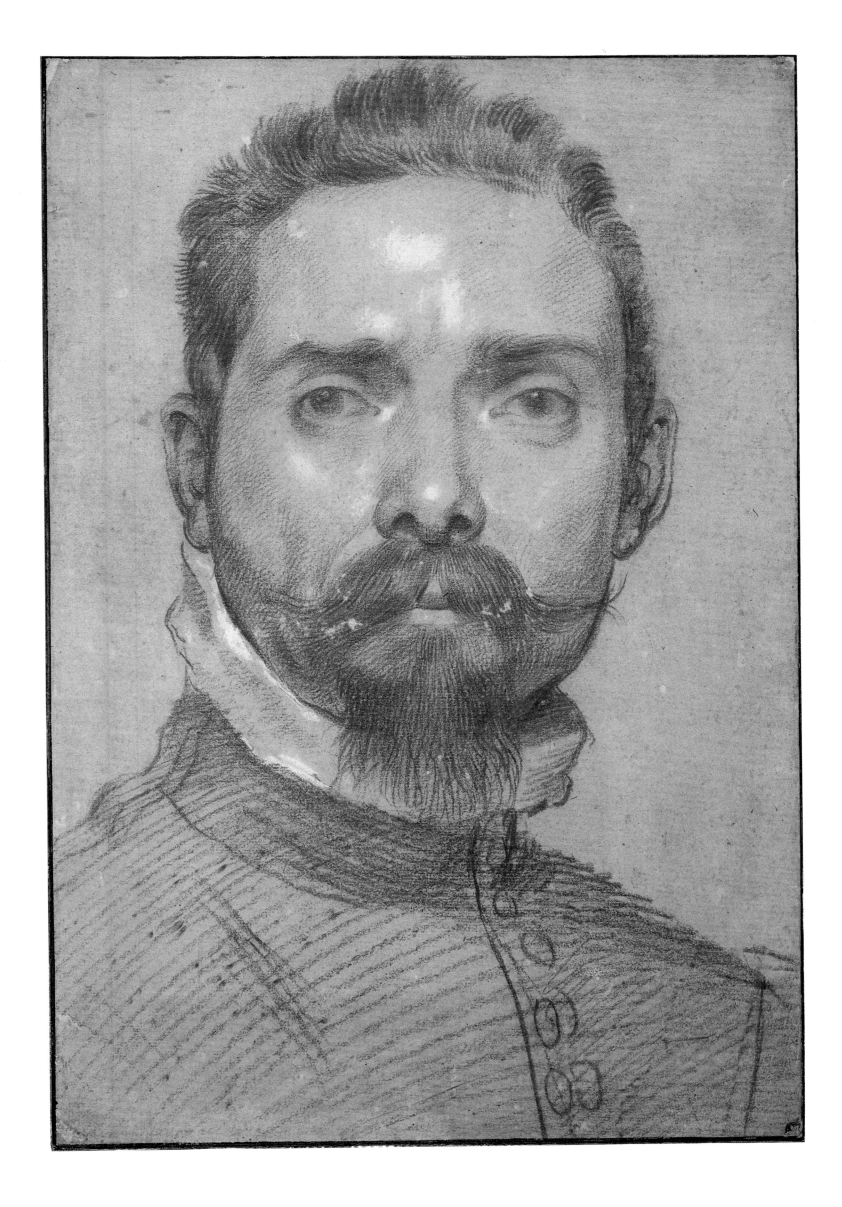

58

FEDERICO BAROCCI (1535–1612)
Madonna della Cintola

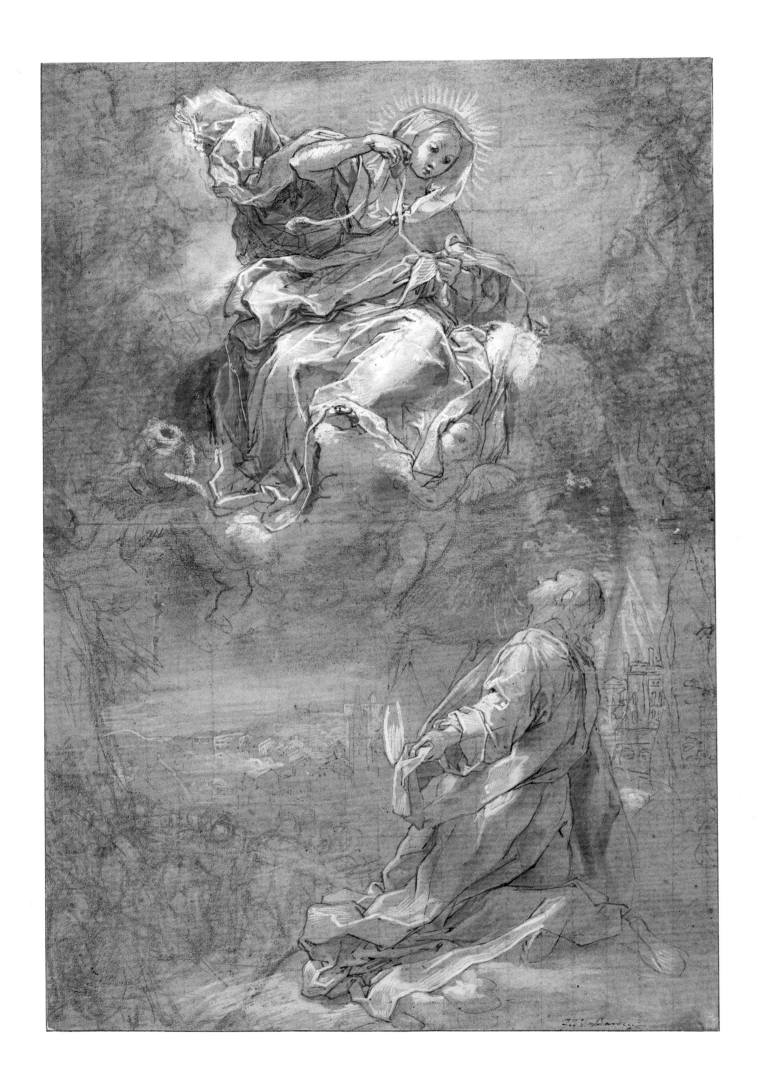

59

Giulio Cesare Procaccini (1574–1625)

Head of a Boy with Curly Hair

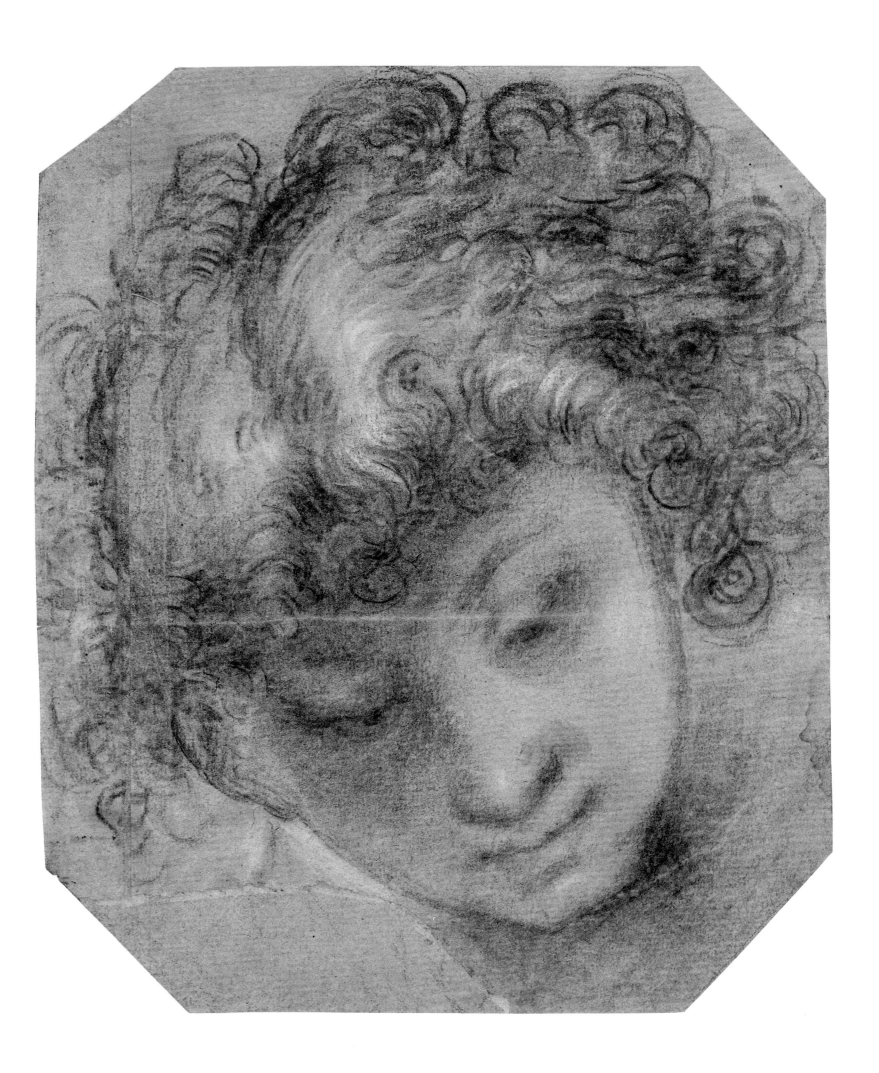

60

GIOVANNI FRANCESCO BARBIERI, called GUERCINO (1591–1666)
The Virgin and Child Adored by Saint Dominic

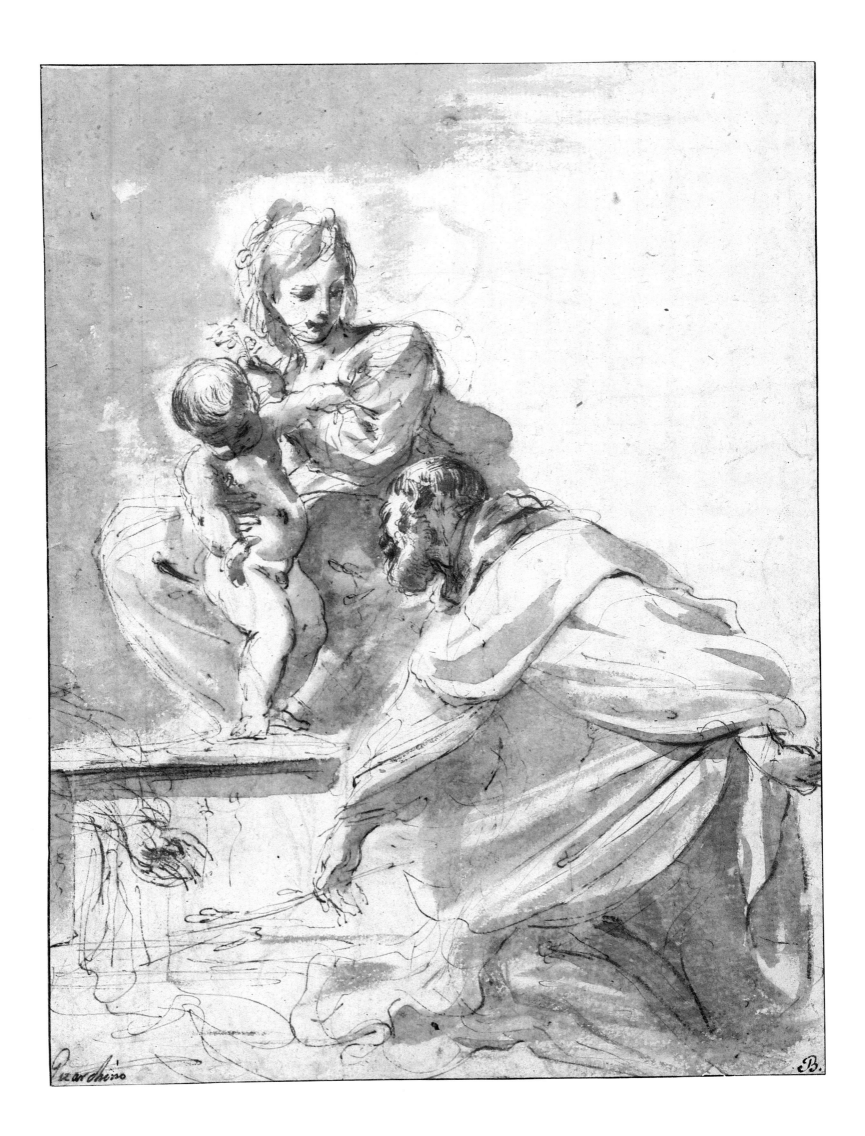

Guardino B.

61

PIETRO BERRETTINI, called DA CORTONA (1596–1669)
Study of a Young Woman

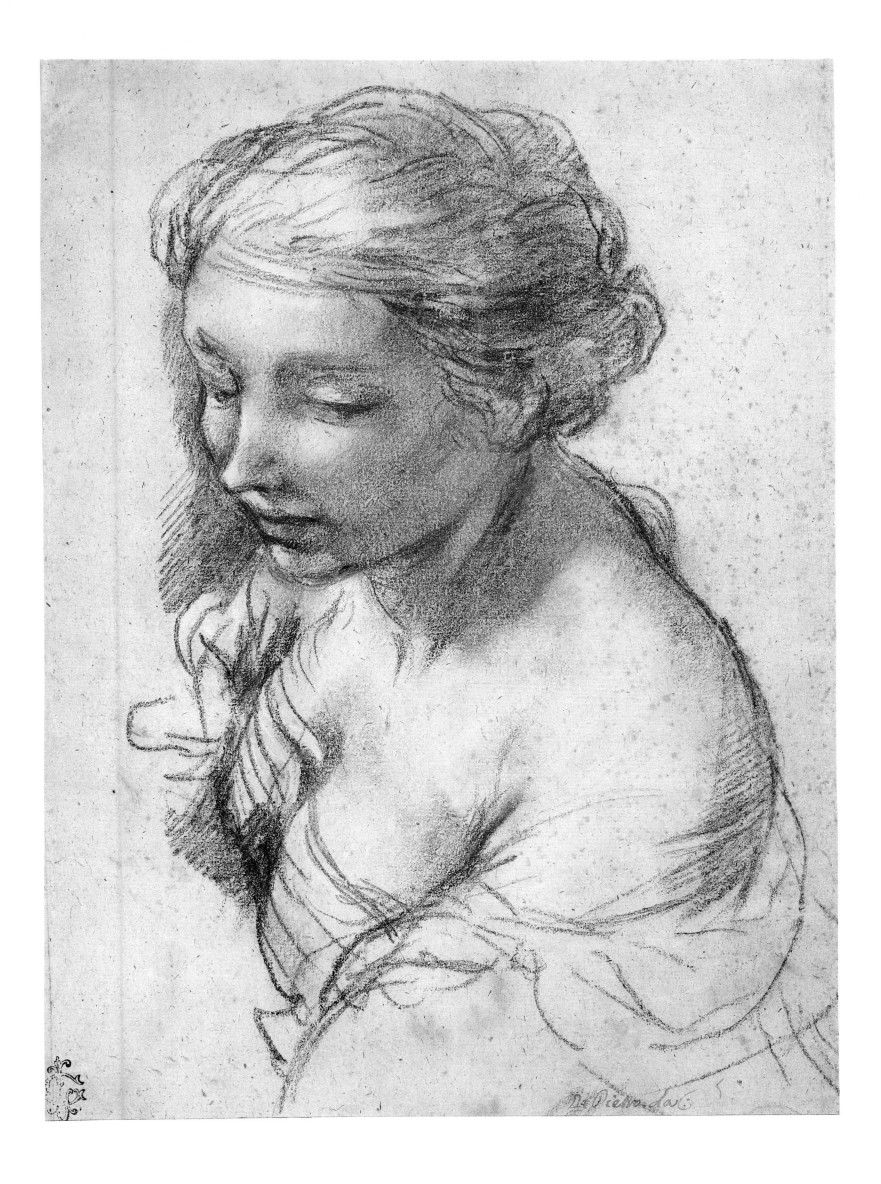

62

GIOVANNI BATTISTA PIAZZETTA (1682–1754)
Head of a Boy with a Broad-brimmed Hat

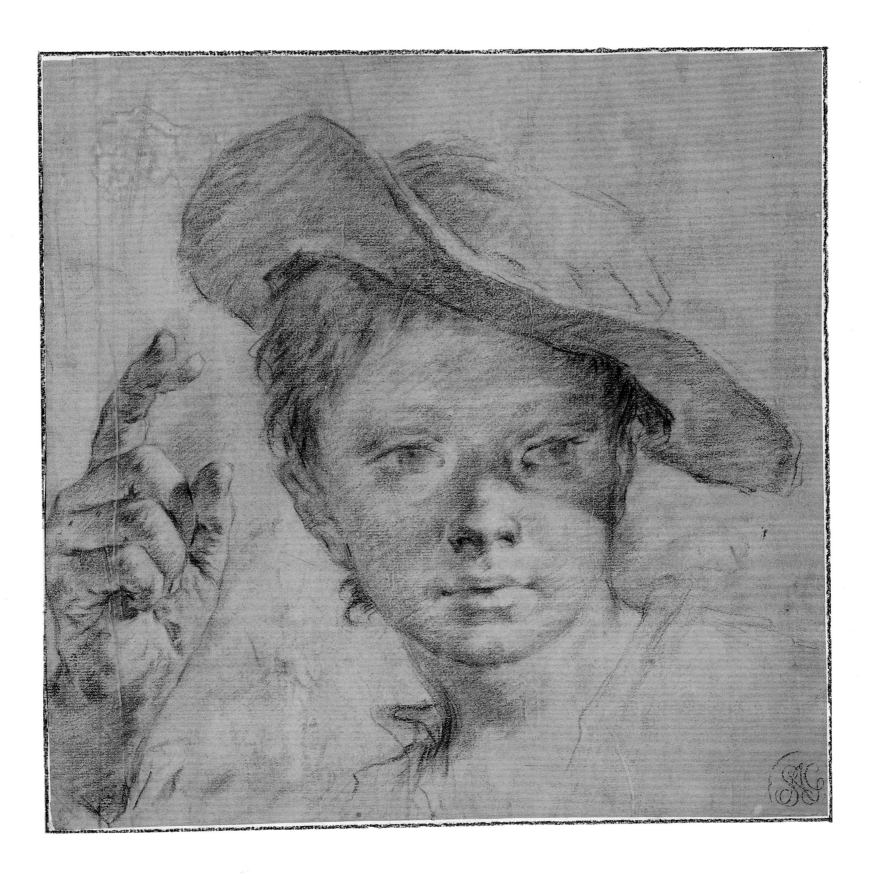

63

GIOVANNI BATTISTA TIEPOLO (1696–1770)
Madonna and Child with Saint

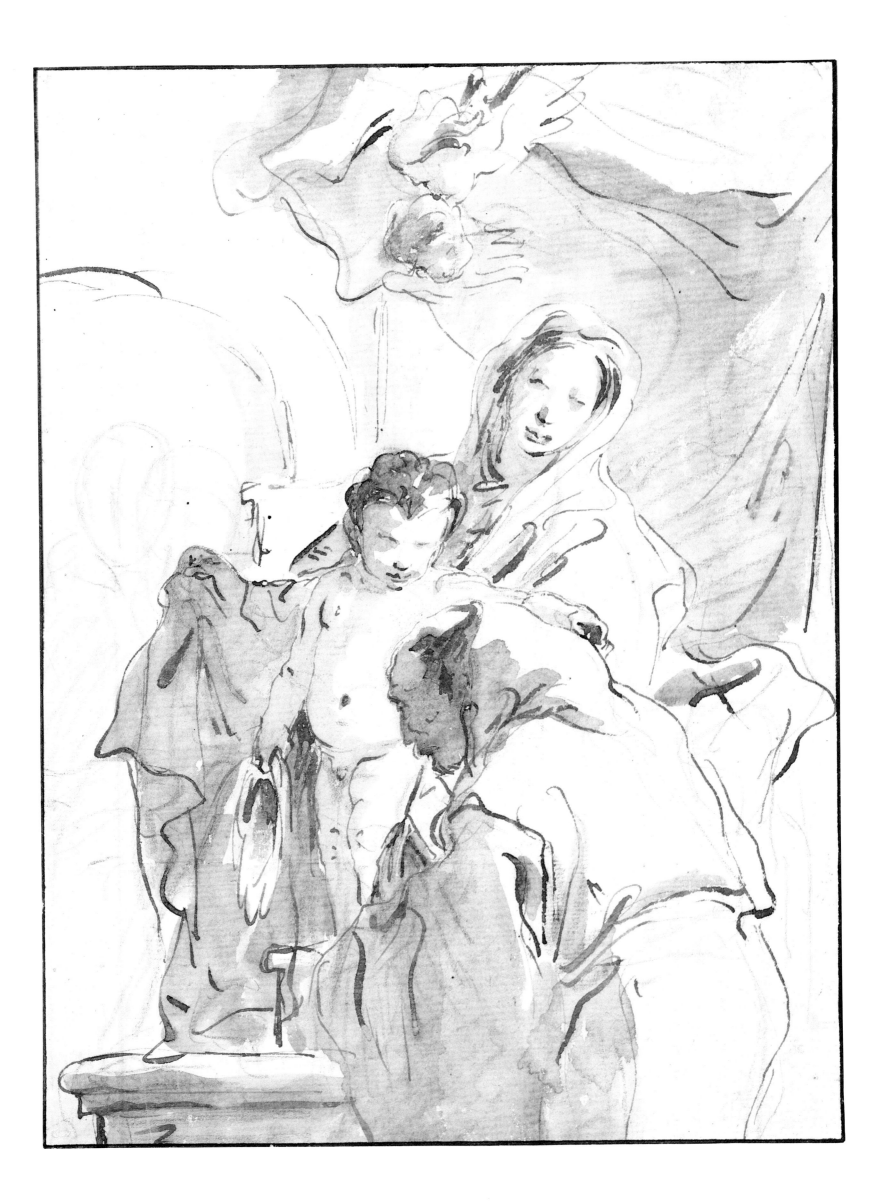

64

FRANCESCO GUARDI (1712–1793)
Houses on the Grand Canal in Venice

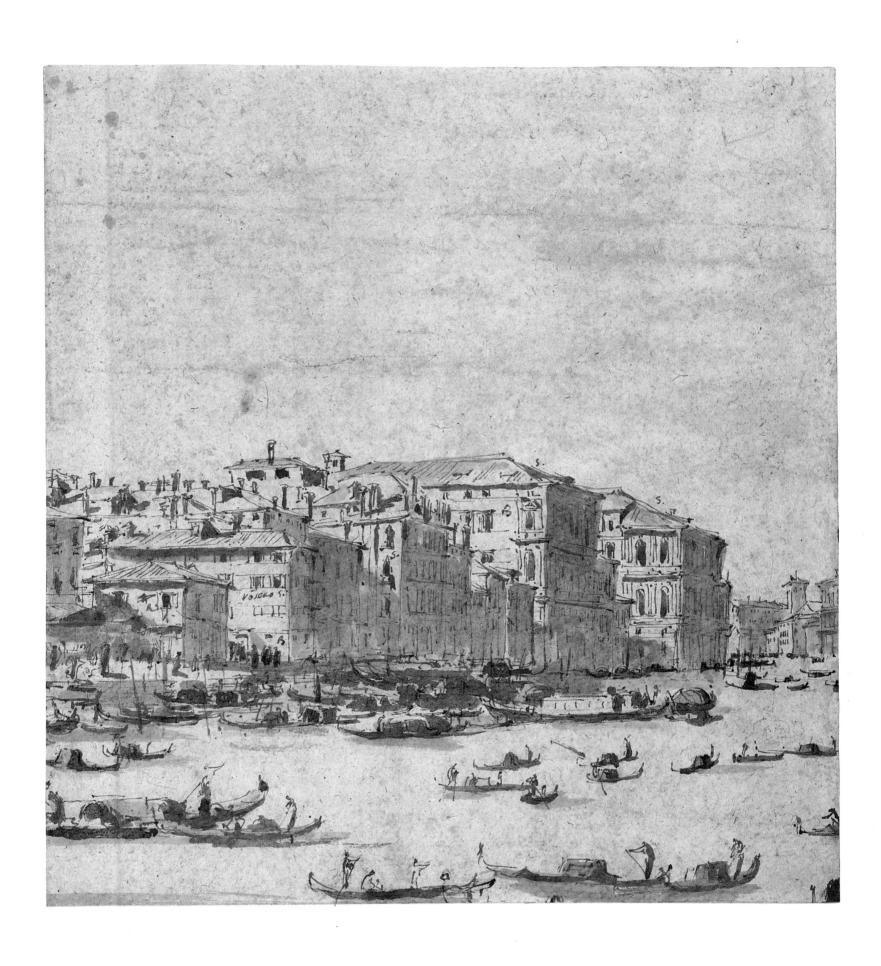

FRENCH SCHOOL

65

JACQUES BELLANGE (end of the 16th C.–before 1624)
The Three Marys at the Tomb

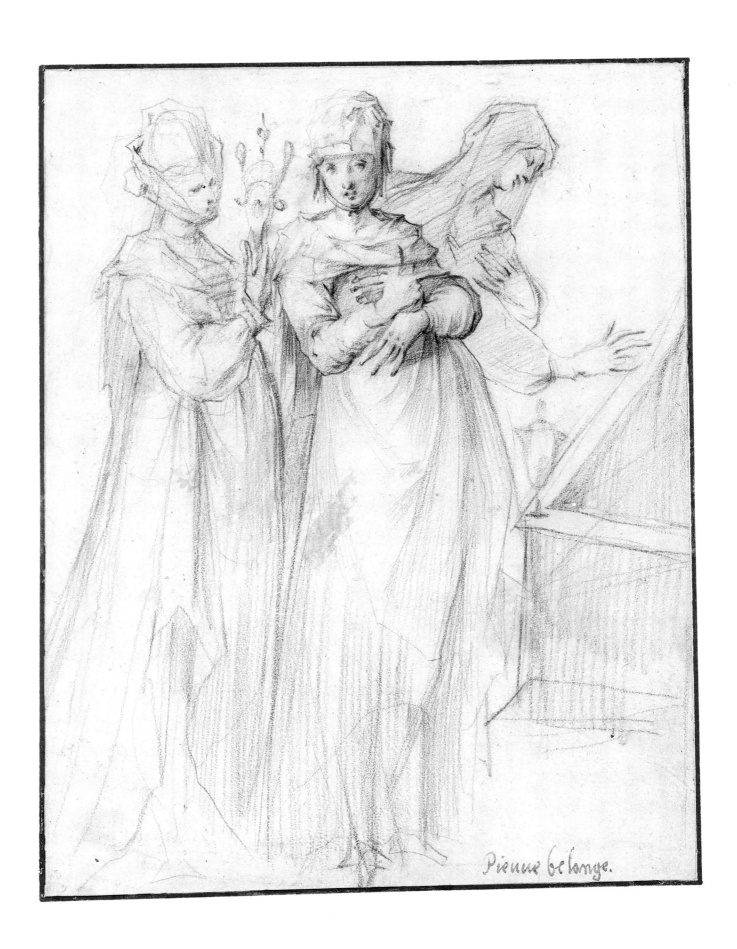

Pierre belange.

66

NICOLAS POUSSIN (1594–1665)
River Landscape

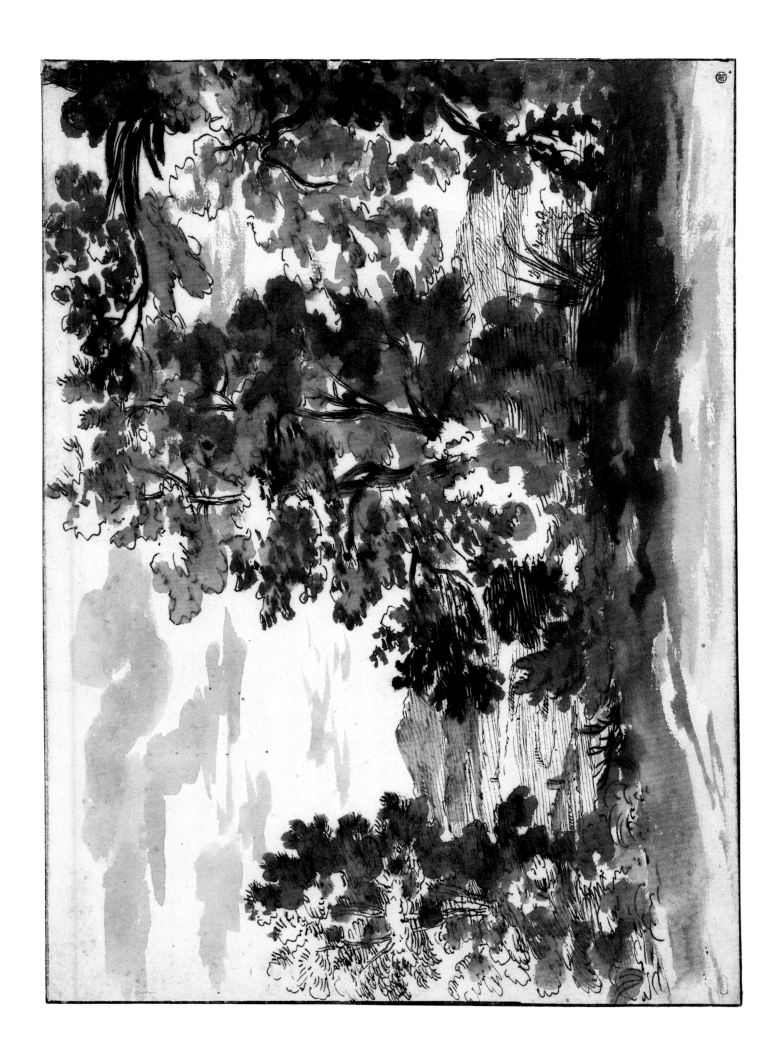

67

CLAUDE LORRAIN (1600–1682)
Tiber Landscape with Rocky Promontory

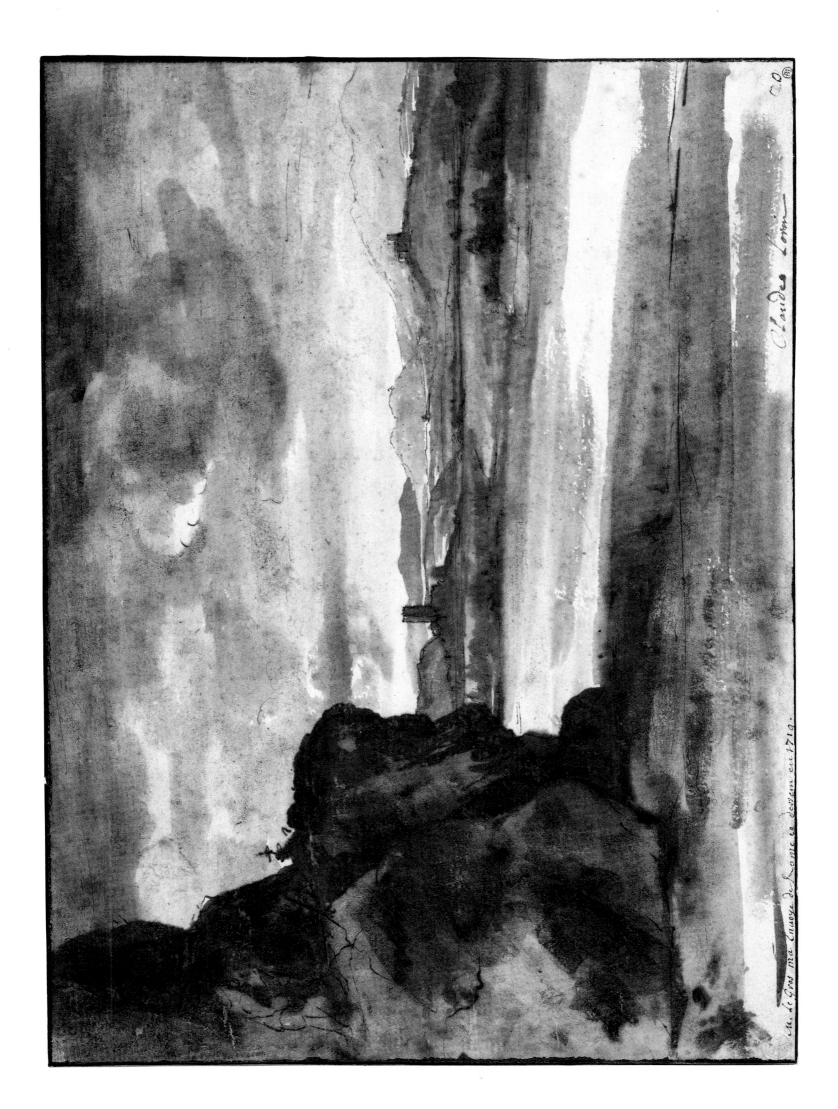

Claude Lorrain

a le Gros ma enuoye de Rome ce desseyn en 1719.

68

JEAN-ANTOINE WATTEAU (1684–1721)
Two Studies of a Young Woman

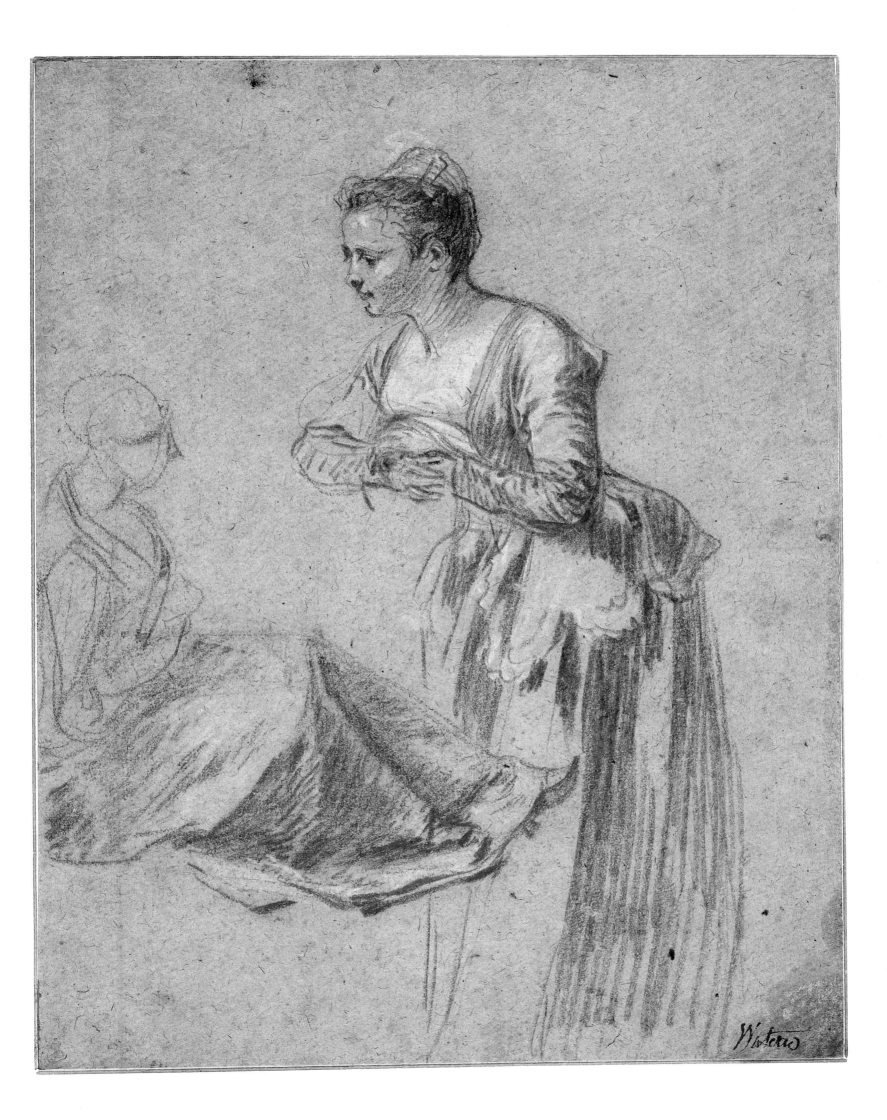

69

JACQUES-ANDRÉ PORTAIL (1695–1759)

The Embroiderers

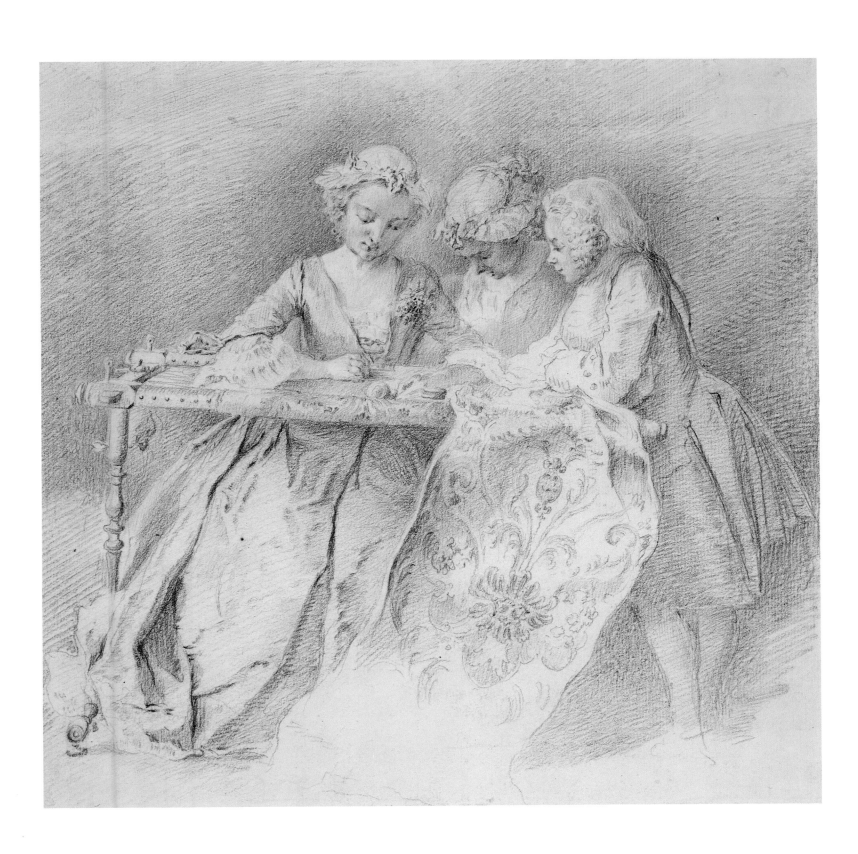

70

FRANÇOIS BOUCHER (1703–1770)
Aqueduct near Arceuil

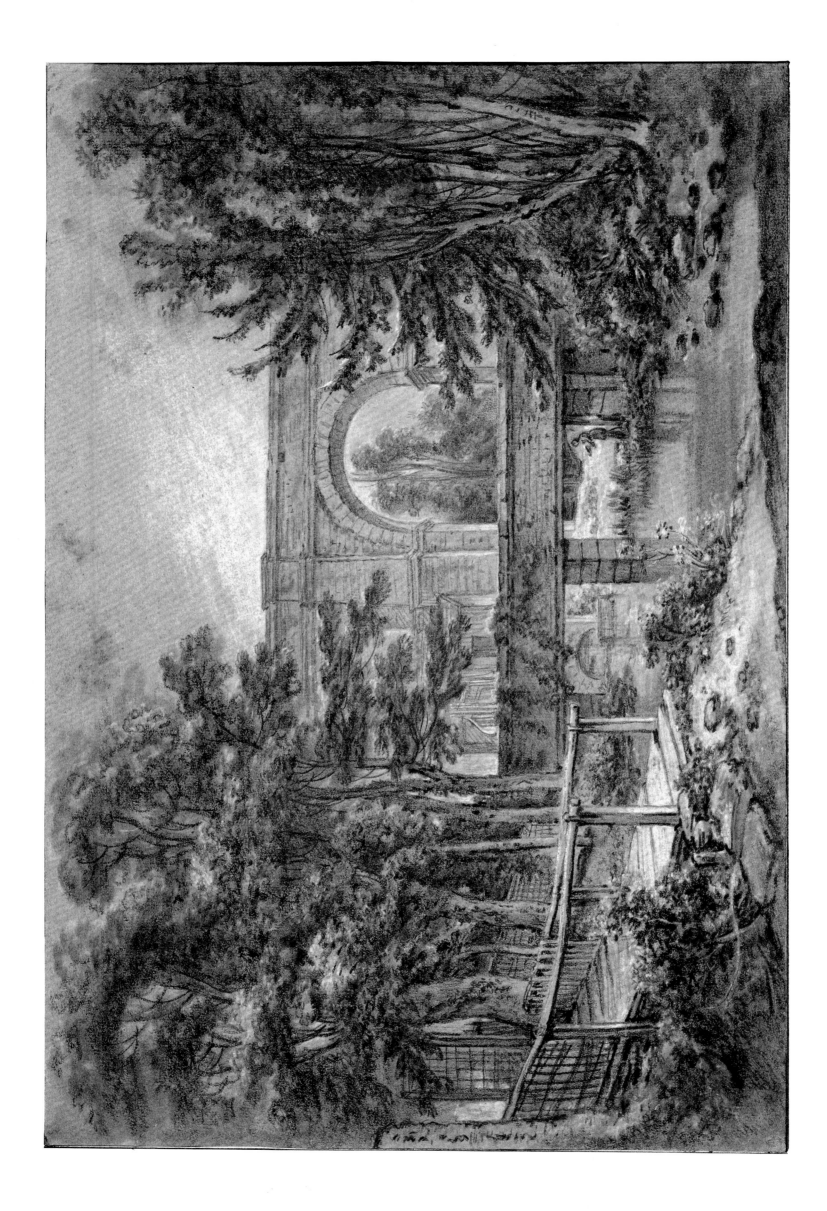

71

CHARLES-JOSEPH NATOIRE (1700–1777)
Italian Landscape in Autumn

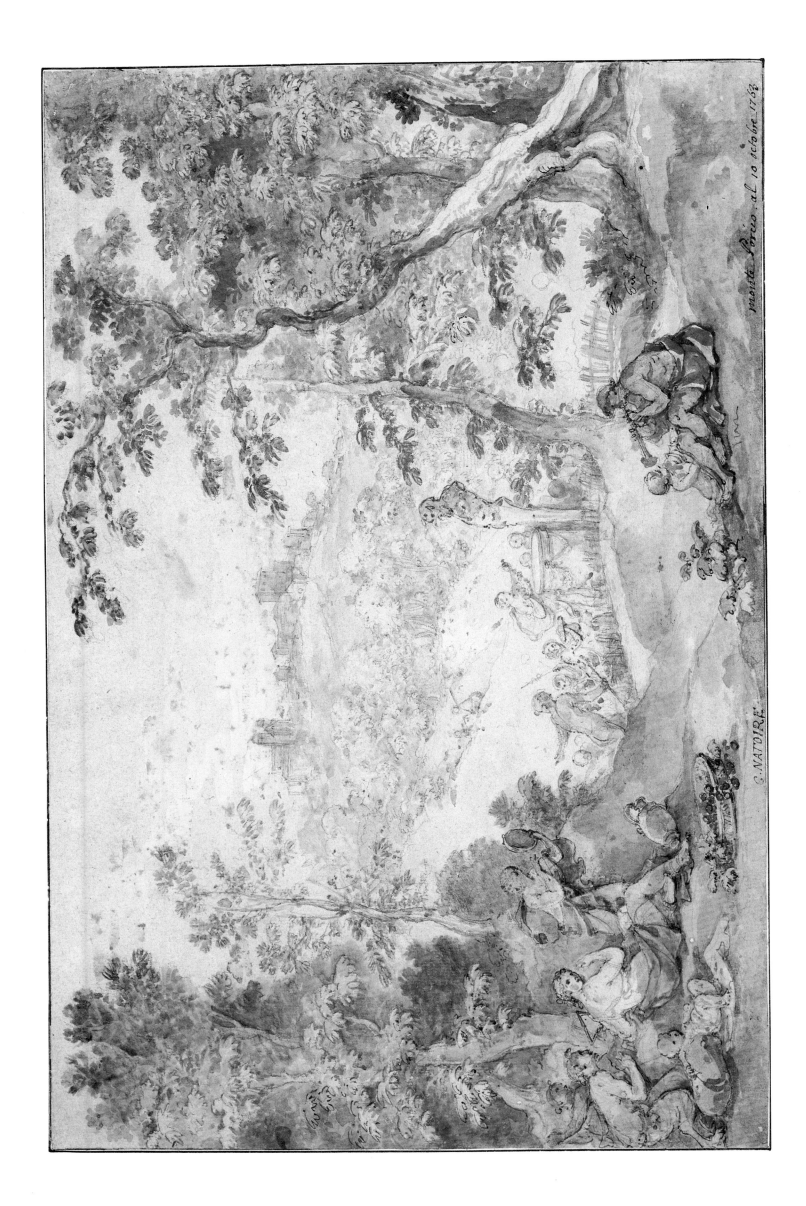

C. NATOIRE

72

Jean-Honoré Fragonard (1732–1806)
Marguerite Gérard Sketching

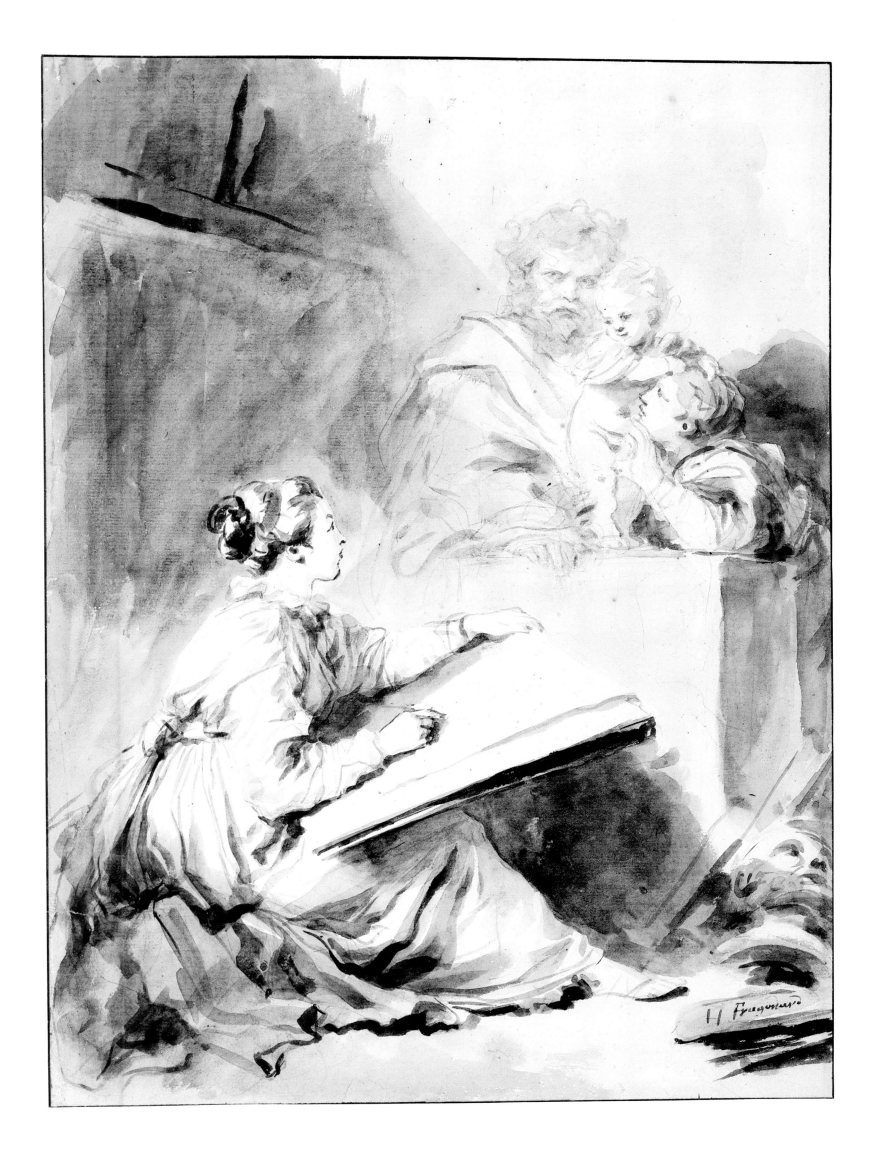

73

JEAN-HONORÉ FRAGONARD (1732–1806)
Avenue of Cypresses at the Villa d'Este

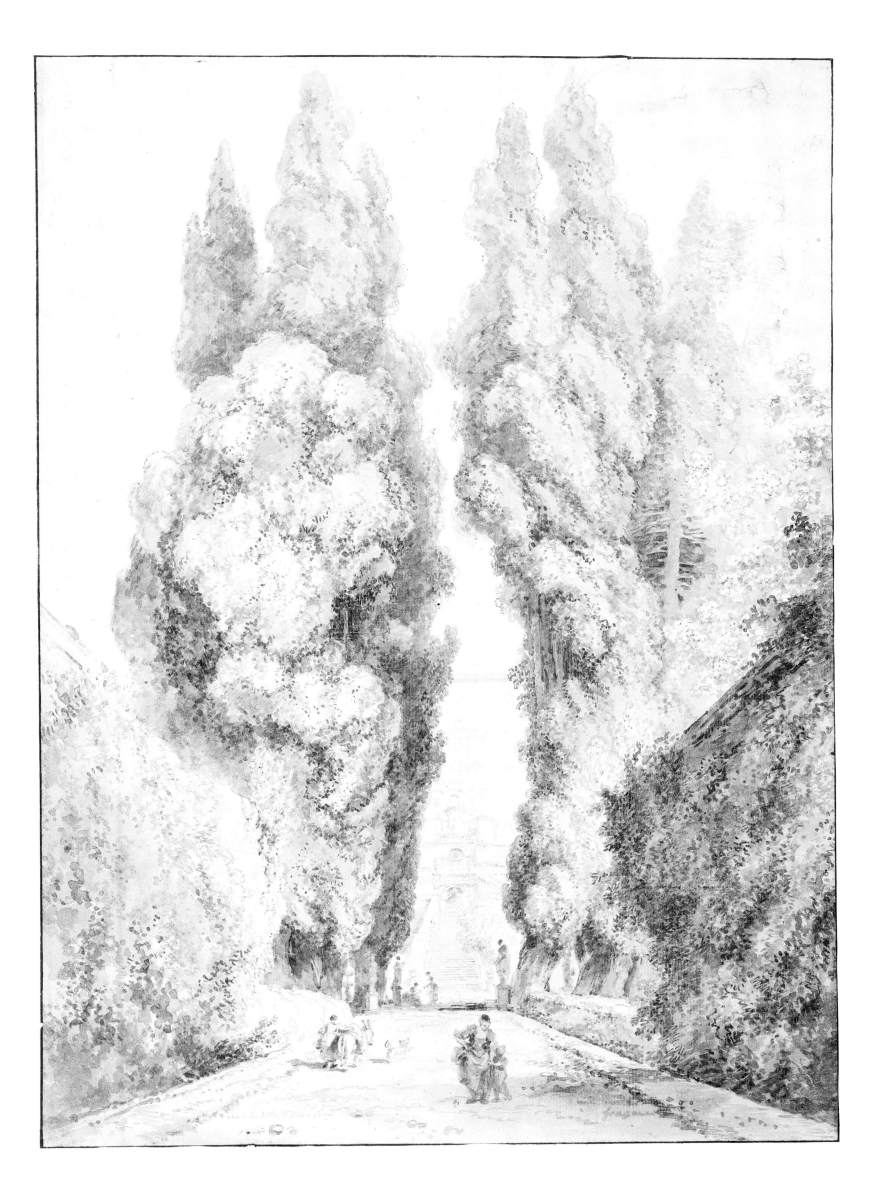

74

HUBERT ROBERT (1733–1808)

Roman Ruins at the Villa Madama, with Washerwomen

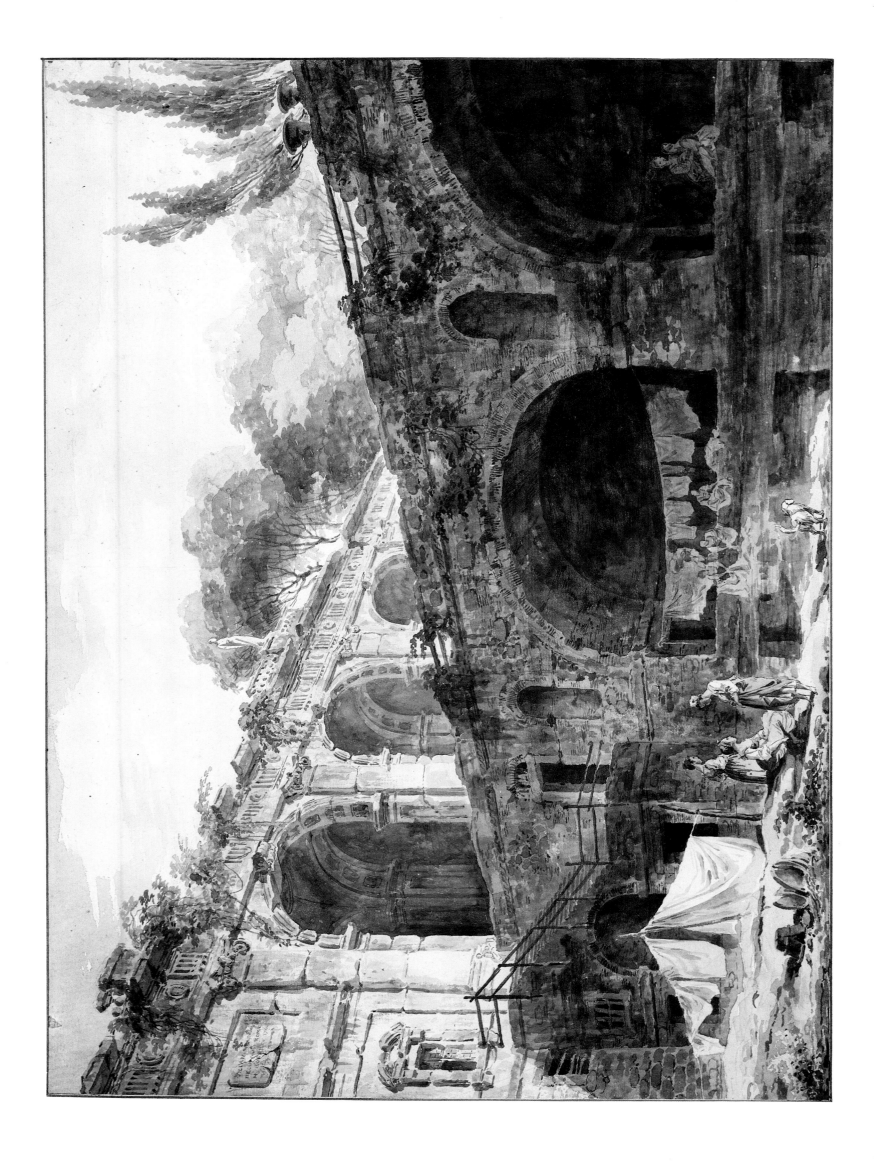

75

Jean-Baptiste Greuze (1725–1805)
Head of a Girl

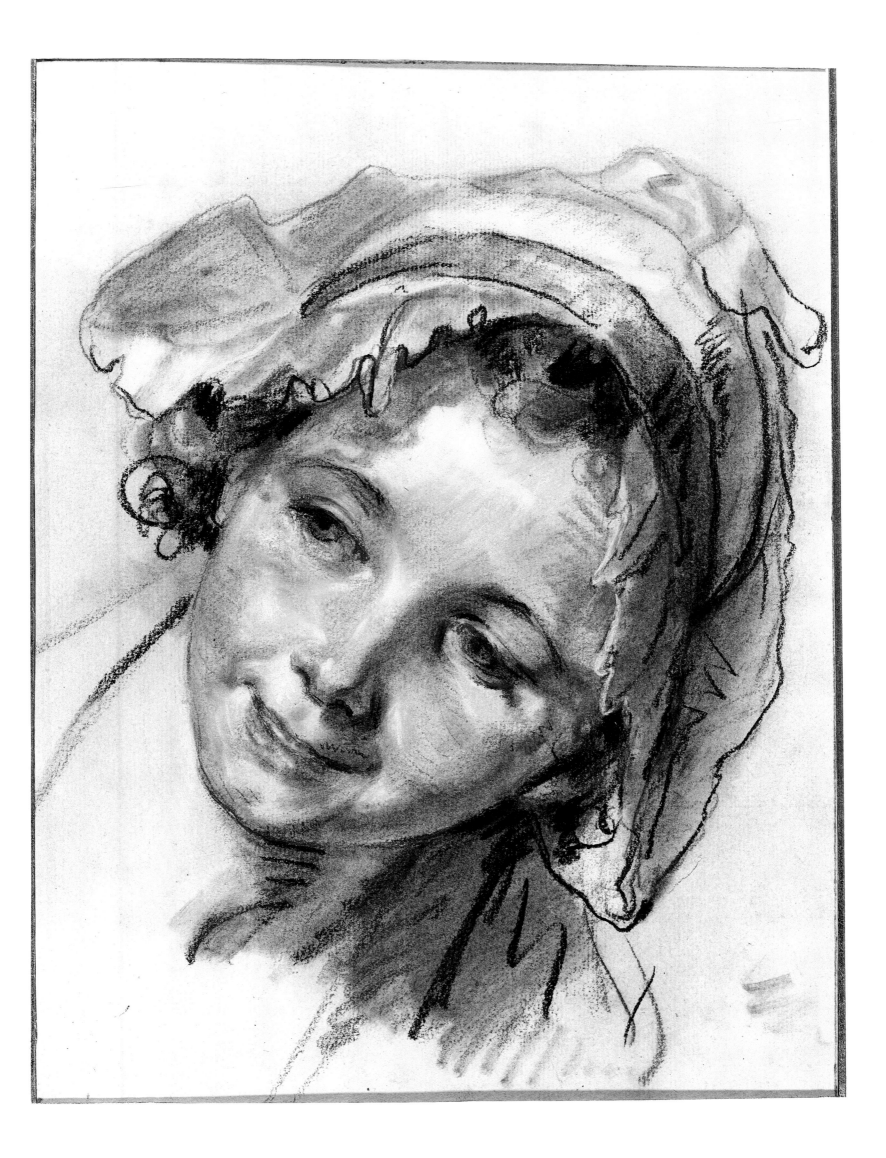

Catalogue

V.B. Dr. Veronika Birke
M.B.-P. Dr. Marian Bisanz-Prakken
Ch.E. Dr. Christine Ekelhart
E.K. Dr. Eckhart Knab
F.K. Dr. Fritz Koreny
W.K. Dr. Walter Koschatzky
E.M. Dr. Erwin Mitsch
A.S. Dr. Alice Strobl

Scholarly assistant and editor: Dr. Ilse Goffitzer

Photographer: Eugen Finkler, Albertina Collection

German School

Upper German (Rhenish?) Master
active c.1430–1440

I

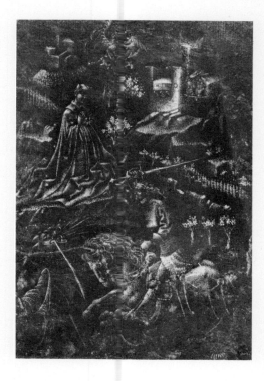

ST. GEORGE AND THE DRAGON
Brush and white bodycolor on black prepared
ground; 18.1 × 12.8 cm; inv. 3.053, D.9

Provenance: Duke Albert of Saxe-Teschen, L.174

Bibliography: Schönbrunner-Meder, no. 1158;
Meder 1922, p. 50, note 2; Alb.Cat. IV(V), 1933,
D.9; Otto Benesch, "Osterreichische
Handzeichnungen des XV. and XVI.
Jahrhunderts," *Die Meisterzeichnung*, V,
Freiburg/Breisgau, 1936, no. 42; F. Winzinger,
Deutsche Meisterzeichnungen der Gotik, Munich,
1949, no. 9; Benesch 1964, Meisterzeichnungen,
no. 63.

The draughtsman of this subtle drawing rendered
his subject in sparingly applied, delicate white
strokes and dots on black paper. The forms
emerge from the black paper as if it were night
scenery and they were illuminated only by the
light of the moon. According to legend, St.
George, a nobleman from a Cappadocian family
who served in the Roman army at the time of the
emperors Diocletian and Maximian,[1] fought a
dragon to rescue a princess who was being offered
as a sacrifice. Here, one sees St. George leaping
forward with arm raised to deliver the deadly
blow against the dragon rearing up in front of him.
Princess Cleodolinda, her hands raised in prayer,
watches the outcome of the battle to free her from
the monster's clutches. Behind trees and wattle
fences, castles rise up on steep cliffs, and higher
still, hardly perceptible today, the draughtsman
added the bust of an angel with outspread wings.

The unusual style and the medium, white on
black, are not only reminiscent of stipple engrav-
ing,[2] which use dots and short strokes to cut the
drawing into the plate, but also a few engravings
by Master E. S.[3] who achieved similar results by
applying the technique of the white-line woodcut
to engravings.[4] Paste prints and metal prints,
little-known printing techniques from the begin-
nings of printmaking in the fifteenth century, also
sought similar effects. A sheet in Frankfurt with
fifteen small sketches used a comparable tech-
nique; dated by E. Schilling to c.1440–45 it was
probably the model sheet for a goldsmith.[5] The
composition is similar to the engraving (L.14) by
the Master of the Nuremberg Passion,[6] whose
compositions have often been proven to derive
from earlier models.[7]

The rich, steep, layered landscape reminded
Otto Benesch of painting found in the Upper
Rhine and the Austrian Vorlande and works of
artists who had been influenced by Konrad Witz.
Benesch assigned a date of c.1445 to the work and
considered the drawing "in the roundness of its
formal articulation . . . close to certain character-
istics of the Austro-Bavarian school, such as the
so-called Master of Weilheim."[8] Details in the
clothing could, however, justify a slightly earlier
date in the 1430s. The zaddeln on the saint's tunic,
his wreath of freshly cut twigs and the saplings
twisted into spirals can all be associated with the
so-called soft style of art around 1400 (e.g.,
Frankfurt Paradise Garden). Moreover, the "little
horn" hairstyle of the princess and the soft folds of
her drapery are reminiscent of the fashion of the
1430s (compare her appearance with that of the
princess in Rogier van der Weyden's depiction of
St. George, National Gallery of Art, Washington,
D.C.). Finally, the dot and dash technique, a kind
of stippling, is similar to that used on panel
paintings during the first decades of the fifteenth
century. For example, the technique the Master
of Heiligenkreuz (Austria, c.1420) used to render
the pattern, clouds and secondary scenes in the
Death of St. Clare corresponds, for all the difference
in medium, to similar ideas about form and effect.[9]

F.K.

Notes

1. J. da Voraigne, *Legenda Aurea*, translated by
 von R. Benz, fourth edition, Heidelberg, 1963,
 p. 325–31.
2. Benesch 1964, Meisterzeichnungen, no. 63.
3. M. Lehrs, *Geschichte und kritischer Katalog des
 deutschen, niederländischen und französischen
 Kupferstichs im 15. Jahrhundert*, II (Vienna,
 1910), no. 70.
4. A. Shestack, comp. *Master E. S., Five
 Hundredth Anniversary Exhibition* (Philadelphia,
 1967), no. 66.
5. E. Schilling, *Städelsches Kunstinstitut
 Frankfurt/Main, Katalog der Zeichnungen, Alte
 Meister*, I–II (Munich, 1973), no. 193.
 Additional volume by K. Schwarzweller.
6. M. Lehrs, *Geschichte*, I (Vienna, 1908), p. 161,
 no. 14.
7. Fritz Koreny, "Ueber die Anfänge der
 Reproduktionsgraphik nördlich der Alpen"
 (Ph.D. Diss., Vienna, 1968).
8. Benesch 1964, Meisterzeichnungen, no. 63.
9. Master of Heiligenkreuz, *Death of St. Clare*,
 National Gallery of Art, Washington, D.C.,
 inv. 1162; cf. *Death of Mary*, The Cleveland
 Museum of Art, inv. 36.496.

Unknown German Master
active end of fifteenth century

2

PORTRAIT OF A MAN
Silverpoint on white prepared paper;
26.5 × 18.6 cm; inv. 4.845, N.15; mounted
Mat inscribed "Israel van Mecheln"

Provenance: Duke Albert of Saxe-Teschen, L.174

Bibliography: Schönbrunner–Meder, no. 307;
Meder, Albertina–Facsimile 1923, p. 13;
Alb.Cat. II, 1928, N.15; *Kindlers Meisterzeichnungen
aller Epochen, II, Niederländische Zeichnungen,*
prepared by F. Lugt, Zurich, 1963, no. 508;
Alb.Vienna 1971, Meisterzeichnungen, no. 32.

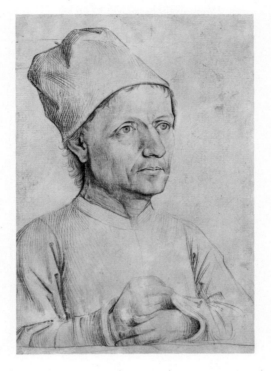

At the beginning of the nineteenth century this drawing was attributed to Israel van Meckenem, a common occurrence in German collections at that time.[1] This unsupported notion (particularly because Meckenem is known only as an engraver) was, in the light of scholarship, as untenable as M. v. Thausing attributing it to Jan van Eyck.[2] Even when this fine drawing was "anonymous," it attracted much consideration[3] until Otto Benesch attributed it, based on comparisons with well-documented paintings, to Petrus Christus.[4] He saw parallels between *Portrait of a Man* and Petrus Christus' early portrait style in "the strong emphasis on the head in relation to the small body."[5] Benesch's attribution found no echo in the literature, and even the new edition of M. Friedländer's *Early Netherlandish Painting*[6] silently passed over the drawing in discussing Petrus Christus' oeuvre; only F. Lugt expressed an opposing opinion. Judging from the position of the hands, Lugt believed the drawing was a later copy of a prototype that must have been close to Christus' late work.[7]

The bust portrait in three-quarter profile with crossed arms and one hand on top of the other at rest either on the image's lower edge or, as here, on a narrow balustrade is common in Netherlandish art and can be traced to early Netherlandish painters, such as Jan van Eyck, the Master of Flemalle and Rogier van der Weyden. This type of portraiture, widespread in Netherlandish art of the fifteenth century, was also transmitted to German painting.

Although this drawing may be similar in its outward appearance to early Netherlandish works (works deriving more from Dirk Bouts than Petrus Christus in my opinion[8]), its inner intensity differs. The psychological penetration of *Portrait of a Man* seems somewhat less acute; the portrayed man is to a certain extent reduced to the visible appearances of his bourgeois existence, a characteristic that belongs more to German portraits than Netherlandish portraits. Late Gothic German portraits,[9] mainly representing merchants and craftsmen, tend to be better comparisons. Compare, for instance, the portraits of the cathedral architect Moritz Ensinger or the architect Nikolaus Eseler.[10]

In addition, the Albertina's drawing is almost identical to a silverpoint drawing in the Hamburg Kunsthalle.[11] Moreover, the Hamburg drawing

focuses our attention on an insignificant detail: it gives the impression that the man is holding something with the middle finger of his left hand. What appears to be a T-shaped fold in the sleeve of the Albertina drawing resembles in the Hamburg copy a short metal pin that has been bent into a ring, ending in a "T," for holding purposes.

On the basis of hardly perceptible outlines, the draughtsman has handled the face and the clothing very differently. While he rendered the facial features in soft hatched strokes that come together as softly modeled planes, the clothes and headgear are only hinted at in quick but confidently executed hatching.

The uniform hatching of the pupil of the right eye, a very draughtsmanly and graphic technique, is reminiscent of the engraving techniques of Schongauer's time, and also encourages one to compare the drawing with late fifteenth-century German works. This does not, however, make it possible to identify positively the drawing as the work of an individual artist. *F.K.*

Notes

1. Old notebook entry; inscription on the mat.
2. Old notebook entry.
3. Schönbrunner-Meder ascribed it to a "Netherlandish master of the 15th century," no. 307; J. Meder illustrated the sheet in the Albertina Facsimile 1923, pl. 1.
4. Alb.Cat. II, 1928, N.15; Benesch repeated his identification in Meisterzeichnungen, no. 124.
5. Benesch, Meisterzeichnungen, no. 124.
6. M. J. Friedländer, *Early Netherlandish Painting,* vol. 1 (Leiden, 1967).
7. F. Lugt, *Kindlers Meisterzeichnungen aller Epochen,* vol. 2 (Zurich, 1963), no. 508.
8. See Friedländer, *Early Netherlandish Painting,* vol. 3, pl. 20, 51.
9. E. Buchner, *Das deutsche Bildnis der Spätgotik und der frühen Dürerzeit* (Berlin, 1953), p. 13 ff.
10. Buchner, *Das deutsche Bildnis,* fig. 69, 71.
11. Anonymous fifteenth-century Netherlandish Master, Hamburg Kunsthalle, inv. 21.926.

2a.
Netherlandish, fifteenth century
Portrait of a Man
Hamburg Kunsthalle, Hamburg

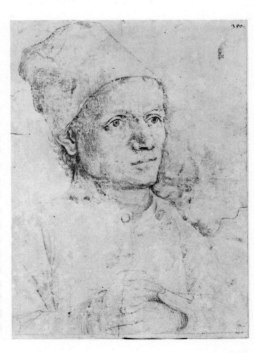

Albrecht Dürer
Nuremberg 1471–1528 Nuremberg

Painter, engraver and woodcut designer. In 1484–85, pupil of his father, the goldsmith Albrecht Dürer the Elder; 1486–89, apprenticed to the painter Michael Wolgemut in Nuremberg. His *Wanderjahre* (journeyman years) from 1490–94 took him to Colmar, Basel and Strassburg. After his return, he traveled to Venice in 1494–95. During his second trip to Italy in 1505–07, he visited Venice, Padua and Bologna and may also have reached Rome. In 1512 Dürer began working for Emperor Maximilian I who from 1515 paid him an annuity of 100 gulden. In 1518 Dürer was present at the Reichstag in Augsburg; 1519, traveled to Switzerland with Willibald Pirckheimer; 1520–21, traveled to The Netherlands. His first theoretical work *Die Unterweisung der Messung* (Art of Measurement) appeared in 1525, while the *Vier bücher von menschlicher Proportion* (Four books on human proportions) appeared posthumously in October 1528.

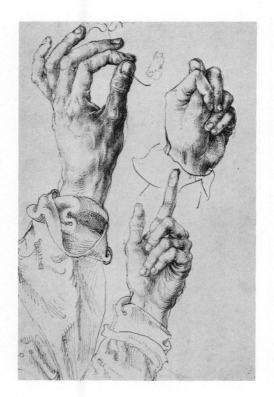

3

STUDIES OF HANDS
1493

Pen and black-brown ink; 27.0 × 18.0 cm; inv. 26.327, D.35
Hand at the left darker than those at the right; cut down at top and right; studies of heads and feet on *verso*

Provenance: Private Polish collection; acquired in 1932

Bibliography: H. Tietze, E. Tietze-Conrat, "Neue Beiträge zur Dürerforschung, Neuerworbene Zeichnungen der Albertina," *Jahrbuch der Kunsthistorichen Sammlungen in Wien*, New Ser. 6 (1932), p. 115 ff; Alb.Cat.IV(V), 1933, D.35; Tietze 1937/38, I, no. 62a; Winkler I, no. 47; Panofsky 1948, II, no. 1213; Alb.Vienna 1971, no. 16; Strauss 1974, I, no. 1493/8.

The sheet belongs to a series of hand studies by Dürer that Alfred Stix acquired from a private Polish collection in 1932. As to the provenance of these drawings, Winkler wondered whether they, like a number of the Dürer drawings in the Lubomirski Museum in Lemberg, could have been part of Duke Albert's former collection that had been surreptitiously removed. These hand studies were first published in 1932 by the Tietzes[1] who identified them as studies of Dürer's own hand by comparing them with the hands in the artist's self-portraits in Erlangen[2] and Lehman (Metropolitan Museum of Art)[3] collections.

Winkler, Panofsky, Adhemar, Pächt, Winzinger and Strauss were convinced this drawing dated from the *Wanderjahre*[4]; the Tietzes, on the other hand, believed the Albertina sheet was more advanced and fluent, more nuanced in shading and inconceivable without the influence of Italian art.[5] A comparison of the hand at the left of the Albertina sheet with the verso of the self-portrait (dated 1493) in the Lehman Collection argues convincingly for the same date because the linear structures and the chiaroscuro values are very similar in the two drawings. This also applies to a contemporaneous study of a left hand in a Dürer sketch of Mary and the Christ Child at the foot of a tree trunk (British Museum, London).[6] These hand studies were all created with the same fine, short, often hooked strokes that softly model the plastic form and emphasize the material quality. They are surely to be assigned to Dürer's early manner of pen drawing which, as Landolt has shown,[7] is rooted in the tradition of fifteenth-century German drawing. Similar considerations also apply to the picture's theme.[8]

The closeness of these hand studies to Dürer's right hand in his 1493 self-portrait in Paris is also a clue to the sheet's date. The Paris oil painting repeats the motif, with small variations, of a hand holding a flower, and the drawing's treatment of details is very similar to that of the painting.[9] Moreover, Pächt pointed out that the position of the hand in the nature study comes from a Netherlandish model, a Madonna by the Master of Flemalle known only through a copy.[10] Dürer transferred the pose to the left hand, turning it ninety degrees.

The sketch at right shows the left hand with outstretched index finger, a very common motif found in many Dürer drawings. In comparison, the hand in the Lisbon St. Jerome is seen from the back. Finally, the third hand study shows a gesture—one of the most recognized but also most vulgar hand movements—that was used from the fifteenth century on. According to court records of the seventeenth and eighteenth centuries, anyone caught using this gesture was punished severely. This and the gesture's use as a sign of courtship indicate that its meaning was almost always current.[11] Moreover, if one refers to J. S. Held's study "Flora, Goddess and Courtesan,"[12] which discusses flowers as symbols of sensual love, the study of a hand and flower could also be interpreted as representing a proposal of love. *A.S.*

Notes

1. H. Tietze and E. Tietze-Conrat, "Neue Beiträge zur Dürerforschung, Neuerworbene Zeichnungen der Albertina," *Jahrbuch der Kunsthistorischen Sammlungen in Wien*, New Ser. 6 (1932), p. 115 ff.
2. Winkler I, no. 26.
3. Winkler I, no. 27.
4. Winkler I, no. 47; Panofsky 1948, II, no. 1213; Paris 1950, no. 54; O. Pächt, "Zur Frage des geistigen Eigentums im bildkünstlerischen Schaffen," *Methodisches zur kunsthistorischen Praxis* (Munich, 1977), p. 168; F. Winzinger, "Eine unbekannte Zeichnung Albrecht Dürers aus seiner Wanderzeit," *Pantheon*, III, (1982):230; Strauss 1974, I, no. 1493/8.
5. H. Tietze, E. Tietze-Conrat, *Jahrbuch der Kunsthistorischen Sammlungen*, p. 116.
6. According to Fritz Koreny. J. Rowlands, "A Sheet of Studies by Albrecht Dürer," *Art at Auction* (Sotheby's 1982–83): 40 ff., no. 1.
7. H. Landolt, "Zur Geschichte von Dürers zeichnerischer Form," *Anzeiger des Germanischen Nationalmuseums* (1971/72), p. 144 ff.
8. Fritz Koreny called my attention to a study with four hands by Hans Holbein illustrated in *Handzeichnungen schweizerischer Meister des XV.–XVIII. Jahrhunderts*, edited by P. Ganz, II.47.
9. Parchment (transferred to canvas), inscribed and dated "1493," O.565 : O.445m; Museé du Louvre, Paris, Inv. R.F.2382; Anzelewsky 1971, no. 10, 11. 9.
10. O. Pächt, *Methodisches*, p. 167, no.5.
11. L. Hansmann, L. Kriss-Rettenbeck, *Amulett und Talismann, Erscheinungsform und Geschichte*, (Munich, 1966), p. 204.
12. Millard Meiss, ed. *De Artibus Opuscula XI, Essays in Honor of Erwin Panofsky* (New York, 1961), p. 201 ff.

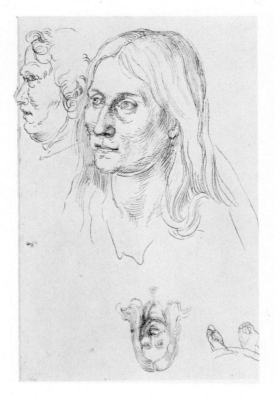

3 (VERSO)

STUDIES OF HEADS AND FEET
Pen and black ink
Verso of cat. no. 3

Bibliography: H. Tietze, E. Tietze-Conrat, "Neue Beiträge zur Dürerforschung, Neuerworbene Zeichnungen der Albertina," *Jahrbuch der Kunsthistorischen Sammlungen in Wien*, New Ser. 6, (1932), p. 116; Tietze 1937–38, I, no. 62b; Winkler I, no. 45; Panofsky 1948, II, no. 1118; Alb.Vienna 1971, no. 16a; Strauss 1974, I, no. 1493/9.

While there is no disagreement that recto and verso were executed at the same time, during the *Wanderjahre*, only the Tietzes expressed an opinion about the identity of the figures represented in the sketches.[1] They thought the artist may have been thinking of his mother when he drew the head, seen in three-quarter profile looking left, because there is a resemblance to Dürer's own facial features. In addition, Barbara Dürer, née Holper, was thirty-eight or thirty-nine in 1490, and if Dürer did, in fact, record his mother's face in the study, he was working from memory because this work was executed three years after he left home. Moreover, his mother's face was firmly in his memory, for he had painted his parents' portraits before his *Wanderjahre*. His father's portrait is in the collection of the Uffizi[2]; unfortunately his mother's has not survived.[3]

The facial type represented in the sketch, which also has certain masculine features, is often found in Dürer's early work. The Tietzes cited, among other examples, the woman in the rain of stars at the opening of the sixth seal of the Apocalypse.[4] It is very doubtful, however, that the small head represents Dürer's wife Agnes. The depiction does indeed bear some resemblance to the Albertina's portrait *Mein Agnes*,[5] but it is not known whether Dürer knew her before his four years of *Wanderjahre*, when she was fifteen. Dürer's statements in the family chronicle give the impression that the marriage was arranged by the fathers just before Dürer's return.[6]

To the left of this head are a left and right foot, which could not be in this position simultaneously.[7] The fourth study, the man in left profile, is representative of Dürer's works, and as the Tietzes emphasized,[8] it is to be found repeatedly after Dürer's copy of Mantegna's *Bacchanal* (1494).[9] A similar male head appears on the Apocalypse sheet with the angels holding the four winds of the earth, but it was also used for a number of other images. *A.S.*

Notes

1. H. Tietze, E. Tietze-Conrat, *Jahrbuch der Kunsthistorischen Sammlungen*, p. 116.
2. Oil on panel in the collection of the Uffizi, Florence, 47 × 39 cm; Anzelewsky 1971, no. 2, ill. 1.
3. H. Rupprich, *Dürer, Schriftlicher Nachlass*, vol. 1 (Berlin, 1956), p. 32, no. 17. The painting was sold from Imhoff's collection to Amsterdam in 1633 and has since been lost.
4. H. Tietze, E. Tietze-Conrat, *Jahrbuch der Kunsthistorischen Sammlungen*, p. 116.
5. Winkler I, no. 151.
6. Rupprich, *Dürer, Schriftlicher Nachlass*, p. 31.
7. H. Tietze, E. Tietze-Conrat, *Jahrbuch der Kunsthistorischen Sammlungen*, p. 116.
8. Ibid.
9. Winkler I, no. 59.

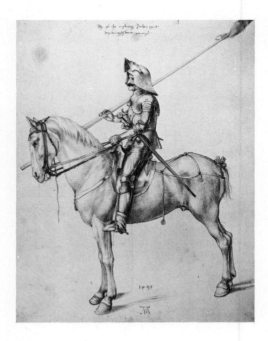

4

THE KNIGHT ON HORSEBACK
1498
Pen and brown ink with watercolor on white
paper; 41.0 × 32.4 cm; inv. 3.067, D.47
Watermark: small crown with inverted triangle
Monogrammed "A D" and dated "1498" at
bottom center
Inscribed upper center "Dz ist dy rustung Zw
der czeit Im tewtzschlant gewest"

Provenance: 1588 Imhoff; Imperial Treasury; 1738
Imperial Court Library; 1796 Duke Albert of
Saxe-Teschen; 1822 Estate inventory, p. 302;
L.174

Bibliography: Heller 1831, p. 118; Vienna 1871,
no. 64; Ephrussi 1882, p. 56; Thausing 1884, II,
p. 181, 238, 310, 371; S. Laschnitzer,
"Artistisches Quellenmaterial aus der
Albertina," *Jahrbuch der Kunsthistorischen
Sammlungen des Allerhöchsten Kaiserhauses* 4 (1886),
p. II, no. 3048; Schönbrunner-Meder, no. 77;
Alb.Vienna 1899/1900; Lippmann 1905, no. 461;
W. Seidlitz, "Dürers frühe Zeichnungen,"
Jahrbuch der Königlich Preussischen Kunstsammlungen
28 (1907), p. 3 ff; Tietze 1928, no. 18
(Workshop); Flechsig 1931, II, p. 364; Alb.Cat.
IV(V), 1933, D.47; Winkler I, no. 176; Panofsky
1948, II, no. 1227; Paris 1950, no. 60; Alb.Vienna
1971, no. 17; P. Strieder et al, *Albrecht Dürer
1471–1971*, Nuremberg, 1971, p. 18 ff; Strauss
1974, I, no. 1495/48, VI, p. 3283; H. Theissing,
Dürer's Ritter, Tod und Teufel, Sinnbild und Bildsinn,
Berlin, 1978, p. 25 ff; F. Anzelewsky, *Dürer,
Werk und Wirkung,* Stuttgart, 1980, p. 89, 178,
210; P. Strieder, *Dürer, Königstein/Taunus,* 1981,
p. 176, 178, no. 206.

This sheet owes its important position in cultural
history to Dürer's inscription (upper margin),
which states, "this was the armor in Germany at
that time," and the date "1498" above his
monogram. It is precisely these two inscriptions
that have generated so many problems. The past
tense of the statement implies that the inscription
was added later, as in the case of the words "when
I was still a child" on his self-portrait as a boy. Was
the date also post-facto? What then does it mean?
Could Dürer have misremembered the year?
Doubts emerged: Seidlitz considered the year
false[1]; Flechsig thought the date was correct but
that it was added in 1512[2]; Pauli suggested a later
date[3]; while the Tietzes did not consider the
drawing a Dürer "because of its low quality"[4]
(but how does one account for Dürer's inscrip-
tion?). Finally, it was suggested that the sheet's
undesirable coolness might indicate an autograph
copy by Dürer of one of his own drawings,[5] an idea
I concurred with in the 1971 Albertina catalogue,[6]
particularly since similar problems exist with
other drawings such as *Covered Bridge at the Haller
Gate* and *Wing of a Blue Rotter.* W. Strauss' detailed
references to the watermarks, in this case datable
to 1495,[7] added a new element to the discussion.

4a. Albrecht Dürer
St. Eustace
Albertina Collection, Vienna

4b. Albrecht Dürer
Knight, Death and Devil
Albertina Collection, Vienna

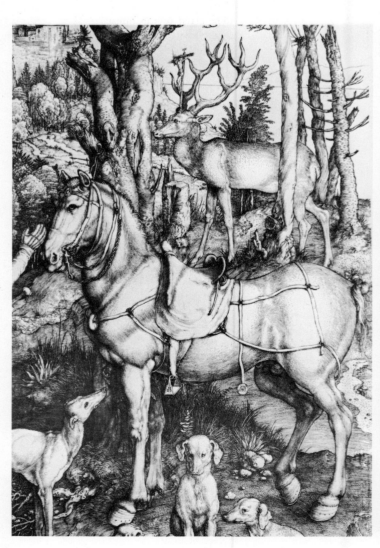

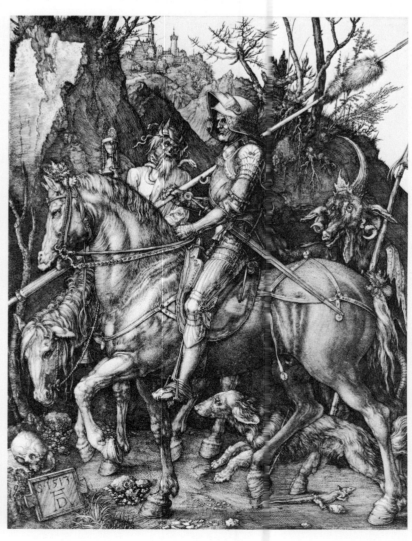

This new method of dating Dürer's sheets proved very useful. The tendency toward later dating had provoked a lot of disagreement because the use of this study for the horse in the engraving of *St. Eustace* sets a terminus antequem of 1500. The horse's raised right rear hoof, which develops and enriches the motif, suggests that the print post-dates the drawing and already shows the transition to a further development, which is evident in the *Stepping Horse* of 1503.[8] The traditional identification of the figure as Philipp Link, stable master and groom of the Baumgartner family has never been confirmed. The important point, however, is that the times had so clearly and significantly changed around 1500 that shortly afterwards this suit of armor was already a thing of the past. A new, historical sense led Dürer to record it as well as the costume studies of the ladies of Nuremberg.

There can surely be no further doubt that the drawing is an authentic first version. A date before 1498 could explain the stiffness of the drawing, for just as the theme of a rider on horseback became exceptionally important for Dürer, so did the process of evolution, which ran from a static, square-on, somewhat over-precise depiction to a diagonally receding, dynamic, loosened composition of a complicated subject. Leonardo's influence was to play its part later[9]; the present sheet is simply a much earlier stage. Similarly the argument that this drawing is a carefully executed "fair copy" and therefore not the original version may be considered obsolete:[10] there are in fact corrections to both front hooves and to the saddle, but especially to the horse's head that upon initial execution was rendered substantially too small, a fact that argues for the drawing being a direct study from the model. This horseman is the point of departure for a quite exceptionally important further enrichment of the motif, which is not limited to the purely formal. The stable master and coachman becomes the "Christian Knight," a humanist ideal that Dürer identified with Erasmus of Rotterdam. The motif finally becomes the 1513 engraving *Knight, Death and Devil* whose meaning could later be interpreted, to use Friedrich Nietzsche's words as "a symbol of our existence." In this progression, we can follow the course of Dürer's own life with its increasing intellectual-spiritual depth. In this image of a rider, the artist marked an early and decisive step in that evolution. *W.K.*

Notes

1. W. Seidlitz, *Jahrbuch der Königlich Preussischen Kunstsammlungen* (1907), p. 11.
2. Flechsig 1931, II, p. 364.
3. Alb.Cat. IV(V), 1933, D.47.
4. Ibid.
5. Ibid.
6. Alb.Vienna 1971, no. 17, p. 153.
7. Strauss 1974, I, no. 1495/48, VI, p. 3283.
8. Alb.Vienna 1971, p. 153.
9. H. Wölfflin, *Albrecht Dürer, Handzeichnungen* (Munich, 1919), p. 20.
10. F. Anzelewsky, *Dürer, Werk und Wirkung* (Stuttgart, 1980), p. 89.

5

HEAD OF AN APOSTLE
1508
Point of brush and gray wash, heightened with white, on green-prepared paper; 31.6 × 22.9 cm; inv. 4.836, D.87
Monogrammed "A D" and dated "1508" at right below center

Provenance: Imperial Treasury; 1783 Imperial Court Library; 1796 Duke Albert of Saxe-Teschen, L.174

Bibliography: Heller 1831, p. 91; Vienna 1871, no. 39; Ephrussi 1882, p. 157; Thausing 1894, II, p. 18; Alb.Vienna 1899/1900; Schönbrunner-Meder, no. 297; Lippmann 1905, no. 510; Meder, Handzeichnung, p. 90 ff; Alb.Cat. IV(V), 1933, D.87; Tietze 1937/38, I, no. 375; Winkler II, no. 449; Panofsky 1948, II, no. 489; Paris 1950, no. 70; Alb.Vienna 1971, no. 70; J. Jahn, "Albrecht Dürer, Seine Leistung in Bildnis- und Landschaftsmalerei," *Albrecht Dürer, Zeit und Werk*, Leipzig, 1971, p. 108; A. Pfaff, *Studien zu Albrecht Dürers Helleraltar*, Nuremberg, 1971, p. 50 ff, no. 23; Strauss 1974, II, no. 1508/3; F. Piel, *Albrecht Dürer, Aquarelle und Zeichnungen*, Cologne, 1983, p. 42, 150.

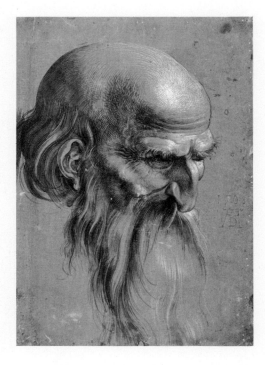

This head of an apostle holds a special place among the surviving preparatory studies for the Heller altar, whose tragic fate makes them the only extant evidence of Dürer's skill in this masterpiece. In the finished painting, the apostle may have occupied a relatively unimportant place at the extreme left edge, as Jobst Harrich's panel clearly shows. The preparatory study, with its psychological depth, expressiveness and formal, graphic mastery must, however, be considered among the best examples of the art of drawing. Thus when J. Jahn speaks of the "round dance of human characters which pass before us in Dürer's drawings," he readily points to the apostle heads from the studies for the Heller altar.[1]

The artist reveals himself as a truly inspired draughtsman whose long-since perfected skill in the graphic mediums (woodcut and engraving) triumphs fully. Notice the almost incredible fact that there are no pen lines, only the brush, which Dürer applies so exactly and with such gentle rhythm that from the play of lines, from the contrasting mesh of tusche and white heightening, there emerges plasticity, powerful form and a rounded psychological interpretation. All the graphic means are available to him; highlights, shadows, contours, modeling, parallel- and cross-hatching — everything works in rhythmic harmony to portray a specific human character. The paper is covered with applied ground in a technique, *carta turcha* (color impregnated into the paper),[2] long known in Italy. In 1390 Cennino Cennini's treatise describes exact recipes for color combinations for grounds. The green, *terra verde* was mostly used by Florentine painters. It is probable that the uniformity of the ground contributed to the practice of using large sheets of paper for several studies, which were later divided into individual sheets. In any event, this was the case with this group.[3] The pink tone noticeable in a number of sheets today is due to a change in the colored pigments and only occurs in the green grounds. Fortunately, it has not occurred in either the 1501 nymph or the *Green Passion.* *W.K.*

Notes

1. J. Jahn, *Albrecht Dürer, Zeit und Werk* (Leipzig, 1971), p. 108.
2. Meder, Handzeichnung, p. 90 ff.
3. Strauss 1974, II, no. 1508/3, cf. 1508/14.

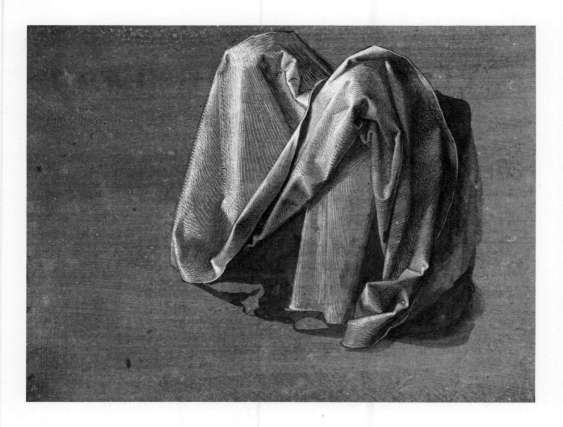

6

DRAPERY STUDY
1508
Point of brush and gray wash, heightened with
white, on green prepared paper; 17.9 × 24.5 cm;
inv. 3.117, D. 89

Provenance: Imperial Treasury; 1783 Imperial
Court Library; 1796 Duke Albert of Saxe-
Teschen, L.174

Bibliography: Heller 1831, p. 106; Vienna 1871,
no. 53–57; Ephrussi 1882, p. 153; Thausing
1884, II, p. 17; Schönbrunner-Meder, no. 24;
Alb.Vienna 1899/1900; Lippmann 1905, no. 513;
Alb.Cat. IV(V), 1933, D.89; Tietze 1937/38, I,
no. 369; Winkler II, no. 458; Alb.Vienna 1971,
no. 68; A. Pfaff, *Studien zu Albrecht Dürers
Helleraltar*, Nuremberg, 1971, no. 27; Strauss
1974, II, no. 1508/17.

In January 1506, when the artist began preparing
his highly important commission, the *Feast of the
Rose Garlands*, in Venice, he had already developed
a new technique for preparatory studies. By using
a brush to draw with tusche and white gouache
(i.e., both light and dark) on green or blue-green
paper, which was available in Venice and much
appreciated by him as a middle tone between the
lights and darks, Dürer was able to achieve both
an exceptionally fine linear structure and a
powerful three-dimensionality on the flat surface.
Such exactness must have been very advan-
tageous when later translating studies into paint-
ing. It appears to have been successful in the *Feast
of the Rose Garlands*, insofar as the ruined painting
can reveal the original masterly skill.

Several commissions awaited Dürer on his re-
turn, including one from the Frankfurt councillor
and linen merchant Jacob Heller for an altar in
the Dominican church in Frankfurt. Preparatory
work began around the middle of 1507; the altar
was completed in the spring of 1509. The present
drawing, as a study for the drapery over the knee
of God the Father, forms part of the entire group
of surviving studies. Dürer wanted to proceed as
he had in Venice by drawing with the brush on
colored paper. Obviously there was no such paper
north of the Alps, so he produced some by
applying a virtually flat coat of colored ground.
This drawing records the crucial alterations the
composition underwent during the preparations.
Another sheet in the Albertina shows the same
motif — drapery gathered across the knee of a
seated figure — but in a substantially different
form, which was not used in the final painting.
The change primarily involves the right knee,
which is covered by Mary's cloak in the painting.
In the drawing present, Dürer did not pay much
attention to this knee, concentrating his incom-
parable skill on the drapery over the left knee,
which would be visible in the painting.

Many scholars have searched for models for
such drapery. The Tietzes located one in an altar
by Bellini, which has only survived in an engrav-
ing by Giralomo Mocetto.[1] The motif actually
goes back further, appearing in Mantegna's San
Zeno altarpiece in Verona, a fact that led the
Albertina to believe that Dürer could very well
have had direct access to it.[2] There has been no
shortage of more far-reaching suggestions, such as
E. Klaiber's idea that Dürer's point of departure
was, in fact, Leonardo's drapery studies.[3] This is,
however, very unlikely because it was Dürer who
had always prepared drapery studies with the
utmost care and used them so masterfully in his
graphic work. His highly detailed and precise
studies, in which every compositional nuance of
the later painting already seems worked out in
a way that presupposes an exactly preplanned
concept, appear in his work only after the *Feast of
the Rose Garlands*. *W.K.*

Notes
1. A. M. Hind, *Early Italian Engraving*, part II
 (Washington, 1948), pl. 731.
2. Alb. Vienna 1971, no. 68.
3. H. Klaiber, "Beiträge zu Dürers
 Kunsttheorie" (PhD Diss., Tübingen,
 Blaubeuren, 1903) p. 32 ff.

7

PRAYING HANDS (STUDY FOR AN APOSTLE)
1508
Point of brush and black ink, heightened with
white, on blue prepared paper; 29.0 × 19.7 cm;
inv. 3.113, D.95

Provenance: 1588 possibly Imhoff; Imperial
Treasury; 1783 Imperial Court Library; 1796
Duke Albert of Saxe-Teschen; 1822 Estate
inventory, p. 300; L.174

Bibliography: Heller 1831, p. 82, no. 53, 95;
Vienna 1871, no. 44; Ephrussi 1882, p. 153;
Thausing 1884, II, p. 18; Schönbrunner-Meder,
no. 188; Alb.Vienna 1899/1900; Lippmann 1905,
no. 502; Alb.Cat. IV(V), 1933, D.95; Tietze
1937/38, I, no. 57 (Workshop); Winkler II,
no. 461; Panofsky 1948, II, no. 493; London
1948, no. 95; Paris 1950, no. 71; Benesch 1964,
Meisterzeichnungen, no. 69; C. White, *Dürer,*
Die schönsten Zeichnungen, Cologne, 1971, no. 49;
Alb.Vienna 1971, no. 72; A. Pfaff, *Studien zu*
Albrecht Dürer's Helleraltar, Nuremberg, 1971,
p. 50 ff, no. 29; H. Bauer, "Dürer's betende
Hände," *Das Münster* 25 (1972), p. 43 ff; Strauss
1974, II, no. 1508/9.

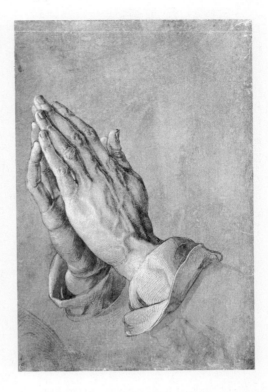

This masterpiece, with the humility and severity
of its refined and noble hands at prayer, has long
been considered the quintessence of piety, a
symbol of a religious attitude that expresses the
entire Christian, indeed the entire Western, value
structure and attitude towards the world and the
powers which control it. These hands have always
represented that melding of medieval devotion
and modern confession that so characterized
Albrecht Dürer, and, indeed, made him an ideal of
God-fearing harmony, an ideal of German spiri-
tuality and artistic fervor. This gesture certainly
expresses an exceptionally unpretentious and,
therefore, very human relationship with God and
the world, a gesture that seems to bring together
in timeless perfection all faith, hope and love. All
this is, however, an interpretation, even a bold
interpretation, and an example of how excessive
admiration can have a negative effect, can lead to
bad misrepresentation. For here, Dürer was
concerned simply with a very precise, if also
expressive, detailed study for the figure of a
kneeling apostle in the difficult commission, the
1508 painting of the Ascension.

In the summer of 1507, Jacob Heller commis-
sioned Dürer, who had recently returned from
Italy, to paint a monumental altarpiece for the
Dominican church in Frankfurt. Immediately,
there were problems — Dürer had to paint *The*
Martyrdom of the Ten Thousand for Prince Frederick
the Wise and he fell ill. Although he did not begin
the altar until March 1508, Dürer had already
"very diligently sketched out the capus"[1] (i.e.,
caput, the centerpiece). Dürer informed Heller
that he should now expect to pay a higher price,
given the work and time necessary for the job;
the patron reacted angrily (a fact that modern
research has taken as a welcome example of
capitalist exploitation and repression). In spite
of further complaints and assurances of having
worked with great diligence, the work was not
completed until Whitsun 1509. Now enthusiastic,
Heller took possession of it in August. The altar
was acquired in 1613 by Prince Maximilian of
Bavaria for his art collection in the Munich Palace,
where it was destroyed in the fire of 1674. All that
remains are the copy made by Jobst Harrich at
the time of the sale (Frankfurt, Städel'sches
Kunstinstitut) and the drawings from Dürer's
estate.

The monumental altarpiece was the first
achievement of its kind for Dürer, and he pre-
pared it very carefully, just as the Italian masters
of the High Renaissance had done: all the studies
were done from the model, but according to a
precisely established monumental composition
of the image. Dürer used the chiaroscuro
technique — linearly structured brush-drawing
in dark tusche with white heightening on colored
paper — he had acquired in Venice.

This hand study — not very felicitously dub-
bed *Praying Hands* (there is a semantic problem
here, as hands alone cannot really pray) — plays a
particularly important role in the structure of the
painting. The hands form, with the kneeling
apostle at the right, the emphatic line of the
compositional pyramid from the right corner to
the crowning apex, and thereby determine the
dynamic but balanced form of the whole. Thus the
diagonal direction and the loose conjunction of the
palms very effectively reinforce the compositional
emphases. The paper's blue ground is sub-
stantially different for the other studies, which has
given rise to some scholarly hypothesizing[2] —
definitely false is the suggestion that a pen not a
brush was used for the drawing; equally false of

course was the Tietzes' opinion that this was not
an original Dürer, but a later copy (they claimed
to see a tighter form in Harrich's copy). By
comparing the drawing with surviving later
copies in Dresden and Budapest the Tietzes'
assertion was quickly proven false.

The drawing of the hands was originally on a
square sheet, double the size, which was later cut.
To the left of the hands, there was the head of the
kneeling apostle (Albertina); below the hands, to
the left, the shoulder of this study is clearly
recognizable. H. Bauer ends his discussion with
the thought that in spite of the verbal error, the
title *Praying Hands* should remain because they are
in effect an "Idea,"[3] a notion put forward by the
Fremdenblatt's reviewer of the Albertina's first
Dürer exhibition: "His praying hands do not
represent prayer, they are indeed really pray-
ing."[4] In order to be fair to this piece, this
masterpiece, one should not just see it as a
preparatory study, as all these sheets are far more
than that. They display, according to Kauffmann,
"an almost unjustifiable care and attention."[5]
They stand on their own. One should not,
however, be satisfied with dry arguments and
refutations, such a work demands more. It was
Benesch who said the *Praying Hands* contained "an
entire world of faith."[6] Excessively pious devotion
should, however, be avoided here; Dürer is not
well served by it. *W.K.*

Notes
1. K. Lange, F. Fuhse, *Dürers Schriftlicher Nachlass*
 (Halle/Saale, 1893). Brief letter, August 24,
 1508, p. 48.
2. H. Weizäcker, "Die Kunstschätze des
 ehemaligen Dominikanerklosters," *Frankfurt/*
 Main (Munich, 1923): 196, 206, no. 19.
3. H. Bauer, "Dürers betende Hände," *Das*
 Münster 25 (1972): 43 ff.
4. J. Meder, "Die Dürer — Ausstellung der
 Albertina," Feuilleton, *Fremdenblatt* 153
 (June 6, 1900).
5. G. Kauffmann, "Albrecht Dürer," *Meilensteine*
 der europäischen Kunst, (Munich, 1965): 435,
 no. 1.
6. Benesch 1964, Meisterzeichnungen, no. 69.

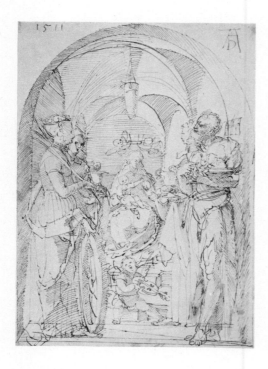

8

THE VIRGIN AND CHILD WITH SAINTS
1511
Pen and bistre ink on white paper;
29.4 × 21.8 cm; inv. 3.127, D.100
Monogrammed "A D" at upper right and dated
"1511" at upper left

Provenance: Imperial Treasury; Duke Albert of
Saxe-Teschen; 1822 Estate inventory, p. 295;
L.174

Bibliography: Waagen 1867, p. 165; Thausing
1884, II, p. 183; E. Heidrich, "Zur Chronologie
des Dürer'schen Marienlebens," *Repertorium für
Kunstwissenschaft* 29 (1906), p. 76; Schönbrunner-
Meder, no. 664; Meder, Handzeichnung, p. 319;
E. Flechsig, *Albrecht Dürer, sein Leben und seine
künstlerische Entwicklung*, I, Berlin, 1928, p. 371;
Alb.Cat. IV(V), 1933, D.100; F. Winkler,
"Dürerstudien," *Jahrbuch der Preussischen
Kunstsammlungen* 50 (1929), p. 26 ff; Tietze
1937/38, I, no. 470; H. Tietze, E. Tietze-Conrat,
"Der Entwurf zu Hans v. Kulmbachs
Tucheraltar," *Anzeiger des Germanischen
Nationalmuseums* 1934/35, p. 72; H. Beenken, "Zu
Dürers Italienreise im Jahre 1505," *Zeitschrift des
Deutschen Vereins für Kunstwissenschaft* 3 (1936);
p. 106; Panofsky 1948, II, no. 781; Paris 1950,
no. 72; H. Tietze, *Dürer als Zeichner und
Aquarellist*, Vienna, 1951, p. 19, 50;
H. Rupprich, *Dürers schriftlicher Nachlass*, II, 1966,
p. 161; H. Röttgen, "Zeichnungen," *Meister um
Albrecht Dürer*, Germanisches Nationalmuseum,
Nuremberg, 1961, p. 229, no. 403 a; Anzelewsky
1971, no. 118; H. Röttgen, "Albrecht Dürer und
seine Werkstatt," *Meister um Albrecht Dürer*,
Germanisches Nationalmuseum, Nuremberg,
1961, p. 221–30, no. 61 a; Alb.Vienna 1971,
no. 79; Strauss 1974, III, no. 1511/1; Australia
1977, no. 21.

The unprejudiced viewer will discover pecu-
liarities that are uncharacteristic of a master
drawing by Albrecht Dürer. For example, the
space is constructed — the floor was drawn with a
diagonal cross and framing parallels, the lines at
the edges were ruled with a straightedge and the

compasses.[1] Similarly, Dürer "built" his figures
from his concept of the ideal, covering the
delicately drawn bodies of the two foremost
figures with clothes and draperies that were
rendered with powerful strokes and quick hatch-
ing, in accordance with the Renaissance habit of
"composition from the nude."[2] Finally, the
manner in which Dürer doubles the number of
saints in the drawing by simply adding heads and
attributes (as if to match the crossed floor lines)
and linking them by connected glances, is a fine
example of marvelous pictorial logic and the
greatest artistic economy.

In this rapidly penned sketch Dürer employs
the compositional form of the *sacra conversazione*
and motifs, such as the Madonna with music-
making angel or putti heads with wings, which
he had used in *Feast of the Rose Garlands* (Venice,
1505–06).[3] Consequently, this drawing has been
connected with Italian models such as Giovanni
Bellini's altarpiece (1505) in San Zaccharia in
Venice.[4] H. Beenken likened the cellarlike space
in the drawing to Florentine artists (such as Fra
Angelico),[5] but this is not necessary because
Venetian painting also provides prototypes for
this.[6]

Following M. v. Thausing's lead, F. Winkler
and E. Flechsig linked the drawing to the Tucher
altarpiece (St. Sebaldus, Nuremberg, 1513),
which Martin Tucher commissioned from Hans
Süss von Kulmbach.[7] The supporting arguments
were, however, unconvincing because they could
not confirm that the preparatory drawing and
another study of St. Catherine were by Dürer's
hand. For this reason, the Tietzes argued em-
phatically against any connection between the
drawing and the Tucher altarpiece.[8]

As far as I can determine, no one has mentioned
that the strong features, expression and pose of
the two saints, Catherine and John the Baptist,
who contribute so much to the drawing's overall
impression, resemble the equivalent saints in
Dürer's *Landauer Altar*. This large panel painting,
begun in 1508 and finished in 1511, incorporates
the saints into the picture in exactly the same
way — in the immediate foreground as leaders of
the heavenly hoard of saints and martyrs — as the
drawing, which was also executed in 1511.

In its combination of simple forms and familiar
figures, this drawing acquires almost exemplary
character. It is as if Dürer wanted to explain his
concept of ideal human proportions and the
regularity of space. He superimposed clothing on
the nude figures and used a traditional tautly
constructed composition and a common figure
type from this period in order to demonstrate the
practical usefulness of his theories in a drawing
executed with a few confident pen strokes. *F.K.*

Notes
1. H. Tietze, E. Tietze-Conrat, "Der Entwurf zu
 Hans v. Kulmbachs Tücheraltar," *Anzeiger des
 Germanischen Nationalmuseums* 1934/35, p. 72.
2. Meder, Handzeichnung, p. 314 ff, (318).
3. Anzelewsky 1971, no. 118.
4. Waagen 1867, p. 165.
5. H. Beenken, "Zu Dürers Italienreise im Jahre
 1505," *Zeitschrift des Deutschen Vereins für
 Kunstwissenschaft* 3 (1936), p. 106.
6. Compare, for example, the high altar of San
 Lorenzo in Selva di Cadore, illustrated in
 B. Berenson's *Venetian Painters of the Renaissance*
 (London, 1957), no. 329.
7. F. Winkler, "Dürerstudien," *Jahrbuch der
 Preussischen Kunstsammlungen* 50 (1929), p. 26 ff.
8. Tietze 1937/38, I, no. 470.

8a. Albrecht Dürer
Landauer Altar, St. Catherine
Kunsthistorisches Museum, Vienna

8b. Albrecht Dürer
Landauer Altar, St. John the Baptist
Kunsthistorisches Museum, Vienna

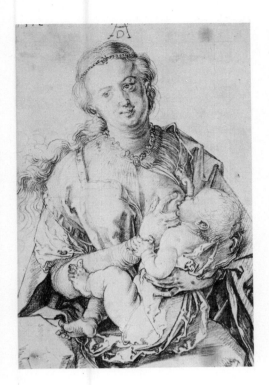

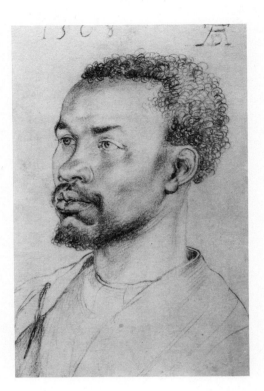

9

THE VIRGIN NURSING THE CHILD
1512
Charcoal on white paper; 41.8 × 28.8 cm; inv.
4.848, D.103
Mounted on card, horizontal crease at center
Monogrammed upper center in charcoal; dated
"1512" at upper left by another hand in brown
and black ink

Provenance: Imperial Treasury; 1783 Imperial
Court Library; 1796 Duke Albert of Saxe-
Teschen; 1822 Estate inventory, p. 295; L.174

Bibliography: Heller 1831, p. 105, no. 44;
Ephrussi 1882, p. 188; Thausing 1884, II,
p. 78 ff; Lippmann 1905, no. 525; G. Pauli, "Ein
neuer Holzschnitt Sebald Behams," *Jahrbuch der
königlich preussischen Kunstsammlungen* 77 (1906),
p. 291 ff; E. Heidrich, "Geschichte des
Dürerschen Marienbildnisses," *Kunstgeschichtliche
Monographien* 3, Leipzig, 1906, p. 94; Alb.Cat.
IV(V) 1933, D.103; Tietze 1937/38, I, no. 503;
Winkler III, no. 512; Panofsky 1948, II, no. 665
(28); F. Winkler, *Albrecht Dürer, Leben und Werk*,
Berlin, 1957, p. 245; Alb.Vienna 1971, no. 82;
Strauss 1974, III, no. 1512/6; Australia 1977,
no. 22.

In this ambitious drawing, Dürer treated the
theme of the *madonna lactans* (from Luke 11:12), a
subject that can be traced through fourteenth-
and fifteenth-century Italian art and Byzantine
icons, all the way back to the early Christian era.[1]
Dürer first used the half-length figure type in
the *Madonna with Siskin* (finch),[2] which he painted
in 1506 on his second visit to Italy.[3] The simi-
larities, such as the framing of the image, the
inclined head and the contemplative gaze into the
distance, are apparent, but there are several
important differences. The Madonna's facial
expression seems far less Italianate in the drawing
than in the painting, and the drawing shows a
much closer relationship between the Virgin and
the Child while still preserving the nobility of the
Madonna. The relationship became even closer
in Dürer's work (e.g., Albertina's preparatory
drawing[4] for the engraving *The Virgin Nursing the
Child*, B.36). Maternal devotion reaches a

maximum in this image, which was intended for a
broad public as woodcuts and engravings were
sold at festivals and fairs.[5]

The similarity to the 1519 *madonna lactans*,
especially in the Child's upper body and in the
positions of the figures' hands, led Thausing to
assume that the original date above the mono-
gram was 1519, not 1512, and that 1512 was
mistakenly transferred to the upper left.[6] It is
quite conceivable that the relatively large sheet
had, over time, suffered damage to its upper edge
and was cut down, necessitating the reinscription
of the date. At the same time, the drawing would
have been folded horizontally to protect it from
any further harm. We can also agree with
Thausing's assertion that the date is not of
Dürer's hand, although Winkler maintained the
opposite, putting forward as evidence the simi-
larity with the numerals on *Anna Selbdritt* and *The
Virgin and Child with Bagpiper*.[7] A closer exam-
ination, however, revealed nothing in common
between the numerals on these sheets or any
other drawings by Dürer. Nevertheless, following
the Tietzes,[8] we cannot accept Thausing's sug-
gested date of 1519, the drawing stylistically suits
Dürer's oeuvre of 1512 much better than 1519.
The resemblances between the engraving B.36
and the 1519 preparatory drawing are derived
largely from the subject matter and are to be
explained as reprises of the earlier version. The
same is true of a second pen drawing from 1519,
the Madonna and Child with music-making
angels,[9] in which the resemblances are found in
the expression and pose of the Madonna, although
not a *madonna lactans* in this case. The Vienna sheet,
however, is more pictorial and more detailed.
Because of this and a compositional format
unusual in a drawing, this work was assumed to be
a preparatory drawing for an unexecuted or lost
painting of the Madonna.[10] In addition, several
artists have used this drawing as a model. An
anonymous painter[11] used the figure of the Christ
Child for a *Madonna with the Iris*; at the time of
the Dürer renaissance (c.1600), Daniel Fröschl
painted a copy on parchment, now in the
Kunsthistorisches Museum in Vienna.[12] Hans
Sebald Beham's woodcut also repeated the
Madonna but in reverse.[13] *A.S.*

Notes

1. *Maria, Die Darstellung der Madonna in der
 bildenden Kunst*, Vienna: Kunsthistorisches
 Museum, 1954. Prepared by H. Aurenhammer.
2. Oil on panel, 91 × 76 cm, Gemäldegalerie
 Staatliche Museen Preussischer Kulturbesitz,
 Berlin. Anzelewsky 1971, no. 94, fig. 109.
3. E. Heidrich, "Geschichte des Dürerschen
 Marienbildnisses," *Kunstgeschichtliche
 Monographien* 3 (Leipzig, 1906), p. 94.
4. Thausing 1884, II, p. 78.
5. In a letter to Pirckheimer Dürer indicates
 that his wife and mother offered prints for
 sale at these occasions. Rupprich 1956, I,
 p. 48 ff.
6. Thausing 1884, II, p. 78 ff.
7. Winkler III, no. 520, 522.
8. Tietze 1937/38, I, no. 503.
9. Winkler III, no. 536.
10. E. Heidrich, *Kunstgeschichtliche Monographien*,
 p. 94.
11. Panofsky 1948, II, no. 28.
12. Tietze 1937/38, I, no. 503.
13. G. Pauli, "Ein neuer Holzschnitt Sebald
 Behams," *Jahrbuch der Königlich preussischen
 Kunstsammlungen* 77 (1906), p. 291 ff.

10

HEAD OF A BLACK MAN
Charcoal on white paper; 32.0 × 21.8 cm; inv.
3.122, D.119
Monogrammed "A D" upper right and dated
"1508" upper left (added later in brown chalk)

Provenance: Imperial Treasury; 1783 Imperial
Court Library; 1796 Duke Albert of Saxe-
Teschen; 1822 Estate inventory, p. 297; L.174

Bibliography: Heller 1831, p. 48; Ephrussi 1882,
p. 158; K. Lange and F. Fuhse, *Dürers schriftlicher
Nachlass*, Halle/Saale, 1893, p. 349;
Schönbrunner-Meder no. 207; Lippmann 1905,
no. 517; Flechsig 1931, II, p. 371; Alb.Cat.
IV(V), 1933, D.119; Tietze 1937/38, I, no. 641;
Winkler II, no. 431; Panofsky 1948, II, no. 1066;
H. Tietze, *Dürer als Zeichner und Aquarellist*,
Vienna, 1951, p. 33, 52; Th. Musper, *Albrecht
Dürer, Der gegenwaertige Stand der Forschung*,
Stuttgart, 1952, p. 257; H. Rupprich, *Dürer's
schriftlicher Nachlass*, I, Berlin, 1956, p. 33, 155;
F. Winkler, *Albrecht Dürer, Leben und Werk*,
Berlin, 1957, p. 265; K. Öttinger and K. Knappe,
Hans Baldung Grien und Albrecht Dürer in Nürnberg,
Nuremberg, 1963, p. 39–100; Alb.Vienna 1971,
no. 98; P. Strieder et al, *Albrecht Dürer,
1471–1971*, Germanisches Nationalmuseum,
Nuremberg, 1971, p. 45 ff, no. 534; J. Jahn,
"Albrecht Dürer, Seine Leistung in Bildnis- und
Landschaftsmalerei," *Albrecht Dürer, Zeit und
Werk*, Leipzig, 1971, p. 108; R. F. Timken-
Zinkann, *Ein Mensch namens Dürer*, Berlin, 1972,
p. 65; Strauss 1974, II, no. 1508/24; P. Strieder,
Dürer, Koenigstein/Taunus, 1981, p. 236, 246;
F. Piel, *Albrecht Dürer, Aquarelle und Zeichnungen*,
Cologne, 1983, p. 149.

This drawing, formerly in the Imperial Treasury,
is one of the most interesting of Dürer's portrait
studies and raises many questions. Although
Dürer's interest in this person may have been
motivated initially by the artist's need to portray
one of the Three Kings as a Moor, his overwhelm-
ing desire to encompass strange worlds, to know
and record anything alien or unusual, probably
provided the real impetus for the study. Consider,
for example, his enthralled journal entries. In

August 1520 he wrote of his journey to The Netherlands when he first saw Montezuma's treasure: "I have seen wonderful artistic things, and have marvelled at the subtle skill of man in foreign parts. . . ."[1] To represent the unfamiliar is to strive to understand the particular,[2] and that also means humanity at the mercy of fate, always frankly and without resentment. Dürer's investigations were always concerned with humanity, and here he devotes all his powers of empathetic insight to the individuality of a foreign race.[3]

Dating this drawing causes difficulty. Flechsig and Winkler considered 1508 authentic,[4] while the Tietzes believed both the signature and the date were false. They dated the sheet 1515[5] because it could not have been from the same time as the studies for the Heller altarpiece; Panofsky concurred.[6] Musper suggested Venice as the place where Dürer might have met the man portrayed,[7] which would date the work 1506; Strieder supports this.[8] Scholars at the Albertina believe that stylistically the *Feast of the Rose Garlands* and the *Head of a Black Man* could not have been contemporaries, and, given the city's active trading links, it would have been possible to meet a black man in Nuremberg anytime.[9] The use of soft charcoal, a medium generally used for preparatory drawings does not yield any definite clues because Dürer was rendering finished works in charcoal as early as 1503. This soft, painterly technique is perfectly characteristic of the time.[10] Definitive help with the dating will only come from examining the watermark by X-rays as Strauss suggested.[11]

Be that as it may, there remains the exceptional importance of Dürer's interest in the beauty in foreign races: "I have seen many of them who are so finely built that one can neither see nor imagine anything more perfect."[12] Human dignity and beauty were the two starting points for Dürer's investigations. *W.K.*

Notes

1. H. Rupprich, *Dürers schriftlicher Nachlass*, I (Berlin, 1956), p. 33, 155.
2. Cf. R. F. Timken-Zinkann, *Ein Mensch namens Dürer* (Berlin, 1972), p. 65.
3. F. Winkler, *Albrecht Dürer, Leben und Werk* (Berlin, 1957), p. 265.
4. Flechsig 1931, II, p. 371; Winkler II, no. 431.
5. Tietze 1937/38, I, no. 641.
6. Panofsky 1948, II, no. 1066.
7. Th. Musper, *Albrecht Dürer, Der gegenwärtige Stand der Forschung* (Stuttgart, 1952), p. 257.
8. P. Strieder et al, *Albrecht Dürer, 1471–1971* (Nuremberg: Germanisches National-museum, 1971), p. 534.
9. Alb.Vienna 1971, p. 324, no. 98.
10. P. Strieder, *Dürer*, Königstein/Taunus (1981), p. 246.
11. Strauss 1974, II, no. 1508/24.
12. Die vier Bücher von menschlicher Proportion, Aestetischer Exkurs im 3. Buch (Nuremberg, 1528) in K. Lange, F. Fuhse, *Dürers Schriftlicher Nachlass* (Halle/Saale, 1893), p. 226.

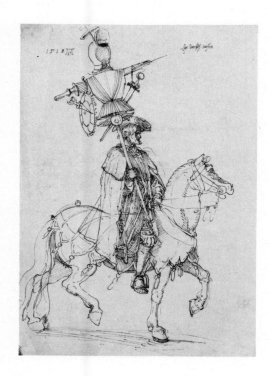

II

THE ITALIAN TROPHIES
1518
Pen and black ink on white paper, numerous pentimenti; 43.2 × 31.6 cm; inv. 3.155, D.130
Inscribed "Dy welsch troffea" upper right and dated "1518" upper left; monogrammed "A D" upper left in brown ink by another hand

Provenance: Imperial Treasury; 1783 Imperial Court Library; 1796 Duke Albert of Saxe-Teschen; 1822 Estate inventory, p. 296; L.174

Bibliography: Heller 1831, p. 30; Vienna 1871, no. 9; Ephrussi 1882, p. 254 ff, 352; Thausing 1884, II, p. 147; S. Laschnitzer, "Artistisches Quellenmaterial aus der Albertina," *Jahrbuch der Kunsthistorischen Sammlungen des Allerhöchsten Kaiserhauses* 4, 1886, 2, I–II, no. 3042; Schönbrunner-Meder, no. 570; Alb.Vienna 1899/1900; Lippmann 1905, no. 552; Flechsig 1931, II, p. 113, 375; Tietze 1937/38, II, no. 719; Winkler, III, no. 698; Panofsky 1948, II, no. 961; F. Winkler, *Albrecht Dürer, Leben und Werk*, Berlin, 1957, p. 283; *Maximilian I*, Österreichische Nationalbibliothek, Graphische Sammlung Albertina, Kunsthistorisches Museum, Vienna, 1959, no. 347; Alb.Vienna 1971, no. 108; Strauss 1974, III, no. 1518/10.

The *Italian Trophies* and five additional images of knights represent Dürer's contributions to Maximilian I's (Holy Roman emperor, 1508–19) propaganda to glorify not only the Holy Roman Empire and the Hapsburg line, but also his battles and matrimonial politics, which ensured Hapsburg supremacy in Europe for centuries.[1]

Emperor Maximilian engaged the best artists of his time to portray certain historical events in a magnificent series of woodcuts. Of these, the *Triumphal Arch* and the *Triumphal Procession* are the most important. The basis for the woodcut version of the *Triumphal Procession* was a luxurious book (pen and brush, watercolor and gouache heightened with gold on parchment[2]) which was produced in 1512–1 in the Innsbruck workshop of Jörg Kölderer.

Dürer designed several scenes for the *Triumphal Procession*, including the chariot showing Maximilian's marriage to Maria of Burgundy, the emperor's chariot and the aforementioned knights. The Tietzes conjectured that Dürer's knights had been conceived as part of the *Emperor's Great Triumphal Chariot*,[3] which is justified if one views the triumphal chariot as an integral unit of the *Triumphal Procession*. They were, however, never printed together.[4]

In 1512 Dürer had already designed a triumphal chariot,[5] which used the chariot from the Kölderer workshop as a starting point,[6] for the woodcut illustration. From 1515 to 1518 Burgkmayr worked with other artists to produce woodcut versions of the remaining chariots whose splendor far exceeded their model. Maximilian was therefore very interested when the Nuremberg provost told him of a carriage "newly invented by Pirckheimer." Maximilian ordered Willibald Pirckheimer, important humanist and Dürer's friend, to send him the drawing, which arrived almost two months after the emperor's initial request. Apologizing for the delay, Pirckheimer added that his job would have been yet harder had Dürer not helped him.[7] He is surely referring to the Albertina's pen and watercolor drawing, *The Triumphal Chariot*, dated 1518.[8]

The six mounted figures, executed in pen, were probably also drawn for the *Triumphal Procession*; of them, four trophy bearers were also executed in finished watercolor versions,[9] which have survived in the so-called Dürer's Art Book, which is in the sculpture collection of the Kunsthistorisches Museum in Vienna.[10] They bear the same date, 1518, as the sketches and were probably to be positioned in front of the emperor's chariot, very much like the *Triumph of Caesar* (1482–92), which Ludovico Gonzaga commissioned from Andrea Mantegna.[11] Admittedly, Mantegna's work, which was an important inspiration for Maximilian's *Triumphal Procession*, does not have mounted trophy bearers. For Dürer, however, men on horseback formed a better transition to the emperor's chariot with its team of twelve horses,[12] which, like the mounts of the trophy bearers, are strongly reminiscent of Leonardo's 1508 horse studies.

Maximilian died during the execution of the woodcuts (January 12, 1519), bringing the work to a halt. Dürer, who owned the blocks, finished the task and in 1522 at his own expense and "cum gratia et privilegio caesareae Maiestatis," published the *Emperor's Great Triumphal Chariot*. Although the *Triumphal Chariot* was shortened from its original concept, the chariot and teams, printed from eight blocks, are still 2.32 meters long.[13] The knights were no longer needed in this version and, therefore were not executed.

In these pen drawings remarkable works of graphic art have survived. The magic of these drawings lies in the spontaneity and transparency of the representation; Dürer placed a light form like the horse, with a very loosely sketched contour, in front of a light background. Only then did he draw the rider with the trophy which, like the other trophies, is inspired by the woodcuts of Francesco Collona's *Hypnerotomachia Poliphili*, published by Aldus Manutius in 1499 in Venice.[14]

A.S.

Notes
1. *Maximilian I* (Vienna, 1959), p. 68 ff.
2. Alb.Cat. IV(V), 1933, D.35, no. 228–86.
3. Tietze 1937/38, II, no. 716.
4. J. Meder, *Dürer Katalog, Ein Handbuch über Albrecht Dürers Stiche, Radierungen, Holzschnitte, deren Zustände, Ausgaben, Wasserzeichen* (Vienna, 1932), p. 225, no. 252.
5. Winkler III, no. 671.
6. F. Winzinger, "Die Miniaturen zum Triumphzug Kaiser Maximilians I," *Veröffentlichungen der Albertina*, I, II (Graz, 1972/73), no. 73.
7. G. Giehlow, "Dürers Entwürfe für das Triumphrelief Kaiser Maximilians I im Louvre, eine Entwicklungsgeschichte des Triumphzuges," *Jahrbuch der Kunsthistorischen Sammlungen des Allerhöchsten Kaiserhauses* 30, no. 1 (1910), p. 43.
8. Winkler III, no. 685.
9. Winkler III, no. 693, 695, 697, 699.
10. H. Fillitz, *Maximilian I*, p. 184.
11. E. Tietze-Conrat, *Mantegna, Paintings, Drawings, Engravings* (London, 1955), p. 183, fig. 108–116. *Triumph of Caesar* at Hampton Court, England.
12. G. Pauli, "Dürer, Italien und die Antike," *Vorträge der Bibliothek Warburg*, I (Berlin, 1921–22), p. 65.
13. J. Meder, *Dürer Katalog*, p. 225, no. 252.
14. V. Scherer, *Die Ornamentik bei Albrecht Dürer* (Strassburg, 1902), p. 108.

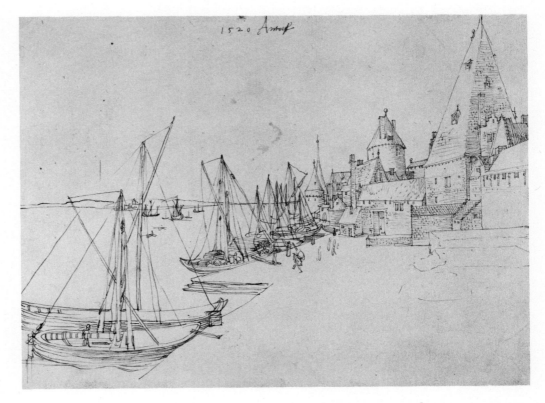

12

VIEW OF ANTWERP HARBOR
1520
Pen and brown ink on white paper;
21.3 × 29.3 cm; inv. 3.165, D.139
Dated and inscribed "1520 Antorff" upper center

Provenance: Imperial Treasury; 1783 Imperial Court Library; 1796 Duke Albert of Saxe-Teschen, L.174

Bibliography: Heller 1831, p. 38; A. Eye, *Leben und Wirken Albrecht Dürers*, Nördlingen, 1869, p. 436; Ephrussi 1882, p. 268 ff; Thausing 1884, II, p. 173, 175; Schönbrunner-Meder, no. 788; Lippmann 1905, no. 566; J. Veth and S. Muller, *Albrecht Dürers Niederländische Reise*, I, Berlin, 1918, p. 31, no. XIV; H. Wölfflin, *Albrecht Dürer, Handzeichnungen*, Munich, 1919, no. 59; Flechsig 1931, II, p. 228; Alb.Cat. IV(V), 1933, D.139; Tietze 1937/38, II, no. 753; Winkler IV, no. 821; London 1948, no. 99; Panofsky 1948, II, no. 140; Paris 1950, no. 78; F. Anzelewsky, "A propos de la topographie du Parc de Bruxelles et du Quai de l'Escaut à Anvers de Dürer," *Bulletin des Musées Royaux des Beaux-Arts* 6 (1957), p. 106 ff; C. White, "The Travels of Albrecht Dürer," *Apollo* 113 (1971), p. 21 ff; C. White, *Albrecht Dürer, Die schönsten Zeichnungen*, Cologne, 1971, no. 79; Alb.Vienna 1971, no. 119; R. F. Timken-Zinkann, *Ein Mensch namens Dürer*, Berlin, 1972, p. 39, 151 ff; Strauss 1974, IV, no. 1520/12; F. Anzelewsky, M. Mende and P. Eeckhout, *Albrecht Dürer au Pays-Bas*, Palais des Beaux-Arts, Brussels, 1977, p. 45, no. 64; F. Anzelewsky, *Dürer Werk und Wirkung*, Stuttgart, 1980, p. 207 ff; P. Strieder, *Dürer*, Königstein/Taunus, 1981, no. 30.

In this late drawing of Antwerp harbor, which is different from his early landscapes, executed during his first journey to Italy, Dürer used a linear mode of representation. *View of Antwerp Harbor* is one of the most important drawings in Dürer's oeuvre; the clarity of the composition and the simplicity of the strokes are remarkable.[1]

Although the sheet is inscribed "1520 Antorff," it does not indicate on which of Dürer's four visits the drawing was done. Veth and Muller suspected that the drawing dated from immediately after his arrival,[2] but Flechsig disputed this;[3] although the discussion on the relative merits of August 2 and August 26 is of little consequence. Paramount is the artist's graphic accomplishment, already noted by Wölfflin,[4] namely that the astonishing depth is achieved with the diminishing perspective of the simplest, most rigorous diagonal lines of the ships. The full potential of lines drawn by an artist on a surface is realized here. This is also effected by the empty space in the foreground, which is certainly not to be considered unfinished, but rather a space-creating element designed to focus all one's attention on the point where the harbor meets the buildings. A great deal of work has been done on the topography.[5] Dürer's vantage point was close to the southern edge of the town near the "Eeckhoff," a building belonging to the Antwerp painters' guild. The city was experiencing an extraordinary economic boom; the Portugese colony moved to Antwerp in 1510 with its trading house and was soon followed by the other maritime nations. This led to a rapid expansion in trade, especially with the newly discovered countries overseas.

The drawing of the Antwerp harbor must be counted as one of Dürer's most beautiful works. It is his most modern drawing, which is to say, it is timeless.

W.K.

Notes
1. F. Anzelewsky, *Dürer Werk und Wirkung* (Stuttgart, 1980), p. 209.
2. J. Veth and S. Muller, *Albrecht Dürers Niederländische Reise*, I (Berlin, 1918), p. 31, no. XIV.
3. Flechsig 1931, II, p. 228.
4. H. Wölfflin, *Albrecht Dürer, Handzeichnungen* (Munich, 1919), no. 59.
5. F. Anzelewsky, "A propos de la topographie du Parc de Bruxelles et du Quai de l'Escaut à Anvers de Dürer," *Bulletin des Musées Royaux des Beaux-Arts* 6 (1957), p. 106 ff.
F. Anzelewsky, M. Mende and P. Eeckhout, *Albrecht Dürer au Pays-Bas* (Brussels: Palais des Beaux-Arts, 1977), p. 45, no. 64.

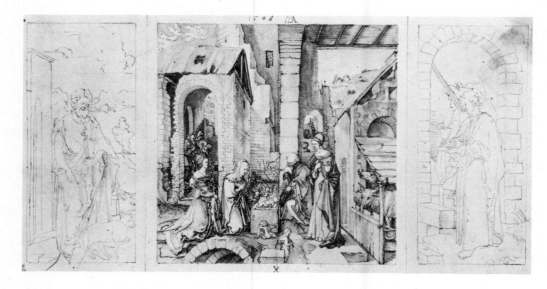

Hans Süss Von Kulmbach
Kulmbach c.1480–1522 Nuremberg

Painter and woodcut and stained-glass designer. Similarities in style suggest Kulmbach worked in Dürer's workshop from about 1500 on. Although Neudörfer indicated Kulmbach trained with Jacopo de' Barbari, it is difficult to detect any influences in Kulmbach's work. He acquired Nuremberg citizenship in 1511. In 1511 and 1514/16, Kulmbach executed commissions for Cracow, probably during short stays in this town.

13a. Hans Süss von Kulmbach
Adoration of the Child with Saints
Albertina Collection, Vienna

13

ADORATION OF THE CHILD WITH ST. JOHN THE BAPTIST AND ST. JOHN THE EVANGELIST
Pen, brown and black ink with bistre on white paper, wash and watercolor; 19.5 × 38.5 cm; inv. 3.120, D.180
Design for a triptych; monogrammed "A D" upper center and dated "1508" in another hand

Provenance: Duke Albert of Saxe-Teschen; 1822 Estate inventory (under Dürer), p. 301; L.174

Bibliography: Neudörfers Nachrichten von Künstlern und Werkleuten, Nuremberg, 1547, p. 134 ff; Vienna 1871, no. 58; H. Tietze, E. Tietze-Conrat, "Ueber einige Handzeichnungen des Hans von Kulmbach," *Zeitschrift für Bildende Kunst* 62 (1928/29), p. 212 ff; F. Winkler, "Verkannte und unbeachtete Zeichnungen des Hans von Kulmbach," *Jahrbuch der Preussischen Kunstsammlungen* 50 (1929), p. 26 ff; Alb.Cat. IV(V), 1933, D.180; H. Tietze, E. Tietze-Conrat, "Der Entwurf zu Hans von Kulmbachs Tucherbild," *Anzeiger des Germanischen Nationalmuseums*, 1934/35, p. 69; F. Winkler, *Die Zeichnungen Hans Süss von Kulmbachs und Hans Leonhard Schäufeleins*, Berlin, 1942, p. 31 ff, 80 ff, no. 83; Panofsky 1948, II, no. 504; F. Winkler, *Hans von Kulmbach*, Kulmbach, 1959, p. 34, 63, 69; P. Strieder et al, *Meister um Albrecht Dürer*, Germanisches Nationalmuseum, Nuremberg, 1961, p. 17 ff, 97 ff, no. 162, 102, 403; Benesch 1964, Meisterzeichnungen, no. 72; Koschatzky-Strobl 1971, no. 158; Strauss 1974, III, p. 1794.

This image was designed for a triptych — a tripartite altarpiece with a central panel and two wings — that was meant to be closed. Conspicuously, only the middle panel was completed in watercolor, the images on the wings are drawn in outline as if they may have been planned as grisailles. The panels show Saint John the Baptist at the left, Saint John the Evangelist at the right and the adoration of the Child with Saints Catherine and Barbara, a rather unusual subject,[1] in the center.

The authorship of the drawing was initially disputed. In Duke Albert's estate inventory it was listed under the works of Albrecht Dürer, as was a second, very similarly executed design of almost identical measurements.[2] This opinion was supported by Heller, Thausing and Ephrussi.[3] Schönbrunner and Meder, on the other hand, favored the Dürer school,[4] and Meder had already attributed the work to Süss von Kulmbach[5]; the Tietzes and Winkler agreed.[6] Since then the attribution of these two drawings to Kulmbach has been considered secure. The corrections in black ink on the center panel were first ascribed to Dürer, then to another sixteenth-century hand and then finally to Kulmbach, an opinion the Albertina supports.

The purpose of these drawings is unknown. Winkler agreed with the suggested connection to the Tucher altar,[7] which Süss von Kulmbach executed in 1513 for St. Sebaldus in Nuremberg.[8] Panofsky and the Tietzes,[9] however, saw no link to this altar, which Martin Tucher donated in the name of his stepbrother Dr. Lorenz Tucher (1447–1503),[10] who was provost of St. Lorenz in Nuremberg from 1478 and canon of St. Peter's Cathedral in Regensburg from 1483.

The drawing in Vienna shows three saints who may be seen as name saints of the Tucher family, which supports a connection to the Tucher altar. The representation of the two Saints John on the wings of the Vienna sketch could refer to the fact that Hans was the name not only of Lorenz and Martin Tuchers' father but also of both their brothers, while Saint Barbara could be linked to the name of Lorenz's mother.[11] Saint Martin, the donor's name saint, is shown next to the Mother of God in the second sketch. One must not, however, forget how common these names were at the time; other families could have commissioned the altar just as easily. The most serious objection to linking the Vienna sketches with the Tucher epitaph is that they do not portray Saint Lawrence, Dr. Lorenz Tucher's name saint, and Saint Peter, the patron saint of the cathedral in Regensburg. Moreover, all the name saints, with the exception of Saint Martin, all are present with Mary, the Christ Child, Saints Catherine and Barbara and Saint John the Baptist in a *sacra conversazione* on the epitaph for Lorenz Tucher.

The dates of the two drawings, are as uncertain as their purpose. Both sheets carry dates that were added later — the *Adoration*, 1508, the *Madonna with Angels and Saints*, 1511. The strong similarity in execution, however, speaks for a single date, and, as the Tietzes maintained, 1508 is preferable.[12] Only with the longer interval can one explain the extraordinary artistic development from the adoration, which is still rooted in the Gothic, to the 1513 Tucher altar, which looks to Italian models. *A.S.*

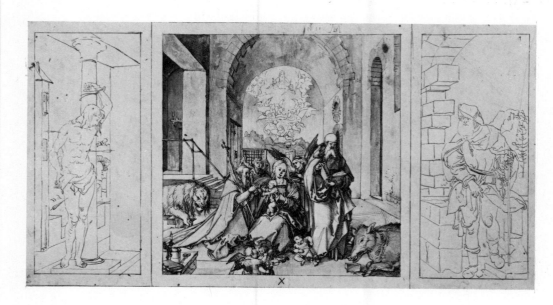

Notes
1. Benesch 1964, *Meisterzeichnungen*, no. 72.
2. F. Winkler, *Die Zeichnungen Hans Süss von Kulmbachs und Hans Leonhard Schäufeleins* (Berlin, 1942), no. 84.
3. Heller 1831, p. 155, no. 112; Thausing 1876, I, p. 158; Ephrussi 1882, p. 158.
4. Schönbrunner-Meder, no. 471.
5. Meder, Handzeichnung, p. 334.
6. H. Tietze, E. Tietze-Conrat, "Ueber einige Handzeichnungen des Hans von Kulmbach," *Zeitschrift für Bildende Kunst* 62 (1928/29), p. 212; Winkler, "Verkannte und unbeachtete Zeichnungen des Hans von Kulmbach," *Jahrbuch der Preussischen Kunstsammlungen* 50 (1929), p. 26.
7. Winkler, Ibid., p. 27.
8. P. Strieder et al, *Meister um Albrecht Dürer* (Nuremberg: Germanisches National-museum, 1961), p. 104, no. 162.
9. Panofsky 1948, II, no. 504; H. Tietze, E. Tietze-Conrat, "Der Entwurf zu Hans von Kulmbachs Tucherbild," *Anzeiger des Germanischen Nationalmuseums* (1934/35), p. 75 ff.
10. P. Strieder et al, *Meister um Albrecht Dürer*, p. 104, no. 162.
11. See the Tucher genealogy in L. Grote, *Die Tucher, Bildnis einer Patrizierfamilie* (Munich, 1961).
12. H. Tietze, E. Tietze-Conrat, *Anzeiger des Germanischen Nationalmuseums*, p. 75.

Albrecht Altdorfer
Regensburg (?) c. 1480–1538 Regensburg

Albrecht Altorfer was the son of the painter Ulrich Altdorfer who resided in Regensburg from 1478 to 1491. Little is known about Albrecht Altdorfer's artistic beginnings; he may have started as a book illustrator for Berthold Furtmayer in Regensburg. Altdorfer's *Wanderjahre* (journeyman years), which began around 1500, had a decisive effect on his development and took him, inter alia, to the Salzburg area where he came in contact with the work of Michael Pacher and Marx Reichlich. His series of dated works began after he acquired Regensburg citizenship in 1505. He journeyed up the Danube in 1511, accepted the commission in 1515 for the altarpiece in St. Florian, became a member of the Outer Council of Regensburg in 1519 and a member of the Inner Council and city architect in 1526. He refused the mayorship in 1528 in order to paint the *Battle of Alexander* for Duke William of Bavaria. Altdorfer is considered the leading master of the Danube School.

14

THE SACRIFICE OF ISAAC
Pen and black ink, heightened with white gouache on gray-green prepared paper; 19.0 × 15.5 cm; inv. 3.212, D.217
Date cropped at upper edge

Provenance: Charles Prince de Ligne, L.592; Duke Albert of Saxe-Teschen; 1822 Estate inventory, p. 304; L.174

Bibliography: Bartsch 1794, p. 140, 141, no. 4; M. J. Friedländer, *Albrecht Altdorfer*, Leipzig, 1891, p. 155, no. 30; Schönbrunner-Meder, no. 514; Alb.Cat. IV(V), 1933, D.217; H. Tietze, *Albrecht Altdorfer*, Leipzig, 1923, p. 80; H. Becker, "Die Handzeichnungen Albrecht Altdorfers," *Münchner Beiträge zur Kunstgeschichte* 1, Munich, 1938, no. 73; *Albrecht Altdorfer und sein Kreis*, Munich, 1938, p. 21, no. 80; L. Baldass, *Albrecht Altdorfer*, Vienna, 1941, p. 80; F. Winzinger, *Albrecht Altdorfer, Zeichnungen*, Munich, 1952, no. 25; K. Öttinger, "Datum und Signatur bei Wolf Huber und Albrecht Altdorfer," *Zur Beschriftungskritik der Donauschulzeichnungen, Erlanger Forschungen* 8, Erlangen, 1957, p. 51; K. Öttinger, *Altdorfer Studien*, Nuremberg, 1959, p. 43 ff; Wilfred Lipp, "Natur in der Zeichnung Albrecht Altdorfers," Ph.D. Diss., Salzburg, 1969, p. 55, 94, 106.

Because this sheet was listed in the estate inventory under the title "un ange arrêtant le bras d'un bourreau prêt à décapiter une Sainte," Max J. Friedländer called it "Martyrdom of a Female Saint by Decapitation."[1] In comparison to Altdorfer's other versions of Abraham's sacrifice,[2] Friedländer thought the sacrificial scene was iconographically too imprecise. For example, the drawing shows Abraham as a young man, not as a patriarch, and the angel is not descending from Heaven to deflect the sword, but is instead standing calmly beside Abraham. Moreover, the scene is not placed in the foreground but integrated, even fused into a mountainous, wooded landscape, whose dynamic strokes seek to parallel the dramatic action. One is able to identify the scene as the sacrifice of Isaac by the angel holding back Abraham's sword, the ram, which will be sacrificed in Isaac's stead, standing to the right of the angel, and the sacrificial altar, a baldacchino with columns, where the sacrificial flame is already burning.

Altdorfer's drawings, of which about 120 have survived, were created over a period of twenty-five years and belong to the most characteristic works of the so-called Danube School. The earliest date from 1506, the latest from between 1526 and 1530. In addition to the medium of pure pen drawing, ink and white gouache on tinted paper answered Altdorfer's artistic concept of producing pictorially complete, independent drawings.[3]

The Sacrifice of Isaac is characterized by a wide variety of active strokes: the foliage is represented by narrow, spiraling lines or short hairpin-like strokes, the rocks are constructed of vertical and horizontal tiers of lines, and a thick web of crossed lines forms the deepest shadows of the altar's cupola. The figure group is also worked in strong chiaroscuro contrasts in which the strongest highlights fall "like lightning flashes"[4] on Abraham and the angel. The drawing style is marked by the rich variation of sets of lines and the rhythm of the stroke which meld the action and the landscape into one ornamental texture.

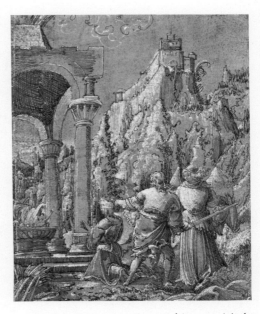

The three figures are arranged in a semicircle with Abraham standing in the foreground with his back turned, and the angel and the kneeling Isaac in the plane beyond. The altar's pillars constitute a further spatial element, carrying the eye into the background. This intensifying of the spatial feeling is also noticeable in the *Martyrdom of St. Sebastian* (1511),[5] in which the figures are similarly arranged in a circular composition. A ring of figures may also be found in Altdorfer's woodcut *The Dream of Paris* (1511)[6]; the composition of the 1511 woodcut of *St. George and the Dragon*[7] may also be compared to this drawing. In both cases we see a castle in a landscape of cliffs and crevices on the right, while the viewer is led into depth at the left. There are even parallels between the drawing and woodcuts in the dynamic ductus and the clear contrasting of light and shadow.

Dating this drawing 1511[8] is supported not only by compositional and stylistic similarities, but also by K. Öttinger's reading of the fragmentary date at the upper right as the lower parts of the number 151.[9] The absence of a fragmentary monogram led Öttinger to conclude that there was no uniform line for the inscription, which is especially true for the drawings of 1510 and 1511. As the closeness of the three numerals on this sheet match those on the Sebastian drawing in Brunswick, a date of 1511 for the *Sacrifice of Isaac* seems probable.

Ch.E.

Notes
1. M. J. Friedländer, *Albrecht Altdorfer*, (Leipzig, 1891), p. 155.
2. F. Winzinger, *Albrecht Altdorfer, Graphik* (Munich, 1963), no. 91, B.41.
3. Cf. H. Becker, "Die Handzeichnungen Albrecht Altdorfers," *Münchner Beiträge zur Kunstgeschichte* 1 (Munich, 1938), p. 47 ff.
4. K. Öttinger, *Altdorfer Studien* (Nuremberg, 1959), p. 43.
5. Pen and ink and white gouache on olive green prepared paper, dated with monogram "1511," 18.6 × 14.4 cm, Herzog Anton Ulrich-Museum, Brunswick.
6. Winzinger, *Albrecht Altdorfer, Graphik*, no. 16, B.60.
7. Ibid., no. 14, B.55.
8. Schönbrunner-Meder, c.1514; H. Tietze, c.1512; L. Baldass, c.1511/12; H. Becker, c.1511.
9. K. Öttinger, "Datum und Signatur bei Wolf Huber und Albrecht Altdorfer," *Zur Beschriftungskritik der Donauschulzeichnungen, Erlanger Forschungen* 8 (Erlangen, 1957), p. 51.

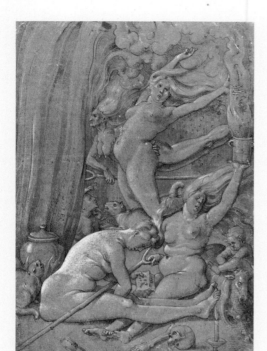

Hans Baldung, called Grien
Schwäbisch-Gmünd 1484/85–1545
Strassburg

Painter, engraver and woodcut and stained-glass designer. Resided in Nuremberg 1503/1506. Woodcuts, paintings and stained glass attributed to him because of style, pointing to a link with Albrecht Dürer. He became a citizen of Strassburg in 1509; was active in Freiburg im Breisgau in 1511/17; afterwards, resided in Strassburg once again.

15a. Andrea Mantegna
Battle of the Sea Gods
National Gallery of Art, Washington, D.C.
Ailsa Mellon Bruce Fund 1984

WITCHES' SABBATH II
Pen and brush and black ink, heightened with white, and wash on reddish-brown prepared paper; 28.6 × 20.5 cm; inv. 3.221, D.300; mounted
Monogrammed "H F" (joined) on the piece of paper and dated "1514" at center to lower right

Provenance: Duke Albert of Saxe-Teschen; 1822 Estate inventory, p. 305; L.174

Bibliography: A. Woltmann, *Geschichte der deutschen Kunst im Elass*, Leipzig, 1876, p. 293; G. v. Térey, *Die Handzeichnungen des Hans Baldung*, III, Strassburg, 1894–96, no. 248; Schönbrunner-Meder, no. 515; C. Koch, *Zeichnungen altdeutscher Meister*, 2d ed., Dresden, 1923, p. 22; Alb.Cat. IV(V),1933, D.300; O. Benesch, *Hans Baldung Grien, 450 Geburtsjahr des Künstlers*, Vienna, 1935, no. 22; H. Perseke, *Hans Baldungs Schaffen in Freiburg*, Freiburg/Breisgau, 1941, no. 8; C. Koch, *Die Zeichnungen Hans Baldung Griens*, Berlin, 1941, no. 64; *Hans Baldung Grien, Karlsruhe*: Staatliche Kunsthalle, 1959, no. 142 (drawings catalogued by E. Ammann); G. F. Hartlaub, *Hans Baldung Grien, Hexenbilder*, Stuttgart, 1961, no. 10; *Les Sorcières*, Bibliothéque Nationale, Paris, 1973, no. 67; J. Marrow and Alan Shestack, *Hans Baldung Grien, Prints & Drawings*, Washington, D.C./New Haven, Connecticut, 1981, under no. 18; W. Strauss, "The Wherewithal of Witches," *Source* 2 (1983), p. 16–22.

Hans Baldung Grien has captured three young naked witches, surrounded by thick plumes of smoke, in the midst of their preparations. Under the influence of the billowing vapors, they act as if in a trance, abandoning themselves to the intoxicating and stimulating effects of the magic potions. One of the voluptuous beauties is being swept along by an old witch; cats and skeletons and a putto mounting a goat complete the scene.

The theme of witchcraft as a motif for paintings and graphic art, its elevation into the visual arts so to speak, was new and relevant when Hans Baldung Grien embraced it; in this, he was a pioneer and a pathfinder. Traditionally, people believed that witches, that is women endowed with magical power, could harm their fellow human beings, enter into pacts with the Devil, transform themselves into animals or influence the weather.[1] Such beliefs, however, were not expressed visually until the beginning of the modern era when increased persecution of magic, which was equated with heresy, was reflected in the Papal Bull of 1484.[2] This, in turn, formed the basis for the so-called Hammer of Witches, a treatise that helped to make the theme popular and current.[3]

The lascivious nature of the witches is emphasized by the youthful, attractive nakedness of the figures. In this, Baldung followed the widespread notion, propagated by the Hammer of Witches, that witches fornicated with both the Devil and humans. The theme undoubtedly provided a welcome opportunity to depict the naked human body, a subject that had been restricted to its biblical theme — first man and woman, Adam and Eve — for centuries. At the beginning of the Renaissance and incipient humanism, nude figures signified an escape from the constraints imposed by the Church and an assertion of artists' independence. Insistent sexuality was soon accepted in themes illustrating pagan events, which were trimmed with antique or humanist subject matter, such as representations of Venus, the Judgement of Paris or witches. Consequently, by the early sixteenth century, witches had become a fashionable theme that even learned men could not avoid. Many artists, including Dürer, Albrecht Altdorfer, Hans Franck, Urs Graf and Baldung, concerned themselves with it.[4]

Witches' Sabbath II, has its origins in earlier works by Baldung. A color woodcut (1510) with its triangular composition (two squatting witches in the foreground and one behind with raised arms) and a drawing (*Witches' Sabbath I*) in Paris[5] may be considered precursors of the Albertina sheet. The witch riding through the air on a goat in the woodcut also has its equivalent in the Vienna drawing: the crone on a broomstick who is sweeping a young witch away. Late medieval witchcraft lore was also mixed with elements from the antique; in this case, the putto mounting the goat. As Mesenzeva has convincingly shown,[6] the woman riding the goat in the woodcut is derived from the antique model of Aphrodite Pandemos, a goddess of lust. Dürer introduced this antique model into German art through his engraving, *The Witch*, which is a deliberate combination of witch and Venus in an expressive and prophetic motif. Baldung heightens the effect of the scene by using tinted paper, which, although available in the fifteenth century, was not widely used until Dürer returned from Venice in 1507.

Questions have been raised about the authorship of this sheet. Based on the monogram "H F," the catalogue of the 1959 Karlsruhe exhibition

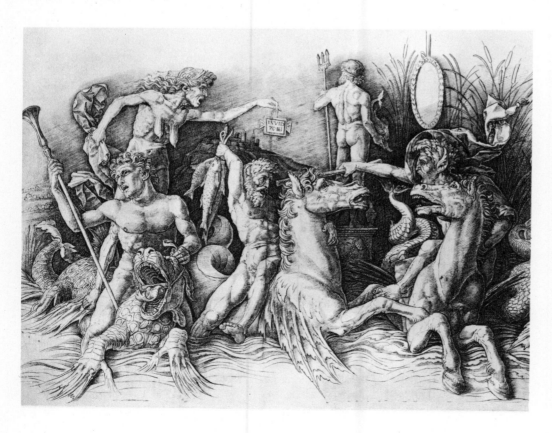

argued that "the sheet should indeed perhaps be considered as a copy from a lost original by Baldung,"[7] probably from the hand of the monogrammist HF, Hans Franck.[8] This opinion, however, relies too heavily on reading the letters on the paper held by the witch as the draughtsman's monogram. Works with the monogram HF and given to Hans Franck, such as the *Four Witches* (Berlin),[9] display no stylistic connection to the Albertina drawing. In fact, the execution of the *Witches Sabbath II*, its clear, sharp, pen-and-ink contours, its rows of hooked-line hatchings that follow the forms and its white heightenings that begin as fine lines and gently merge into a thick mesh of short hatching strokes and small hooked marks, attests to the contrary. The style fits so well that there is no reason to abandon the attribution to Hans Baldung Grien on the basis of the two letters alone, although they do still require explanation.

The flying witch betrays the decisive influence of Mantegnesque figures. Albrecht Dürer had already been affected by it,[10] and this is undeniably true of Baldung's drawing too: his old witch in the background is clearly derived from Andrea Mantegna's engraving, *The Battle of the Sea Gods*.[11] F.K.

Notes

1. J. Hansen, *Zauberwahn, Inquisition und Hexenprozess im Mittelalter und die Entstehung der grossen Hexenverfolgung*, Histor. Bibl. 12, (Munich/Leipzig, 1900), p. 210, 448–52.

2. "Bulla excommunicationis contra haereticos"(Rome: Stefan Planck, 1485); Hain 9200. The full text is available in J. Hansen, *Quellen und Untersuchungen zur Geschichte des Hexenwahns und der Hexenverfolgungen im Mittelalter* (Bonn, 1901), p. 24–27; reprinted in Hildesheim, 1963.

3. Hain 9238; L. Hain, *Repertorium bibliographicum in quo libri omnes ab arte typographica inventa usque ad annum MD.*, I–II (4 vols.), (Paris/Stuttgart, 1826–1838), no. 92.

4. G. F. Hartlaub, *Hans Baldung Grien, Hexenbilder* (Stuttgart, 1961), figs. 1–16.

5. *Witches Sabbath*, 1510, color woodcut, B.55, G.121, H.235. *Witches Sabbath I*, Louvre, Paris; pen drawing, heightened with white, on green prepared paper, 28.9 × 20.0 cm.

6. Ch. Mesenzewa, "Zum Problem: Dürer und die Antike," *Zeitschrift für Kunstgeschichte* 46 (1983), p. 187–202.

7. Staatliche Kunsthalle, *Hans Baldung Grien* (Karlsruhe, 1959), no. 142.

8. W. Strauss, "The Wherewithal of Witches," *Source* 2 (1983), note 5. Strauss, without reference to the Karlsruhe exhibition catalogue, expresses the same opinion.

9. Hans Franck, *Witches' Sabbath*, Kupferstichkabinett, Berlin, inv. 4.454; pen and ink, heightened with white, on gray prepared paper, 14.3 × 10.4 cm.

10. F. Anzelewsky, "Die Hexe," *Dürer Studien* (Berlin, 1983), p. 116.

11. H.5; A. M. Hind, *Early Italian Engraving*, V (London, 1938–48), p. 15, no. 5.

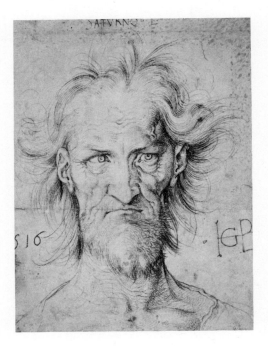

16

HEAD OF SATURN
Black chalk on paper; 33.2 × 25.5 cm; inv. 17.549, D.302
Monogrammed "HGB" at right and below center and dated "(1)516" at left; inscribed "SATURNO L" at top center in bistre ink by another hand and "Jean Baldung Gruen" at lower right in red chalk, partly erased

Provenance: Charles Prince de Ligne, L.592; Duke Albert of Saxe-Teschen; 1822 Estate inventory, p. 305; L.174

Bibliography: Bartsch 1794, p. 141, no. 1; G. v. Térey, *Die Handzeichnungen des Hans Baldung, gen. Grien*, III, Strassburg, 1894–96, no. 245; Schönbrunner-Meder, no. 211; O. Benesch, *Hans Baldung Grien, 450 Geburtsjahr des Künstlers*, Vienna, 1935, no. 24; O. Fischer, *Hans Baldung Grien*, Munich, 1939, p. 39; C. Koch, *Die Zeichnungen Hans Baldung Griens*, Berlin, 1941, no. 48; Paris 1950, no. 86; Staatliche Kunsthalle, *Hans Baldung Grien*, Karlsruhe, 1959, no. 150 (drawings catalogued by E. Ammann); P. Strieder et al, *Meister um Albrecht Dürer*, Germanisches Nationalmuseum, Nuremberg, 1961, p. 13 ff, 20 ff, 47 ff; C. Koch, "Kopf eines Narren," *Festschrift für F. Winkler* (ed. H. Möhle) Berlin, 1961, p. 197 ff; G. F. Hartlaub, *Hans Baldung Grien, Hexenbilder*, Stuttgart, 1961, p. 19 ff; Benesch 1964, Meisterzeichnungen, no. 74; Albertina, *200 Jahre Albertina*, Vienna, 1966, no. 303; Alb.Vienna 1971, Meisterzeichnungen, no. 96; J. Marrow and Alan Shestack, *Hans Baldung Grien, Prints and Drawings*, Washington, D.C./New Haven, Connecticut, 1981, no. 55, p. 219.

Executed in 1516, at the height of Baldung's Freiburg period, the drawing represents a highpoint of his drawing oeuvre. Among all Baldung's drawings and paintings one cannot find a work to compare with it in immediacy and expressive power.

The gaunt, deeply wrinkled features of the old man — his aquiline nose over mean narrow lips, the fierce and inquiring gaze under a high forehead with protruding vein, tousled hair standing up in all directions as if filled with fury, and the head as though set in an electrified atmosphere — create "all that is ugly, choleric, unkempt, savage even to the point of madness" in this overwhelmingly expressive face. With stupendous assurance Baldung places every line with such care that the play of light over the features captures a striking character "with spiritual fire flashing in the piercing gaze."[1] This drawing, which for all its boldness is very carefully composed, seems so immediate that it has been seen as a particularly faithful depiction of a live model.[2]

Although not added until later by another hand, the inscription "Saturno" contributes decisively to the understanding of this image. Saturn was the Roman god of agriculture, who was robbed of his sovereignty by his son, Jupiter, and fled to Latium where he reigned during the Golden Age. Saturn, always connected with magic, sorcery and the realm of the dead, is considered the highest of the planetary rulers and is associated with the constellations Aquarius and Capricorn. Although he could grant wealth and power as the previous sovereign of the Golden Age, Saturn was generally seen as an adverse starsign, linked to affliction, all manner of misery and death. Those born under him were warriors, poor farmers, those with "ignoble" professions.

Proceeding from the ideas of Florentine Neoplatonism, humanist exegesis also linked the planets with the four temperaments; melancholy was assigned to Saturn. According to old tradition and the interpretation offered in the writings of Marsilio Ficino, the melancholic temperament is close to madness. It is, however, a "divine madness" that offers the melancholic person, who alternates between raging lunacy and imbecility, the opportunity to excel over all other men by virtue of his "anomaly," provided he understands how to balance the extremes of his nature. Melancholy counts as the temperament of important people, philosophers, statesmen, poets and artists; it is therefore equated with genius.[3]

If one sees Saturn, melancholy and madness linked in such an intellectual framework, then the drawing's later inscription shows its author to have had a highly cultivated mind alert to the philosophical trends of the time. Hans Baldung Grien's image, which unites many of the characteristics of those born under Saturn, could then be interpreted, in spite of its suggestive natural liveliness, as an ideal portrait that encompasses the intellectual world of Neoplatonism in the personification of Saturn. F.K.

Notes

1. Benesch 1964, Meisterzeichnungen, p. 338, no. 74.

2. J. Marrow and Alan Shestack, *Hans Baldung Grien, Prints and Drawings* (Washington, D.C./New Haven, Connecticut, 1981), no. 55.

3. E. Panofsky, *Das Leben und die Kunst Albrecht Dürers*, (Munich, 1977), p. 208 ff.

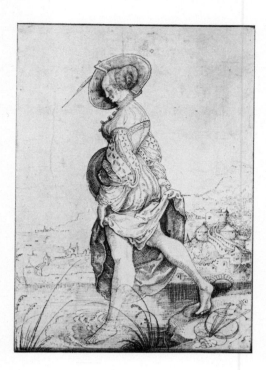

Urs Graf
Solothurn c.1485–1527/1529 Basel

The artist studied as a goldsmith, probably in Solothurn with his father, Hug Graf, at first, then in Basel. His journeyman travels took him to, among other places, Strassburg. He trained as a glass painter with Lienhard Triblin in Zurich (1507/8) and from 1509 lived in Basel where he designed book illustrations. Urs Graf also participated in the Swiss military campaigns in Italy and France.

17

WOMAN WADING A STREAM
Pen and black ink on white paper, 19.9 × 14.5 cm; inv. 3.051, D.334
Monogrammed lower right with dagger emblem and Basel staff, cropped date "152" (the 2 also a little cropped) at right

Provenance: Duke Albert of Saxe-Teschen; 1822 Estate inventory, p. 292–93; L.174

Bibliography: Schönbrunner-Meder, no. 250; Alb.Cat. IV(V), 1933, D.334; K. T. Parker, "Die verstreuten Handzeichnungen Urs Grafs," *Anzeiger für schweizerische Altertumskunde* 23 (1921), p. 207 ff, no. 36; K. T. Parker, "Zu den Vorbildern Urs Grafs," *Anzeiger für schweizerische Altertumskunde*, New Ser. 24 (1922), p. 227–35; K. T. Parker, *Zwanzig Federzeichnungen von Urs Graf*, Zurich, 1922; H. Koegler, *Beschreibendes Verzeichnis der Basler Handzeichnungen des Urs Graf nebst einem Katalog der Basler Urs Graf-Ausstellung 1926*, Basel, 1926, no. 134; W. Lüthi, *Urs Graf und die Kunst der alten Schweizer*, Zurich, 1928, p. 40 ff; H. Koegler, *Hundert Tafeln aus dem Gesamtwerk des Urs Graf*, Basel, 1947, no. 674; Benesch 1964, Meisterzeichnungen, no. 93; Ch. Andersson, "Popular Love and Imagery in the Drawings of Urs Graf," Ph.D. Diss., Stanford, 1977; Ch. Andersson, *Dirnen, Krieger, Narren, Ausgewählte Zeichnungen von Urs Graf*, Basel, 1978, p. 54 ff; E. Major and E. Gradmann, *Urs Graf*, Basel, n.d., no. 23.

This drawing shows a landscape around a lake with a conspicuously dressed young woman in the foreground. She has gracefully gathered up her dress in both hands so that her naked legs are visible as she steps unhesitatingly into the water. She is wearing a fashionable feathered hat, from under which she challenges the spectator with her gaze.

While the older literature interpreted the step into the water as a pretext for the woman to raise her skirt and show her naked legs,[1] Christiane Andersson was the first to point out that this was a literal translation of a sixteenth-century colloquial idiom, "to step into the stream," (*miteinem Fuss in den Bach treten*)[2] which referred to the loss of virginity or a moral lapse. Urs Graf underlines the woman's loose life through her coquettish glance and the emphasis on her splendid clothes. In the sixteenth century clothing was regulated according to class by sumptuary laws that applied to everyone except prostitutes who could decorate themselves with finely embellished, rich clothes. In a carnival play (1522) Niklaus Manuel Deutsch described prostitutes' dress as equal to the nobility's in luxury.[3] The coquettish glance was considered characteristic of easy women[4] and, therefore, forbidden to women of moral standing.

Urs Graf portrayed prostitutes several times in his drawings,[5] especially in this attempt to represent the meaning of a proverb visually.

Apart from problems of content, there are also differences of opinion about the dating of this sheet because the year was cut off from the lower right edge, leaving only the first two numerals, "1" and "5," legible. 1513 or 1514 are most often mentioned in the literature.[6] Only Koegler dates the drawing to around 1524, arguing it is "less easily and personally drawn" than the drawings of 1514 and "more studied, with firmer contours, more like a finished work of art than a sketch. . . ."[7] In comparison to dated drawings of the 1520s, such as the *Courtesan and Hanged Man* (1525, Öffentliche Kunstsammlung, Kupferstichkabinett, Basel; inv. U.10.93), one does indeed find a similarly compact contour line; for example, the treatment of the legs whose shadowed areas are rendered with liberal parallel- or crosshatching. Another strong similarity with the 1525 Basel drawing is the way in which the calm surface of the water is handled with thick grids of lines that dissolve into thin, parallel strokes and, finally, short hyphenlike accents. The decorative rendering of the dress with its detailed pattern and luxurious folds — an ornamental technique that reveals the hand of the trained goldsmith and engraver — is also evident in drawings of 1523 to 1525, while a more generous and spontaneous ductus predominates the works of c.1514/15.[8] The monograms of the 1520s have decorative, ornamental loops and arabesques as well.

However, apart from stylistic parallels supporting a 1523/24 date, traces of a third numeral can be seen on the Albertina sheet. This is unequivocally a "2." Graf always wrote "1" as a straight line; the Albertina drawing, on the other hand, has the remnants of an upper and a lower cross-stroke that must therefore have belonged to a "2." In addition, the conclusions drawn from stylistic analogies are confirmed by an engraved copy[9] by Carl Rahl the Elder (1779–1843). When Rahl copied the drawing it evidently had not been cut down because he added the inscription, "Urs Graf inv. 1523," at the lower left. *Ch.E.*

Notes
1. E. Major and E. Gradmann, *Urs Graf* (Basel, n.d.), p. 19.
2. Ch. Andersson, *Dirnen, Krieger, Narren, Ausgewählte Zeichnungen von Urs Graf* (Basel, 1978), p. 54, 55.
3. Ibid., p. 55.
4. Ibid., p. 54: Broadsheet of 1509, "Keep your eyes to yourself and wink at no-one."
5. For example, *Old Fool Waylays a Naked Prostitute*, inv. U.X.105, and *Prostitute Distributes Money*, inv. U.X.80, Öffentliche Kunstsammlung, Kupferstichkabinett, Basel.
6. E. Major and E. Gradmann, *Urs Graf*, p. 19; K. T. Parker, "Die verstreuten Handzeichnungen Urs Grafs," *Anzeiger für schweizerische Altertumskunde* 23 (1921), p. 210; W. Lüthi, *Urs Graf und die Kunst der alten Schweizer* (Zurich, 1928), p. 40.
7. H. Koegler, *Hundert Tafeln aus dem Gesamtwerk des Urs Graf* (Basel, 1947), p. XXI.
8. For example, *Armless Girl with a Wooden Leg*, inv. U.I.58, Öffentliche Kunstsammlung, Kupferstichkabinett, Basel.
9. Albertina Collection, Vienna, inv. ÖK Rahl, p. 24, no. 355.

17a. Carl Rahl the Elder
Girl Stepping into Water, engraving after Urs Graf
Albertina Collection, Vienna

Hans Holbein the Younger
Augsburg 1497/98–1543 London

Painter and woodcut and stained-glass designer. Probably first trained with his father, Hans Holbein the Elder. In 1515 Holbein resided in Basel (probably apprenticed to Hans Herbster); was active in Lucerne in 1517/18; then again in Basel until 1526. In 1519 Holbein was accepted into the painter's guild in Basel. His patrons were Basel patricians and humanists with whom he had close ties. Traveled to France in 1524; to Antwerp and England, where he met Thomas More on the recommendation of Erasmus of Rotterdam in 1526. Returned to Basel in 1528; in 1532 moved to London where his first patrons were German merchants. Holbein was in the service of Henry VIII from 1536. Traveled to the continent in 1538; visited Basel. Especially significant as a portraitist. Other than Dürer, Holbein was the most important master of the German Renaissance.

18

TWO ANGELS HOLDING AN ESCUTCHEON
Pen and black ink, brush and gray wash, chalk underdrawing (which appears to be suggested corrections); 43.8 × 32.5 cm; inv. 31.705, D.341a
Watermark: Grape (similar to Briquet 13017); inscribed "H. Holbein" (the letters H joined)

Provenance: P. Lely, L.1753; J. Richardson, L.2184; G. de Hunte; P. & C. Colnaghi; acquired from the art market in 1955

Bibliography: P. Ganz, *Handzeichnungen von Hans Holbein d.J.*, Berlin, 1908; C. Glaser, *Hans Holbein d.J., Zeichnungen*, Basel, 1924, p. 10 ff; P. Ganz, "Holbein," *Burlington Magazine* 48, no. 272 (1925), p. 231 ff; Th. Muchall-Vielrook, "Ein Beitrag zu den Handzeichnungen Hans Holbeins d.J." *Münchner Jahrbuch der bildenden Kunst* 2 (1931), p. 156 ff; P. Ganz, *Die Handzeichnungen Hans Holbein d.J., Kritischer Katalog*, Berlin, 1937; H. A. Schmid, *Hans Holbein d.J., Sein Aufstieg zur Meisterschaft und sein englischer Stil*, III, Basel, 1945–48, no. 41; O. Benesch, comp., *Neuerwerbungen alter Meister*, Albertina Collection, Vienna, 1958, no. 11; *Die Malerfamilie Holbein in Basel*, (drawings prepared by M. Pfister-Burkhalter), Basel, 1960, no. 257; Benesch 1964, Meisterzeichnungen, no. 94; R. Klessmann, comp., *Burgmair und die graphische Kunst der deutschen Renaissance*, Brunswick, 1973, no. 54; P. Dreyer, *Zeichnungen aus dem ältesten Bestand des Berliner Kupferstichkabinetts*, Berlin, 1982, no. 8.

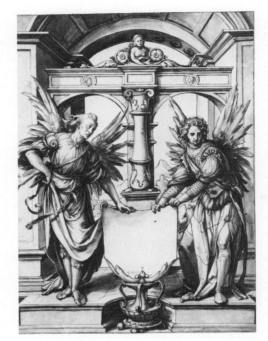

The precise tracing of the figure and surrounding architecture, the careful balance of light and shade, and the manner of drawing everything, even the last detail, with equal clarity in pen and brush with strong washes, indicates that this large-scale study was unmistakably prepared as a design for a glass painter. During the transition from late Gothic to Renaissance, stained-glass painting was as significant and as esteemed as oil painting, particularly in Switzerland and, to a lesser degree, in southern Germany. The aristocracy, the middle classes, the peasants, guilds, secular and spiritual authorities all vied for such glass. Therefore, even important artists became active in this area of decorative art.

In the early years of his career (1519–26), while in Basel, Holbein the Younger executed a considerable number of designs for windows. By opening the background and giving precedence to the figures — "the holders of the escutcheon are more important to Holbein than the escutcheons"[1] — in his earliest works, of which the Albertina drawing is one, Holbein freed glass painting from its late medieval flat and decorative character to an independent depth. Holbein made glass paintings a fully valid means of Renaissance artistic expression and thereby helped Swiss glass painting achieve a highpoint in its development.

Benesch has pointed out that the stylistic parallels in a design in the Barber Institute (Birmingham, England) are, in his opinion, so close to the Albertina drawing that the two works could be companion pieces.[2] The design for an angel with two escutcheons[3] and an image of Saint Michael weighing souls, which may perhaps have been intended as a design for a statue,[4] are closer still.

Evaluating Holbein's drawings is hard because numerous, sometimes deceptively exact copies, especially of the stained-glass designs, exist. For instance, by laying the original and the copy of the wild man design, both of which survive, side by side, one may judge how astonishingly close these workshop copies came to their prototypes.[5] This kind of comparison also underlines the difficulties to be faced when no such opportunity exists. In terms of Holbein's graphic oeuvre as it is known today, such comparisons teach us that individual attributions are far less secure than we would like to think.

Delicate questions like the issue of authenticity and its extensive consequences cannot be treated

18a. Hans Holbein the Younger
An Angel with Two Escutcheons
Barber Institute, Birmingham, England

18b. Hans Holbein the Younger
St. Michael Weighing Souls
Kunstmuseum, Basel

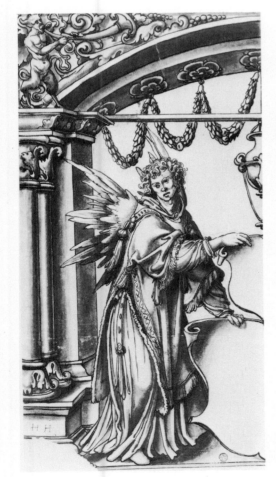

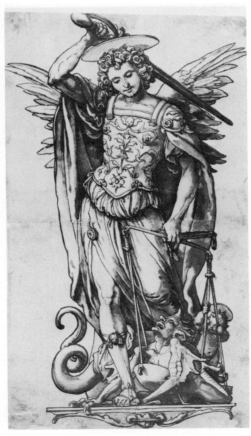

adequately in the few sentences of a catalogue entry. One should, however, take into consideration that future research will, for a large number of these designs, including the present sheet, alter some of the attributions currently ascribed to Hans Holbein the Younger. *F.K.*

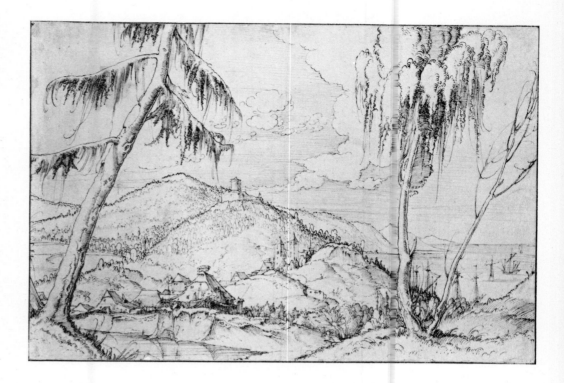

Notes

1. P. Ganz, *Die Handzeichnungen Hans Holbeins d.J., Kritischer Katalog* (Berlin, 1937), p. XXVIII.

2. Benesch 1964, Meisterzeichnungen, no. 94; O. Benesch, comp., *Neuerwerbungen alter Meister* (Vienna: Albertina Collection, 1958), no. 11.

3. P. Ganz, *Die Handzeichnungen Hans Holbeins d.J.,* no. 184, fig. XVI, 5.

4. Ibid., no. 109 (dated 1522 by Ganz in connection with the paintings in Karlsruhe); *Die Malerfamilie Holbein in Basel* (Basel, 1960), no. 262, fig. 89.

5. P. Dreyer, comp., *Zeichnungen aus dem ältesten Bestand des Berliner Kupferstichkabinetts* (Berlin, 1982), no. 9, pl. 15; cf. Ganz, *Die Handzeichnungen Hans Holbeins d.J.,* no. 200.

Erhard Altdorfer
Regensburg(?)c.1480–1561/62 Schwerin

19

Painter, printmaker, woodcut designer, architect; younger brother of the painter Albrecht Altdorfer, the leading master of the Danube School, whose works are stylistically so close to Erhard's early work that one may assume there was a cooperative workshop in Regensburg in the years around 1506. Erhard Altdorfer may have been active in Austria around 1510; in 1512 Duke Frederick the Peaceful summoned him to Schwerin, where he was a court painter from 1516 to 1561 and an architect.

PANORAMIC COASTAL LANDSCAPE
(attributed to Erhard Altdorfer)
Pen and gray-black ink on white paper;
20.6 × 31.1 cm; inv. 17.546, D.221; mounted
Inscribed "Augustin Hirschvogel"

Provenance: Duke Albert of Saxe-Teschen; 1822 Estate inventory, p. 308 (under Hirschvogel); L.174

19a. Erhard Altdorfer
Landscape
Albertina Collection, Vienna

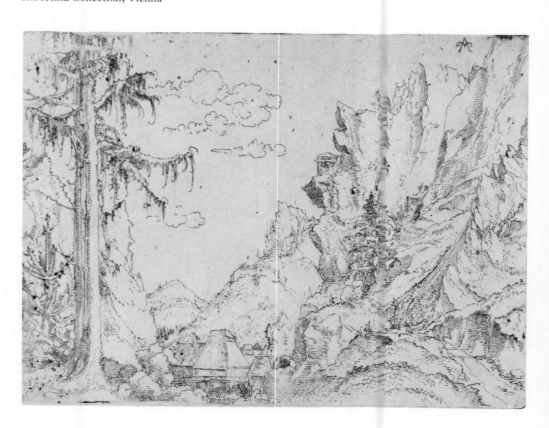

Bibliography: Schönbrunner-Meder, no. 867; C. Dodgson, "Erhard Altdorfer als Kupferstecher und Zeichner, *Mitteilungen der Gesellschaft für vervielfältigende Kunst,* 1911, p. 22 ff; M. Friedländer, *Albrecht Altdorfer,* Berlin, 1923, p. 155; E. Bock, *Die Zeichnungen in der Universitätsbibliothek Erlangen,* Frankfurt am Main, 1929, p. 200; W. Jürgens, *Erhard Altdorfer,* Leipzig, 1931, p. 67; Alb.Cat. IV(V), 1933, D.221; O. Benesch, "Erhard Altdorfer als Maler," *Jahrbuch der Preussischen Kunstsammlungen* 57 (1936), p. 163 ff; H. Becker, "Die Handzeichnungen Albrecht Altdorfers," *Münchner Beiträge zur Kunstgeschichte,* 1, Munich, 1937, p. 281; *Albrecht Altdorfer und sein Kreis,* Munich, 1938, no. 351; L. Baldass, "Albrecht Altdorfers künstlerische Entwicklung und Herkunft," *Jahrbuch der kunsthistorischen Sammlungen in Wien* 12 (1938), p. 117 ff.; L. Baldass, *Albrecht Altdorfer,* Vienna, 1941, p. 151, 153, 221; V. Stöver, "Erhard Altdorfer" Ph.D. Diss., Würzburg, 1945, no. 26; F. Winzinger, *Albrecht Altdorfer, Zeichnungen,* Munich, 1952, no. 146; F. Winzinger, "Neue Zeichnungen Albrecht und Erhard Altdorfers," *Wiener Jahrbuch für Kunstgeschichte* 18 (1959/60), p. 7 ff.; O. Benesch and A. Auer, *Die Meister der Historia Fredericianae et Maximilianae,* Berlin, 1957, p. 132; K. Öttinger, *Altdorfer Studien,* Nuremberg, 1959, ill. 15; Benesch 1964, Meisterzeichnungen, no. 85; F. Winzinger et al, comp., *Die Kunst der Donauschule,* St. Florian, Linz, 1965, no. 165; D. Köpplin, "Altdorfer und die Schweizer," *Alte und Moderne Kunst* 84 (1966), p. 6 ff; C. Talbot and A. Shestack, comps., *Prints and Drawings of the Danube School,* 1969 (Yale University Art Gallery, New Haven, Connecticut and traveling); O. Benesch, *German and Austrian Art of the 15th and 16th Centuries,* vol. 3 of *Collected Writings,* London, 1972, p. 331 ff; A. Stange, *Die Maler der Donauschule,* Munich, 1971, p. 87 ff; R. Packpfeiffer, "Studien zu Erhard Altdorfer," Ph.D. Diss., Vienna, 1974, (published in Vienna in 1978), no. 22; Alb.Vienna 1978, no. 132.

The oeuvre of Erhard Altdorfer, Albrecht Altdorfer's younger brother, is small and, even within it, only a few works can with certainty be assigned to his hand. The starting point is the engraving of *Lady with a Peacock Shield,*[1] monogrammed and dated 1506. A drawing in Berlin, signed and also dated 1506, can definitely be paired with it on the basis of style. In addition, we have the monogrammed Tournament woodcuts, dated 1512, which were executed from drawings by Erhard Altdorfer for the Low German Luther Bible of 1533, and finally an undated landscape etching, which carries Erhard Altdorfer's monogram.[2] The attribution of the Albertina drawing is based on its stylistic similarity to this single landscape etching.[3]

The viewer is guided from the elevated foreground with its coniferous and deciduous trees across to a hilly landscape with farm buildings that line a steeply rising road (partly hidden by a line of hills) which leads to a Romanesque church on the hilltop. The view through the trees in the right foreground opens onto a broad expanse of water with ships. It is not known whether this scene is a topographically exact site as the placement of the massive church would tend to suggest, or just a panoramic landscape assembled from both real and imagined elements. For this reason, the drawing has been described as a lakeside landscape, a landscape (on Lake Constance?) or a coastal landscape with bay.

While the attribution to Erhard Altdorfer has been unanimously accepted, different opinions have been expressed about the sheet's date, c.1525. For example, C. Dodgson suggested c.1530 based on connections to the Lübeck Bible of 1533/34, which was designed by Erhard Altdorfer.[4] W. Jürgens arrived at an even later date[5] by assuming that Erhard Altdorfer did not come into renewed contact with his brother's art until 1538 when he returned to Regensburg to settle Albrecht's estate. Only at that time would Altdorfer have seen his brother's landscape etchings and the mountainous countryside of southern Germany again. K. Öttinger, on the other hand, following an oral suggestion by F. Winzinger, thought a date of shortly after 1510 possible.[6] Winzinger was less than convincing in arguing for his date of c.1512/15. He supported the long-standing belief that this sheet was influenced by Albrecht Altdorfer's landscape etchings, which were long considered not to have been executed until 1525/30 and not in the second decade of the century.[7] In this context Winzinger called attention to a 1513 drawing by Hans Leu that allegedly shows similarities in the treatment of the birch leaves.

In light of the style of Erhard Altdorfer's securely dated prints, Dodgson's proposed date of c.1530 or a little later seems wholly appropriate. Mannerisms in the drawing style — the long, fine parallel lines creating the shadows of the branches on the tree trunk, the heavily drooping boughs or their idiosyncratic construction out of shaded and lit sections, or the clouds embedded in the sky's bands of horizontal lines — reinforce the assumption that the drawing is temporally very close to Erhard Altdorfer's woodcuts for the Lübeck Bible.

The stylistic conformity of Erhard's etching and drawing forms the basis for the attribution as well as for their contemporaneity. However, in terms of Albrecht Altdorfer's landscape etchings on the one hand and Erhard's Lübeck Bible woodcuts on the other, differences between Erhard's etching and the drawing are noticeable. In its conception as a broad but nevertheless enclosed landscape, Erhard's etching is even closer to his brother's landscapes, which are currently dated c.1515–22. The drawing, which in my opinion relates more to the style of the Lübeck Bible, opens the landscape space into the distance and onto the infinite expanse of sea, thereby tending more toward a Netherlandish concept of landscape as seen in, say, Hieronymous Cock or Pieter Bruegel.[8]

F.K.

Notes

1. B.VI, p. 416, no. 1; Hollstein 1954, no. 1.
2. B.VII, no. 71 (under Albrecht Altdorfer); F. Winzinger, "Albrecht Altdorfer," *Graphik* (Munich, 1963), no. 242.
3. J. Meder was the first to note this connection; Schönbrunner-Meder, no. 867.
4. C. Dodgson, "Erhard Altdorfer als Kupferstecher und Zeichner," *Mittelungen der Gesellschaft für vervielfältigende Kunst,* 1911, p. 21 ff, no. 2.
5. W. Jürgens, *Erhard Altdorfer* (Leipzig, 1931), p. 67.
6. K. Öttinger, *Altdorfer Studien* (Nuremburg, 1959), p. 94.
7. F. Winzinger et al, comp., *Die Kunst der Donauschule* (Linz, 1965), no. 165; Winzinger, *Albrecht Altdorfer, Graphik* (Munich, 1963), p. 116–17.
8. The entire group of drawings given to Erhard Altdorfer by Bock, Schilling and Winzinger, especially the four sheets clearly by the same hand in Copenhagen (W.151), Dresden (W.150), Paris (L. Demont, *Inventaire générale des Dessins des Écoles du Nord, Écoles allemande et suisse,* I, Paris, 1937, no. 14), and Erlangen (Bock 815), deserves to be studied again in connection with the Vienna drawing, as I am by no means absolutely sure that they belong together.

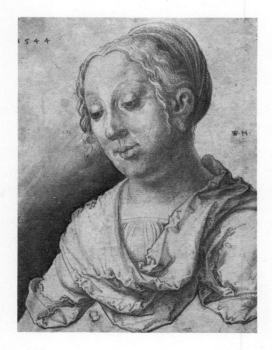

Wolf Huber
Feldkirch 1480/85–1553 Passau

Painter, draughtsman, city architect of Passau. Around 1505 Huber traveled to Innsbruck, Salzburg and possibly Vienna and Augsburg. Between 1510 and 1519 he settled in Passau, where he acquired citizenship and became court painter to Ernst of Bavaria and Wolfgang von Salm, bishop of Passau. Journeyed up the Danube River around 1513/14; documentation shows Huber in Vienna in 1530, in Lower Austria and Vienna in 1531. Confirmed as court painter in 1540, and city architect in 1541. Of his oeuvre, in which portrait painting holds an important place alongside religious works, his drawings had extensive influence. Next to Albrecht Altdorfer, Huber was the main representative of the Danube School.

BUST OF A WOMAN
Red chalk on paper, with green-black watercolor applied to the left background (by a later hand?); 23.4 × 18.1 cm; inv. 3.016, D.289; mounted
Monogrammed "W H" at right center and dated "1544" at upper left

Provenance: Duke Albert of Saxe-Teschen, L.174

Bibliography: R. Riggenbach, *Der Maler und Zeichner Wolf Huber,* Basel, 1907, p. 69; H. Voß, *Der Ursprung des Donaustils, Ein Stück Entwicklungsgeschichte deutscher Malerei,* Leipzig, 1907, p. 14; Meder, Handzeichnung, p. 127; L. Baldass, "Die Bildnisse der Donauschule," *Städel-Jahrbuch,* 1922, p. 73 ff.; Alb.Cat. IV(V), 1933, D.289; M. Weinberger, *Wolfgang Huber, Deutsche Malerei,* Leipzig, 1930, p. 203; *Albrecht Altdorfer,* Munich, 1938, no. 495; W. Hugelshofer, "Wolf Huber als Bildnismaler," *Pantheon* 7 (1939), p. 203 ff.; L. Baldass, *Albrecht Altdorfer,* Vienna, 1941, p. 223 ff; O. Benesch, comp., *Wolf Huber,* Albertina Collection, Vienna, 1953, no. 9; E. Heinzle, *Wolf Huber,* Innsbruck, 1953, no. 161; K. Öttinger, "Zu Wolf Hubers Frühzeit," *Jahrbuch der Kunsthistorischen Sammlungen in Wien* 53 (1957), p. 71 ff; G. van der Osten, "Ein Ott-Heinrich Bildnis von Wolf Huber," *Pantheon* (1960), p. 145 ff; G. Künstler, "Wolf Huber als Hofmaler des Bischofs von Passau Graf Wolfgang von Salm," *Jahrbuch der Kunsthistorischen Sammlungen in Wien* 58 (1962), p. 73 ff; A. Stange, *Die Malerei der Donauschule,* Munich, 1964, p. 102; Benesch 1964, Meisterzeichnungen, no. 92; Australia 1977, no. 26; F. Winzinger, *Wolf Huber, Das Gesamtwerk,* I–II, Munich/Zurich, 1979, no. 124.

Giorgio Vasari remarked that red chalk or *redstone* comes from the mountains of Germany. Nevertheless, drawing in red chalk, increasingly found in Italian art from the end of the fifteenth century, plays virtually no role in German art during Dürer's time. It is therefore worth noting that Wolf Huber's portrait study, as a pure red chalk drawing, belongs to the earliest examples of an artist's use of red chalk in German art.[1]

Upon surveying Wolf Huber's painted oeuvre,[2] one observes a period, between 1530 and 1545, for which examples of his artistic activity are lacking. The extent to which this gap is due to the accidents of preservation or results from the artist's employment elsewhere, perhaps as architect and on lost murals related to this activity, is currently unknown. Wolf Huber's painted works show a sharp break, without any transitional phase, between the religious paintings, which are infused with the expressive natural and spiritual atmosphere of the Danube School, and the Renaissance works of the later years that are strongly based on the human portrait (e.g., *Allegory of the Cross* or the portrait of the humanist Wolfgang Ziegler[3]).

This change is also clear from Huber's drawing *Bust of a Young Woman,* with autograph date and monogram. Benesch spoke of its "portrait character"[4]; the features of the young woman, however, correspond to an ideal female type that recurs over and over again in Huber's oeuvre, from the works of the 1520s up until the late period around the middle of the century. The contemplative gaze of the slightly protruding eyes, the narrow bridge and rounded tip of the nose, the small but curvaceous mouth with thick lips, the broad cheek and neck planes, all create that distinctive and unmistakable touch which characterizes Huber's facial types throughout his career.[5] The softly modeled face, conceived with a monumentality appropriate to a portrait, contrasts with the broken up, almost nervous and graphic rendering of the folds in the scarf. By ending abruptly at the bottom, this scarf so to speak transforms the half-length view into a sculptural bust. Thus the Tietzes noted that the drawing "gave the impression of being a partial copy from a painting."[6]
 F.K.

Notes
1. Meder 1923, p. 127. For the sake of completeness, it should be noted that a series of head studies by Huber, dated 1522 in black chalk heightened with white on red toned paper, precede this one.
2. F. Winzinger, *Wolf Huber, Das Gesamtwerk* (Munich/Zurich 1979).
3. Ibid., nos. 296, 293.
4. Benesch 1964, Meisterzeichnungen, no. 92.
5. Cf. also *Girl with a Laurel Wreath,* Winkler III, no. 123.
6. Alb.Cat. IV(V), 933, D.289.

Lucas Cranach the Younger
Wittenberg 1515–1586 Wittenberg

Painter, woodcut designer. He presumably apprenticed in the workshop of his father, Lucas Cranach the Elder, from 1527/29. In 1535 first mentioned as a member of this workshop, which he heads alone after his father's move to Weimar in 1550. Judging by the signatures, Lucas Cranach the Younger produced his first independent works around 1537. He was town councillor in 1549; chamberlain in 1555, 1561, 1564; and mayor of Wittenberg in 1565/68. Elector August of Saxony and Archduke Ferdinand of Austria were among his most important patrons from 1555. Archduke Ferdinand commissioned Cranach the Younger to paint fifty half-length portraits of Saxon rulers for Ambrass Castle in the Tyrol.

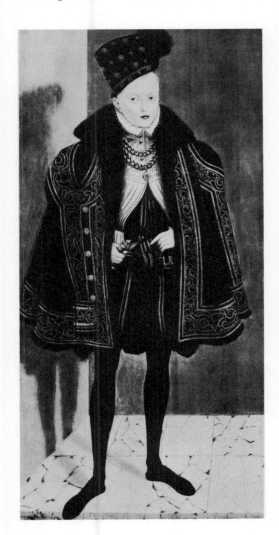

21a. Lucas Cranach the Younger
Prince Alexander
Gemäldegalerie Alte Meister, Dresden

21

PORTRAIT OF PRINCE ALEXANDER OF SAXONY
Brush and gouache on rose-gray prepared paper, traces of charcoal underdrawing; 32.7 × 24.0 cm; inv. 3.202, D.371

Provenance: Duke Albert of Saxe-Teschen; 1822 Estate inventory, p. 303; L.174

Bibliography: Ch. Schuchardt, *Lucas Cranach d.Ä. Leben und Werk*, part 2, Leipzig, 1851, p. 144, no. 7; M. Friedländer, "Eine Porträtstudie des jüngeren Lucas Cranach," *Amtliche Berichte aus den königlich Preussischen Kunstsammlungen* 32 (1910/1911), p. 134 ff; E. Bock and M. Friedländer, *Handzeichnungen der Meister des 15. und 16. Jahrhunderts*, Berlin 1921, p. 55; Alb.Cat. IV(V), 1933, D.371; Benesch 1964, Meisterzeichnungen, no. 76; W. Schade, *Die Malerfamilie Cranach*, Vienna/Munich, 1977, p. 102 ff, 465, no. 247.

Listed in Duke Albert's estate inventory as a drawing by Lucas Cranach the Elder, this sheet was identified by C. Schuchardt in 1851 as the work of Lucas Cranach the Younger.[1] It shows the nine- or ten-year-old Prince Alexander (1553–65),[2] son of Elector August of Saxony (1526–86) and Anna (1532–85), the daughter of Christian III, king of Denmark. Alexander's brother, Elector Christian I (1560–91), was related by direct descent to Duke Albert of Saxe-Teschen (1738–1822), the founder of the Albertina.[3] This drawing is a sketch for the head of the full-length portrait now in the Historisches Museum in Moritzburg, near Dresden.[4] Comparison of the Albertina drawing with this signed work (c.1564) reveals that very little time elapsed between the study and its execution. We may therefore assume a date of 1563 or, at the latest, 1564 for this sheet.[5] In addition to the prince's portrait, Cranach painted two other full-length portraits in the same year, Alexander's mother and his sister Elizabeth, and in 1565 his father, the Elector.[6] A study for the portrait of Elizabeth, which is very similar in execution to the Vienna drawing,[7] is housed in the Staatliche Museen Preussischer Kulturbesitz, Berlin.

Lucas Cranach the Younger followed his father's method in these two drawings; he also used the brush to produce studies from the model.[8] The use of oil-tempera on paper gives the drawing a more pictorial character; the sheet could have served as a *modello*, thus securing the commission. Compared to the painted versions, both sketches are more expressive. They reflect the young people's inner life, while the paintings with their splendid garb are more official and the faces remain blank. Werner Schade made a similar observation when he concluded that these two heads on a light ground were the strongest and most individual examples of the younger Cranach's work as a portraitist.[9] *A.S.*

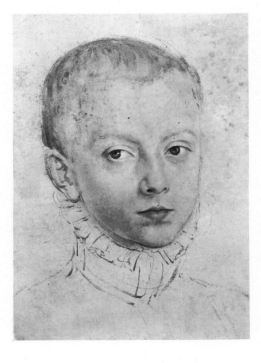

Notes
1. Ch. Schuchardt, *Lucas Cranach d.Ä. Leben und Werk* (Leipzig: 1851), no. 7.
2. W. K. Isenberg, *Stammtafeln zur Geschichte der europäischen Staaten*, I/II (Marburg, 1953), pl. 54.
3. Ibid., pl. 55.
4. W. Schade, *Die Malerfamilie Cranach* (Vienna/Munich, 1977), p. 465, no. 244.
5. Benesch 1964, Meisterzeichnungen, no. 76.
6. W. Schade, *Die Malerfamilie Cranach*, p. 465, no. 242, 243, 245.
7. Ibid., p. 465, no. 246.
8. Benesch 1964, Meisterzeichnungen, no. 76.
9. W. Schade, *Die Malerfamilie Cranach*, p. 102, 465, no. 246.

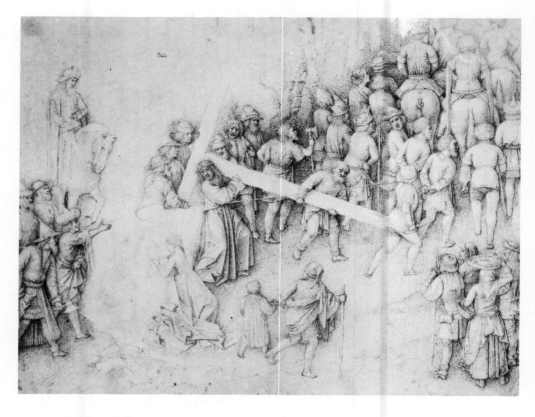

Netherlandish Master
fourth quarter of the fifteenth century *22*

THE CARRYING OF THE CROSS
Pen and bistre ink on paper; 20.4 × 27.7 cm;
inv. 3.025, N.22
Inscribed "Martin Schön" on the mount

22a. Netherlandish Master, fourth quarter of the
fifteenth century
Carrying of the Cross (the group with Marys added
by E. Panofsky)
Albertina Collection, Vienna

Provenance: Duke Albert of Saxe-Teschen, L.174

Bibliography: Schönbrunner-Meder, no. 1021;
F. Winkler, "Über verschollene Bilder der
Brüder van Eyck," *Jahrbuch der Königlich
preussischen Kunstsammlungen* 37 (1916), p. 287 ff;
O. Benesch, "Über einige Handzeichnungen des
15. Jahrhunderts," *Jahrbuch der Königlich
preussischen Kunstsammlungen* 46 (1925), p. 181 ff;
F. Saxl, "Studien über Hans Holbein d.J., I, Die
Karlsruher Kreuztragung," *Belvedere* 9 (1926),
p. 139 ff; G. J. Kern, *Die verschollene
"Kreuztragung" des Hubert oder Jan van Eyck,*
Berlin, 1927; E. Panofsky, review of G. J. Kern's
"Die verschollene 'Kreuztragung' des Hubert
oder Jan van Eyck," *Kritische Berichte zur
kunstgeschichtlichen Literatur,* 1/2, Leipzig,
1927–29, p. 74 ff; Alb.Cat. II, 1928, N.22;
L. Baldass, *Jan van Eyck,* Cologne, 1952, p. 275,
no. 63; F. Winkler, "Die Wiener Kreuztragung,"
Nederlands Kunsthistorisch Jaarboek 9 (1958),
p. 83 ff; Benesch 1964, Meisterzeichnungen,
no. 123; E. Panofsky, *Early Netherlandish Painting,*
Cambridge, Massachusetts, 1966, p. 237;
F. Lugt, *Musée du Louvre, Inventair Général des
Dessins des Ecoles du Nord, Maitres des Anciens Pays
Bas, nés avant 1550,* Paris, 1968, no. 66;
F. Anzelewsky et al, comps., *Pieter Bruegel d.Ä.
als Zeichner,* Staatliche Museen preußischer
Kulturbesitz, Berlin, 1975, no. 178; R. Genaille,
"La Montée au Calvaire de Bruegel, l'Ancien,"
*Jaarboek van het Koninklijk Museum voor Schone
Kunsten,* Antwerp, 1979, p. 143 ff; K. Baetjer,
*European Paintings in the Metropolitan Museum of
Art by Artists Born in or Before 1865,* I, New York,
1980, p. 51, no. 43, 95.

F. Winkler was the first to observe that characteristics of the composition, figures and costumes in the Albertina's drawing, *The Carrying of the Cross,* point to a prototype from the early Eyckian circle that is similar to the *Crucifixion* and the *Last Judgment* (Metropolitan Museum, New York) by the Master of the Turin Book of Hours.[1] While no immediate model has survived, we do have a number of copies of a Carrying of the Cross that support this thesis. Enough similarities exist between, for example, a Carrying of the Cross from the Turin Book of Hours,[2] a Netherlandish copy from the late fifteenth century[3] and another copy in Budapest from the sixteenth century[4] to allow us to presuppose a common source, to which the Albertina drawing would be distantly related. A painted copy in the Suermondt-Museum in Aachen, which corresponds to the Albertina drawing in many of the figure details, would also be derived from this common source.[5]

A small silverpoint drawing, including the mounted procession only, proves that the Budapest copy is the closest to the lost Eyckian original.[6] F. Saxl was able to show that the Eyckian source for all these works must have been an important composition, which itself would have been derived from precursors in the Italian trecento.[7] The Albertina copy does not reproduce the prototype, as is assumed elsewhere, rather it copies a later work from around the middle of the fifteenth century that had already altered the prototype.[8] Therefore, it is an important, modified reflection of the lost composition by the Van Eyck brothers that exerted great influence for more than a century. "Based upon the grand, epic tradition of the Trecento it was able to stimulate the imaginations of Schongauer, Dürer and Raphael,"[9] and was also able to point the way

for a development which, via L. v. Leyden, C. Massays, F. Aertsen, led to Pieter Bruegel the Elder's large *Carrying the Cross.*[10]

E. Panofsky thought the drawing was a free copy of a painting by Jan van Eyck. O. Benesch attempted to attribute the model, deriving from the Eyckian prototype, to a Dutch artist, perhaps from the circle of Ouwater, while Winkler traced the drawing back to a lost work by Jean Fouquet.[11] In the last analysis, the repetitions, for all their similarities, point to two different source compositions; thus, the possibility that there were two versions of the Carrying of the Cross theme from the circle of the Van Eycks is feasible. Given the trecentesque elements of the Albertina sheet, it would reflect the earlier version of the theme.

In the Albertina drawing the area towards which Saint Veronica turns to show Christ's sudarium was left unfinished. Panofsky convincingly argued that a group of three Marys completed the composition,[12] thereby interrelating the turn of Christ's head, Veronica's pose and the gesturing hand of the man at the left. The consistent and careful application of the crossed lines, short strokes and dots, one might even say their "measuring out," reveals a system. Point and line seem to ripple across the surface, producing the loose texture of the graphic form. Based on this method of drawing, which Benesch considered typical of the years around 1450/60, he recognized the Louvre's *Fall of the Damned* (also a copy of an older model that was derived from a composition of the Van Eycks) as being from the same hand.[13] Winkler, on the other hand, considered this specific manner of drawing to be typical of Pieter Bruegel the Elder and, therefore, dated the drawing c.1559/60. (Boon, Grossman, Tolnai and later Benesch, in an oral opinion, agreed with this view.) F. Anzelewsky, however, rejected this, arguing, correctly in my view, that the drawing technique did not justify such a conclusion because it could be found not only in Bruegel but among artists of the second half of the fifteenth century, particularly Hugo van der Goes.[14]

In all fairness we must admit that art historical scholarship, especially in the area of early Netherlandish drawing where even the few surviving drawings can hardly be attributed with

any certainty, is not yet in a position to offer satisfactory solutions to the problems posed by this drawing. *F.K.*

Notes

1. F. Winkler "Über verschollene Bilder der Brüder van Eyck," *Jahrbuch der Königlich preussischen Kunstsammlungen* 37 (1916), p. 287 ff.
2. Ibid., fig. 4.
3. Ibid., fig 3. The painting is now in the Metropolitan Museum of Art, New York, New York.
4. Ibid., fig. 1.
5. G. J. Kern, *Die verschollene "Kreuztragung" des Hubert oder Jan van Eyck* (Berlin, 1927), fig. 2.
6. F. Winkler, *Jahrbuch der Königlich preussischen Kunstsammlungen,* fig. 2.
7. F. Saxl, 1926, "Studien über Hans Holbein d.J., I, Die Karlsruher Kreuztragung," *Belvedere* 9 (1926), p. 139 ff.
8. Benesch 1964, Meisterzeichnungen, no. 123.
9. E. Panofsky, *Early Netherlandish Painting* (Cambridge, Massachusetts, 1966), p. 237.
10. R. Genaille, "La Montée au Calvaire de Bruegel, l'Ancien," *Jaarboek van het Koninglijk Museum voor Schone Kunsten* (Antwerp, 1979), p. 143.
11. F. Winkler, "Die Wiener Kreuztragung," *Nederlands Kunsthistorisch Jaarboek* 9 (1958), p. 83 ff.
12. E. Panofsky, "Rezension zu: G. J. Kern" *Kritische Berichte zur kunstgeschichtlichen Literatur,* 1/2 (Leipzig, 1927–29), p. 74 ff, fig. 5.
13. O. Benesch "Über einige Handzeichnungen des 15. Jahrhunderts," *Jahrbuch der Königlich preussischen Kunstsammlungen* 46 (1925), p. 181 ff.
14. F. Anzelewsky et al, comps., *Pieter Bruegel d.Ä. als Zeichner* (Berlin: Staatliche Museen, preußischer Kulturbesitz, 1975), no. 178.

22b. Netherlandish, mid-sixteenth century
Christ on the Way to Calvary
Museum of Fine Arts, Budapest

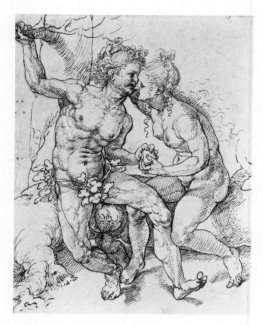

Jan Gossaert, called Mabuse
Maubeuge 1478/88–1532 Unknown

The earliest mention of Gossaert as a master in the guild of St. Luke in Antwerp is in 1503. From 1508 to 1510 he accompanied Philip of Burgundy on his trip to Rome. In 1509 he was in Middelburg, where, before 1516, he painted the altarpiece for the Premonstratensine Abbey among other works. In 1516 Philip of Burgundy commissioned Gossaert to paint the decorations for Souburg Castle with Jacopo de' Barbari; he also worked in the castle of Wijk bij Duurstede for Philip of Burgundy. In 1523 he was briefly active at the court of Margaret of Austria in Mechelen. Gossaert returned to Middelburg, probably in the service of Adolf of Burgundy, in 1525. Around 1525 he executed commissions for Christian II of Denmark; 1526/28 designed the tomb of Christian II's wife, Isabella of Austria. Gossaert is considered one of the first "romanists" in Netherlandish art.

23

THE FALL OF MAN
Pen and dark brown ink; 25.7 × 21.0 cm;
inv. 13.341, N.36
Inscribed "Get (ekend) den 6./1525" at left center, very faded (autograph?), "MB" below this

Provenance: Duke Albert of Saxe-Teschen, L.174

Bibliography: Schönbrunner-Meder, no. 1189; E. Weiss, *Jan Gossaert, genannt Mabuse*, Parchim i.M., 1913, p. 31, 35–38; Alb.Cat. II, 1928, N.36; W. Krönig, *Der italienische Einfluß in der flämischen Malerei im ersten Drittel des 16. Jahrhunderts*, Würzburg, 1936, p. 75; J. Folie, "Les dessins de Jean Gossaert dit Mabuse," *Gazette des Beaux-Arts* 38, no. 93 (1951), p. 85, no. 17; H. Schwarz, "Jan Gossaert's Adam and Eve Drawings," *Gazette des Beaux-Arts* 42, no. 95 (1953), p. 156 ff; Benesch 1964, Meisterzeichnungen, no. 127; H. Pauwels, H. R. Hoetink and S. Herzog, comps., *Jan Gossaert genaamd Mabuse*, Museum Boymans-van Beuningen, Rotterdam/ Groeningemuseum, Brugges, 1965, no. 61.

The theme of the Fall of Man occupies an important place in Gossaert's oeuvre, which also includes Madonnas, portraits and mythological nudes. The earliest examples, dating from 1510/11, were clearly inspired by Dürer and follow the Gothic tradition of showing the first man and woman standing.[1] Later Gossaert depicted Adam and Eve, seated across from one another or reclining, with an increasing emphasis on the erotic element and Eve's role as seducer.[2] Italian art, prints of which were available long after Gossaert's journey to Italy, played an important role in this development. The Albertina sheet, first ascribed to Gossaert by Meder, is generally assigned to the late representations (c.1525) of Adam and Eve, which are characterized by mannered and overcomplicated twisting poses of seated or half-reclining figures.[3] Several authors have noted the resemblance between Gossaert's dynamic drawing style, with its rounded modeling lines, and that of Dürer, who had been in The Netherlands in 1520/21.[4] Krönig points to the similarity of Adam to Gossaert's etching, *Man of Sorrows*,[5] which seems to have been derived from models in Dürer and Marcantonio Raimondi.[6] For Krönig, Eve's *contraposto* pose is also evidence of Marcantonio's influence.[7]

The possibility that the Albertina sheet might be a preparatory drawing for an unexecuted woodcut (first suggested by E. Weiss and later by H. Schwarz)[8] was rejected by the Rotterdam exhibition catalogue, which describes the drawing as "perhaps a first sketch for an unexecuted or lost painting." It is argued that such a woodcut would show Adam to the right of Eve, an arrangement unknown in Gossaert's other versions of the Fall of Man. It is, however, also admitted that the left-handedness of the figures in the drawing remains an unsolved problem. The possibility of a link to a woodcut should not be wholly excluded. Such a link could be supported not only by the left-handedness but also by the rhythmic and animated linear structure, which never wholly fuses, and the even, unmodulated contours; we can find similar instances in Dürer.[9] Moreover, our drawing may well be compared with *Hercules and Deianira*,[10] a woodcut by Gossaert. The detailed similarities of the motif, the hatchings that form light and shade and the handling of the outline attest to the closeness between the drawing and the woodcut.

The correction to Adam's right leg has been noted many times. The Rotterdam exhibition catalogue was the first to record the erroneously represented right hand. This and other anatomical imperfections do not impair the drawing's quality and intimate mood. They are typical of Gossaert, the transitional artist between late Gothic traditions and "romanism." M.B.-P.

Notes

1. See the painting (c.1510) in the Thyssen-Bornemisza Collection, Castagnola, Switzerland (cf. Dürer, B.1); F. Anzelewsky, M. Mende and P. Eeckhout, comps., *Albert Dürer aux Pays-Bas* Brussels: Palais des Beaux-Arts, 1977), no. 350; see the Malvagna triptych (after 1511) in Palermo, (cf. Dürer, B.17).
2. On the development of the Fall of Man theme in contemporary prints, see L. Silver and S. Smith, "Carnal Knowledge, The Late Engravings of Lucas v. Leyden," *Nederlands Kunsthistorisch Jaarboek* 29 (1978), p. 245 ff.
3. The painting is in Schloss Grunewald, Berlin, and the black chalk cartoon is in the Museum of Art, Rhode Island School of Design, Providence (Folie, no. 18); see W. Robinson entry in D. J. Johnson, *Old Master Drawings from the Museum of Art* (Providence, Rhode Island: Rhode Island School of Design, 1983), no. 73; the pen drawing in the Städel'sches Kunstinstitut, Frankfurt (Folie, no. 13).
4. There is no record of a meeting between the two artists. See J. Veth and S. Müller, *Albrecht Dürers Niederländische Reise* II (Berlin/Utrecht, 1-18), p. 217–18.
5. Hollstein VIII, no. 1.
6. Dürer (B.4, B.16), Marcantonio (B.345).
7. Marcantonio (B.39).
8. Schwarz: as a pendant to Gossaert's *Cain and Abel* woodcut; Hollstein VIII, no. 4.
9. For example *The Visitation* (D.55) or *Adam and Eve* (D.98), Albertina Collection, Vienna.
10. Hollstein VIII, no. 5.

Pieter Bruegel The Elder
Breda (?) 1525/30–1569 Brussels

In 1550/51 Bruegel worked in Mechelen with Peter Baltens on a commissioned altarpiece. He was admitted to the painters' guild in Antwerp in 1551. Presumably shortly thereafter, he traveled through France to Italy as far as Messina. In 1553 the artist met the miniature painter G. Clovio in Rome. He returned to Antwerp via Switzerland. From 1555 Bruegel produced drawings for Hieronymus Cock's Antwerp engraving house. He began dating his paintings in 1557. In 1563 he married Mayken, the daughter of Pieter Coecke van Aelst, and moved to Brussels. His son Pieter (the Younger) was born in 1564/65, Jan (the Elder), 1568.

24

SPRING
1565
Pen and bistre ink, 22.1 × 28.9 cm; inv. 23.750, N.83
Signed and dated "MDLXV BRUEGEL" lower right; inscribed "de lenten Mert April Meij"

Provenance: Max Strauss, no. 18; Gottfried Eissler; acquired from Eissler in 1924

Bibliography: K. Tolnai, *Die Zeichnungen Pieter Bruegels*, Munich, 1925, p. 35/6, no. 48; Alb.Cat. II, 1928, N.83; F. Novotny, *Die Monatsbilder Pieter Bruegels des Älteren*, Vienna, 1948, p. 3 ff, 33; E. van der Vossen, "De 'Maandenreeks' van Pieter Bruegel den Ouden," *Oud-Holland 66* (1951), p. 111 ff; Ch. de Tolnay, *Die Zeichnungen Pieter Bruegels*, Zurich, 1952, p. 31–32, no. 67; L. Münz, *Bruegel Drawings*, London, 1961, no. 151.

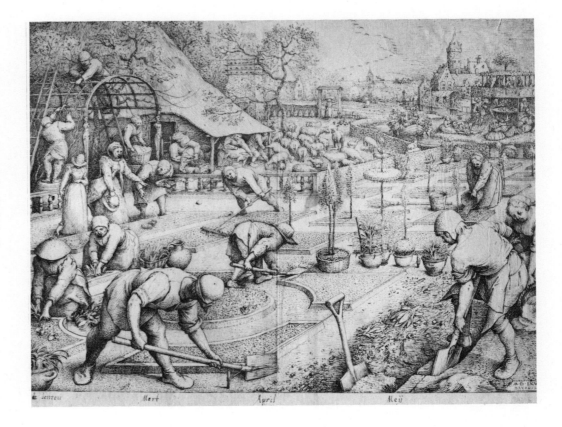

This sheet belongs to a series of Four Seasons, which Hieronymous Cock published in 1570. Of the four scenes Bruegel only completed *Spring* (1565) and *Summer* (1568) before his death in 1569.[1] Hans Bol's compositions of *Autumn* and *Winter* completed the set, the engravings of which are attributed to Pieter van der Heyden (Hollstein IX, no. 63–66; the print of *Spring* carries van der Heyden's monogram).

Bruegel's drawings of *Spring* and *Summer* carry on the medieval tradition of the Book of Hours, in which the countryman's labors are the focus of attention; perhaps the publisher's commission was decisive in this. In his contemporary paintings of the seasons, on the other hand, the landscape is more important.[2] Bruegel's *Spring* treated the traditional concept of the cycle of the seasons in a very personal way — by "uniting work in the garden and in the fields, shearing sheep and the joys of spring in a curiously divided juxtaposition in one single landscape space," in which "the temporal sequence of spring's labors unfolds in spatial succession."[3] The monumentally three-dimensional figures in the foreground are typical of Bruegel's compositions dating from 1565. The remaining figures are reduced dramatically in size as they recede into the background along a diagonal line; this design element was used more freely and to a greater extent three years later in *Summer*. This and other characteristics Bruegel employed, such as the *contraposto* pose of the figures, are usually ascribed to Italian influence. The decisive influences on Bruegel's work, however, have not been clearly identified. Tolnay believes that the foreground figure at the right in *Spring* was inspired by Michelangelo's digging Noah in the Sistine Chapel.[4] *M.B.-P.*

Notes
1. Kunsthalle, Hamburg. See C. Malke in *Pieter Bruegel der Ältere als Zeichner* (Berlin: Staatliche Museen Preussischer Kulturbesitz, Kupferstichkabinett, 1975), no. 106, fig. 137.
2. Cf. *Dark Day*, *The Return of the Herd, Hunters in the Snow*, Kunsthistorisches Museum, Vienna; *Hay Harvest*, National Gallery, Prague; *Wheat Harvest*, Metropolitan Museum of Art, New York. *Flämische Malerei von Jan van Eyck bis Pieter Bruegel, d.A.*, entries by K. Demus (Vienna: Kunsthistorisches Museum, 1981), p. 86 ff.
3. F. Novotny, *Die Monatsbilder Pieter Bruegels des Älteren*, (Vienna, 1948), p. 33.
4. Ch. de Tolnay, *Die Zeichnungen Pieter Bruegels* (Zurich, 1952), p. 31–32.

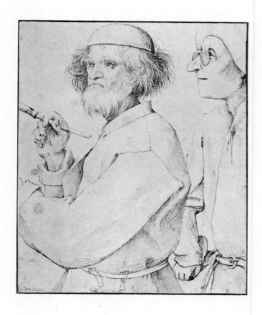

25

PAINTER AND CONNOISSEUR

Pen and bistre ink; 25.5 × 21.5 cm; inv. 7.500, N.84

Signed BRUEGEL in light bistre ink by another hand at lower left; the same ink used to strengthen the pupils of the painter's eyes

Provenance: Duke Albert of Saxe-Teschen; 1822 Estate inventory, p. 515; L.174

Bibliography: A. Romdael, "Pieter Brueghel der Ältere und sein Kunstschaffen," *Jahrbuch der Kunsthistorischen Sammlungen des Allerhöchsten Kaiserhauses* 25 (1904/05), p. 147; R. van Bastelaer and H. De Loo, *Pieter Bruegel l'Ancien, son oeuvre et son temps*, Brussels, 1907, p. 201 ff, no. 104; K. Tolnai, *Die Zeichnungen Pieter Bruegels*, Munich, 1925, p. 71, 88, no. 83; Alb.Cat. II, 1928, N.84; G. Jedlicka, *Pieter Bruegel, der Maler in seiner Zeit*, Erlenbach-Zurich/Leipzig, 1938, p. 278 ff; Ch. de Tolnay, *Die Zeichnungen Pieter Bruegels*, Zurich, 1952, no. 118; O. Benesch, review of Charles de Tolnay's "Die Zeichnungen Pieter Bruegels," *Kunstchronik* 6 (1953), p. 180; C. G. Stridbeck, "Der Maler und Kenner," *Bruegelstudien*, Stockholm Studies in History of Art 2, Acta Universitatis Stockholmiensis, Stockholm, 1956, p. 15–42; M. Auner, "Pieter Bruegel, Umrisse eines Lebensbildes," *Jahrbuch der Kunsthistorischen Sammlungen in Wien* 52 (1956), p. 102; O. Benesch, "Zur Frage der Kopien nach Pieter Bruegel," *Bulletin des Musées Royaux des Beaux-Arts* 8 (1959), p. 35 ff; Ch. de Tolnay, "Remarques sur quelques dessins de Bruegel l'Ancien et sur un dessin de Bosch recemment reapparus," *Bulletin des Musées Royaux des Beaux-Arts* 9 (1960), p. 6 ff; L. Münz, *Bruegel Drawings*, London, 1961, no. 15, p. 26; O. Benesch 1964, Meisterzeichnungen, no. 138; O. Benesch, "Soul and Mechanism of the Universe," *The Art of the Renaissance in Northern Europe* (rev. ed., first published in 1945), London, 1965, p. 8; W. Stechow, *Pieter Bruegel the Elder*, New York, n.d. [1970], p. 46 ff; E. H. Gombrich, "The Pride of Apelles: Vives, Dürer and Bruegel," *Album Amicorum J. G. van Gelder*, The Hague, 1973, p. 132–34 (republished: "The Heritage of Apelles," *Studies in the Art of the Renaissance*, Oxford 1976, p. 133–34); *Pieter Bruegel der Ältere als Zeichner* (F. Anzelewsky's entry) Berlin, Staatliche Museen Preussischer Kulturbesitz, Kupferstichkabinett, 1975, no. 95.

The meaning of this drawing, whose enigmatic and unconventional character has led to many different interpretations, may to a certain extent be deduced directly from the image itself[1]: the great distance between the world of the artist and the world of the client is clearly established through the contrasts of expression, dress and activity between the two figures. Whether Bruegel depicted himself in the figure of the painter is uncertain; opinions range from a self-portrait (Auner), an idealized self-portrait (Jedlicka) or a spiritual self-portrait (Stechow) to an apotheosized portrait of Hieronymous Bosch (Benesch) and a personification of painting (Stridbeck).[2] Several authors refer to the similarity between the connoisseur and figures in Bosch's painting, *The Juggler*.

The possibility that the figure of the painter could have developed in two separate phases has hitherto not been considered. Apart from the unclear spatial relationship between the two figures — the painter is in front of the client, but the latter's head seems closer to the spectator — there is also a discrepancy in perspective between the head and upper body of the painter; furthermore, these two parts of the body are drawn differently. The carefully executed head seems to be viewed from a distant, relatively low vantage point, whereas the vividly drawn upper body was clearly observed close up and more from above. It is conceivable that Bruegel used himself as the model, seated in front of a mirror, resting his right elbow (with the drawing hand invisible) and holding the brush in his left hand. The hip area would then have been added from memory, which may account for the somewhat flat, mechanical execution in this part of the drawing. The discrepancy in perspective between the painter's head and torso apparently became a problem when rendering the neck because the relatively undifferentiated handling and somewhat forced and uncertain contours do not create a fully convincing organic link between the two parts of the body. It remains unclear which part came first, the head or the body. Equally unresolved is the question of whether the head is to be seen as a self-portrait by Bruegel or a model representing the prototype of the otherworldly, spiritual artist.

The possibility that the sheet was trimmed at a later date has been the subject of lengthy discussions. F. Anzelewsky believes that two of the four copies of this drawing (J. Savery, Münz no. A 45 and the drawing in the Korda Collection, London, Münz no. A 46) show it in its original, uncropped state.[3] This supposition, as far as the lower margin is concerned, is refuted by the fact that the visible contours of the artist's clothing in the original would spread to an improbable width, were they continued as in the copies. In order to enable the body to be extended downwards, Savery has therefore narrowed the waist and has made the rear of the garment fall at a steeper angle. (Contrary to current opinion the Korda sheet is, in fact a copy after the Savery drawing, not after the original, as shown by its pedantic repetition of passages that differ from the original.[4]) The Savery drawing's extension of the composition upwards is also not very convincing; the figure of the connoisseur gets lost in empty space, while the cropping of his head in the original anchors the composition and mitigates the aforementioned confusion in the spatial arrangement. Therefore, the Hoefnagel copy (Münz no. A 47), which is closest to the Bruegel prototype,[5] shows only slightly more on the upper, lower and right edges and may perhaps reflect the original composition, while the copy in the British Museum[6] reproduces the image as it is today.

Ever since the *Naar het leven* drawings were excluded from Bruegel's oeuvre, the value of the *Painter and Connoisseur* (mostly dated 1565 or a little later) as a unique monumental figure composition and character study has increased further. In its physiognomical perceptiveness, the sheet would have been comparable to Bruegel's lost drawings for the series of etched peasant heads (1564–65).[7] In its blocklike isolation and its masterfully handled light, the figure of the painter comes very close to the figures in the *Beekeepers* drawing (1568).[8] Of the late, large-figured paintings, the subject of *The Misanthrope*[9] is particularly related to the Albertina drawing: for both main figures, which are even physiognomically similar, the negative, purely financial relationship to the world is personified in a contrasting figure.

M.B.-P.

Notes

1. The most comprehensive review of the literature has been undertaken by F. Anzelewsky in *Peter Bruegel der Ältere als Zeichner*.
2. M. Auner, "Peter Bruegel, Umrisse eines Lebensbildes," *Jahrbuch der Kunsthistorischen Sammlungen in Wien* 52 (1956), p. 102; G. Jedlicka, *Pieter Bruegel, der Maler in seiner Zeit* (Erlenbach-Zurich/Leipzig, 1938), p. 278 ff; W. Stechow, *Pieter Bruegel the Elder* (New York, n.d. [1970]), p. 46 ff; O. Benesch 1964, Meisterzeichnungen, no. 138; C. G. Stridbeck, "Der Maler und Kenner," *Bruegelstudien*, Stockholm Studies in History of Art 2 (Stockholm: Acta Universitatis Stockholmiensis, 1956), p. 15–42.
3. All four copies are illustrated together in L. Münz, *Bruegel Drawings* (London, 1961), fig. 196–99; see also O. Benesch, "Zur Frage der Kopien nach Pieter Bruegel," *Bulletin des Musées Royaux des Beaux-Arts* 8 (1959) and Ch. de Tolnay, "Remarques sur quelques dessins de Bruegel l'Ancien et sur un dessin de Bosch recemment reapparus," *Bulletin des Musées Royaux des Beaux-Arts* 9 (1960).
4. Tolnay's opinion that the Korda sheet is Bruegel's own repetition of the Albertina drawing is generally disputed today. Ch. de Tolnay, *Die Zeichnungen Pieter Bruegels* (Zurich, 1952).
5. M. Winner, *Pieter Bruegel der Ältere als Zeichner* (Berlin: Staatliche Museen Preussischer Kulturbesitz, Kupferstichkabinett, 1975), no. 96, fig. 128.
6. L. Münz, *Bruegel Drawings*, no. A 48; recently attributed to Rubens, see M. Jaffé, "Rubens and Bruegel," *Pieter Bruegel und seine Welt* (Berlin, 1979), p. 41 fig. 17.
7. Cf. K. Oberhuber, "Pieter Bruegel und die Radierungsserie der Bauernköpfe," *Pieter Bruegel und seine Welt* (Berlin, 1979), p. 147.
8. *Beekeepers*, Kupferstichkabinett, Berlin; *Pieter Bruegel der Ältere als Zeichner*, no. 100, fig. 131.
9. *The Misanthrope*, Museo Nazionale, Naples; W. Stechow, *Pieter Bruegel the Elder*, pl. 42.

Hendrick Goltzius
Mühlebrecht near Venlo 1558–1617
Haarlem

Goltzius received his first artistic training from his father, the glass painter Jan Goltz. Around 1575 he was apprenticed to Dirck Volkertsz Coornhert (1522–1590) in Xanten to learn engraving. After both had moved to Haarlem in 1576/77, Goltzius' first dated engravings were published by Philip Galle; from 1582 Goltzius published his prints himself. Karel van Mander introduced him to the drawings of Barthomeus Spranger. He finally broke with the extreme mannerism of the 1580s after his journey to Italy in 1590/91. Perhaps because of an eye problem, he gradually gave up engraving after 1600; around 1600 he completed his first paintings. Goltzius was famous above all as an engraver, but he also left a multifaceted and extensive drawing oeuvre as well as a smaller number of paintings.

26

SELF-PORTRAIT
Black and colored chalks, white bodycolor and watercolors; 43.0 × 32.2 cm; inv. 17.638, N.375
Monogram "HG" (linked) at center left

Provenance: D. Muilman; C. Ploos van Amstel, L.2034; Duke Albert of Saxe-Teschen; 1822. Estate inventory, p. 534; L.174

Bibliography: Alb.Cat. II, 1928, N.375; E. K. J. Reznicek, *Die Zeichnungen von Hendrick Goltzius*, Utrecht, 1961, K 256, p. 122 (vol. I), A 362 (vol. II); Benesch 1964, Meisterzeichnungen, no. 142.

26a. Hendrick Goltzius
Detail from *The Circumcision*
Albertina Collection, Vienna

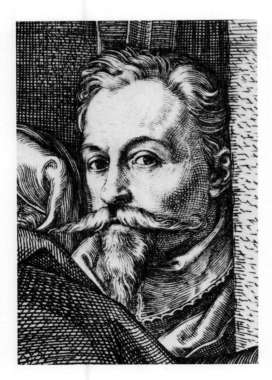

Goltzius occupies an outstanding place in the history of the Netherlandish portrait. His early portraits, both the miniaturelike metalpoint drawings and engravings, from the late 1570s and 1580s reveal his talent at expressing the qualities of materials and tonal values, while simultaneously capturing the individuality of his sitters. The portraits from the Italian journey, executed in two or more colored chalks with lightly brushed washes, show the influence of artists like F. Zuccaro, F. Barocci and the Carraccis (1590/91).

The self-portrait from the Italian period (Reznicek K 255) has the same pose of the head, in reverse, as the Albertina's self-portrait, which Reznicek dated almost a decade later.[1] A date of c.1600[2] for this sheet, however, raises a number of questions. Admittedly, the drawing in Vienna does not have the immediacy of expression or the dramatic chiaroscuro of the Stockholm self-portrait; but, in spite of the more mature appearance and the distanced pose, it does not seem as far removed from the latter as it is from the small metalpoint self-portrait of 1605 (Reznicek K 257), with which it has been connected. However, in the presentation of the self, the Vienna drawing shows a striking resemblance, even down to the same bald spots in the hair, to the small self-portrait that Goltzius included in the background of his 1594 engraving *The Circumcision* (Hirschmann, no. 12).[3] The individual mixture of softness and sharp precision in the Vienna self-portrait does not comport well with the painterly style of the often proto-baroque chalk portraits from after 1600. Reznicek states that the drawing's style follows the "rich colorfulness" of Goltzius' portraits from the early 1590s. The supposition that this drawing may indeed date from this time is further reinforced by the comparison with Goltzius' portrait of his stepson and pupil, Jacob Matham (1592, Reznicek K 279).[4] Common to both is the use of partially rubbed chalks and their combination with watercolors, particularly in the hair, ears and eye areas, the background and in the treatment of the ruff and jerkin. Nevertheless, the self-portrait is far superior to the portrait of Jacob Matham both in expression and in coloristic subtlety. The carefully modeled, seemingly transparent face and the white ruff around the neck as a supporting element in the composition, are of especially high quality.

The drawing's provenance from the collection of Ploos van Amstel could raise the question as to whether the latter might have reworked parts; this is, for example, known in the case of the portrait *Styntje van Poelenburg* (Reznicek K 350), in which Ploos added the green background.[5] A close inspection, however, convincingly shows that the background watercolors, especially where they lie under chalk and brush strokes, (e.g., under the monogram or in the hair silhouette) form an integral and inseparable part of the materials. The medallionlike format, unique as far as is known in Goltzius' chalk portraits, with its background of various tonal gradations, finds parallels in his printed oeuvre from the beginnings up into the 1590s. This manner of presenting the sitter as if in front of a metallic, gleaming oval niche was often used by portraitists, especially in the seventeenth century. In Goltzius' case it may be connected with its original function in his work as a designer of precious metal reliefs.[6] An example of this kind, the engraved portrait of Hans Bol from 1593 (Hirschmann, no. 177) is close to the Albertina self-portrait in the side view of the shoulder, the

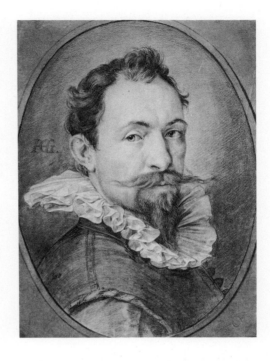

angle of the head, the treatment of the ruff and the expression. The portrait of Coornhert (1591, Hirschmann, no. 180),[7] also enclosed like a medallion, parallels the self-portrait in an unusually large format, but is more similar to the Italian portrait drawings of 1590/91 in its strongly three-dimensional chiaroscuro. Still open is the question of whether our drawing was used for an engraving or was created as an independent work of art for some official purpose. *M.B.-P.*

Notes
1. E. K. J. Reznicek, *Die Zeichnungen von Hendrick Goltzius* (Utrecht, 1961), p. 122.
2. If the possibility that this is an idealizing self-portrait is set aside, the healthy appearance of the figure in the drawing can hardly be reconciled with the artist's exremely critical condition around 1600. Cf. the "Sieck-troostig klinck-dicht" of his artist friend Cornelis Ketel, quoted in E. K. J. Reznicek, "Het begin van Goltzius' loopbaan als Schilder," *Oud Holland* 75 (1960), p. 31. In the portrait of Goltzius by C. Ketel, dated 1601 (Boymans Museum, Rotterdam, inv. 1431; cf. G. J. Hoogenwerf, *De Noord-Nederlandse Schilderkunst*, IV, The Hague, 1941/42, fig. 313), the artist seems older, less lively. Otherwise, this painting has very little in common with the self-portrait drawing, other than the composition, upon which to draw any conclusions about dating.
3. O. Hirschmann, *Verzeichnis des graphischen Werks von Hendrick Goltzius* (Leipzig, 1921). Lawrence W. Nichols kindly brought this resemblance to my attention.
4. The inscription "AETAT.21" indicates that the portrait was done in 1592 because J. Matham was born on October 15, 1571. The identical provenance of the two sheets (D. Muilman, auction Amsterdam, 1773, livre C, no. 162, cf. Reznicek, K 256, 279) may point to an even earlier historical connection.
5. My thanks to Lawrence W. Nichols for his valuable remarks.
6. Cf. the *Bust of a 38-Year-Old Man*, Reznicek, *Die Zeichnungen von Hendrick Goltzius*, K 335.
7. O. Hirschmann, *Verzeichnis des graphischen Werks von Hendrick Goltzius* (Leipzig, 1921), no. 180.

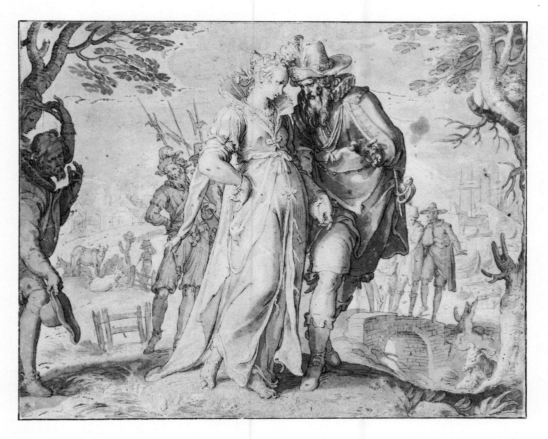

Joachim Antonisz. Uytewael
Utrecht 1566–1638 Utrecht

Son and pupil of the glass painter Antonis Jansz. Uytewael. Apprenticed to J. de Beer at eighteen. At twenty met the Bishop of St. Malo in Padua, with whom he traveled through Italy for two years and subsequently spent two years in France before returning to Utrecht. In 1592 he became a member of the saddler's guild. He managed a flax and linen business. Uytewael designed the first of the famous windows of the St. Jans church in Gouda in 1595. In 1611 he was a member of the guild of St. Luke. An important representative of Utrecht late mannerism, of which the leading master was A. Bloemart. The majority of Uytewael's paintings and drawings focus on mythological and religious subjects.

27

THE RECEPTION OF THE PRINCESS

Pen and ink, gray wash, heightened with white: 19.0 × 24.3 cm; inv. 8.161, N.412
Signed and numbered "Jo wte wael/1" lower center

Provenance: Charles Prince de Ligne, L.592; Duke Albert of Saxe-Teschen; 1822 Estate inventory, p. 542; L.174

Bibliography: Bartsch 1794, p. 192, no. 4; Alb.Cat. II, 1928, N.412; C. M. A. A. Lindeman, *Joachim Antonsz. Wtewael*, Utrecht, 1929, p. 129, 131, 157, no. 7; E. McGrath, "A Netherlandish History by Joachim Wtewael," *Journal of the Warburg and Courtauld Institutes* 38 (1975), p. 182–183, 191–93; K. G. Boon, *Netherlandish Drawings of the Fifteenth and Sixteenth Centuries*, II, Rijksmuseum, Amsterdam/The Hague, 1978, under no. 503.

A festively attired young woman with a wreath of flowers is being led by the hand by a nobleman wearing the Order of the Golden Fleece, who flatters and cajoles her. At the right, ships in the harbor are being unloaded and small fishing boats are visible. A group of soldiers is following the elegant couple, and behind them is another group with a nobleman or merchant and a fisherman. In the background at left farmhouses with cows in the meadows can be seen. At the left foreground stands a couple giving a respectful greeting.

This sheet is one of six drawings in the Albertina Collection from an allegorical series by Uytewael. The iconography of the series was unclear in 1928 when the Albertina Catalogue II was published; in 1929 Lindeman was unable to definitely explain its content, but suspected that the series was concerned with events at the beginning of the Eighty Years War. The gradual emergence of other sheets in the series, both in the original and in copies, has made recent reconstructions and interpretations easier[1]; the majority of the thirteen sheets that have so far come to light are signed and ten are numbered.

The major differences in opinion revolve around the authenticity and the meaning of the series. McGrath doubts that the third sheet is autograph and thinks the second (Rijksprentenkabinet, Amsterdam) is a replica of the drawing in the Daniels Collection, New York[2]; Boon, on the other hand, believes the New York drawing to be a copy of the one in Amsterdam.[3] Boon further believes that the series portrays the events from the arrival of Duke Alba (1567) until the twelve-year armistice with Spain (1609/21); McGrath, however, is convinced that the beginning of the Duke of Alba's reign of terror, in accordance with historical sequence, is not represented until the fourth episode, after the scene of the nobles' petition to Margaret of Parma (1566).[4] On this theory, the nobleman in our drawing, the first in the series, cannot be Alba, as Boon believes. McGrath sees this figure as the personification of the House of Hapsburg, which was then trying to gain control of the as yet undivided Netherlands — at first by flattery but soon thereafter by military power (the soldiers in the nobleman's

retinue) so as to get possession of their wealth (hence the references to agriculture, fishing and trade in the background).[5] The Netherlands appears in the form of a young lady — a common iconographic motif at the time — whose troubled fortunes unfold in the subsequent scenes with their changing cast of characters.

In light of the careful execution, the moralizing content and the uniform format of the mostly numbered sheets, the prevailing assumption is that they were intended as models for a series of engravings, which, as far as is known, were not executed. E. McGrath attributes this to political developments and thinks that the designs, dated on stylistic grounds between 1605 and 1608 by Lindeman, were drawn after the signing of the armistice (1609); the planned series would then have been a warning against a compromise with Spain and at the same time propaganda for the militant, Calvinist and patriotic policies of Prince Maurits von Oranien, whom Uytewael, as a member of the city council, actively supported in 1610.[6] However, after this short period of ascendancy for the rebel party which he preferred, the more moderate Remonstrants were again dominant in his city.

McGrath points out the uniqueness of this series of drawings in Netherlandish art of the time and notices that the expressive liveliness of the figures benefited from the series' confessional character. Their manneristic features are not, as in most of the works by Uytewael, joined with a certain superficiality. In its charm and elegance of execution, the Albertina drawing may definitely be considered one of the best of the series.

M.B.-P.

Notes

1. E. McGrath, "A Netherlandish History by Joachim Wtewael," *Journal of the Warburg and Courtauld Institutes* 38 (1975), p. 182–217; K. G. Boon, *Netherlandish Drawings of the Fifteenth and Sixteenth Centuries*, II (Rijksmuseum, Amsterdam/The Hague, 1978), no. 501–03.
2. E. McGrath, "A Netherlandish History," p. 189, fig. 26a (no. 3), p. 182–83, 193–94, fig. 25b (no. 2).
3. K. G. Boon, *Netherlandish Drawings*, no. 501.
4. E. McGrath, "A Netherlandish History," p. 185, fig. 26b.
5. Ibid., p. 192–93.
6. Ibid., p. 209–11, p. 216–17; C. M. A. A. Lindeman, *Joachim Antonsz. Wtewael* (Utrecht, 1929), p. 37.

Rembrandt Harmensz. van Rijn
Leiden 1606–1669 Amsterdam

Rembrandt was born on July 15, 1606, to the miller, Harmen Gerritz. van Rijn, and the baker's daughter, Neeltge van Zuytbrouck. After attending grammar school and a brief stay at the university in Leiden, Rembrandt began a three-year apprenticeship to the Leiden painter, Jacob Isaakz. van Swanenburgh in 1621. He subsequently worked with Pieter Lastman in Amsterdam for six months. Constantijn Huygens visited Rembrandt and Lievens in 1629, when they were probably working in the same studio in Leiden. In 1631 Rembrandt moved to Amsterdam where he married Saskia van Uylenburgh in 1634. The artist prospered. Titus, the artist's fourth child, was born in 1641. Saskia died in 1642. Hendrickje Stoffels is first mentioned in documents in 1649. In 1656 the artist's belongings were officially inventoried because of his increasing financial difficulties. After his goods had been auctioned and sold, Rembrandt moved to the Rosengracht in 1660. Hendrickje Stoffels died in 1663, his son Titus in 1668. The artist died on October 4, 1669.

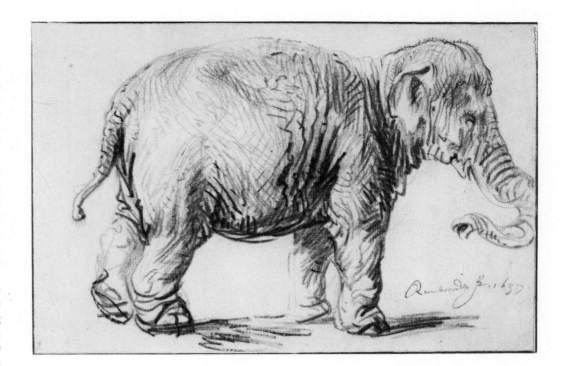

28

AN ELEPHANT
1637
Black chalk, 23.3 × 35.4 cm; inv. 17.558
Signed and dated "Rembrandt fl. 1637" at lower right

Provenance: Duke Albert of Saxe-Teschen; 1822 Estate inventory, p. 601; L.174

Bibliography: Schönbrunner-Meder, no. 263; HdG., no. 1469; Graul 1906, no. 22; Neumann 1919, no. 19; Benesch 1935, p. 28; Amsterdam 1935, no. 42; Benesch 1947, no. 83; Rosenberg 1948, p. 154; Benesch I–VI, no. 457, fig. 515; Stockholm 1956, no. 89; Rotterdam-Amsterdam 1956, no. 67; Alb.Vienna 1956, no. 28; Benesch 1960, no. 27; Benesch 1964, Meisterzeichnungen, no. 170; Rosenberg 1964, ill. 226; Haak 1969, p. 147; Gerson 1969, p. 252; Amsterdam 1969, no. 46; Alb.Vienna 1969/70, no. 12.

Animal scenes were popular in seventeenth-century Dutch art. Rembrandt too dealt repeatedly with the theme in his graphic works. Among the considerable number of animal studies he executed over the years, elephants and lions are the most prominent.

In all, four drawings of elephants by Rembrandt have survived; all probably date from 1637. Two are in the Albertina, one in the British Museum, London, and the last exists only as a counterproof in The Pierpont Morgan Library, New York.[1] An elephant also appears in the paradisical landscape of Rembrandt's 1638 etching *Adam and Eve* and in *Rebecca Leaves Her Parents' House*, a drawing, c.1637, that also contains the exotic dromedary camel.[2]

The Albertina's elephant is a masterpiece of characterization that is not confined to the external appearance of the animal alone. The weight of his body is carried by the light, almost dancing step of the legs; the sensitive outline of the head and the gaze of the eyes reveal wisdom and intelligence. Precise rendering of the light covers the thick, wrinkled skin with a silvery gray shimmer. The artistic representation of the animal's nature and its physical appearance is unexcelled, even though the artist eschews color completely.

An anonymous Dutch engraving of the seventeenth century (Rijksprentenkabinett, Amsterdam) shows an elephant, with a waving flag raised in his trunk, surrounded by a frame containing sixteen small images of other circus tricks performed by the animal. The name of this extraordinary elephant, Hansken, is given by the engraving's inscription, and there is good reason to believe that this is the same animal which Rembrandt eternalized in his drawings.[3] *E.M.*

Notes
1. Benesch I–VI, nos. 457, 458, 459, 460.
2. Benesch I–VI, nos. 435, 453, 454. Two drawings with camel studies were in the Kunsthalle, Bremen.
3. Amsterdam 1969, p. 140, no. 45; L. J. Slatkes, "Rembrandt's Elephant," *Simiolus, The Netherlands Quarterly for the History of Art* 2 (1980), p. 7 ff; P. Schatborn, "Beesten nae't leven," *De Kroniek van het Rembrandthuis* 29 (1977), p. 20 ff.

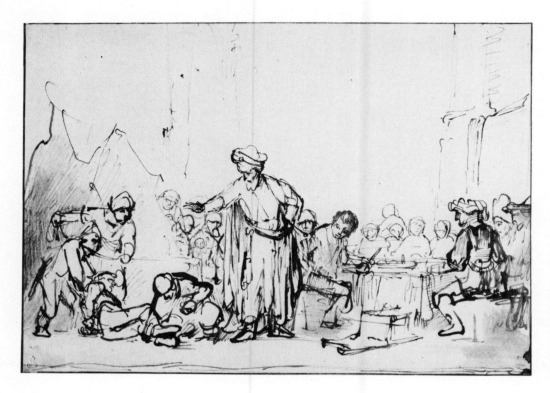

29

THE PARABLE OF THE UNWORTHY WEDDING
GUEST
Pen and bistre ink and wash; 18.3 × 26.5 cm;
inv. 8.802

Provenance: Duke Albert of Saxe-Teschen; 1822
Estate inventory, p. 396; L.174

Bibliography: HdG, no. 1419; Benesch 1935,
p. 42; Benesch 1947, no. 165; Benesch I–VI,
no. 612, fig. 742; Stockholm 1956, no. 120;
Rotterdam-Amsterdam 1956, no. 137;
Alb.Vienna 1956, no. 78; Sumowski 1957/58,
p. 225; Sumowski 1961, p. 13; Scheidig 1962,
no. 91; Alb.Vienna 1969/70, no. 39.

The drawing's subject is the biblical parable of the
royal marriage feast: "... But when the king came
in to look at the guests, he saw there a man who
had no wedding garment; and he said to him,
'Friend, how did you get in here without a
wedding garment?' And he was speechless. Then
the king said to the attendants, 'Bind him hand
and foot, and cast him into the outer darkness;
there men will weep and gnash their teeth.' For
many are called, but few are chosen." (Matthew
22:11–14.)

Rembrandt's Bible illustrations belong to the
realm of history painting. Recent scholarship has
shown them to be largely based on pictorial
tradition,[1] but Rembrandt's personal artistic
achievement is unaffected by this: the psychologi-
cal depth and drama permeating the composition
give Christ's message an unprecedented human
presence. The iconography of the Albertina
drawing, a subject not often represented, is
eloquent testimony of this.

The scene is divided in two groups of figures,
in a manner not unlike the *Hundred Guilder Print*,
an etching completed around 1649 (B.74). The
prominent figure of the king joins both groups,
but belongs entirely with the action of the left-
hand group. With a powerful gesture he pro-
nounces judgment on the unworthy guest, who is
being bound by the servants and thrown to his
damnation. A cavelike shadow circumscribed by
jagged lines suggestively evokes the idea of the
jaws of hell. The protagonists' movements and

gestures are reduced to a few shorthand strokes,
accurate and clear in their expressive forcefulness.
This conciseness in the drawing and the firm
structure of the forms reflect the spiritual con-
centration that characterized Rembrandt's work
at mid-century (Benesch convincingly dates the
drawing to c.1648–49). The dinner guests recede
into the background in contrast with the dramatic
emphasis on the first group. The way they are
arranged and interpreted seem to reflect the art of
Caravaggio, which was one of the most important
sources for Rembrandt's work.

The division of the composition into two halves
of differing formal and interpretive weights and
the contrast of active and passive people can often
be found in Rembrandt's oeuvre.[2] *E.M.*

Notes
1. Ch. Tümpel, "Studien zur Ikonographie der
 Historien Rembrandts," *Nederlands
 Kunsthistorisch Jaarboek* 20 (1969), p. 107 ff;
 Ch. Tümpel, "Ikonographische Beiträge zu
 Rembrandt," *Jahrbuch der Hamburger
 Kunstsammlungen* 13 (1968), p. 95 ff;
 Ch. Tümpel, *Rembrandt legt die Bibel aus*
 (Berlin, 1970).
2. Compare, for example, the drawing of
 c.1640–42 showing the doubting Thomas
 (Benesch I–VI, no. 511a, fig. 673) or the 1652
 etching *Jesus among the Doctors* (B.65).

LANDSCAPE WITH A DRAWBRIDGE
Pen and bistre ink and wash; 15.6 × 28.6 cm;
inv. 8.890
Inscribed "Rembrandt" and "16" (?) lower
right

Provenance: Duke Albert of Saxe-Teschen, L.174

Bibliography: HdG, no. 1487; Schönbrunner-
Meder, no. 688; Alb.Vienna 1936, no. 45;
Benesch I–VI, no. 851 fig. 999; Stockholm 1956,
no. 137; Rotterdam-Amsterdam 1956, no. 147;
Alb.Vienna 1956, no. 31; Scheidig 1962, no. 109;
Chicago 1969, no. 121; Alb.Vienna 1969/70,
no. 40.

This sheet is dated to around 1648–50, in a period
when Rembrandt was intensely involved with
landscape, which led to the zenith of his achieve-
ment in this area in the 1650s. Benesch refers to
the close stylistic parallels of two related drawings
in the Louvre, Paris and the Teyler Museum,
Haarlem,[1] which are perhaps not studies after
nature but free inventions from memory. Similar
compositional structure and graphic vocabulary
may also be found in a landscape study in
Chatsworth.[2]

The canal leads directly into depth. After a
sharp curve to the right a drawbridge, which also
presents its narrow side and is seen as a thorough-
fare, crosses the canal. A figure standing in the
doorway of the adjacent hut is visible. The scene is
further enlivened by figures on the canal and a
group of ducks gliding over and taking off from the
water. This choice of motif as well as the formal
balance reveal the artist's intention of creating
a fully developed pictorial image. Haverkamp-
Begemann has referred to landscape drawings by
Van Borssum and Furnerius, which are based on
Rembrandt's drawing style of that time. His
reading of the number "16" after the pro-
gressively fainter strokes of the inscription
"Rembrandt" is not certain.[3] *E.M.*

Notes
1. Louvre, Paris, Benesch I–VI, no. 848; Teyler
 Museum, Haarlem, Benesch I–VI, no. 849.
2. Chatsworth, Derbyshire, England, c.1648–50,
 Benesch I–VI, no. 1217.
3. Chicago 1969, no. 121; O. Benesch I–VI
 (complete edition in six volumes,
 enlarged and edited by Eva Benesch, London,
 1973), no. 851.

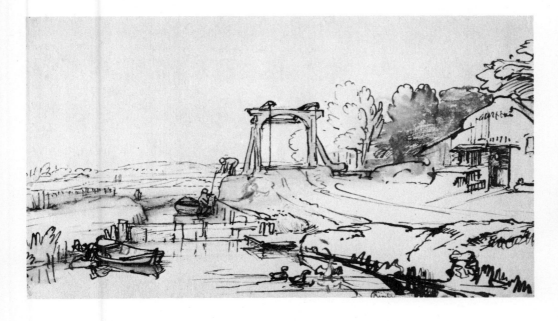

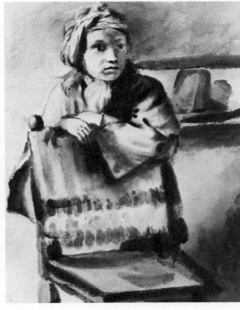

Gerbrand van den Eeckhout
Amsterdam 1621–1674 Amsterdam

Son of the goldsmith Jan Pietersz. van den Eeckhout. From 1635 to 1640 he was a pupil of Rembrandt, who remained a lifelong friend. Earliest independent artistic activity from 1640, the first dated paintings from 1642. Van den Eeckhout was the most versatile artist of the Rembrandt circle; he also executed designs for ornamental engravings and goldsmith work.

31

BOY LEANING ON A CHAIR
Black chalk, brush and bistre wash;
18.2 × 14.7 cm; inv. 9.559

Provenance: Duke Albert of Saxe-Teschen; 1822 Estate inventory, p. 643; L.174

Bibliography: Schönbrunner-Meder, no. 1019; W. Bode and W. R. Valentiner, *Handzeichnungen Altholländischer Genremaler*, Berlin, 1907, no. 40; W. R. Valentiner, "Die Austellung holländischer Gemälde in New York," *Monatshefte für Kunstwissenschaft*, III, 1910, 1, p. 12; E. Plietzsch, *Vermeer van Delft*, Leipzig, 1911, p. 122; A. M. Hind, *Rembrandt and His School*, vol. 1 of *Catalogue of Drawings by Dutch and Flemish Artists Preserved in the Department of Prints in the British Museum*, London, 1915, p. 51; M. Eisler, "Der Raum bei Jan Vermeer," *Jahrbuch der Kunsthistorischen Sammlungen des Allerhöchsten Kaiserhauses* 33 (1916), p. 264–65; J. Kruse, *Die Zeichnungen Rembrandts und seiner Schule im Nationalmuseum zu Stockholm*, The Hague, 1920, p. 70; E. Tietze-Conrat, *Die Delfter Malerschule*, Leipzig, 1922, p. 12, no. 17; B. Reiffenberg and W. Hausenstein, *Vermeer van Delft*, Munich, 1924, p. 28; H. Leporini, *Die Künstlerzeichnung*, Berlin, 1928, p. 247, 403; E. Plietzsch, *Vermeer van Delft*, Munich, 1939, p. 53; P. T. A. Swillens, *Johannes Vermeer, Painter of Delft*, New York, 1950, p. 110, no. 3; W. Sumowski, "Gerbrand van den Eeckhout als Zeichner," *Oud Holland* 77 (1962), p. 20, note 24; Benesch 1964, Meisterzeichnungen, no. 179; W. Sumowski, *Drawings of the Rembrandt School*, vol. 3, New York, 1980, p. 1686, 1688, no. 785.

The stylistic and thematic versatility of Van den Eeckhout may be noted in both his paintings and his drawings. In his biblical and mythological scenes he shows himself to be an accomplished follower of Rembrandt, although he was in many respects also influenced by Pieter Lastman. However, he never completely escaped the danger of becoming a little shallow, particularly in the later years. The drawings done directly from nature are undoubtedly more independent. These include portraits, landscapes, genre scenes and figure studies. Within this category the technically and stylistically coherent group of figure and dog studies executed in brush and bistre wash[1] to which the Albertina drawing belongs, stands out in particular. Benesch notes that this group illustrates the method that Rembrandt taught and Samuel van Hoogstraten later formulated theoretically, by which pupils were encouraged to practice on appearances modeled by light — in other words, the artist should avoid distracting details by studying the model through half-closed eyes and render the hollow shadows of the eyes, nose and mouth in broad strokes.[2] Van den Eeckhout distanced himself from Rembrandt in his application of this pure brush technique; the airiness of Van den Eeckhout's technique is similar to that found in the eighteenth century[3].

Several brush studies from the aforementioned group were already attributed to Van den Eeckhout in the eighteenth century. These attributions were later doubted by a number of authors; the many names that have been connected to the various drawings range from Vermeer, Terborch, Netscher and numerous other Netherlandish artists of the seventeenth and eighteenth centuries to Fragonard.[4]

Although the Albertina sheet was considered Van den Eeckhout's work in Duke Albert's time, it has also been attributed to G. Terborch (Schönbrunner-Meder, Bode-Valentiner), J. Vermeer (Eisler, Tietze-Conrat, Reiffenberg-Hausenstein), N. Maes (Hind, Leporini, who also mentions an untestable attribution to S. Hoogstraten). Kruse and Plietzsch (1939), who revised the attribution to Van den Eeckhout from 1911, decided on "unknown" and "undetermined." Thereafter, however, the attribution of the entire group of drawings to Van den Eeckhout gained general acceptance; in 1962 Sumkowski's suggested a date of the mid 1650s, which has never been challenged. *M.B.-P.*

Notes
1. W. Sumowski, *Drawings of the Rembrandt School*, vol. 3 (New York, 1980), nos. 781–97.
2. S. van Hoogstraten, *Inleyding tot de Hooge Schoole der Schilderkonst: Anders de Zichtbaere Werelt* (Rotterdam, 1678), p. 27.
3. Cf. R. Roy, "Studien zu Gerbrand van den Eeckhout" (Ph.D. Diss., Vienna, 1972), p. 7.
4. A detailed review of the literature is given by W. Sumowski in *Drawings of the Rembrandt School*, vol. 3 (New York, 1980), p. 1686, 1688.

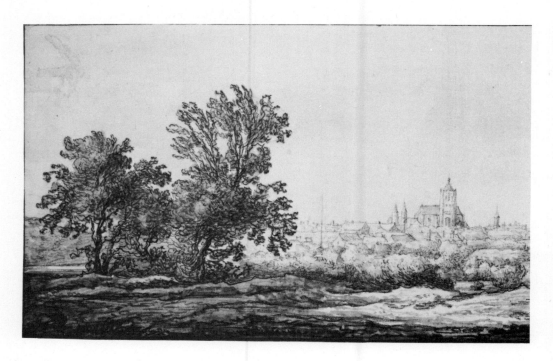

Aelbert Cuyp
Dordrecht 1620–1691 Dordrecht

Aelbert Cuyp, the third generation from a family of painters. He lived with his father, the animal and portrait painter Jacob Gerritsz. Cuyp, until the latter's death. Some of the portraits by Jacob have landscape backgrounds by Aelbert. The father's respected position helped the son's career. Because of his marriage to Cornelia Boschman, a regent's widow, in 1658, Aelbert occupied several high social offices, which may explain the decrease in his artistic production. Although Cuyp was mostly famous as a painter of monumental landscapes infused with light, he was also a master of animal compositions, portraits and religious scenes.

32

LANDSCAPE WITH A DISTANT TOWN (ARNHEM)
Black chalk and watercolor; 18.3 × 29.6 cm;
inv. 8.756

Provenance: Duke Albert of Saxe-Teschen; 1822 Estate inventory, p. 593; L.174

Bibliography: W. Bernt, *Die niederländischen Zeichner des 17. Jahrhunderts*, I, Munich, 1957, no. 172; Benesch 1964, Meisterzeichnungen, no. 195; St. Reiss, *Aelbert Cuyp*, London, 1975; W. Veerman, M. de Groot and J. G. van Gelder, *Aelbert Cuyp en zijn familie — schilders te Dordrecht. Gerrit Gerritsz. Cuyp, Jacob Gerritsz. Cuyp, Benjamin Gerritsz. Cuyp, Aelbert Cuyp*, Dordrecht, 1977/78.

Research on the life and work of Aelbert Cuyp is substantially hindered by the scarcity of biographical information and the absence of dates on most of his paintings and drawings. In addition, many forgeries of this very popular artist (especially prized in England) appeared on the market in the late eighteenth and nineteenth centuries. A 1975 monograph by St. Reiss and an exhibition, organized in 1977–78 in Dordrecht, focusing on Aelbert Cuyp and his family have contributed much to the available information on this artist. The Dordrecht catalogue not only presents new documentary material but also examines for the first time the chronological development of his drawing style through his work.[1] One can only draw partially valid parallels in the various phases of Cuyp's painted oeuvre — from the beginnings under his father's influence (until 1640), through the periods inspired by van Goyen (1640–45) and Jan Both (1645–49) to the more detailed and decorative works of the late years. The development of his drawing style seems to go its own way. Dating his drawings from panoramic views of towns often relies on topographical and historical data; for instance, we know that *Arnhem* (Rijksprentenkabinett, Amsterdam)[2] was executed "before 1650/51" because the octagonal lantern on the Eusebius tower is missing. This same sheet also proves that the Albertina drawing shows Arnhem from the northeast, which was first recognized by Benesch. Based on the chronology offered in the catalogue, this drawing was executed in the second half of the 1640s. It is difficult, however, to say whether the Albertina and Amsterdam sheets are contemporaneous. There seem to be parallels in the treatment of the trees and in the handling of line, but the impression of space is stronger in the Amsterdam sheet because of the emphasis on the horizontal format (characteristic of Cuyp's late period) and an all-pervasive luminosity. The Vienna drawing is structured around layers that become progressively lighter toward the background, with the golden yellow strips of the meadow and the shrubbery alternating harmoniously with the olive green and brown areas. The entire composition is unified by the rhythm of the black chalk marks, which become more delicate as they approach the silhouette of the town. Seen this way, the sheet is most reminiscent of the drawings from the early 1640s. *The Hague* (1641–43, Teyler Museum, Haarlem)[3] is stylistically similar and largely corresponds to the Albertina drawing in ductus, use of color, distribution of accents and the relation of the foreground to the background.

It is remarkable that *Landscape with a Distant Town (Arnhem)* was acquired with eight other sheets then attributed to Cuyp just as interest in Cuyp's drawings was burgeoning[4] and that the attribution in this case has endured to this day.

M.B.-P.

Notes
1. St. Reiss, *Aelbert Cuyp* (London, 1975); W. Veerman, M. de Groot and J. G. van Gelder, *Aelbert Cuyp en zijn familie — schilders te Dordrecht. Gerrit Gerritsz Cuyp, Jacob Gerritsz. Cuyp, Benjamin Gerritsz. Cuyp, Aelbert Cuyp* (Dordrecht: Dordrechts Museum, 1977/78), no. 67.
2. *Aelbert Cuyp en zijn familie*, no. 67.
3. Ibid., no. 47.
4. Ibid., p. 112.

Pieter Jansz. Saenredam
Assendelft 1597–1665 Haarlem

Son of Jan Pieterszoon Saenredam (1565–1607), an engraver who had been a pupil of Goltzius. From 1612 to 1623 he was apprenticed to Franz Pieter de Grebber in Haarlem, with whom he stayed until 1623. His earliest dated drawing is from 1617. He began painting views of churches and other buildings in 1628, at which time he was acquainted with the architect Jacob van Campen and Salomon de Bray. In 1635 he was appointed secretary of the painters' guild in Haarlem. Saenredam was the most important architectural painter of the seventeenth century in The Netherlands; he specialized in church interiors. Numerous artists who painted similar subjects — such as the Berckheyde brothers, Hendrik van Vliet, Gerard Houckgeest and E. de Witte — emulated Saenredam, but none ever attained his virtuosity.

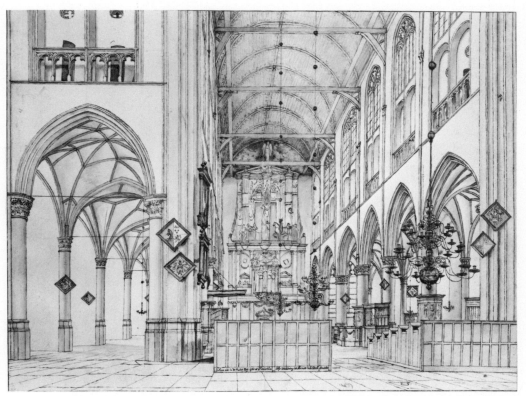

33

INTERIOR OF THE GROOTE KERK AT ALKMAAR
1661
Pen and bistre ink, and watercolor;
45.3 × 60.5 cm; inv. 15.129
Inscribed on the back of the choirstall "Anno 1661, in de Maent Maij, hab ick Pr Saenredam dese teeckening tot Alcmaer in de kerck gemaeckt."[1]

Provenance: Duke Albert of Saxe-Teschen; 1822 Estate inventory, p. 573; L.174

Bibliography: Schönbrunner-Meder, no. 1009; P. T. A. Swillens, *Pieter Janszoon Saenredam*, Amsterdam, 1935, no. 210, p. 61; M. E. Houtzager, P. T. A. Swillens and J. Q. van Regteren-Altena, *Pieter Janszoon Saenredam, Catalogue Raisonné*, Centraal Museum, Utrecht, 1961, no. 3; Benesch 1964, Meisterzeichnungen, no. XVI.

In 1661, four years before his death, Saenredam drew a series of interior views of the Great Church (or Church of St. Lawrence) in Alkmaar that were used as models for later paintings.[2] Although the Albertina drawing is almost identical to a painting in the Stedelijk Museum in Alkmaar, there remains a question as to whether Saenredam actually painted the work.[3] The most important differences between the two works rest on the perspective, with the vanishing point somewhat lower in the painting, and the organ, shown closed in the drawing but open in the painting. The composition of the painting may have come from several studies, such as an Albertina watercolor of the open organ by Saenredam, also dated 1661[4] and a construction drawing of this wall area prepared by Saenredam in 1638/39 for Jacob van Campen, who had been commissioned to design a new architectural framework for the organ.[5]

The function of Saenredam's drawings, including the Albertina's sheet, may be explained by his working method, which he developed and followed for decades. First he drew an "inventory," which focused mainly on the colors, details and overall impression. At this stage he also made a conscious and subjective choice of vantage point; a very few construction lines were drawn to help with orientation.[6] He then followed a precise construction drawing, which was later enlarged and transferred to the painting's ground. The painting was developed (sometimes years later) from these two stages. The many small but crucial changes in perspective throughout this process reveal much about the way Saenredam mastered the problem of translating three dimensions into two.

Compared to his contemporary architectural painters Saenredam's works appear uniquely natural. Because of the way he positioned the vanishing point off-center and remarkably low (at eye-level, giving the sense of immense height), many viewers feel as if they are standing in the space itself. This feeling is strengthened by the disposition of architectural elements — one or more columns, sometimes a wall — in the very near foreground. (These effects are milder in the late work.) Saenredam is unsurpassed in the subtle handling of light — he worked with few colors but infinite gradations of tone. Our sheet is an excellent example of the all-encompassing tonality of his paintings and watercolors. Contrasting with the gray and light brown watercolors, the white of the paper becomes the main tone and is enlivened even more by the few, effectively placed color accents. This conception of light and atmosphere has its origin in the tonalism of Dutch painting of the late 1620s and 1630s; in Saenredam it survived for decades without diminishing in quality. *M.B.-P.*

Notes
1. "In the year 1661, in the month of May, I, Pieter Saenredam, made this drawing in the church at Alkmaar."
2. *Pieter Janszoon Saenredam, Catalogue Raisonné* (Utrecht: Centraal Museum, 1961), nos. 1–10.
3. This question is raised because of the unusual format and the use of canvas rather than Saenredam's normal panel. Ibid., no. 2.
4. Ibid., no. 8.
5. Ibid., no. 9.
6. See the detailed study of the problem of space in W. A. Liedtke, "Saenredam's Space," *Oud Holland* 86, no. 2/3 (1971) p. 116 ff.

Peter Paul Rubens
Siegen (Westphalia) 1577 – 1640 Antwerp

Born on June 28 to the lawyer Jan Rubens and his wife Marie. After the death of his exiled father in 1587, Rubens returned with his family to Antwerp (1589 at the latest). Following his humanist education, Rubens trained under the artists Tobias Verhaecht, Adam van Noort and Otto van Veen. He was elected to the Antwerp guild of St. Luke in 1598. Summoned to the court of Duke Vincenzo (I) Gonzaga in Mantua, Rubens traveled to Italy in 1600; Vincenzo I sent Rubens to Spain in 1603/04. He went to Rome in 1605, and in 1608, after the death of his mother, he returned to Antwerp. Appointed court painter to Archduke Albert and the Infanta Isabella. Married Isabella Brant. Henceforth, the artist occupied a magnificent house and maintained a large workshop with important assistants, including the young Van Dyck. Received numerous commissions from, among others, Marie de Medici. Rubens' diplomatic career began in 1623, and in 1624 he became a member of the nobility. Isabella Brant died in 1626; Rubens married Hélène Fourment in 1630. Moved into the Chateau de Steen, near Brussels, in 1635. In 1636 he was appointed court painter to the Cardinal-Infante Ferdinand and in 1640 he became an honorary member of the Accademia di San Luca in Rome. The artist's chronic arthritis worsened and caused partial palsy of the hands. Rubens died on May 30, 1640.

STUDIES OF HEADS AND HANDS
Black chalk heightened with white,
34.2 × 23.1 cm; inv. 8.307

Provenance: Duke Albert of Saxe-Teschen, L.174

Bibliography: Rooses 1886–92, V, no. 1.579; Schönbrunner-Meder, no. 784; Haberditzl 1912, p. 7; Burchard 1913, p. 58; Glück 1921, no. IX; Glück-Haberditzl 1928, no. 74; Held 1959, no. 81; Martin 1969, fig. 30; Kuznetsov 1974, no. 33; Alb.Vienna 1977, no. 9; Held 1980, under no. 358.

These studies were prepared for the *Presentation in the Temple*, the right-hand wing of the triptych of the Deposition of the Cross in the Antwerp Cathedral. The contract for this altarpiece was signed with the Kolveniers guild (archers) on September 7, 1611. The central image, *Deposition of the Cross*, was completed on September 12, 1612, and the two wings were delivered in February and March 1614. The altar was dedicated on August 2, 1614.[1]

Rubens' first ideas for the Presentation are recorded in two drawings — in the Metropolitan Museum of Art, New York, and the other, in the former collection of Count Seilern, London. These drawings and the studies for the Visitation (Musée Bonnat, Bayonne) were originally one sheet of sketches.[2] By contrast, the Albertina drawing represents a very advanced stage in the development of the pictorial idea. All the motifs on the Albertina sheet reappear in the painting: the folding hands of the Prophetess Hannah, the head of the kneeling Joseph, as well as the hands and head of the High Priest Simeon. Such similarities prove that the drawing can only have been executed when the composition as a whole had already been determined, that is, it probably follows from the oil sketch formerly in Count Seilern's collection.[3]

The compositional arrangement of the studies was obviously intentional and corresponds to contemporary tendencies in Rubens' style. They emphasize the sense of harmony and deliberate, ingenious composition, which is beautifully exemplified by the altarpiece itself. In spite of all the similarities between the studies and the finished painting, the discrepancy in characterization and intensity of expression is striking, which is particularly clear in Simeon's face. The relatively youthful facial features in the drawing, which portrays the model's, are altered in the painting to achieve the iconographically appropriate dignity and emotion. This distance between study after nature and the finished painting's artistic interpretation can be observed repeatedly in Rubens' work. *E.M.*

Notes
1. H.G. Evers, *Rubens und sein Werk, Neue Forschungen* (Brussels, 1943), chronological tables.
2. Held 1959, no. 28, fig. 50.
3. A. Seilern, *Flemish Paintings & Drawings at 56 Princes Gate London SW7* (London, 1955), no. 17, pl. XXXIX (Count Seilern's collection was bequeathed on his death to the Courtauld Institute, London.); Held 1980, no. 358.

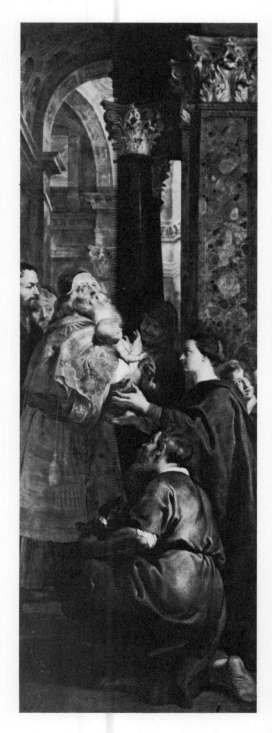

34a. Peter Paul Rubens
Presentation in the Temple from the triptych of the Deposition of the Cross
Cathedral, Antwerp

35

THE ASSUMPTION OF THE VIRGIN
Pen and brown ink, brush and brown wash;
29.0 × 23.1 cm; inv. 8.212
Inscribed "82" in pen lower right

Provenance: Duke Albert of Saxe-Teschen; 1822
Estate inventory, p. 549; L.174

Bibliography: Rooses 1886–92, V, no. 1.437; Held
1959, no. 35; Benesch 1959, p. 35; Burchard-
d'Hulst 1963, no. 73; Baudouin 1968, p. 12;
Baudouin, *Rubens*, p. 57; Baudouin 1972, p. 64 ff;
Kuznetsov 1974, no. 14; Van de Velde 1975,
p. 252; Alb.Vienna 1977, no. 8; Vienna 1977,
under no. 16; Held 1980, under no. 375.

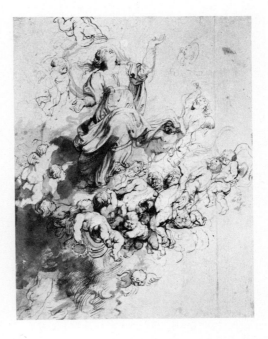

The numerous pentimenti, especially around the
putti, show this drawing to be a preparatory
sketch concerned with clarifying the forms. It
allows us to reexperience the process by which the
idea developed. The attempt to attribute the
sheet to Van Dyck (Benesch) has found no
support. The drawing belongs firmly with
Rubens' many depictions of the Assumption.

Rooses pointed out that the drawing re-
sembled the painting of the Assumption commis-
sioned by the Archduke Albert and his wife
Isabella for the high altar (dedicated in 1614)
in the Carmelite Church in Brussels.[1] The
Madonna's pose and the veil surrounding her
head are motifs sometimes found in Rubens'
work.[2] Closer connections may be established, as
Held and Burchard-d'Hulst recognized, with the
painting of the Assumption in Buckingham Palace
(London) and with the altarpiece of the same
theme in the Kunsthistorisches Museum
(Vienna), which can be dated on stylistic grounds
as early as c.1614/15.[3] Both paintings are virtually
identical in the composition of the upper half. The
rhythmic movement of Mary's ascending form is
closely related to our drawing, in spite of the
reversed position of the upper body. The spatial
foreshortening is comparable, as is the head seen
sharply from below, which led Held to refer to the
earlier painting of the Circumcision in Genoa.[4]

The Hermitage (Leningrad) has an oil sketch
that dates to Rubens' stay in Italy. Although its
lower half, with the apostles surrounding the
empty tomb, prefigures the Vienna painting, the
depiction of the Madonna ascending diagonally
into Heaven adopts quite another type of
Assumption.[5] Baudouin convincingly linked the
Leningrad oil sketch with the documentary
minutes of the Antwerp Cathedral chapter meet-
ing of April 22, 1611, which speak of two modelli
of an Assumption submitted by Rubens for a new
high altar in the cathedral. Baudouin hypothesized
that the second variant differed only in the upper
part of the Assumption and that the Albertina
sheet was a sketch for this second version.
Kuznetsov also thought the Albertina drawing
dated to c.1611, while Held and Burchard-d'Hulst
preferred 1614/15. The thick grapelike arrange-
ment of the putti under the Madonna was inspired
by Pordenone's fresco in S. Niccolo, Treviso,
which Rubens copied in a drawing.[6] As has been
correctly noted, however, the Albertina drawing
is further removed from this model than the
London or Vienna paintings.[7] *E.M.*

Notes
1. Oldenbourg, no. 120.
2. Cf. Oldenbourg, nos. 193, 301; Held 1980,
 nos. 376, 377, 379.
3. Held 1980, no. 375; Vienna 1977, no. 16.
4. Oldenbourg, no. 21.
5. Held 1980, no. 374.
6. A. Seilern, *Flemish Paintings & Drawings at
 56 Princes Gate London SW7* (London, 1955),
 no. 50; Burchard-d'Hulst 1963, no. 24.
7. Vienna 1977, no. 16, p. 70; Held 1980, under
 no. 375, p. 511.

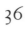

36

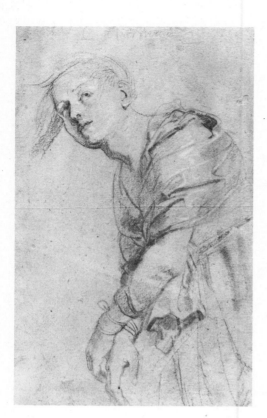

ST. CATHERINE
Black chalk heightened with white,
37.3 × 23.3 cm; inv. 8.293
Inscribed "S.Catarina" in red chalk in
upper margin

Provenance: Duke Albert of Saxe-Teschen, L.174

Bibliography: Rooses 1886–92, V, no. 1.443;
Schönbrunner-Meder, no. 19; Haberditzl 1912,
p. 5; Meder, Albertina-Facsimile 1923, p. 13;
Glück-Haberditzl 1928, no. 143; Delen 1944,
no. 13; Held 1959, p. 138; Vlieghe 1972, no. 78a;
Kuznetsov 1974, no. 87; Alb.Vienna 1977,
no. 21; Paris 1977, under no. 121.

36a. Peter Paul Rubens
The Martyrdom of St. Catherine
Musée de Beaux-Arts, Lille

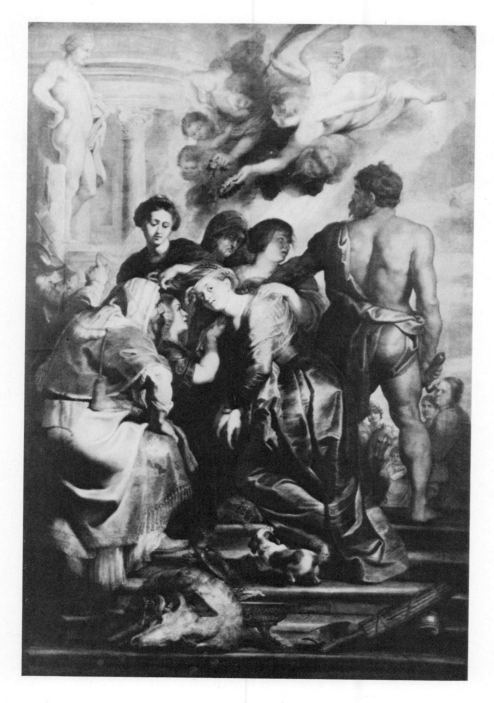

Saint Catherine of Alexandria, the daughter of the
King of Cyprus, was horribly tortured and finally
beheaded in the early fourth century for believing
in the Christian faith (Legenda Aurea).

This drawing was a study for the altarpiece in
St. Catherine's church in Lille (Musée des Beaux-
Arts, Lille) and depicts the saint's decapitation.
Oldenbourg dated the painting, and Glück and
Haberditzl the drawing, at 1622/23, which is too
late because the altarpiece was finished by June 2,
1621.[1] For stylistic reasons Vlieghe assumes a date
as early as c.1615 or a little later.[2]

Although the drawing served as the direct
preparatory study for the painting, it differs in
several details and takes no notice of the over-
lapping hand of the figure behind Saint Catherine.
The rendering of bodily volume, especially around
the shoulder, by means of angular, vigorously
bunched drapery and applied highlights is related
to a study for a ladder-carrier[3] in the painting
Le coup de lance (Antwerp Museum), which was
made for the 1620 high altar of the Church of
the Recollects.

A piece has been added to the sheet at the lower
right corner, and the drawing has obviously been
completed by another hand. According to Held,
the red chalk inscription at the upper edge is by
the same hand as on several other drawings by
the artist.[4] *E.M.*

Notes
1. Rooses 1886–92, I, p. 236; Oldenbourg,
 no. 242.
2. Vlieghe 1972, no. 78.
3. Inv. 8.298, Albertina Collection, Vienna;
 Alb.Vienna 1977, no. 22.
4. Glück-Haberditzl 1928, nos. 152, 156, 157,
 162, 164 and 165.

PORTRAIT OF SUSANNA FOURMENT
Black and red chalks heightened with white, the
eyes strengthened in black; 34.4 × 26.0 cm;
inv. 17.651
Inscribed "P P Rubbens" in pen at lower right,
"No. 8" in chalk at lower left "Suster van Heer
Rubbens" in red chalk in upper margin

Provenance: Duke Albert of Saxe-Teschen, L.174

Bibliography: Rooses 1886–92, V, no. 1.506;
Schönbrunner-Meder, no. 527; Glück-Haberditzl
1928, no. 162; Glück 1933, p. 136 ff; Held 1959,
under no. 104; Burchard-d'Hulst 1963, under
no. 136; Benesch 1964, Meisterzeichnungen,
no. XIII; Kuznetsov 1974, no. 117; Alb.Vienna
1977, no. 43.

Rubens portrayed the elder sister of his second
wife, Hélène Fourment, several times. Born in
1599, Susanna Fourment married her second
husband, Rubens' friend Arnold Lunden, in 1622.
Rubens already knew his sister-in-law when
Hélène was still a child and his first wife Isabella
Brant was still alive. The family ties continued
after Rubens' death; his son Albert married Clara
Delmonte, Susanna's daughter from her first
marriage.

A painting based on the Albertina's sheet has
not come to light. The portrait is, however,
similar to the woman in *Le chapeau de paille*
(National Gallery, London), who is traditionally
identified as Susanna Fourment. The standing
collar that casts a framing shadow around the face
recurs in the portrait of Isabella Brant (British
Museum, London),[1] and thereby gives us a
stylistic reference point for dating the Albertina
drawing. Glück and Haberditzl set the date at
c.1626–27, Benesch and Kuznetsov, c.1625. The
inscription "Suster van Heer Rubbens" can only
have been added after the artist's marriage to
Hélène Fourment (December 6, 1630), as Held
explains.[2] There is another portrait drawing of
Susanna Fourment in the Museum Boymans-van
Beuningen, Rotterdam.[3] E.M.

Notes
1. Glück-Haberditzl 1928, no. 160.
2. Held 1959, under no. 106.
3. Glück-Haberditzl 1928, no. 161.

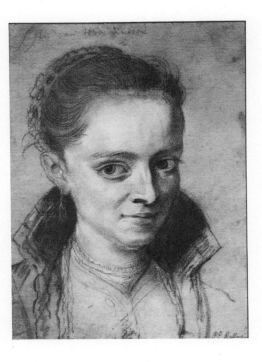

37a. Peter Paul Rubens
Le chapeau de paille
Reproduced by the courtesy of the Trustees,
The National Gallery, London

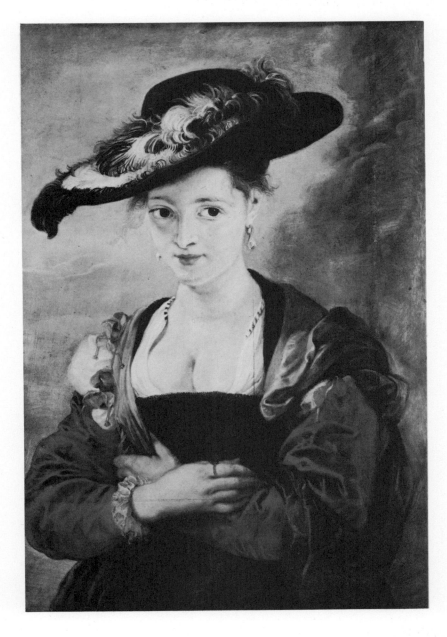

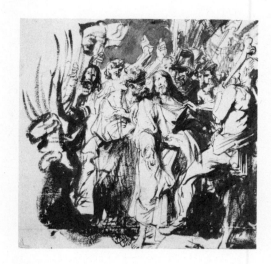

Sir Anthony Van Dyck
Antwerp 1599–1641 London

The son of a rich silk merchant, Van Dyck entered the Antwerp guild of St. Luke as apprentice to Hendrik van Balen in 1609. 1615/16 worked independently and lived with Jan Bruegel the Younger. 1618 free master of the guild of St. Luke. During his first Antwerp period (until 1621), he painted many religious works; was Rubens' pupil and assistant. Resided in London for a short time (1620/21); from 1621 to 1627 he lived in Italy where he painted equestrian portraits, religious scenes, portraits, copies of Italian artists and antique models. Returned to Antwerp in 1627; became court painter to the Archduchess Isabella in 1630; resided in England from 1632 to 1634. Knighted by Charles I in 1632 and named "principalle Paynter in ordinary to their Majesties." Became honorary dean of the Antwerp guild of St. Luke in 1634. Returned to London in 1635. Married Mary Ruthven in 1639. 1640/41 journeyed to Paris and returned to London.

38

THE ARREST OF CHRIST
Pen and brush, bistre and wash, touches of white bodycolor, 21.8 × 23.0 cm; inv. 17.537

Provenance: Duke Albert of Saxe-Teschen; 1822 Estate inventory, p. 577; L.174

Bibliography: Schönbrunner-Meder, no. 696; G. Glück, *Van Dyck, Klassiker der Kunst*, XIII, 1921, p. 527; O. Benesch, "Die großen flämischen Maler als Zeichner," *Jahrbuch der Kunsthistorischen Sammlungen in Wien* 53 (1957), p. 32; H. Vey, *Die Zeichnungen Anton van Dycks*, Brussels, 1962, no. 83; Benesch 1964, Meisterzeichnungen, no. 151; Australia 1977, no. 31; J.R. Martin and G. Feigenbaum, comps., *Van Dyck as a Religious Artist*, The Art Museum, Princeton University, Princeton, 1979, p. 104, sub. no. 25; A. McNairn, *The Young Van Dyck*, National Gallery of Canada, Ottawa, 1980, p. 103, under no. 42.

The exhibited sheet belongs to a group of preparatory drawings for the *Arrest of Christ* (Prado, Madrid). The painting is generally dated, along with two smaller autograph versions (Lord Methuen collection, Corsham Court, and the Minneapolis Institute of Art),[1] toward the end of the first Antwerp period, that is not later than autumn 1621. Opinions differ, however, on the sequence of the three paintings and on the function of the version at Corsham.[2]

The evolution of the design may be traced through the surviving drawings.[3] A horizontal composition with a relieflike group of figures leading the betrayed Christ away gradually developed into a vertical pictorial structure with more depth, in which the Christ-Judas group is depicted at the moment of betrayal in constantly changing positions. The dynamic, often discontinuous working process, in which each study forms a new approach to the final solution, is characteristic of Van Dyck and lends his drawings a special freshness and spontaneity.

The Albertina drawing shows neither the Peter Malchus group, which occupies an important foreground position in other studies[4] and in the paintings in Minnesota and Madrid, nor the sleeping apostles in the left foreground as in the Louvre drawing.[5] The central placement of the Christ-Judas group connects our drawing most closely to the Corsham painting, in which the tree scenery is much reduced and the man with a club, already present in an earlier design, no longer appears.[6] The Albertina sheet presents a virtuoso combination of individual technical and stylistic possibilities from other studies: the detailed treatment of the faces of Judas and Christ forms a powerful contrast to the sketchiness of the rapidly brushed tree, the quickly, but confidently, sketched figures, the washes of the night sky and the flickering shadows.

In terms of technique and expressiveness, the drawing is without a doubt exceptional, not only within the series but also in the drawing oeuvre of the young Van Dyck. Van Dyck's preference for elongated figures and S curves indicates that he could have already studied the Venetian mannerists with his teacher Hendrik van Balen.[7] Italian art played a significant role for Van Dyck even before he left for Italy.[8] *M.B.-P.*

Notes
1. G. Glück, *Van Dyck, Klassiker der Kunst*, XIII (1931), figs. 70, 71; J. R. Martin and G. Feigenbaum, comps., *Van Dyck as a Religious Artist* (Princeton, N.J.: The Art Museum, Princeton University, 1979), fig. 25, pl. 24; A. McNairn, *The Young Van Dyck* (Ottawa: National Gallery of Canada, 1981), no. 45.
2. J. R. Martin and G. Feigenbaum, comps., *Van Dyck as a Religious Artist*, p. 102; A. McNairn, *The Young Van Dyck*, p. 106.
3. H. Vey, *Die Zeichnungen Anton van Dycks*, (Brussels, 1962), nos. 79–86; J. R. Martin and G. Feigenbaum, comps., *Van Dyck as a Religious Artist*, nos. 24–27; A. McNairn, *The Young Van Dyck*, nos. 40–45.
4. H. Vey, *Die Zeichnungen Anton van Dycks*, nos. 80–82, 86.
5. Ibid., no. 84.
6. Australia 1977, no. 31.
7. A. McNairn, *The Young Van Dyck*, p. 6.
8. Ibid., p. 18–23.

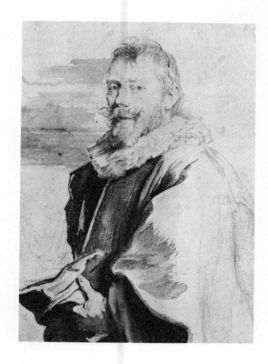

39

PORTRAIT OF ARTUS WOLFAERT
Black chalk and black ink, and watercolor, 23.2 × 17.3 cm; inv. 3.659

Provenance: Duke Albert of Saxe-Teschen; 1822 Estate inventory, p. 580; L.174

Bibliography: H. Vey *Die Zeichnungen van Dycks*, I, II, Brussels, 1962, no. 251; Benesch 1964, Meisterzeichnungen no. 152.

The drawing represents the religious history painter, Artus Wolfaert (1581–1641), who was a pupil of F. Francken. This portrait is one of the many surviving drawings Van Dyck created for his *Iconography* of famous contemporaries that was executed by various engravers. It is not certain whether Van Dyck planned this extensive undertaking when in Italy (some of the drawings must have been done there)[1] or after his return to The Netherlands in 1627.[2] Most of the drawings date from the artist's two stays in Flanders between 1627 and 1635. The first edition of *Iconography* appeared between 1636 and 1641[3] as a book published by Martinus van den Enden in Antwerp. This eighty-page edition did not contain Van Dyck's own etchings, which only appeared posthumously. Gillis Hendrix acquired the plates from Martin van den Enden on Van Dyck's death and published the artist's etchings, which were partially reworked by other engravers, in a expanded 100-page edition (1645/46). From 1645/46 until the eighteenth century many different editions and arrangements appeared.[4] Vey pointed out the innovative character of Van Dyck's *Iconography* within a long and widespread tradition.[5]

In this unconventional compilation of personalities any strict hierarchical division into dynasties or schools is absent (the first edition included sixteen princes and generals, twelve statesmen and scholars and fifty-two artists and connoisseurs). The usual long commentaries and decorative borders, especially common in the sixteenth century, were not included in Van Dyck's *Iconography*, which further emphasizes the personal character of the series that was dominated largely by artists and connoisseurs.

Vey and Benesch only mention Cornelis Galle as the engraver of the plate after the Albertina drawing. His name, however, does not appear until the third state, the one immediately preceding Hendrix's. The second state with Van den Enden's imprint lists Schelte A. Bolswert as engraver.[6] Both authors refer to the fact that the raised hand which is only sketchily indicated in the drawing is no longer visible in the engraved image where the painter stands with his left hand on his hip.

The free unfinished execution of the drawing in chalk and gray washes is typical of the majority of the series. Van Dyck was apparently very concerned about capturing his sitters' individuality and immediate expression. As in his etched portraits, the sharply observed and finely nuanced faces contrast strongly with their more broadly rendered environment. This high artistic quality is lost in the engraved versions and in those etchings reworked by others. *M.B.-P.*

Notes
1. H. Vey, *Die Zeichnungen van Dycks*, I, II (Brussels, 1962), p. 44.
2. F. Wibiral, *L'Iconographie d'Antoine Van Dyck d'apres les recherches de H. Weber* (Leipzig, 1877), p. 9.
3. H. Vey, *Die Zeichnungen van Dycks*, p. 47.
4. F. Wibiral, *L'Iconographie d'Antoine Van Dyck*, p. 9 ff; Hollstein VI, p. 108.
5. H. Vey, *Die Zeichnungen van Dycks*, p. 41 ff.
6. F. Wibiral, *L'Iconographie d'Antoine Van Dyck*, no. 27; Hollstein III, no. 345; Hollstein VI, p. 111, no. 81; Hollstein VI, p. 114, no. 224; Hollstein VII, no. 283.

Sir Peter Lely
Soest (near Utrecht) 1618 – 1680
London

His given name was Pieter van der Faes. Became a pupil of F. P. de Grebber in Haarlem in 1637. He was called to the English court as a portrait painter in 1641 and there received the commission for the wedding picture of Prince William II of Orange and Mary of England. Visited Holland in 1656. Knighted by the English king in 1680. Lely was the most important representative of the tradition of Van Dyck's court portrait style in England.

40

TWO HERALDS
Black and white chalk on blue-gray paper; 51.3 × 27.9 cm; a strip of paper 25 mm wide added by the artist at the lower edge; inv. 17.594
Inscribed "herauten" in leadpoint at lower left; numbered "486" in pen and brown ink at lower left

Provenance: Moriz v. Fries, L.2903; Duke Albert of Saxe-Teschen; 1822 Estate inventory, p. 579; L.174

Bibliography: Schönbrunner-Meder, no. 8; Meder, Albertina-Facsimile 1923, p. 14; F. Lugt, "Beiträge zu dem Katalog der niederländischen Handzeichnlungen in Berlin," *Jahrbuch der Preussischen Kunstsammlungen*, 52 (1931), p. 47–48; E. Croft-Murray and P. Hulton, *Catalogue of British Drawings I, XVI and XVII Centuries*, British Museum, London, 1960, p. 409; Benesch 1964, Meisterzeichnungen, no. 153; Australia 1977, no. 34.

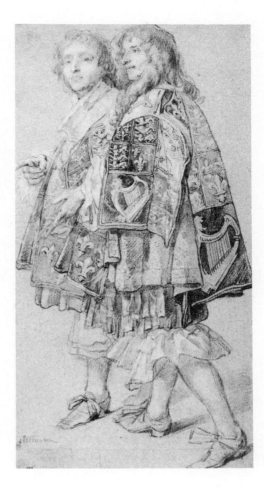

The costumes of the two heralds show the three leopards and the fleur-de-lis of England, the harp of Ireland and the double tressure of Scotland.

The drawing belongs to a group of studies representing figures from the St. George's Day (April 23) procession by the Knights of the Garter. (Three studies seem to be connected with other ceremonies on this day.[1]) About thirty such drawings are currently known.

The British Museum, London, houses sixteen of these studies, all in the same technique. The remaining drawings are divided between European and American collections. The resemblance of *Two Heralds* to portrait and figure studies by Van Dyck probably contributed to the early attributions to Van Dyck. F. Lugt was the first to recognize the work as being by P. Lely (J. Meder relied on this attribution in 1923) and connect it with other studies that already carried an attribution to Lely in the eighteenth century.[2] Croft-Murray and Hulton increased the number to the total known today and dated the drawings between 1663 and 1671 on the basis of the biographies of some recognizable figures. The authors were unable to determine definitely the function of the drawings: they may perhaps have been designs for a wall decoration in paintings or tapestries.
 M.B.-P.

Notes
1. E. Croft-Murray and P. Hulton, *Catalogue of British Drawing I, XVI and XVII Centuries* (London: British Museum, 1960), p. 410.
2. F. Lugt, "Beiträge zu dem Katalog der niederländischen Handzeichnungen in Berlin," *Jahrbuch der Preussischen Kunstsammlungen* 52 (1931), p. 47–48.

Italian School

Stefano da Zevio
Verona c.1375–post 1438 Verona

Called Stefano di Giovanni da Verona in Vasari and contemporary sources. O. Panvinio (*Antiquitatum Veronesium Libri acto*, 1648) could have been mistaken when he connected the artist with the village, Zevio, near Verona. In 1425 Stefano is mentioned as "etatis L annorum"; further mention is made in various archives in northern Italy until 1483.

Stefano, a contemporary of Altichiero and Pisanello, was the leading painter in Verona. He was one of the more important masters of the so-called soft or international Gothic style, to which he added occasional dramatic and expressive plasticity. This is also seen in his drawings, of which the Albertina possesses several. Florentine traits can be seen in Stefano's oeuvre, especially in the drawings that are very close to those by Parri Spinelli and Lorenzo Monaco. In fact, many sheets by Stefano were attributed to Parri Spinelli for a while. Only a fraction of the frescoes and panel paintings mentioned in various documents and by Vasari have survived.

41

THREE STUDIES OF PROPHETS WITH BANDEROLES
Pen and brown ink; 29.6 × 18.1 cm; inv. 24.014, V.3; diagonally cut at lower margin, the upper right corner added; old restorations
Inscribed "Stefano Falconeto" lower right, probably added towards the end of the fifteenth century

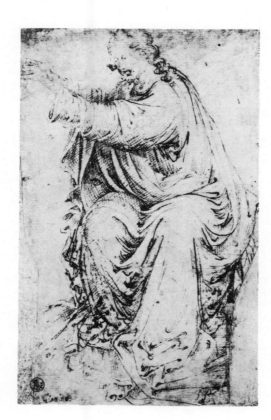

41a. Parri Spinelli
Study of Christ
Uffizi, Florence

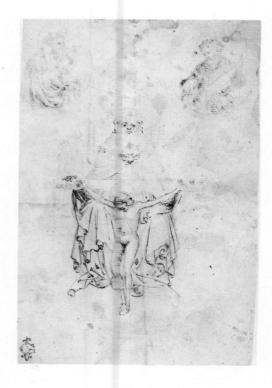

41b. Stefano da Zevio
Gnadenstuhl
Uffizi, Florence

Provenance: Moscardo; Calceolari; Luigi Grassi, L.1171b

Bibliography: Stix 1925, no. 7; B. Degenhart, "Stefano da Zevio," *Thieme-Becker Künstlerlexikon* 31 (1937), p. 528; G. Fiocco, "Disegni di Stefano da Verona," *Proporzioni* 3 (1950), p. 60; L. Maganato, comp., *Da Altichiero a Pisanello,* Verona, 1958, no. 46; Vienna 1962, no. 290; Benesch 1964, Meisterzeichnungen, no. 2; Venice 1981, p. 1 ff.

The name "Falconeto," which appears on several sheets, is a mark of ownership that refers to the descendants of Stefano's brother and pupil Giovan' Antonio who were active in Verona at the end of the fifteenth century.[1]

According to Degenhart these three studies are related to the prophets in the fresco at the side portal of Sant'Eufemia in Verona. Vasari writes: "In Sant'Eufemia . . . he [Stefano] painted St. Augustine with two other saints [Nicholas of Tolentino and Eufemia] above the side portal; under the cloak of St. Augustine stand many monks and nuns of his Order. However, the most beautiful part of this work is the pair of prophets, half-length figures in life-size, as they have the liveliest and most beautiful faces ever done by Stefano. . . ."

Obviously, this drawing shows three preparatory studies for the latter, studies that are among the liveliest and most expressive of the Veronese School in the Quattrocento. The dramatic elements of the prophet figures echo the Pisani sculpture, which also inspired Michelangelo. The spontaneous handling can compete with Ghiberti and Uccello. In this, the Albertina sheet stands out from all others in Stefano's oeuvre and also from the majority of Parri Spinello's drawings which are so similar that the artists' works have often been confused. Maganato discusses a second Albertina sheet[2] which appears to be connected to the aforementioned fresco in Sant'Eufemia. It shows the Gnadenstuhl (Throne of Mercy) as painted above Saint Augustine and two prophets in medallions who lack the vital immediacy of our three studies.[3]

<div style="text-align: right;">E.K.</div>

Notes
1. B. Degenhart, *Thieme-Becker Künstlerlexikon* 31 (1937); Degenhart 1942; Verona 1958; Florence 1978; Swoboda 1979, p. 97 ff.
2. L. Maganato, comp., *Da Altichiero a Pisanello* (Verona, 1958), no. 46.
3. Alb.Cat. I, 1926, V.2; Stix 1925, no. 2; Ibid., no. 44; Popham-Pouncy 1950, no. 254, 255.

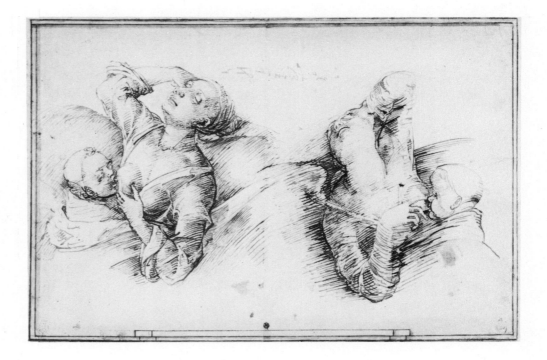

Liberale da Verona
unknown c.1445–1526/29 Verona

Around 1465 Liberale was working for the monks at S. Maria in Organo in Verona. From 1467 to 1469 he worked as a miniaturist in the monastery at Monte Oliveto Maggiore near Siena. In his later years he lived mainly in Verona, where he married for the third time in 1525. Influenced by Mantegna, he primarily achieved great significance as a miniaturist with a palette of clear colors.

42

TWO STUDIES OF A SLEEPING WOMAN WITH A CHILD AT HER BREAST
Pen and bistre ink; 20.3 × 27.9 cm; inv. 17.617, V.24; two sheets joined in the middle and somewhat reworked at seam Inscribed "Liberale de Verona" by Vasari on the mount; on the verso an old inscription visible through the paper: m° "Liberale fece."

Provenance: G. Vasari; P. J. Mariette, L.2097; C. de Tersan; Moriz v. Fries, L.2903; Duke Albert of Saxe-Teschen, L.174

Bibliography: Basan 1775, p. 75, no. 463; Wickhoff 1891, ScV.17; Alb.Cat. I, 1926, V.24; M. Dobrocklonsky, *Old Master Drawings*, London, 1929, p. 2; Paris 1950, no. 11; R. Longhi, "Un apice espressionistico di Liberale da Verona," *Paragone Arte* 6, no. 65 (1955), p. 7; *Andrea Mantegna*, Mantua, 1961, no. 141; Benesch 1964, Meisterzeichnungen, no. 11; C. del Bravo, *Liberale da Verona*, Florence, 1967, p. CXLVI; B. Degenhart and A. Schmitt, *Corpus der italienischen Zeichnung* I, vol. 2, Berlin, 1968, p. 634; Alb.Vienna 1971, no. 17; *Biblioteca dei Disegni*, IV, Florence, 1978, no. 10.

Originally there were two sheets, which Giorgio Vasari united; he then noted Liberale's name across the seam on the verso. Later he added the sketches to his *Libro* and again supplied the name of the artist in gothicizing letters on the mount.

It was not unusual for Vasari to arrange, according to his principles of organization, drawings that he believed belonged together. For example, Vasari colored the mat to match the mounted sketches[1] and backed the drawing with a dark sheet so that it would be consistent with the formal requirements of his *Libro*. In the case of this drawing, however, Vasari has probably not just reworked the passages where the cut edges of the drawings meet, he may have also maintained the balance of the composition by adding to the right-hand part of the sketches.

The dark penstrokes not only emphasize contours but also strengthen the graphic contrasts in a way similar to the later reworked engravings by Mantegna. Therefore, one cannot exclude the possibility that these "two" drawings did not acquire this partly disjointed accentuation until the time of Vasari.

For the choice of subject and its interest in the everyday, this sheet has always been seen as a unique study from life, far ahead of its time in its audacious realism. No painting is known for which these sketches could have served as studies, but C. del Bravo points out that the managable corpus of Liberale's drawings has not yet been studied in detail.[2]

<div style="text-align: right;">V.B.</div>

Notes
1. B. Degenhart and A. Schmitt, *Corpus der italienischen Zeichnung* I (Berlin, 1968), p. 633–34.
2. C. del Bravo, *Liberale de Verona* (Florence, 1967), p. CXLVI.

Lorenzo di Credi
Florence c.1459–1537 Florence

Lorenzo di Credi was the son and pupil of a Florentine goldsmith. In 1480, after his father's early death, he worked primarily as a painter in Verrocchio's workshop. Leonardo and perhaps also Perugino were fellow pupils. After Verrocchio had received the commission to cast the equestrian statue of Colleoni in 1479, he left Credi in charge of his Florentine workshop.

In his will (June 25, 1488), Verrocchio named Credi as both executor and beneficiary. Vasari tells of Lorenzo's enthusiasm for Leonardo's *maniera*, which he was occasionally able to imitate very deceptively. When Leonardo moved to Milan in 1483, not to return to Florence until 1500, Lorenzo was, in a sense, his representative on the Arno and a model for other artists such as Raffaellino del Garbo, Perugino and the young Raphael. However, as a student of Verrocchio, Lorenzo often retained the latter's realism and harder *disegno*, in which he often came close to Pollaiuolo and Ghirlandaio. His portraits are an outstanding part of his oeuvre. He liked to transfigure and soften their realism with Leonardo's manner of shading (*sfumato*).

43a. Lorenzo di Credi
Bust of an Old Man
Louvre, Paris

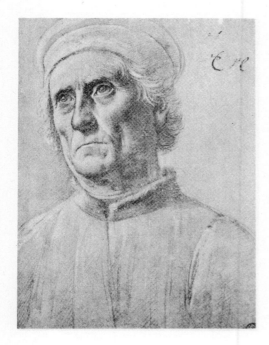

43

BEARDED SAINT
Metalpoint, heightened with white, on ochre prepared paper; 15.6 × 16.5 cm; inv. 4.871, R.25; lilac strip about 7 mm wide added at top; pen and ink framing line

Provenance: P. J. Mariette, L.2097; Duke Albert of Saxe-Teschen, L.174

Bibliography: Basan 1775, under no. 381; Waagen 1867, II, p. 143; Schönbrunner-Meder, no. 589; Wickhoff 1892, ScR.106; Alb.Cat. III, 1932, R.25; Degenhart 1932, p. 154; Berenson 1938, no. 732; G. Dalli Regoli, *Lorenzo di Credi*, Pisa, 1966, p. 153; Alb.Vienna 1971, Meisterzeichnungen, no. 3.

The sheet's traditional attribution to Lorenzo di Credi, which Waagen had also upheld, was recently doubted. Wickhoff and Meder gave the drawing to an older Florentine contemporary of Lorenzo, and Scharf, in an oral opinion, described it as very close to Raffaellino del Garbo, a pupil of Filippino Lippi. Raffaellino, like Filippino, was influenced by the later works of Filippo Lippi and Verrocchio, but like Lorenzo di Credi he followed Leonardo's harmonious and ideal expression. Stix gave the sheet to an anonymous Florentine master active around 1470, Degenhart to Tommaso di Stefano, a pupil of Lorenzo. Only Berenson and most recently Dalli Regoli retained the original attribution to Credi, whereby the latter was thinking of the master's late period.

As with many of his drawings, the clarity of line in this sheet reveals Credi's roots in goldsmithing and the precise finish that Vasari ascribed to him. Leonardo's influence may be seen in the manner of shading. Admittedly, this *sfumato* is harder and more sculptural in the spirit of traditional Florentine *disegno* than in comparable drawings by his greater contemporary.

One must agree with Wickhoff, Meder and Stix that the type and character of the depicted saint relate to older models, above all to late works by Fra Filippo Lippi, who had also influenced Verrocchio, Botticelli and Filippino Lippi.[1] The Albertina saint's head is therefore probably to be seen as an early work by Lorenzo, like the *Bust of an Old Man* in the Louvre that was perhaps a study in contemporary costume for the figure of Saint Donatus in the *Sacra Conversazione* altarpiece in Pistoia Cathedral, which was commissioned from Verrocchio around 1479 and finished in his workshop by Credi around 1485.[2] The drawing of the prophet David in Berlin, once attributed to Botticelli, may also be compared in character and expression to the study in the Albertina.[3]

All his life Lorenzo used a many-sided repertoire of types and modes of expression. In his studies one may thus encounter Leonardo's idealizing approach, Botticelli's rapture, or Perugino's *espressione languida* alongside the more realistic expression in drawings of heads by Verrocchio, Pollaiuolo and Ghirlandaio, or, looking further back, those by Benozzo Gozzoli, whose frescoes of the Three Kings (Palazzo Medici Riccardi, Florence) with their realistic group portraits inspired Credi in several different ways.

E.K.

Notes
1. Related heads may be found in the *Coronation of the Virgin* from Sant' Ambrogio in the Uffizi, the frescoes by Filippo in Prato Cathedral, the panel showing the Lamentation of Saint Jerome in Prato Cathedral, the paintings of the *Adoration of the Child* previously in the Kaiser-Friedrich-Museum in Berlin and in the Uffizi in Florence, as well as in the apse frescoes of Spoleto Cathedral, the last work by Frato that was completed after his death in 1469 by Fra Diamante. See Oertel 1942, figs. 43, 74–82, 94, 115, 117, 122–25.
2. This altarpiece was already ascribed by Vasari to Lorenzo Credi. See Dalli Regoli 1966, p. 11–17, figs. 56–58, nos. 22, 30.
3. Ibid., fig. 34, no. 21; Oertel 1942.

43b. Lorenzo di Credi
Sacra Conversazione
Cathedral, Pistoia

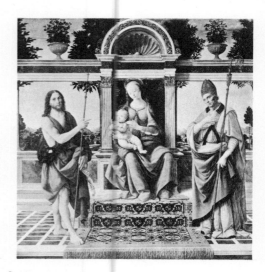

43c. Lorenzo di Credi
Prophet David
Staatliche Museen, Berlin

44

BUST OF A YOUTH WITH LONG HAIR
Metalpoint, heightened with brush and white,
on yellow-gray prepared paper; 22.8 × 14.9 cm;
inv. 24.414, R.28

Provenance: W. Mayor, L.2799; acquired 1923

Bibliography: Stix 1925, no. 39; Alb.Cat. III, 1932,
R.28; B. Berenson, *I Disegni dei Pittori Fiorentini*,
Milan, 1961, 732A; Benesch 1964,
Meisterzeichnungen, no. 6; G. Dalli Regoli,
Lorenzo di Credi, Pisa, 1966, p. 138, no. 77.

In this drawing the graphic value of precise line
and the white heightenings that lend plasticity to
the face work together in the individual manner
typical of Lorenzo di Credi. The locks of hair fall
in a silky sheen of glimmering light. The face
presents itself in firm, clear contours, but the
strokes diminish toward the upper and lower
margins, so that the attention of the viewer is
focused fully on the face. The boy seems to be
turning his head to listen, but without meeting
the gaze of the viewer. The alert, clear eyes are a
striking and attractive feature of Credi's por-
traits. They endow the sitter with an independent
self-awareness.

Compared with a similar study in the British
Museum,[1] the Albertina sheet has a slightly more
delicate, harmoniously resolved surface. Lorenzo
di Credi acquired his sense of plastic form
in Verrocchio's workshop, where his master
was an example not only as painter but mainly
as a sculptor. *V.B.*

Notes
1. British Museum, Department of Prints and
 Drawings, inv. 1895-9-462; B. Degenhart,
 "Studien über Lorenzo di Credi's
 Porträtdarstellungen, II," *Pantheon* 7/8 (1931),
 p. 463.

Domenico Ghirlandaio
Florence 1449–1494 Florence

Like many painters of his time, Domenico di
Tommaso Bigordi Ghirlandaio began as a gold-
smith. He and his father were named Ghirlandaio
after the popular headgear that his father
produced for the Florentine girls.

His religious and church paintings gave lasting
life to the festive pomp and glittering life style of
contemporary Florentine society; for example,
the large fresco cycles in Santa Trinita and Santa
Maria Novella unite Masaccio's and Castagnola's
monumental figure style with Benozzo Gozzoli's
and Filippo Lippi's pleasure in narrative. He
owed less to his teacher Alessio Baldovinetti.

His stays in Rome in 1475 and 1481–82 were
important for the development of his monumental
and powerfully architectural style. In Rome he
painted two murals in the Sistine Chapel and
studied the monuments of the Antique.

Painting is drawing, Ghirlandaio used to say,
thereby anticipating the view of his pupil
Michelangelo. His drawings are rigorous and
vigorous. He achieved perfection in the ideal of
disegno fiorentino, the clear rendering of body and
space by contour and hatching.

In the three-dimensional articulation of his
individual studies, Ghirlandaio often used cross-
hatching as Michelangelo, Raphael and Fra
Bartolomeo later did. He was also like them in
preparing his paintings through many sketches
and studies, of which, however, relatively few
survive today.

45

THE ANGEL APPEARING TO ZACHARIAS
Pen and bistre ink with brown and gray washes;
25.7 × 37.4 cm; inv. 4860, R.26
Signed "Ghirlandaio" at lower center; signature
and original inscriptions "Giuliano" and
"Giovanni Francesco" in pen and the same ink
as the drawing on two of the figures at right

Provenance: P. J. Mariette, L.1852; Moriz von
Fries, L.2903; Duke Albert of Saxe-Teschen,
L.174

Bibliography: Basan 1775, p. 70, no. 438; Wickhoff
1892, ScR.102; Schönbrunner-Meder, no. 216;
Meder, Handzeichnung, fig. 300; Meder 1923,
pl. 3; Alb.Cat. III, 1932, R.26; Berenson 1938,
no. 891; London 1948, no. 12; Paris 1950, no. 9;
Benesch 1964, Meisterzeichnungen, no. 9;
Alb.Vienna 1971, Meisterzeichnungen, no. 6;
Knab-Mitsch-Oberhuber 1983, no. 39.

The drawing is a study for the last fresco on the
right wall of the choir in the Florentine church of
Santa Maria Novella.[1] The fresco carries a dedi-
cation by Poliziano with the year 1490 above the
triumphal arch in the right background.[2]

The painting is located to the right of the fresco
with the meeting of Elizabeth and Mary, for which
preparatory drawings also survive. Ghirlandaio
began the fresco cycle in 1486, decorating the
choir walls and vaults with scenes from the lives of
Saint Mary and Saint John the Baptist. Giovanni
Tornabuoni, a banker and relative of the Medicis,
commissioned the work in 1485. He and many of

Baccio della Porta, called Fra Bartolomeo
Florence 1472–1517 Pian di Mugnone/
Florence

He entered Cosimo Roselli's workshop in 1484
and remained there until 1490, when he set
himself up as an independent with Mariotto
Albertinelli. Under the influence of Savonarola he
burnt all his paintings on secular themes and
entered the Dominican Order in 1500, first in
Prato and later in the Florentine monastery of San
Marco. He took up painting again around 1504.
While visiting Venice in 1508 he was newly
stimulated by the paintings of Giovanni Bellini
which awakened Fra Bartolomeo's interest in land-
scape. His tendency towards Michelangelesque
monumentality was reinforced by a stay in Rome
in 1514. Together with Andrea del Sarto, Fra
Bartolomeo was one of the leading masters of the
Florentine High Renaissance.

his relatives and friends are represented in the
accessory figures and groups in the narratives of
the saints. This is also true of the *Annunciation to
Zechariah* in which the main event is almost
overwhelmed by the representation of high
society. Although their features are indistinguish-
able and rendered in a schematic, almost geomet-
ric manner, two of the patron's relatives, Giulio
and Gianfrancesco Tornabuoni, are already noted
on the drawing. The patron, to the left of the
angel, is even less recognizable and in a different
pose from the finished fresco, in which Ghirlandaio
substantially expanded the group portraits,
showing the philosopher Marsilio Ficino, the
Dante exegete Cristoforo Landino, the poet
Angelo Poliziano and Lorenzo the Magnificent's
tutor, Gentile de' Becchi, below the group around
Giovanni Tornabuoni. Benedetto di Luca
Landucci identified the individuals in the fresco in
1561 when he was eighty-nine years old.[3]

The architectural frame in the drawing cor-
responds to the one in the painting, although the
reliefs on the temple walls, which were derived
from antique monuments and arches, were prob-
ably altered, not altogether happily, by an
apprentice. Although the building, which repre-
sents the temple, was inspired by Brunelleschi's
Pazzi Chapel in the crossing of Sante Croce, it
reveals Ghirlandaio's own architectural imag-
ination, which is more apparent in the drawing. In
all, this sheet is one of the liveliest works by the
great fresco painter. In addition to the rigorous
disegno, it also does justice to the painterly
element, the atmospheric washes and loose line. In
this it is close to early sketches by Raphael, an
artist who learned from Ghirlandaio.[4] *E.K.*

45a. Domenico Ghirlandaio
The Angel and Zacharias
Sta. Maria Novella, Florence

Notes

1. See, among others: Van Marle 1931, XII/XIII,
 p. 1 ff; Swoboda 1979, Renaissance, p. 38–41;
 Rosenauer 1965, 1969, 1972; Knab-Mitsch-
 Oberhuber 1983, p. 37–40.
2. "An. MCCCCLXXX, quo pulcherrima civitas
 opibus Victoriis artibus aedificiisque nobilis
 copia salubritate pace perfruebatur."
3. L. Landucci, *Diario fiorentino dal 1450–1516*
 (Florence, 1883); Lauts 1943, p. 54, pl. 79–82.
4. See: Knab-Mitsch-Oberhuber 1983,
 p. 37–40, 45.

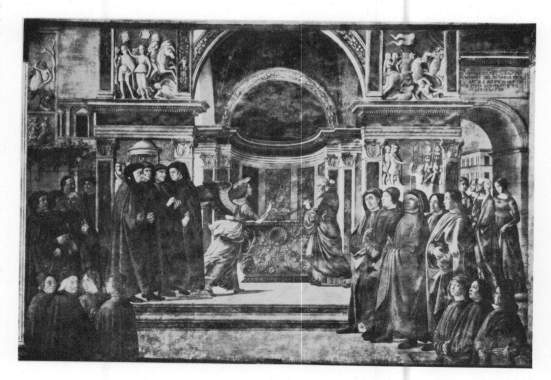

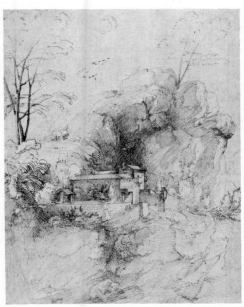

46

BUILDINGS AT THE FOOT OF A CLIFF
Pen and bistre ink; 25.9 × 20.8 cm;
inv. 270, R.150

Provenance: Duke Albert of Saxe-Teschen, L.174

Bibliography: J. D. Passavant, *Rafael von Urbino
und sein Vater Giovanni Sant*, II, Leipzig 1893,
p. 445, no. 237; Waagen, *Kunstwerke und Künstler
in Wien*, II, p. 150, 247; *Weigels Kunstkatalog*, I,
Vienna, 1838/II, 1843, no. 7392, 7397; Wickhoff
1891, ScR.322; Fischel 1898, no. 637;
H. v. Gabelentz, *Fra Bartolomeo und die Florentiner
Renaissance*, Leipzig, 1922, no. 860; Alb.Cat. III,
1932, R.150; I. Härth, "Zu Landschaftszeichnungen
Fra Bartolomeos und seines Kreises," *Mitteilungen
des Kunsthistorischen Institutes Florenz* 9 (1959),
p. 129; B. Berenson, *I Disegni dei Pittori Fiorentini*,
Milan, 1961, no. 511A; Benesch 1964, Meisterzeich-
nungen, no. 19; Koschatzky-Oberhuber-Knab
1971, no. 28; Alb.Vienna 1975, no. 21.

There seems to be no access to the group of
buildings nestled in the cliffs. Surrounded by
thickets and precipitous rockfaces, the site shields
itself from any intruder. The relationship of the
size of the trees to the building is unusual and this
creates tension between the vegetation, the
towering cliffs and the buildings, which, in this
environment, have a fairytale appearance.

The drawing was previously attributed to
both Andrea del Sarto and Raphael. Since the
sketchbook of Cavaliere Francesco Maria Nicolo
Gaburri (1675–1742) was auctioned in London in
1957,[1] more is known about Fra Bartolomeo's
landscape drawings, which were primarily studies
after nature. In the Albertina drawing, however,
Fra Bartolomeo fused natural occurrences with an
impulse to stylize, which is reminiscent of A.
Altdorfer and the Danube School. Along with
Dürer's travel sketches, Fra Bartolomeo's draw-
ings influenced the future development of Italian
landscape. Dürer was in Venice in 1506, Fra
Bartolomeo two years later. This drawing prob-
ably dates from the same period. I. Härth pointed
out that Fra Bartolomeo's landscape sketches
were used and copied by his students. One of these
sheets shows the monastery buildings as a motif in
a more expansive landscape. *V.B.*

Notes
1. Sotheby's auction catalogue, November 20,
 1957, introduced by Carmen Gronau.

Francesco Bonsignori
Verona c.1460–1519 Verona

First documented works from 1483. Around 1488
Francesco Gonzaga summoned Bonsignori to the
Mantuan court to paint, according to Vasari,
altarpieces and portraits. His early works are
noticeably influenced by Mantegna. Besides visit-
ing Venice he worked primarily in Verona.

47

BUST OF A YOUNG MAN
Black chalk on brownish paper; 39.8 × 31.5 cm;
inv. 1.453, V.84; the shoulder and sleeve at the
left margin were reworked by another hand

Provenance: Duke Albert of Saxe-Teschen, L.174

Bibliography: Wickhoff 1891, ScV.10;
Schönbrunner-Meder, no. 487; D. v. Hadeln,
Venezianische Zeichnungen des Quattrocento, Berlin,
1925; Alb.Cat. I, 1926, V.84; A. Venturi, *Studi
dal vero*, Milan, 1927, p. 268; J. Byam Shaw, *Old
Master Drawings*, II (March 1928), London, p. 54;
R. v. Marle, *Italian Schools of Paintings, XVII*,
The Hague, 1935, p. 352; H. Tietze, E. Tietze-
Conrat, *The Drawings of the Venetian Painters*,
New York, 1944, no. A 326; A. Banti-Boschetto,
Lorenzo Lotto, Florence, n.d., p. 119; E. Tietze-
Conrat "A Gonzaga Portrait by F. Bonsignori,"
Critica d'arte VIII (1949), p. 218; B. Berenson,
Lorenzo Lotto, London, 1956, p. 47;
U. B. Schmitt, Francesco Bonsignori," *Münchner
Jahrbuch der bildenden Kunst* 12 (1961), p. 89,
no. 27; Venice 1961, no. 10; Benesch 1964,
Meisterzeichnungen, no. 14; Moscow 1973,
p. 73.

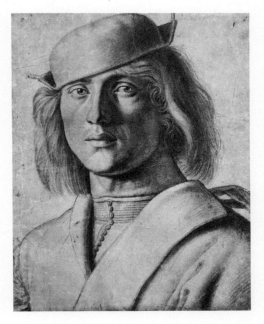

Wickhoff was the first to attribute the sheet to
Bonsignori. Others saw this drawing as a work by
Giovanni Bellini, while Fiocco and Berenson
argued for Lorenzo Lotto because of its re-
semblance to the Onigo tomb in S. Niccolo in
Treviso. Based on this, the sheet would be an
early work by Lotto from the first years of the
sixteenth century.

In 1961 Schmitt reverted to the old attribution
to Bonsignori, which Tietze-Conrat had already
confirmed in 1949. It is generally agreed that this
is probably a portrait of the fabled ancestor,
Adhelbertus Gonzaga, the third marchese of
Mantua, whose portrait appeared as the third
engraving in A. Possevino's *Gonzaga Iconography*
of 1617.[1]

Bonsignori was active at the Mantuan court
from about 1488; this drawing could have been
done there before his death in 1519. It may in fact
have been known to Possevino, given that it was
still in Mantua 100 years later. Tietze-Conrat
assumes that the Gonzaga's owned other genea-
logical images that would have been available
to later historiographers. There is also no firm
proof that this life study was used for an ideal-
ized portrait of a long-since deceased ancestor
in Possevino's genealogy. Nevertheless,
Bonsignori's many years of activity in Mantua as
well as the resemblance to the engraved portrait
and to a portrait study of a Gonzaga in the
Cooper-Hewitt Museum in New York[2] reinforce
the identification of the image.

Bonsignori's portraiture style is indebted to
works by Antonello da Messina, who captured the
expressiveness and drama of the human face in
close-up. *V.B.*

Notes
1. Doct. Antonii Possevini . . . Gonzaga. Calci
 operis addita genealogia totius Familiae,
 Mantuae apud Osamos Typographos Ducales,
 1617, in J. Wilde, "Zum Werke des Domenico
 Fetti," *Wiener Jahrbuch für Kunstgeschichte* 10
 (1936), p. 216, n. 19.
2. Cooper-Hewitt Museum, New York,
 inv. 1901-39-107; black chalk; 36.4 × 24.9 cm;
 U. B. Schmitt, "Francesco Bonsignori,"
 Münchner Jahrbuch der bildenden Kunst 12
 (1961), no. 26, fig. 20.

Michelangelo Buonarroti
Caprese (near Sansepolcro) 1475–1564
Rome

Michelangelo grew up in Florence. In 1488 he learned the rudiments of painting and drawing from Domenico Ghirlandaio. In 1489 Lorenzo de' Medici, "Il Magnifico," accepted Michelangelo into his academy where he was trained as a sculptor under Bertoldo, a pupil of Donatello. When the Medicis were expelled from Florence (1494) Michelangelo went to Bologna. Two years later he traveled to Rome for the first time. Back in Florence in 1501, he created his *David*, the cartoon for the *Battle of Cascina* and other works that inspired many artists, including Raphael.

Pope Julius II summoned Michelangelo to Rome in 1505 and commissioned his tomb, which was not completed until four decades later, and then only in a substantially reduced form. Michelangelo quarreled with the Pope in April 1506 and fled to Florence. In November he was called to Bologna to cast a bronze statue of Julius, which was finished in 1508; it was destroyed by the Pope's opponents in 1511. Michelangelo returned to Rome in 1508 to decorate the ceiling of the Sistine Chapel; the frescoes were unveiled October 31, 1512. In the same year, the Medicis returned to Florence. On February 21, 1513, Julius II died. Michelangelo continued to work on the Pope's tomb for a few years; he returned to Florence in August 1516.

Pope Leo X commissioned him to build the facade of San Lorenzo, but this did not get beyond the preparatory stage. In 1519/20 Michelangelo created the statue of Christ for the Roman church of Santa Maria sopra Minerva. He worked on the Medici tombs in San Lorenzo from 1520 to 1534; from 1524 to 1534 he built the vestibule and the reading room of the Laurentian Library, he did not design the staircase until 1559/60. The Medicis were again expelled from Florence in 1527 and the city became, for the last time, a republic. During the city's defense against imperial and papal troops in 1528/29 Michelangelo served as a military architect. In 1530 Florence was forced to capitulate, the Medicis returned and Michelangelo continued with his interrupted work.

The Popes Clement VII and Paul III gave him the commission for the fresco of the *Last Judgement* on the altar wall of the Sistine Chapel, which was unveiled on October 31, 1541. In 1538 he made his first designs for the Capitol, which were carried out after his death by Giacomo della Porta. In the years 1542–50 he painted the frescoes of the *Conversion of Saint Paul* and the *Crucifixion of Saint Peter* in the Capella Paolina in the Vatican. He completed the Palazzo Farnese in 1546/47, and was named architect of Saint Peter's by Paul III in 1547. In this capacity he gave final form to the cupola begun by Bramante. It was not until 1590 that the vault was executed, when his pupil, Giacomo della Porta, slightly changed Michelangelo's plan by extending the cupola. The marble group of the *Lamentation of Christ*, installed in the Florence Cathedral, dates from between 1547 and 1553. Michelangelo intended it for his own tomb, and it was later called *Palestrina's Pietà*. From 1555 until a few days before his death Michelangelo worked on the unfinished *Rondanini Pietà*, which is in the Castel Sforzesco in Milan today. In his last years he also designed the *Porta Pia* (1561) and the church and cloister of Santa Maria degli Angeli in the Baths of Diocletian. He died on February 18, 1564, in Rome.

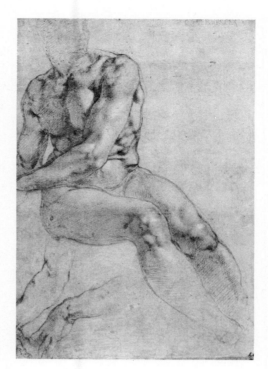

48

SEATED MALE NUDE
Light and dark red chalks, heightened with white; 26.8 × 18.8 cm; inv. 120, R.142
Inscribed "C. P. P. Rubbens" (owner's autograph) in leadpoint at upper right, "50" in ink at lower right

Provenance: P. P. Rubens; P. J. Mariette, L.1852; Charles Prince de Ligne, L.592; Duke Albert of Saxe-Teschen, L.174

Bibliography: Bartsch 1794, p. 35, no. 5; Wickhoff 1892, ScR.155 recto; Thode 1908–13, no. 1527; Alb.Cat. III, 1932, L.142 Wilde 1953, p. 19; Berenson 1938, no. 1748 A; Dussler 1959, no. 701; Koschatzky-Oberhuber-Knab 1971, no. 26; Hartt 1975, no. 105 Paris 1975, no. 19; Alb.Vienna 1975, no. V; Australia 1977, no. 6.

A study for the *Ignudo* to the left above the Persian Sibyl on the ceiling of the Sistine Chapel. The arms and hands are repeated below the figure. The emerging, softly modeled head reflects the great sculptor's working method, as if he created the head out of the stone and then translated it into the medium of red chalk.

Michelangelo returned to Rome in the spring of 1508 in order to resume work on Julius II's tomb. But the Pope had other ideas and commissioned the ceiling frescoes in the Sistine Chapel; Michelangelo was occupied with this task until 1512. The paintings have been repeatedly and justly described as the work of a frustrated sculptor, and it is very understandable that Michelangelo drew inspiration from the statues that he had devised for the Julian tomb; this is evident in the drawings.

The final section of work on the ceiling began with the Persian Sibyl. Hartt therefore dated this study for the *Ignudo* to 1511, noting that its high degree of finish was a foretaste of the presentation drawings from the early 1530s. Michelangelo dedicated these drawings to Tommaso Cavalieri and other friends. The same may be said for some other studies for the Sistine ceiling, of which relatively few have survived, either because they were destroyed during the working process or were consigned to the flames by the artist, which happened in 1517 (after Michelangelo's return to Florence from Rome) and shortly before his death.

From the time of the studies for the *Battle of Cascina* (1504–05) Michelangelo increasingly used red and black chalks. In 1510 and 1511, while working on the Sistine Chapel, he came to prefer red chalk more and more for coloristic reasons.

E.K.

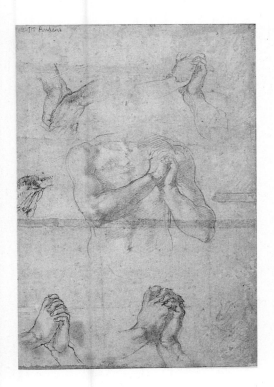

48 (VERSO)

STUDY SHEET WITH A TORSO AND FOLDED
HANDS
Stylus, red chalk, partly worked up in pen and
ink, the back of the hand at left drawn with pen
alone; a diagonal strip added at lower margin;
further old restorations
Inscribed "Coll. P. P. Rubens" at upper left in
chalk
Verso of cat. no. 48

Bibliography: Wickhoff 1892, ScR.155 verso;
Hartt 1977, no. 72; for further literature see cat.
no. 48.

Even though Eve crosses her arms and has an
oblique *contraposto* pose in the fresco, Hartt
conjectures that Michelangelo drew these studies
in connection with the figure of Eve from the
Expulsion from Paradise (Sistine ceiling). Clearly
Michelangelo chose the final figure from among
several study sheets. As Wilde and Hartt observed,
Sebastiano del Piombo, whom Michelangelo
helped repeatedly, used these studies in their
present form for the mourning Virgin in his
painting *Pietà* in the museum at Viterbo.[1] *E.K.*

Notes
1. Hartt suspects that Sebastiano del Piombo
 added the hand studies at the lower margin;
 at least the pen outlines could be from his
 hand. The aforementioned painting in Viterbo
 is dated c.1517.

Raphael Santi
Urbino 1483–1520 Rome

Born March 28 or April 6, the son of Giovanni
Santi and Magia Ciarla, the artist first received
artistic training from his father, who died in 1494.
He was a pupil in the workshop of Pietro Vanucci
— called Il Perugino — in Perugia from 1494 to
1496(?); from 1505 to 1508 he was active primarily
in Florence (cf. Giovanna da Montefeltre's letter
of recommendation to Piero Soderini in Florence,
October 1, 1504). At the end of 1508, Raphael
moved to Rome where he was primarily in the
service of Popes Julius II (died 1513) and Leo X, as
well as the banker Agostino Chigi. In 1509 he was
appointed Writer of the Papal Briefs and in 1514,
after Bramante's death, Architect of St. Peter's.
The artist was made Commissary of Antiquities in
Rome in 1515. Raphael maintained a large work-
shop for the execution of numerous commissions;
his most important assistants were Giulio Romano
and Giovanni Francesco Penni. On Good Friday,
April 6, 1520, Raphael died of a "long and serious
fever." He was buried in the Pantheon.

49a. Raphael Santi
Madonna with Child in Landscape
Louvre, Paris

49

MADONNA OF THE BALDACCHINO
Pen and red-brown ink on reddish ground;
17.6 × 13.7 cm; inv. 202, R.54; a narrow strip of
paper added at right
Inscribed "Raphael Urb" lower right in pen

Provenance: T. Viti; P. Crozat; Gouvernet; Julien
de Parme; Duke Albert of Saxe-Teschen, L.174
Bibliography: Passavant 1860, II, p. 435, no. 192;
Ruland 1876, p. 94, XXXIII, no. 4; Crowe-
Cavalcaselle 1883, I, p. 295; Koopmann 1890,
p. 61; Morelli 1891/92, p. 573, no. 150; Wickhoff
1892, ScR.242; Dollmayr 1895; Koopmann 1897,
no. 97; Fischel 1898, no. 453; Schönbrunner-
Meder, no. 742; Fischel 1922, III, no. 150;
Alb.Cat. III, 1932, R.54; London 1948, no. 26;
Alb.Vienna 1983, no. 13; Knab-Mitsch-
Oberhuber 1983, no. 268; Joannides 1983, no. 168.

This drawing is related to Raphael's painting of
the Madonna del Baldacchino in the Pitti Palace in
Florence. A study for the painting at Chatsworth[1]
shows the Madonna without her architectural
niche but with the hovering pair of angels in a
form related to the Albertina's drawing. The
Albertina sheet is, however, not a *sacra conver-
sazione*; rather it shows the Madonna seated in
front of a landscape surrounded by a crowd of
praying angels, whose arrangement almost exactly
matches that in the sheet at Chantilly with the
exception of the Madonna's pose.[2] Great simi-
larities to the Madonna and Child, and to the
depth of the landscape view in the Albertina
drawing can also be found in a sheet in the Louvre
that shows a strong Leonardesque influence.[3]
Its pronounced painterly character derives from
the generous bistre washes that also characterize
the study for St. Bernard in the Madonna del
Baldacchino (Uffizi, Florence).[4] Our sheet
achieves a similar effect through the free, loose
pen strokes. The pointed profile at right, often
falsely identified as St. Joseph, is most closely
related in style to the chalk underdrawing of
Adam on a sheet in the Louvre.[5] *E.M.*

Notes
1. Fischel 1922, III, no. 143.
2. Ibid., no. 159.
3. Ibid., no. 144.
4. Ibid., no. 148.
5. Ibid., no. 244.

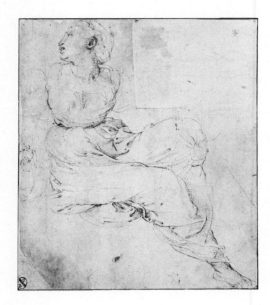

50

SEATED MUSE (TERPSICHORE)
Pen and brown ink; 24.7 × 21.9 cm; inv. 220,
R.66
Lower left corner repaired; a largish piece of
paper added to upper right

Provenance: T. Viti; P. Crozat; Gouvernet; Julien
de Parme; Charles Prince de Ligne, L.592; Duke
Albert of Saxe-Teschen, L.174.

Bibliography: Bartsch 1794, p. 6, no. 13;
Passavant 1860, II, p. 438, no. 203; Waagen
1867, II, p. 146, no. 211; Grimm 1872, p. 307;
Ruland 1876, p. 187, no. 74; Lübke 1878/79, II,
p. 267; Crowe-Cavalcaselle 1883, II, p. 68;
Springer 1883, I, p. 231; Morelli 1891/92, p. 573,
no. 170; Wickhoff 1892, ScR.263; Fischel 1898,
no. 112; Schöbrunner-Meder, no. 444; Fischel V,
1924, no. 251; Alb.Cat. III, 1932, R.66;
Ueberwasser 1948, p. 10; Becatti 1968, p. 526 ff;
Forlani-Tempesti 1969, p. 382; Pope-Hennessy
1970, p. 140 ff; Dussler 1971, p. 75; Alb.Vienna
1983, no. 28; Knab-Mitsch-Oberhuber 1983, no.
376; Joannides 1983, no. 239.

This is a study for the Muse on Apollo's right in
the Parnassus fresco of the Stanza della Segnatura
in the Vatican, executed in 1509–11. The pose,
with the figure supported by her right arm and
holding the lyre in her left, is modeled after the
Antique (Achilles Sarcophagus).[1] Only in the
fresco does the figure have the lyre; in the draw-
ing her left hand still holds her knee, giving the
impression of an unforced study after nature.
H. Grimm has also noted that the raised position
of the arm in the fresco is also suggested in
the drawing.

Morelli ascribed the drawing to Giulio
Romano, but as early as 1898 Fischel defended
Raphael's authorship. While the style of the
drapery folds admittedly differs from the prepara-
tory drawing for the Muse Calliope (Albertina
Collection, inv. 219), which is derived from the
antique statue of the sleeping Ariadne in the
Vatican, it corresponds closely to the back view
on the verso of the Calliope sheet (which Fischel
erroneously gave as the verso of the drawing
under discussion). Drapery studies were of second-
ary importance during Raphael's Florentine
period but played an important role in the
preparation of the frescoes of the Stanza della
Segnatura, especially the Parnassus scene. A large
number have survived in which "the allure of
drapery dawned as it were in a praxitelean way"
on Raphael.[2]

According to recent research, the Muse,
previously identified as Erato, represents
Terpsichore.[3] *E.M.*

Notes
1. Achilles Sarcophagus, Louvre, Paris; Fischel
 1948, fig. 80.
2. Fischel I–VIII, p. 288.
3. E. Schroeter, *Die Ikonographie des Themas Parnass
 vor Raphael, Studien zur Kunstgeschichte*, VI,
 (New York: Hildesheim, 1977).

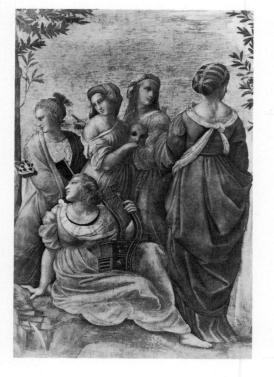

50a. Raphael Santi
Detail from *Stanza della Segnatura*
Vatican, Rome

TWO STUDIES OF MALE NUDES
Red chalk, traces of metalpoint; 40.1 × 28.2 cm;
inv. 17.575, R.74
Inscribed "1515 / Raffahell de Vrbin der so hoch
peim / popst geacht ist gewest hat der hat / dyse
nackette bild gemacht Und hat / sy dem albrecht
dürer gen nornberg / geschickt Im sein hand zw
weisen"[1] in ink in Albrecht Dürer's hand

Provenance: A. Dürer; W. Imhoff; Rudolf II;
Imperial Treasury; Imperial Court Library;
Duke Albert of Saxe-Teschen; 1822 Estate
inventory, p. 14; L.174

Bibliography: Fuessli 1801, p. 207 ff; Passavant
1860, II, p. 162a, 443, no. 225; Waagen 1867,
p. 149, no. 235; Ruland 1876, IV, p. 210, no. 5;
Lübke 1878/79, II, p. 305; Crowe-Cavalcaselle
1883, II, p. 211; Springer 1883, II, p. 78, 131;
Thausing 1884, II, p. 92 ff; Grimm 1886, p. 402;
Morelli 1891/92, p. 574, no. 176; Wickhoff 1892,
ScR.282; Dollmayr 1895, p. 249; Koopmann
1895, p. II, XXI ff; Schönbrunner-Meder,
no. 155; Fischel 1898, no. 199; Venturi 1927,
no. 44; Weixlgärtner 1927, p. 164 ff; Alb.Cat. III,
1932, R.74; Hartt 1944, p. 71, note 17, p. 73,
note 21; Panofsky 1948, p. 284; London 1948,
no. 31; Redig de Campos 1950, p. 59; Hartt
1958, p. 21 ff, 287, no. 9; Shearman 1959, p. 458;
Freeberg 1961, p. 297; Oberhuber 1962, p. 46;
Shearman 1964, p. 84; Shearman 1965, p. 175;
Dussler 1966, p. 94; Cocke 1969, pl. 125;
Forlani-Tempesti 1969, p. 407; Marabottini
1969, p. 223; Fischel-Oberhuber 1972, IX,
no. 426, pl. 29; Oberhuber 1972, no. 39; Kaplan
1974, p. 50 ff; Siblik 1974, p. 28, no. 55;
Alb.Vienna 1975, no. 32; Alb.Vienna 1983,
no. 39, Knab-Mitsch-Oberhuber 1983, no. 504;
Joannides 1983, no. 371; Forlani-Tempesti 1983,
no. LIII.

No other drawing in the Albertina has engaged
Raphael scholarship as much as this one. There is
now an extraordinary amount of literature about
it. The main reason is undoubtedly Dürer's
inscription, which proves to be a unique docu-
ment on the relations and mutual influences
between the art (and artists) of the North and the
art of the South.

The authenticity of the inscription is now
unquestioned. The provenance can be traced back
by way of Emperor Rudolph II and Willibald
Imhoff to Dürer himself. Both Vasari's life of
Raphael and Dürer's diary of his journey in The
Netherlands tell of the relations between the two
artists and the exchange of works. Hans Rudolph
Fuessli's 1801 review of Duke Albert of Saxe-
Teschen's collection of prints and drawings
begins with a discussion of this sheet. Its excep-
tional quality as a nude study was further praised
by, among others, Passavant, Lübke and Springer.
To the nascent scientific-critical spirit of the
nineteenth century, however, this unusual docu-
ment seemed suspect. Morelli, whose opinion
carried much weight for nineteenth-century
research, was the first to declare the inscription
false and ascribe the drawing to Raphael's young
pupil Giulio Romano. It is remarkable, however,
that this judgment encountered opposition from
such critical contemporaries as Wickhoff and
Dollmayr, for Morelli's view has been influential
up until very recently. Fischel was clearly un-
decided. In an oral opinion quoted in the 1932
Albertina catalogue, he accepted Raphael's
authorship, but withdrew his opinion in his
1935 article on Raphael for Thieme-Becker's
Kunstlerlexikon.

In his 1958 monograph on the artist Hartt
attributed this drawing to Giulio Romano. The
critical debate on this publication, which was so
stimulating for Raphael scholarship, led to the
decisive steps in the reattribution of our drawing
to Raphael particularly through Shearman's
criticisms of Hartt and Oberhuber's detailed
analysis of Raphael's late work.

The combination of lively immediacy and
idealization in the figures, their powerful plas-
ticity and organic unity (despite an astonishing
richness of detail), the sensitivity to light, the
individuality and clarity of expression, and the
solid connections within the artist's oeuvre leave
virtually no doubt as to Raphael's authorship.

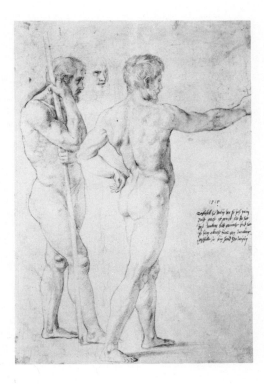

The sheet brings together two detailed studies
of male nudes whose heads are so similar that one
is tempted to assume a single model. Between
them there is a third face, but the flowing vertical
leadpoint lines suggest rather than define a figure.
Kriehuber's 1826 lithograph completes them as a
third standing man. The left figure is resting on a
staff, a common studio prop and a feature of other
drawings by Raphael.[2] The right figure with the
outstretched arm, on the other hand, is a study of
expressive gesture. It was used for the captain in
the fresco of the *Battle of Ostia* in the Stanza
dell'Incendio, probably executed by Giulio
Romano. The right foot of a figure, approxi-
mately the same height as the drawing's second
male nude study, can be seen standing behind this
one, the foot has been moved a little more to the
right, however.

In Kaplan's opinion the Albertina drawing was
a preparatory study for the Apostle Paul in the
tapestry cartoon of the *Blinding of Elymas.* The
correspondences are undeniable but there are also
serious differences — the left arm holding the
book is less sharply bent and the feet are in
completely different positions. *E.M.*

Notes
1. "1515, Raphael of Urbino, who is so much
 admired by the Pope, made this nude study
 and sent it to Albrecht Dürer to illustrate his
 hand to him."
2. For example, a study (Albertina Collection,
 inv. 4.883) for the Pythagoras group in the
 School of Athens; Alb.Vienna 1983, no. 25.

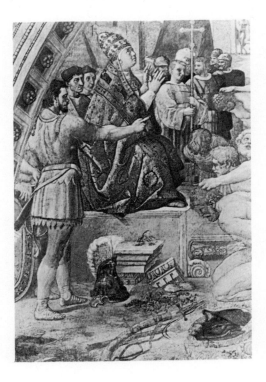

51a. Raphael Santi
Detail from *The Battle of Ostia*
Vatican, Rome

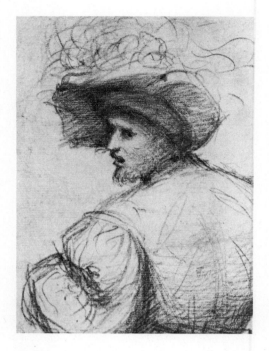

Giovanni Antonio de Sacchi, called
Il Pordenone
Pordenone 1484–1539 Ferrara

Il Pordenone, named after his birthplace, worked as a fresco painter in Cremona in 1520 and Piacenza around 1529/31, as well as in Friuli and Veneto. In 1526 journeyed south, probably to Rome. Influenced by Titian and German painting.

Ed. — Since the catalogue went to press, recent research (exhibition catalogue *Il Pordenone*, Pordenone, 1984) has revised the artist's dates to 1482–1539.

 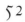

MAN WITH A PLUMED HAT
Red chalk; 15.6 × 11.8 cm; inv. 2.408, V.53

Provenance: Duke Albert of Saxe-Teschen, L.174

Bibliography: Wickhoff 1891, ScB.469; Alb.Cat. I, 1926, V.53; K. Schwarzweller, "Giovanni Antonio da Pordenone," Ph.D. Diss, Göttingen, 1935, p. 133; E. Tietze-Conrat, "Zwei venezianische Zeichnungen der Albertina," *Die Graphischen Künste*, New Ser. 2 (1937), p. 87; G. Fiocco, *Giovanni Antonio Pordenone* (first edition), Udine, 1939, p. 104, 154 (second edition, Pordenone, 1969, p. 133, fig. 101); H. Tietze, E. Tietze-Conrat, *The Drawings of the Venetian Painters*, New York, 1944, no. 1358; Venice 1961, p. 27–28; Benesch 1964, Meisterzeichnungen, no. 18; Koschatzky-Oberhuber-Knab 1971, no. 62; Vienna 1975, p. 100, no. 54; C. E. Cohen, "Pordenone's Cremona Passion Scenes and German Art," *Arte Lombarda* 42/43 (1975), p. 74–96; C. E. Cohen, *The Drawings of Giovanni Antonio da Pordenone* (Corpus graficum 3), Florence, 1980, p. 125; "Giornata di studio per il Pordenone," Piacenza, S. Maria di Campagna, September 26, 1981, a cura die Paolo Ceschi Lavagetto, p. 81.

Previously, this drawing was considered to be by Guercino. Wickhoff attributed it to Romanino; this opinion was still held in 1926 by Stix and Fröhlich-Bum. In 1937 Tietze-Conrat was able to identify positively the drawing as a preparatory study for Pordenone's important fresco *Crucifixion* in the Cremona Cathedral.

The *Crucifixion*, finished by October 1521 at the latest,[1] dramatically shows the moment when the sun darkened and the earth shook. The Albertina drawing is a study for a rider in the fresco whose horse is balancing on the edge of an open rift. In the sketchy lightness of the stroke one may still recognize details, such as the slash in the garment on the rider's back as he anxiously turns. The development of the artist's intention and the increasing tension in the action is visible in the preparatory studies.

A study in Modena[2] shows the figure from behind, sitting calmly on his horse, while another sheet in Paris[3] has the figure looking at the ground in alarm but not yet fully aware of what is going on around him. The spontaneity of the Albertina study also accentuates the psychological effect of the dramatic action. His gestures and the emotional values they express, which disguise crude mannerisms in various forms, and the modifications of northern iconographic motifs draw attention to Pordenone's close links with German art. *V.B.*

Notes
1. C. E. Cohen, "Pordenone's Cremona Passion Scenes and German Art, *Arte Lombarda* 42/43 (1975), p. 75.
2. Galleria Estense, Modena, inv. 887; C. E. Cohen, *The Drawings of Giovanni Antonio da Pordenone* (Florence, 1980), p. 99, fig. 17.
3. Louvre, Paris, inv. 5671; Ibid., p. 114, fig. 16.

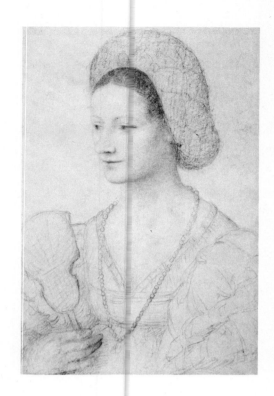

Bernardino Luini
Milan 1480–1532 Milan

Influenced by Borgognone, Bramantino and Vicenzo Foppa, but above all by Leonardo and his Milan circle, in which Luini played an important role as a draughtsman, easel and fresco painter. Other than Milan, the main centers of his activity were the Abbey Chiaravalle (the site of his earliest dated work, a Madonna fresco of 1512), and the Certosa at Pavia and the towns Luino, Saronno, Como and Lugano. Earlier authors, such as Padre Resta or Luigi Lanzi, thought they detected Raphael's influence in Luini's characteristic calm, sometimes even simple classicism transfiguring Leonardo's light and *sfumato*. Ottino della Chiesa most recently revived this opinion. However, the model of Borgognone and the early classicism of Lorenzo Costa, Francesco Francia and Perugino seem more relevant.

PORTRAIT OF A NOBLEWOMAN WITH A FAN
Black, brown, yellow and red chalks, heightened
with white, on white paper; 41.4 × 28.4 cm;
inv. 59, B.405

Provenance: Duke Albert of Saxe-Teschen, L.174

Bibliography: Wickhoff 1892, ScR.71;
Schönbrunner-Meder, no. 352; E. Schaeffer, "Un
disegno del Luini dell'Albertina di Vienna,"
Rassegna d'Arte 11 (1911), p. 144; L. Beltrami,
Bernardino Luini, Milan, 1911, p. 360; Alb.Cat.
VI, 1941, B.405; A. Ottino della Chiesa,
Bernardino Luini, Novara, 1956, p. 148, no. 41;
Benesch 1964, Meisterzeichnungen, no. II;
Koschatzky-Oberhuber-Knab 1971, no. 52; Paris
1975, no. 44; Alb.Vienna 1975, no. 44.

For a long time this drawing was actually
attributed to Leonardo, whose influence is dis-
tinguishable in the treatment of light and shade
(*sfumato*) gently transfiguring the sitter's features.
Wickhoff gave the sheet to an unidentified
Lombard master of the first half of the sixteenth
century. Frizzoni was the first to recognize Luini's
hand, as a note in the Albertina's *cahier* (files)
clearly indicates. Both Schäffer and Beltrami
pointed out the resemblance to the portrait of
Ippolita Sforza in the Milan monastery church of
San Maurizio and considered the drawing a
preparatory study.

In the large fresco cycle on the wall, the
portrait of Ippolita represented as a kneeling
donor surrounded by three standing female saints,
is situated in a lunette that divides the lay and the
monastic churches. On the other side of the altar
kneels her husband, Alessandro Bentivoglio,
amidst three male patron saints. Ippolita, a close
relative of the Milanese Duke Lodovico il Moro,
who also employed Leonardo, was one of the
leading intellectual and social women of her day.

53a. Bernardino Luini
Ippolita Sforza and Saints
San Maurizio, Milan

As with Isabella Gonzaga in Mantua, Elisabetta
Gonzaga in Urbino and Catarina Cornaro in
Asolo, a circle of scholars, artists and poets
gravitated to her. The poet Matteo Bandello, the
"Lombard Boccaccio," especially praised her
humanist knowledge and virtues and her feeling
for literature. Ippolita's husband came from the
well-known noble family that ruled Bologna.[1]

The frescoes in San Maurizio were executed
between 1522 and 1524. In 1522 the donors'
daughter, Alessandra Bentivoglio, entered the
Benedictine monastery (*Il Chiostro maggiore*)
attached to the church. Otto Benesch and Konrad
Oberhuber agree that the woman in the drawing
is not Ippolita Sforza, whose features in the fresco
do indeed appear fuller and more robust.
Oberhuber considers the more relaxed and gentle,
younger features of a portrait of a lady in the
National Gallery of Art, Washington, D.C., to
be a better comparison. Ottino della Chiesa
associates the National Gallery painting with a
more general group of Bentivoglio portraits,
which includes the young kneeling nun (depicting
Alessandra Bentivoglio[2]) in the painting of the
Madonna Filangieri in Naples. Benesch emphasizes
that the Albertina drawing was done for its own
sake, just as the younger Holbein's colored chalk
portraits and the no less famous "crayon" portraits
by Jean Clouet and his followers in France were.

In spite of these reservations, a general re-
lationship between the drawing and the figure in
the fresco cannot be wholly dismissed. Pose,
hairstyle and headgear, the luxuriously padded
dress and the hand (which, admittedly, lacks the
fan in the fresco) are very similar. Perhaps Luini
remembered this study when painting, even
though the drawing shows a younger Ippolita or
perhaps a lady from her circle. In any event, the
Albertina sheet is closer to the fresco than another
portrait study that has also been connected to
Ippolita — the Fogg Museum of Art, Harvard
University Art Museums, has a drawing which
depicts a similar costume.[3] E.K.

Notes

1. See: F. Malaguzzi-Valeri, *La Corte di Ludovico il
 Moro*, I–IV (Milan, 1913–23), I, p. 490,
 582 ff; Schäffer 1911, p. 144; L. Beltrami, "La
 Chiesa di San Maurizio in Milano," *Emporium* 9
 (1899), p. 58; U. Nebbia, "Note intorno alla
 Chiesa di San Maurizio al Monastero
 Maggiore," *Rassegna d'Arte* 11 (1911), p. 9–15.
2. Ottino della Chiesa, *Bernardino Luini*
 (Milan/Florence, 1953), figs. 80–83; Ottino
 della Chiesa, *Bernardino Luini* (Novara, 1956),
 p. 29 ff, 142, no. 254, pl. 85, 86, 162.
3. Ottino della Chiesa, *Bernardino Luini* (Novara,
 1956), p. 143, no. 3; *Vasari Society*, Second series,
 II (Oxford, 1921), pl. 8; A. Mongan and P. J.
 Sachs, *Drawings in the Fogg Museum of Art*
 (Cambridge, Mass., 1967), p. 118. Recently
 attributed to Giovanni Antonio Boltraffio.

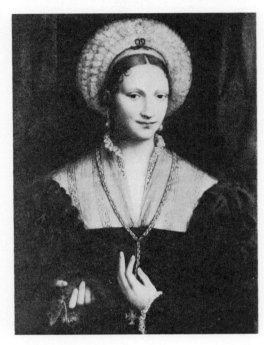

53b. Bernardino Luini
Portrait of a Lady
National Gallery of Art, Washington, D.C.,
Andrew W. Mellon Collection 1937

53c. Bernardino Luini(?)
Portrait of a Lady
Courtesy of the Fogg Art Museum, Harvard
University
Gift – The Hon. and Mrs. Robert Woods Bliss

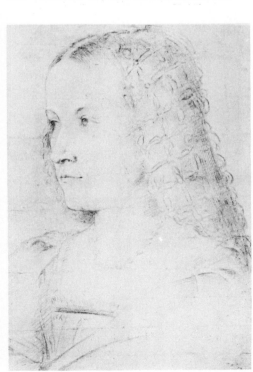

Perino del Vaga
Florence 1501–1547 Rome

Perino spent his youth in Florence, where he was a pupil of Andrea de Ceri. He subsequently trained with Ridolfo de Ghirlandaio. Around 1515 he went to Rome, where he worked in Raphael's workshop on the decoration of the Vatican Loggie. In 1523 Perino fled the plague in Rome and returned to Florence for a short time. In 1528 he moved to Genoa where he rose to be court painter in the service of Prince Andrea Doria. In 1536 he became consul of the Genoese painters' guild. Perino deserves the credit for having transmitted Raphaelesque forms of decoration to Genoa. In 1537/38 he returned to Rome.

THE MARTYRDOM OF THE TEN THOUSAND
Pen and brush with bistre ink and wash, heightened with white, on brown paper; 36.4 × 33.9 cm; inv. 2.933 ScL.384; lower left corner missing, line of a cut in the upper area

Provenance: P. J. Mariette, L.1852; Duke Albert of Saxe-Teschen, L.174

Bibliography: Basan 1775, p. 38, no. 223; Wickhoff 1891, ScL.384; H. Voss, *Die Malerei der Spätrenaissance*, Berlin, 1920, p. 68, note 2; Benesch 1964, Meisterzeichnungen, no. 30; B. Davidson, "Early Drawings by Perino del Vaga, II," *Master Drawings*, 1, no. 4 (1963), p. 19; Fischel-Oberhuber 1972, p. 14.

In 1523 Perino returned to Florence from Rome. The reasons for returning to his home town were the plague, which had broken out in Rome in 1522 and reached Florence a year later, and financial constraints which affected continuing and new commissions after the election of Pope Hadrian VI and the latter's absence from Rome for several months.

Perino interrupted his work in S. Andrea in Carmine (Florence) to begin the *Martyrdom of the Ten Thousand* (under the reign of King Sapor of Persia), commissioned by the Compagnia de'Martiri for the monastery in Camaldoli. According to Vasari, this work, which was planned as a fresco but never developed beyond the preparatory stage, could have become the most important mural decoration after those of Leonardo and Michelangelo, who had worked in the Palazzo Vecchio in Florence. Perino's *Martyrdom of the Ten Thousand*, mentioned by Vasari in the *Vita*, survives today only in this preparatory drawing. The cartoon from the Albertina sheet, which was admired by contemporaries, is lost. The composition not only occasioned several copies, but also influenced artists such as Pontormo, Vasari or Salviati.

Perino stages the arrangement of his figure groups perfectly, balancing light and shade and enclosing the rising and receding terrain with a fence of crucified Christians. Vasari reports that the artist "tired" of working and left the monastery when it was converted into a hospital for plague victims. Davidson remarks that Perino may have found his composition all too perfect and abandoned work in Camaldoli.

In the Fogg Museum of Art, Harvard University Art Museums, there is a copy of this sheet, perhaps by Vasari himself.[1] In addition, Davidson mentions a copy in Chantilly attributed to Naldini and a weaker copy in the Louvre.

V.B.

Notes
1. A. Mongan and P. J. Sachs, *Drawings in the Fogg Museum of Art* (Cambridge, Mass, 1940), no. 191, fig. 101.

Francesco Parmigianino
Parma 1503–1540 Casalmaggiore/Parma

After Correggio, who was a model for his early works (c.1520), Parmigianino was the most significant Emilian painter. Between 1524 and 1527 he was in Rome where he met the generation of Raphael pupils and assistants who were his contemporaries. Subsequently he spent several years in Bologna. Work for the church of S. Maria della Steccata brought him back to Parma in 1531. Inexperienced in coping with large-scale mural compositions, he was confronted by a task he could not finish. Many later generations of artists took his elegance of proportion and mannered virtuosity and almost metalically smooth painting as a model.

STUDY OF A CARYATID
Red chalk over stylus, heightened with white,
22.9 × 11.1 cm; inv. 17.661, ScL.117; upper right
corner added, old number "69" at upper left
Inscribed "Del Parmigianino D.50.–" on the
verso (showing through)

Provenance: Duke Albert of Saxe-Teschen, L.174

Bibliography: Wickhoff 1891, ScL.117; Alb.Vienna
1963, p. 13, no. 25; A. E. Popham, *Catalogue of the
Drawings by Parmigianino*, New Haven, Conn.,
1971; Koschatzky-Oberhuber-Knab 1971,
no. 56; B. Adorni et al, *Santa Maria della Steccata
a Parma*, Parma, 1982, p. 127.

Benesch confirmed the accuracy of the original
attribution to Parmigianino. The sheet shows a
study for the central figure on the vault above the
south wall of the vaulting in the church of S. Maria
della Steccata in Parma. The arch, whose massive-
ness is reinforced by fourteen large gilded
rosettes, spans two groups of three female figures
bearing vessels, a composition that Parmigianino
slowly developed through many studies.

The difficulties experienced by the artist in
decorating the large expanse of wall in the
Steccata may be inferred from documentary
evidence. A contract was signed on May 10, 1531,
commissioning Parmigianino to decorate the apse
and the adjoining vaulting and frieze.[1] The
projected date for finishing the work was
November 1532. As hardly anything had hap-
pened by autumn 1535, the future course of the
work was established in a new agreement
(September 27, 1535). In order to exert a little
pressure when Parmigianino did not avail himself
of one last extension to complete the job, nor did
he return the money already paid, as the contract
stipulated, he was imprisoned. Once released, the
artist destroyed portions of the frescoes that he
had begun and then fled to Casalmaggiore, where
the long arm of the Parma law could not reach
him. On December 19, 1539, Parmigianino was
excluded from any further work in the church of
S. Maria della Steccata.

A series of studies, the chronological sequence
of which can no longer be reconstructed, clearly
shows how intensively the artist concerned
himself with the subject of the wise virgins —
three on each side. He took the classical caryatid
as his model, perhaps as transmitted through the
female figure in Raphael's fresco in the Stanza
dell'Incendio in the Vatican. But the execution of
this willful composition was to all intents and
purposes no longer in his hands. The drawings
however, convey the fascination of this great
mannerist master. *V.B.*

Notes
1. A. E. Popham, *Catalogue of the Drawings by
 Parmigianino* (New Haven, Conn., 1971), p. 22.

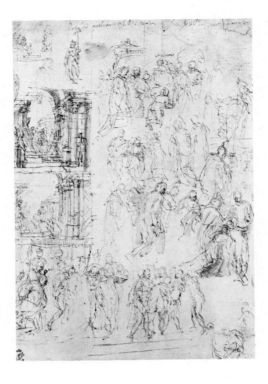

Paolo Caliari, called Veronese
Verona 1528–1588 Venice

A pupil of Antonio Badile in Verona from 1541.
First paintings around 1548. In 1553 he traveled
to Venice where he settled some years later. A
comprehensive life's work in painting laid the
basis for Veronese's fame as one of the most
important painters of the late Renaissance along
with Titian and Tintoretto. The fresco cycles and
altarpieces in Venice, on the mainland, in Padua
and Friuli combine with portrait painting to form
Veronese's full and rounded oeuvre.

56

SHEET OF STUDIES
Pen and bistre ink and wash; 29.8 × 21.7 cm;
inv. 24.476, V.108
Various autograph inscriptions, including the
word "Capitanio" several times and "Capitanio
gradiscente il Papa a Venezia"; illegible
inscription at lower right
Verso: Studies of boats for the same composition
Pen and brown ink with wash

Provenance: Luigi Grassi, L.1171b; acquired 1923

Bibliography: Stix 1925, pl. 28; D. v. Hadeln,
Venezianische Zeichnungen der Spätrenaissance, Berlin,
1926, p. 27; Alb.Cat. I, 1926, V.108; G. Fiocco,
Paolo Veronese, Bologna, 1928, p. 210, no. 3;
H. Tietze, E. Tietze-Conrat, *The Drawings of the
Venetian Painters*, New York, 1944, no. 2152;
Paris 1950, no. 45; B. Degenhart, "Eine
Zeichnung des Paolo Veronese," *Münchner
Jahrbuch der bildenden Kunst 6* (1955), p. 209;
B. Degenhart, P. Halm and W. Wegener, comp.,
*Meisterzeichnungen aus der Staatlichen Graphischen
Sammlung*, Munich, 1958, p. 50; Benesch 1964,
Meisterzeichnungen, no. 39; R. Cocke,
"Observation on Some Drawings by
P. Veronese," *Master Drawing 11*, no. 2 (1973),
p. 143, note 37; W. Wolters, *Der Bildschmuck des
Dogenpalastes*, Wiesbaden, 1983, p. 175, note 2.

After the fire in the Doges' Palace on December
20, 1577, which destroyed a substantial portion of
the decorations, Paolo Veronese was given the
task, probably as an official commission of the
Venetian Republic, of executing paintings for the
Sala del Maggior Consiglio that related to the
programmatic "Historia" (e.g. the "Myth of
Venice").

The two paintings to which the Albertina
sketches relate — *The Doge Sebastiano Zeni Receiving
Pope Alexander III Disguised as a Pilgrim at the Scuola
della Carita* and the *Departure of the Venetian
Ambassadors*[1] — were finished by his two assis-
tants, Carlo and Gabrielle Caliari (who called
themselves "Haeredes Pauli Carliari
Veronensis") after Veronese's death in 1588.
Ridolfi complained[2] that these two painters had
not adhered to a Veronese modello. How far
Veronese's drawings had in fact already estab-
lished the composition of the first two paintings in
the Sala del Maggior Consiglio cycle can only be
sketchily reconstructed.

L. Oehler pointed to a group of drawings in
Kassel,[3] among which there is one sheet, as noted
by Cocke, where Veronese recorded the *primo
pensiero* for the first painting in the cycle. There is
another drawing in the Staatliche Graphische
Sammlung, Munich,[4] that resembles the
Albertina sheet in the handling, arrangement of
the sketches and even in the damages at the
corners. They show two variations of the com-
position at the right, one above the other, which
correspond to the ideas in the Albertina sketch.
The three sheets, however, are only notations of
thoughts, which would have left the "Haeredes"
much freedom to maneuver in working out the
painting (if Veronese did not establish the com-
position in a more elaborate design before he
died). Wolters also noted that there may be
connections to another painting commissioned
from Veronese, the *Return of the Doge Contarini after
the Victory at Chioggia* on the west wall.[5]

Veronese's nervous drawing style reflects
the glimmering atmosphere characteristic of
Venetian painting; it not only prefigures the great
masters of the eighteenth century, but is a
constant feature of Venetian art. *V.B.*

Notes
1. W. Wolters, *Der Bildschmuck des Dogenpalastes*
 (Wiesbaden, 1983), p. 174, figs. 167–68;
 U. Franzoni, *Storia e leggenda del Palazzo Ducale
 di Venezia* (Verona, 1982), p. 250–51,
 figs. 146–48.
2. C. Ridolfi, *Le meraviglie dell'arte, Le vite degli
 illustri pittori veneti*, I, (Venezia, 1648), edited
 by D. v. Hadeln, Berlin 1914–24), p. 355.
3. L. Oehler, "Ein Gruppe von Veronese-
 Zeichnungen in Berlin und Kassel," *Jahrbuch
 der Berliner Mussan 3* (1953), New Ser.,
 p. 27–36.
4. B. Degenhart, "Eine Zeichnung des Paolo
 Veronese," *Münchner Jahrbuch der bildenden
 Kunst 6* (1955), p. 209, fig. 2.
5. W. Wolters, *Der Bildschmuck des Dogenpalastes*,
 p. 175, note 2.

Annibale Carracci
Bologna 1560–1609 Rome

Together with his brother Agostino, Annibale studied with his cousin Ludovico Carracci. In 1585/86 the three founded the famous Accademia degli Incamminati, which consciously turned away from mannerism toward a fresh, unprejudiced study of nature, the Renaissance masters and the Antique. It became a model for later academies. Shortly before, Annibale and Agostino had visited Parma and Venice, where they studied the works of Correggio, Parmigianino, Niccolo del Abbate, Titian, Tintoretto and the Bassani. In 1595 Annibale was summoned to Rome by Cardinal Odoardo Farnese; here he created his masterpiece, the Galleria Farnese in the Palazzo Farnese between 1595 and 1604. His brother Agostino collaborated on the project from 1597 to 1600.

57a. Annibale Carracci
Il Mascheroni
Gemäldegalerie Alte Meister, Dresden

PORTRAIT OF A MEMBER OF THE MASCHERONI FAMILY

Red chalk, heightened with white chalk, on rose-gray paper; 40.7 × 28.1 cm; inv. 25.606, B.109 Inscribed "Annibal Carracci del" in pencil by a collector, probably Lempereur

Provenance: Lempereur, L.1740; F. Amerling; Archduke Frederick (acquired through Joseph Meder from the estate of the painter Amerling in 1916); reacquired by the Albertina 1929

Bibliography: L. Baldass, "Die Originalzeichnung zum Lautenspieler des Annibale Carracci," *Die Graphischen Künste* 41 (1918), p. 1 ff; Alb.Cat. VI, 1941, B.109; Mahon 1947, p. 266, note 50; Wittkower 1952, p. 27, 433; Bologna 1956, no. 103; Fenyö 1960; Paris 1961; Benesch 1964, Meisterzeichnungen, no. 46; Koschatzky-Oberhuber-Knab 1971, no. 71; Paris 1975, no. 64; Vienna 1975, no. 64; Vienna 1978, no. 31.

A study for the portrait, titled *Giovanni Gabrielli* or *Il Mascheroni*,[1] in the Dresden Gemäldegalerie that shows the musician in half-length with lute, pen and sheet of music. Malvasia saw that painting, which Annibale painted shortly before he was summoned to Rome in 1595, when it was still in the collection of the Duke of Modena, "quello del sonatore Mascheroni tanto suo famigliare & amico."[2] A pen sketch at Windsor Castle, probably the *primo pensiero*, also shows just the face and bust of the musician, but in greater detail.[3] Another red chalk study, which lacks the liveliness of the Albertina sheet, is in the Uffizi (inv. 12405), with a copy in the Louvre (inv. 7265, excoll. Jabach). A certain resemblance, though not a compelling one, between the sitter and Agostino Carracci's engraved portrait of the actor Giovanni Gabrielli, called "Il Sivello," (B.153) who was also a friend of the Carraccis, led to the identification of Gabrielli with Mascheroni in the nineteenth century.

The Albertina drawing rivals the pen sketch in Windsor in the immediacy of lively expression. Annibale prefigures the characteristics of portrait drawings by Rubens, Van Dyck and even Bernini. Even his younger Roman contemporary, the portrait painter Ottavio Leoni, rarely equalled him in this. The soft vibrant fluency of the painterly chalk technique especially anticipates the Flemish masters and Bernini. Annibale, who during his youth in Bologna studied reality no less intensely and objectively than his contemporary Caravaggio, became one of the most important founders of baroque portraiture. The Albertina's red chalk portrait is a significant landmark in that process. *E.K.*

Notes
1. Voss 1924, p. 161, 490; Mahon 1947, p. 266 ff, note 50.
2. Felsina Pittrice, I (1678), p. 502.
3. Wittkower 1952, p. 133, fig. 27.

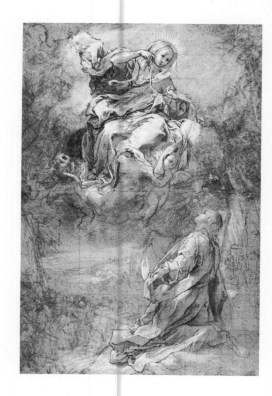

Federico Barocci
Urbino 1535–1612 Urbino

In the 1550s Barocci had already gone to Rome where he became the protege of Cardinal Giulio della Rovere. From 1561 to 1563, together with Federico Zuccaro, he executed the frescoes in the Casino of Pope Pius IV in the Vatican gardens and in the Belvedere. After a four-year illness he settled in Urbino and created a many-sided oeuvre as painter and draughtsman. Foreign patrons, such as Emperor Rudolf II in Prague and King Philip II of Spain, also appreciated the work of Barocci who, towards the end of late mannerism, became the most significant harbinger of counter-reformation religious painting.

57b. Annibale Carracci
Il Mascheroni
By permission of Her Majesty Queen Elizabeth II

MADONNA DELLA CINTOLA
Black chalk, pen and brown ink with wash,
heightened with white, on blue paper;
50.6 × 35.1 cm; inv. 545, R.392
Old inscription "Fed.º Barocci" in pen, squared
in chalk

Provenance: Moriz v Fries, L.2903; Duke Albert
of Saxe-Teschen, L.174

Bibliography: Wickhoff 1891, ScR.640;
A. Schmarsow, "Federigo Baroccis Zeichnungen,
III," *Abhandlungen der königlich sächsischen
Gesellschaft der Wissenschaften*, Phil.-hist. Klasse
XXVI, Leipzig, 1909, p. 53; R. v. Krommes,
Studien zu F. Barocci, Leipzig, 1912, p. 95;
Alb.Cat. III, 1932, R.392; H. Olsen, *Federico
Barocci*, Copenhagen, 1962, p. 214, no. 68;
Alb.Vienna 1968, no. 731; Koschatzky-
Oberhuber-Knab 1971, no. 48; Alb.Vienna 1975,
no. 40.

This composition shows traces of a chalk grid,
which are evidence of an intention to translate the
image to a larger format, either a cartoon or a
direct projection onto the canvas. Such a finished
version has not, however, come to light yet and
was perhaps never executed, if the drawing is
dated to the artist's late years.

A compositional study in Chatsworth[1] for the
painting *Assumption of the Virgin*, housed in a
Milanese private collection,[2] is related in style
and medium. In that late preparatory sketch the
glistening light of the heavenly apparition is
similar to the Albertina sheet, in which the
vertically falling light vividly illuminates certain
parts of the drapery. In the Albertina drawing,
however, the brightness is somewhat restrained
so that the surroundings, as yet not fully articu-
lated, may be more effective as atmospheric mood.

The Madonna has loosened the belt of her
raiment and is passing it to the doubting Saint
Thomas, the patron saint of Urbino. One may,
therefore, assume that this picture was commis-
sioned by the city, which is unmistakably sil-
houetted in the background. The composition of
the *Madonna della Cintola*, for which H. Olsen
mentions other preparatory studies,[3] modifies the
Madonna of the Rose Garland (Archepiscopal Palace,
Senigallia), which was painted between 1592 and
1594.[4] The drawing, however, reverses the pose
of the kneeling saint. E. Pillsbury mentions
another study for the kneeling figure[5] and a sheet
with sketches for the angels in the Uffizi.[6] At the
left margin of the image a second figure is visible,
as if the artist had not yet decided whether he
should give more space to the crowded and
compressed group of figures.

Sustained by the ideas of the counter refor-
mation, Barocci became a forerunner of the
baroque altarpiece with his narrative virtuosity
and the strength of his representations of
religious messages. *V.B.*

Notes
1. H. Olsen, *Federico Barocci* (Copenhagen, 1962),
 no. 66, fig. 110.
2. Ibid., no. 66, fig. 111.
3. Ibid., no. 68.
4. Ibid., no. 44, fig. 79.
5. E. Pillsbury, "Barocci at Bologna and
 Florence" (review), *Master Drawings* 14, no. 1
 (1976), p. 36, 63; Bibl. Ambrosiana, Milan,
 no. F 271, inv. no. 81.
6. Uffizi, Gab. Disegni e Stampe, Florence,
 inv. 11476 F.

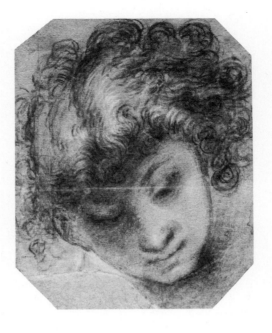

Giulio Cesare Procaccini
Bologna 1574–1625 Milan

First studied under his father Ercole Procaccini
the Elder. He moved with his father and elder
brother, Camillo, to Milan after 1585. Giulio
Cesare first worked as a sculptor on the Milan
Cathedral, but started to paint soon after 1600.
The decisive influence on his style came from his
brother, who was also an important engraver;
another influence was the early work of the
Carraccis, primarily Lodovico, and the art of
Correggio and Parmigianino. He was in fact called
"il Correggio insubre." Active in Milan and other
places in Lombardy, and in Genoa (around 1618).

59

HEAD OF A BOY WITH CURLY HAIR
Black chalk, heightened with white, on green-
blue paper; 26.5 × 22.9 cm; inv. 24.985, B.448;
cut octagonally, a strip of paper added by the
artist at left, lower left corner repaired

Provenance: Bequest of Oswald Kutschera-
Woborsky

Bibliography: N. Pevsner, "Giulio Cesare
Procaccini," *Rivista d'Arte* 11 (1929), p. 321 ff;
Alb.Cat. VI, 1941, B.448; N. Ivanhoff, "Disegni
dei Procaccini," *La Critica d'Arte* 5 (1958),
p. 223 ff, 328; Milan 1959, p. 34 ff, 60 ff, no. 25,
42; Fenyö 1965, p. 100; Koschatzky-Oberhuber-
Knab 1971, no. 70; G. Bora, comp., *Il Seicento
Lombardo*, Milan, 1973, no. 66 ff; Alb.Vienna
1975, no. 63; H. Brigstocke, "Giulio Procaccini
Reconsidered," *Jahrbuch der Berliner Museen* 18
(1976), p. 84 ff.

"Quel pittore delineava queste divine fattezze,
perche i suoi pensieri erano angelici" wrote Carlo
Torre in *Ritratto di Milano* in 1674,[1] and Malvasia
reported, "Disegno questo pittore con gratiosa
maniera a tanto di lapis, come di penna, e gustava
d'istradar'alla perfettione del buon disegno i
giovani principanti."[2]

Similar heads appear on the angels in the
paintings, *Freeing of Peter* in the Museo Civico in
Turin,[3] *Madonna with St. Francis and St. Charles*[4] in
the church of Santa Maria di Carignano in Genoa
and *Lamentation of Christ* in Edinburgh (Old

College) and in the Brera, among others. The
head of the prophet Deborah in the painting in
Santa Maria in Caneparnuova near Pavia is also
comparable.[5] Among the drawings by Procaccini
that have so far been published, the Albertina
drawing occupies a special position. It is very
close to the works of Correggio and Parmigianino
and may be closely compared to Parmigianino's
study, also in the Albertina, for the head of the
Christ Child in the painting *Vision of St. Jerome*,
which is in the National Gallery in London.[6]
 E.K.

Notes
1. "This painter drew these divine features
 because his thoughts were angelic."
2. "This painter drew in a gracious manner
 whether with brush or pen and enjoyed
 instructing beginners in the perfection of good
 drawing."
3. Luigi Malle, *Museo Civico di Torino, I Dipinti del
 Museo d'Arte Antica* (Turin, 1963), pl. 112–13.
4. N. Pevsner, "Giulio Cesare Procaccini,"
 Rivista d'Arte II (1929), fig. 11.
5. G. Bora, comp., *Il Seicento Lombardo* (Milan,
 1973), nos. 93, 94, 97, pl. 108, 109, 111.
6. Alb.Cat. VI, 1941, B.355; K. Oberhuber in
 Alb.Vienna 1963, no. 17, fig. 17.

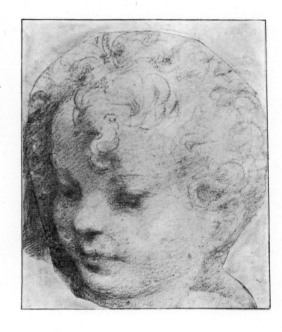

59a. Francesco Parmigianino
Head of the Christ Child
Albertina Collection, Vienna

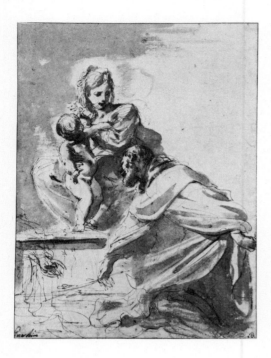

Giovanni Francesco Barbieri, called Guercino
Cento 1591–1666 Bologna

Guercino received his basic training from Benedetto Gennari in Cento. Around 1610 he went to Bologna where the group of artists trained in the Carraccis' Accademia was dominant. He was also influenced by artists in Rome, where Guercino stayed from 1621 to 1623. Worked in Piacenza 1626–27. From 1642, the year Guido Reni died, he lived in Bologna. As one of the most important painters and draughtsmen of the second quarter of the seventeenth century, he exercised decisive influence on the conception of art in the Bolognese School. Many of his drawings were copied.

60

THE VIRGIN AND CHILD ADORED BY SAINT DOMINIC
Red chalk, pen and brown bistre and ink wash, 27.2 × 20.6 cm; inv. 2.345, B.215
Old inscription "Guarchino" at lower left, W. G. Becker's collector's mark lower right

Provenance: W. G. Becker, L.324; Duke Albert of Saxe-Teschen; 1822 Estate inventory, p. 216; L.174

Bibliography: Wickhoff 1891, ScB.403; Alb.Cat. VI, 1941, B.215; Koschatzky-Oberhuber-Knab 1971, no. 74.

For a long time it was assumed (following an old note by Wickhoff) that this drawing, although lacking the appropriate collector's mark, once belonged to Mariette because Basan[1] described a representation of Saint Dominic in his catalogue of the Mariette collection. That drawing, however, passed to Brupbacher-Bourgois in Switzerland (1935) by way of the J. P. Heseltine collection.[2] Wickhoff also mentioned that Charles Prince de Ligne allegedly owned the Saint Dominic study after Mariette. While there is indeed a note in A. Bartsch's catalogue[3] of a *Mary with the Christ Child and St. Anthony*(!), the drawing itself does not carry a collector's mark, an unusual circumstance for a sheet from the de Ligne collection. Moreover, the "B" in the lower right corner was read as A. Bourduge's mark; it is, however, almost impossible for this sheet to have passed from Mariette to Prince de Ligne and Bourduge.

The misinterpreted "B," in fact, turned out to be the clue to the drawing's provenance. Duke Albert of Saxe-Teschen acquired it in 1784 from W. G. Becker (1753–1813), a collector from the Duke's home town, Dresden. Becker had just returned, with a large number of sheets, from a lengthy journey to Italy which had taken him as far as Naples. In the inventory of Duke Albert's estate, this drawing is mentioned on page 216 with the figures identified as Saint Charles Borromaeus kneeling before the Virgin. However, if the few strokes hinting at the saint's attribute are read as a lily, then the traditional interpretation of the Virgin appearing to Saint Dominic is surely correct.

A painted version of this subject is not known. A stylistically similar study in Turin,[4] which comes from the collection of Giovanni Volpato (1633–1706) and is considered an early work, bears the same peculiar inscription "Guarchino." Perhaps that study and the Albertina sheet were once in the same collection. This would reinforce the possibility of an early date of c.1618, provided the manuscript notation with the artist's name was added very soon after the drawings were done.

Saint Dominic, whose tomb is in San Domenico in Bologna, was commemorated there in 1621, on the occasion of the 400th anniversary of his death, August 6, 1221. The choice of subject and the date of this drawing could therefore be connected with this event.

A drawing in Princeton[5] shows a similar scene, in which the Madonna appears on a pedestal and offers a lily to the kneeling Saint Anthony(!). Again, no painted version of this sheet dated between 1616 and 1618 is known. The choice of subject also reflects the renewed devotion to Mary under Pope Paul V. The fine handling of line and the use of the brush are early evidences of the artist's later virtuosity. *V.B.*

Notes

1. Basan 1775, p. 24, no. 137.
2. D. Mahon, comp., *Il Guercino — Disegni* (Bologna, 1968), p. 52.
3. Bartsch 1794, p. 107, no. 23.
4. A. Bertini, *I Disegni italiani della Biblioteca Reale di Torino, Catalogo* (1958), p. 70, no. 569; D. Mahon, *Il Guercino*, no. 177.
5. J. Bean, *Italian Drawings in the Art Museum* (Princeton, N.J.: Princeton University), no. 34.

Pietro Berrettini, called da Cortona
Cortona 1596–1669 Rome

Born in 1596 in Cortona to a long-established family of architects and stonemasons. Pupil of Andrea Commodi, whom he followed to Rome in 1612; pupil of Baccio Ciarpi in 1614. Studied the art of Antiquity, Raphael, Michelangelo, the Carraccis and Caravaggio, and particularly Borgianni and Rubens. Through Marchese Sacchetti, his first patron, and the poet Marino Marini, Cortona was introduced to the circle of Pope Urban VIII, under whom he became one of Rome's leading painters and architects. While active in Rome and Florence, where he worked on the decoration of the Pitti Palace in 1637, 1640–42 and 1644–48, Cortona stood at the center of Roman artistic life, decisively influencing the high baroque period. He frequented the circle of Cassiano del Pozzo with Poussin, Mola and Testa, his pupil; he presided over the Accademia di San Luca from 1634 to 1638 during the argument with the Netherlandish Schilderbent (1635) and the struggle with Andrea Sacchi and representatives of the classical tendency. He died in 1669 in Rome, where the ceiling frescoes in the Palazzo Barberini (1633–39) and the Chiesa Nuova (Santa Maria in Vallicella, 1648–65) are among his best-known works, the pinnacle of Roman high baroque painting. His innovative, uninhibited, open handling of paint in broad patches and planes, "quella immediatezza e frescezza di scrittura" (Briganti), was much imitated and made him leader of the "macchiettisti."[1]

Notes

1. See the biographies by Passeri (edition by Jacob Hess), Filippo Baldinucci and Briganti, Florence 1962, and Voss 1924. In addition: Wibiral, "Contributi alle ricerche sul Cortonismo in Roma," *Bollettino d'Arte* 45 (1960), p. 123 ff; Bologna 1962; Roli, Campbell, Cortona 1977.

61

STUDY OF A YOUNG WOMAN
Black and red chalks, heightened with white, on
gray-blue paper; 28.5 × 21.0 cm; inv. 24.554,
R.704
Old pen notation "Di Pietro da C." at lower
margin

Provenance: L. Grassi, L.1171b

Bibliography: A. Stix, "Barockstudien," *Belvedere*
2 (1930), p. 180 ff; Alb.Cat. III, 1932, R.704;
G. Briganti, *Pietro da Cortona*, Florence, 1962,
p. 326; M. Campbell, *Mostra di disegni di Pietro
Berrettini da Cortona per gli affreschi di Palazzo Pitti*,
Florence, 1965, Gab. di Disegni degli Uffizi;
M. Campbell, Addenda: "Two Pietro da
Cortona," *Burlington Magazine* 107 (1965),
p. 526 ff; Koschatzky-Oberhuber-Knab 1971,
no. 78; M. Campbell, *Pietro da Cortona at the Pitti
Palace*, Princeton, N.J., 1977, no. 26.

61a. Pietro Berrettini
The Golden Age
Pitti Palace, Florence

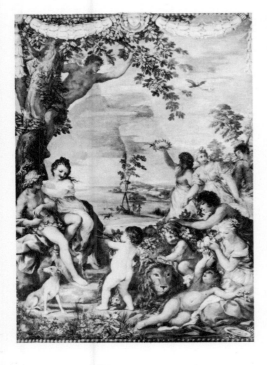

Study for the young woman who is holding a plant
and kneeling at the lower right-hand corner of the
fresco of *The Golden Age* in the Camera della Stufa
in the Palazzo Pitti in Florence. Pietro da Cortona
executed the wall frescoes of the Four Ages from
Ovid's Metamorphoses in the years 1637 and 1641.
An almost exact equivalent, but less lively
drawing, of the same detail is in the Louvre (inv.
519), as well as a study of the entire figure (inv.
529). The Uffizi also has a study, but it merely
outlines the essential features or *il primo pensiero*
(inv. 11758F). The preparatory drawings for the
other figures in the frescoes of the Golden and
Silver Ages are also in the Uffizi.[1] In style and
technique they match the Albertina sheet, the
sensual vitality of which — also found in the
frescoes themselves — rivals works by Peter Paul
Rubens. *E.K.*

Notes
1 For further sketches and studies for this and
 the other Ages, see Briganti and Campbell
 1965 and 1977; A. Schmitt, comp., *Italienische
 Zeichnungen 15. bis 18. Jahrhundert* (Munich:
 Staatliche Graphische Sammlung, 1967).

61b, c. Pietro Berrettini
Study of Two Heads for *The Golden Age*
Louvre, Paris

61d. Pietro Berrettini
Study for *The Golden Age*
Uffizi, Florence

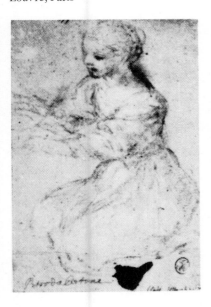

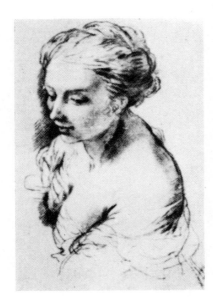

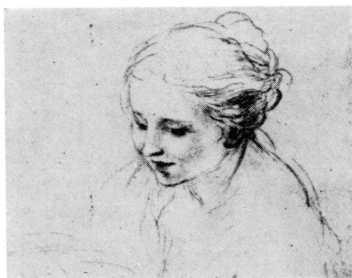

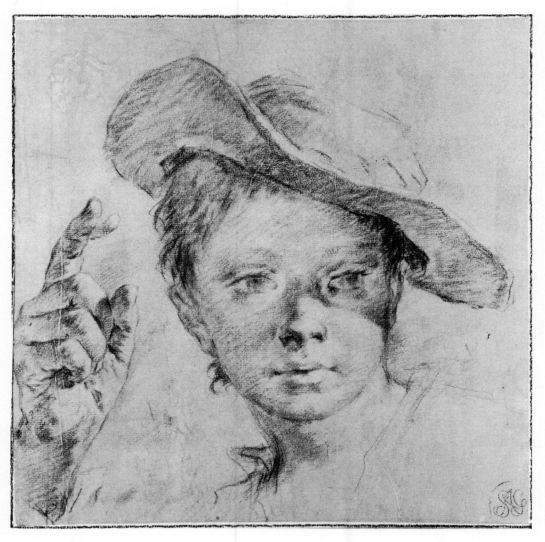

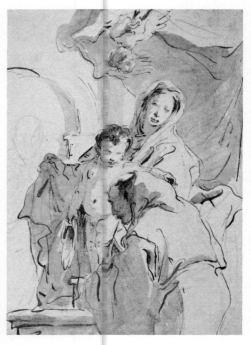

Giovanni Battista Piazzetta
Venice 1682–1754 Venice

Piazzetta received his first artistic training from his father, the woodcarver Giacomo Piazzetta, but soon turned to painting under the guidance of Antonio Molinari. He studied the works of the Carraccis and the paintings of Guercino in Bologna. Meeting Giuseppe Maria Crespi in Bologna had a profound effect on his art. He entered the Crespi's workshop around 1703. In 1711 he became a member of the Fraglia dei Pittori (painter's guild) in Venice, where he was active from then on. He was named director of the Venice Academy in 1750. Because he worked slowly, his oeuvre is small enough to be surveyed relatively easily. His drawings, which were often copied, form an important part of this oeuvre.

62

HEAD OF A BOY WITH A BROAD-BRIMMED HAT
Black chalk, heightened with white, on gray-rose paper; 28.0 × 28.4 cm; inv. 1.796, V.249

Provenance: Fagan; Count Saint-Germain, L.2347; Duke Albert of Saxe-Teschen, L.174

Bibliography: Wickhoff 1891, ScV.390; Alb.Cat. I, 1926, V.249; A. Ravà, *Giovanni Battista Piazzetta*, Florence, 1921, p. 71, no. 1796; R. Pallucchini, *L'Arte di Giovanni Battista Piazzetta*, Bologna, 1934, p. 58; R. Pallucchini, *Giovanni Battista Piazzetta*, Milan, 1956, p. 52; Venice 1961, no. 90; Koschatzky-Oberhuber-Knab, 1971, p. 96; Australia 1977, no. 16; A. Bettagno, U. Ruggeri et al, *Dessins vénitiens du dix-huitième siècle*, Brussels, 1983, p. 96.

It has not yet been established if Giovanni Battista Piazzetta used this study of a boy whose broad-brimmed hat shades his forehead and eyes, for a painting. It is conceivable that this drawing may have been related to a lost composition by Piazzetta, which was reproduced in an engraving by Theodoro Viero.[1] In addition to the similarity of the portrayed boy, this print repeats the pointing gesture of the hand, which in the study has such a peculiarly loose relation to the portrait head. From a stylistic point of view, this drawing could date from 1740, which has often been suggested, when Piazzetta was working on the painting, *The Soothsayer*.[2] The dissolution of the surface into soft patches of *sfumato* tones tends to confirm this date.

It may be that Piazzetta's idea, or even the model himself, was used by pupils in his circle. Compare, for example, Dall'Oglio's *Hunting Scene*,[3] now considered lost. The background of this picture contains a figure reminiscent of the Albertina study. *V.B.*

Notes

1. U. Ruggeri et al, comp., *Giovanni Battista Piazzetta, Il suo tempo, la sua scuola* (Venice, 1983), p. 191.
2. R. Pallucchini, *Giovanni Battista Piazzetta* (Milan, 1956), fig. 78; Ibid., no. 35 ill., p. 104 ill.
3. *Giovanni Battista Piazzetti* (Venice), p. 31 ill.

Giovanni Battista Tiepolo
Venice 1696–1770 Madrid

Initially Tiepolo was Gregorio Lazzarini's pupil; he further educated himself independently under the influence of Giovanni Battista Piazzetta and Sebastiano Ricci. In his early period, Tiepolo copied works by Veronese. In 1717 his name appeared in the lists of the Venetian painters' guild, and after decorating the Palazzo Archivescovile in Udine, he became one of the most highly paid and internationally sought after artists. He worked a great deal for German patrons, his largest commission being the frescoes in the Würzburg Residence which he completed with his sons Domenico and Lorenzo in 1753. On his return to Venice he was showered with honors. In 1761 the King of Spain, Charles III, summoned him to Madrid to paint the huge ceiling fresco, *The Apotheosis of Spain*, in the royal palace. Further commissions delayed his return to Venice. He died in Madrid on March 27, 1770.

MADONNA AND CHILD WITH SAINT
Pen and brown ink, sepia wash over red chalk;
28.9 × 22.0 cm; inv. 2.346, V.300

Provenance: Duke Albert of Saxe-Teschen, L.174

Bibliography: Wickhoff, ScV.405 A; Alb.Cat. I,
1926, V.300; Australia 1977, no. 17.

Tiepolo fluently sketched his compositions in red
chalk and then accentuated the details with loose
pen strokes. He used the brush to give the figures
body and the setting, which is just hinted at in
outline, a sense of space.

The drawing depicts another variation on a
theme that Tiepolo repeated almost seventy
times — the Holy Family.[1] Only a few of these
sheets, however, allow the viewer to experience
so clearly the intimacy between the Christ Child
and the saint bowed in humility before Him.

In a comparable study for *Holy Family with St.
Anthony* in Trieste,[2] the Madonna's gesture closes
the circle around the saint's meeting with the
Child. In the present drawing the Madonna
monumentalizes the intimacy of the scene by
raising her cloak to shield the moment of direct
contact.

The softly flowing lines, the sketchiness and
the role of shadow place this sheet close to the
studies for the Villa Valmarana frescoes, which
were begun in 1757.[3] Knox dates similar drawings
between 1754 and 1762[4] and indicates that they
were executed for their own sake and not intended
as studies for paintings or frescoes. *V.B.*

Notes
1. D. v. Hadeln, *Handzeichnungen von G. B. Tiepolo,*
 I, II (Munich, 1927), nos. 99, 107 and 100;
 G. Knox, comp., *Tiepolo, A Bicentenary
 Exhibition* (Cambridge, Mass.: Fogg Museum
 of Art, Harvard University, 1970), nos. 15, 25.
2. G. Vigni, *Disegni del Tiepolo* (Padua, 1942),
 no. 70.
3. G. Knox and Ch. Thiem, *Tiepolo* (Stuttgart,
 1970), nos. 17–19.
4. Ibid., no. 89 ill.

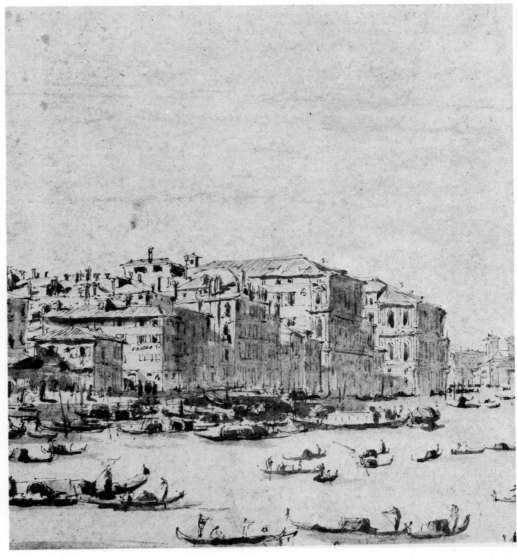

Francesco Guardi
Venice 1712–1793 Venice

Francesco Guardi, a pupil of his brother
Gianantonio; upon his brother's death in 1760
Francesco took over the workshop. From 1761 to
1763 he was a member of the Fraglia dei Pittori
(painters' guild) in Venice. He traveled to the
Valtinella, near Lake Como, in 1782; he was
elected *pittore prospettico* to the Venetian Academy
in 1784. His fame lies in his particular inter-
pretation of the Venetian painted view.

64

HOUSES ON THE GRAND CANAL IN VENICE
Pen and sepia ink and wash; 26.9 × 24.5 cm;
inv. 24.333, V.376; manuscript color notes on
the houses

Provenance: acquired 1924

Bibliography: Alb.Cat. I, 1926, V. 376; J. Byam
Shaw, *The Drawings of Francesco Guardi*, London,
1951, p. 11, 51; Venice 1961, no. 116;
Koschatzky-Oberhuber-Knab 1971, no. 99.

As Byam Shaw has shown, this sheet depicts the
left side of the Grand Canal above the Rialto. The
format of the drawing, unusual for works by
Guardi, suggests that it was the right half of a
larger sheet whose left half is lost. The assumption
that the drawing was originally a panoramic view
of the canal is supported by comparing it to a
drawing in the Metropolitan Museum of Art in
New York.[1] The same wide-angle perspective
appears in a painting in the Brera in Milan,[2]
showing the canal as far as the Ca' Pesaro.

The Albertina's drawing, which contrasts light
and dark more clearly than the painting, was
dated c.1760 by Byam Shaw. It confirms that
Guardi was the master among the Venetian view
painters of the eighteenth century. *V.B.*

Notes
1. Byam Shaw, *The Drawings of Francesco Guardi*
 (London, 1951), p. 10, 59.
2. M. Goering, *Francesco Guardi* (Vienna, 1944),
 fig. 47; L. Rossi Bortoletto, *Francesco Guardi,
 L'opera completa* (Milan, 1974), no. 285.

FRENCH SCHOOL

Jacques Bellange
end of 16th century–before 1624

Painter, etcher and festival designer for the dukes of Lorraine. Documentary evidence places him at the court of Nancy from 1602 to 1616, when he worked for both Duke Charles III (1546–1608) and Henry II (1608–1624) and his two wives, Catherine of Bourbon and Margaret of Gonzaga.

Claude Deruet became his pupil and assistant in 1605. In 1606 Bellange painted the *Galerie des Cerfs* in the castle at Nancy and created the decorations for the reception of Margaret of Gonzaga. He was sent to France in 1608 to study the royal chateaux and their paintings. He created the decorations for a ballet in 1615. Thereafter all trace of him is lost. In 1624 he is mentioned as having died. (When Claude Deruet returned from Italy in 1621, he was named Bellange's successor as court painter.)

The majority of Bellange's paintings have not survived the ravages of time. The ex-libris etching for Melchoir de la Vallée is dated 1613. Bellange's style is similar to that of Barocci, Vanni and Salimbeni, but also shows affinities to Dubois, Dubreuil and Freminet of the second Fontaine-bleau School.

He must have also known Tempesta's etchings, in particular the hunting scenes, which also inspired Callot who, according to Sandrart, was a pupil of Bellange. Mariette believed Spranger also influenced Bellange. Bellange is linked to El Greco by his visionary depth and expressiveness and to Callot by his striking content.

Praised by Sandrart as "the most famous French print-maker," Bellange was long forgotten and unrecognized by posterity.

THE THREE MARYS AT THE TOMB
Red chalk; 21.9 × 15.4 cm; inv. 11.756; old marks, one in white bodycolor
Old inscription "Pierre belange" in pen and ink

Provenance: Duke Albert of Saxe-Teschen, L.174

Bibliography: Schönbrunner-Meder, no. 16; Lavallée 1930, no. 1-1; Mongan-Sachs 1946, III, no. 650; F.-G. Pariset, "Jacques Bellange et Jacob van der Heyden," *Archives alsaciennes d'Histoire de l'Art* 12 (1933), p. 115; Lavallée 1948, p. 291; Alb.Vienna 1949, no. 73; Alb.Vienna 1950, no. 17; Paris 1950, no. 34; F.-G. Pariset, "Deux Dessins de Jacques Bellange au Musée Lorrain," *Pays lorrain,* 1951, p. 3 ff; Vallery-Radot 1953, p. 178; Benesch 1964, *Meisterzeichnungen,* no. 208; Knab 1967; Alb.Vienna 1968, no. 752; *200 Jahre Albertina,* Albertina, Vienna, 1969; Alb.Vienna 1978, no. 104.

65a. Albrecht Dürer
Nuremberg Lady Dressed for Church
Albertina Collection, Vienna

65b. Jacques Bellange
Lamentation
Kupferstichkabinett der Akademie der Bildenden
Künste, Vienna

This drawing is considered one of Bellange's most beautiful. Executed in 1600 or before, it is thematically connected to the famous engraving *The Three Marys at the Tomb*,[1] to which Welsh Reed and Walch assign a late date because of its artistic perfection, but Pariset and Oberhuber prefer an earlier one because the steep spatial perspective, which is similarly indicated in the drawing by the sarcophagus seen from above in an almost late-gothic manner, is close to Barocci. The airy, unsubstantial quality of the figures is also common to both the drawing and the etching. The etching, however, represents a different, much expanded and thematically altered version of the subject,[2] in which only the women at the entrance to the cave are reminiscent of the Albertina drawing. The latter is much closer, as Pariset recognized, to an oval engraving by Crispijn de Passe after Bellange that belongs to a Passion sequence executed in Cologne, of which several prints are dated 1600 and 1601.[3]

The drawing style and the dry red chalk technique with its taut, sometimes brittle lines and precious accents find their precursors and parallels in the works of Andrea del Sarto and Rosso, as well as in drawings by Barocci, Vanni, Salimbeni, Poccetti and Cavaliere d'Arpino. It has hitherto hardly been noticed that the timelessly historicizing drapery and costume, and even the facial expressions, are inspired by Albrecht Dürer. Bellange also borrowed from Dürer for the Annunciation triptych in Karlsruhe.

The Three Marys echo not only Dürer's Nuremberg costume studies,[4] but also the figures in the *Large Passion* (Bearing of the Cross, Entombment and Lamentation, B.10, 12, 13) and in the *Life of Mary* (Visitation, Presentation of Christ in the Temple, B.84, 88). The arrangement on the Albertina sheet resembles a group of Marys in a drawing, in the Print Cabinet of the Vienna Academy of Fine Arts, that Pauline Abel identified as *Lamentation* by Bellange.[5] E.K.

Notes
1. R.-D.9; Alb.Vienna 1968, IV, no. 370;
 N. Walch, *Die Redienungen des Jacques Bellange* (Munich, 1971), p. 208, no. 46.
2. Blunt 1953, p. 126.
3. Hollstein, no. 153; Des Moines 1975, no. 65.
4. Winkler, nos. 224, 225, 232.
5. Alb.Vienna 1950, no. 18.

Nicolas Poussin
Villers near Les Andelys 1594–1665
Rome

Born in 1594 in Villers near Les Andelys in
Normandy, Poussin received his first artistic
training from a local artist, Quentin Varin of
Amiens, who was temporarily in Les Andelys in
1612. He followed Varin to Paris, where he
became acquainted with works by the second
Fontainebleau School and by those Flemish
masters involved in the transition from man-
nerism to early baroque. For a short time Poussin
was the pupil of Lallemand, who had trained with
Bellange; after some years traveling in Poitou and
Touraine, he studied Raphael and his circle.

Poussin worked for Maria de Medici in the
Palais Luxembourg in 1622 where he befriended
the poet Gian Battista Marino, who furthered
Poussin's literary education. Poussin made his
first documented drawings for Marino, which
illustrated scenes from Ovid's metamorphoses. In
1624 Marino introduced him into the circle of
Cardinal Francesco Barberini in Rome. The col-
lector Cassiano dal Pozzo gave him important
commissions. In these circles Poussin also met the
masters of the Roman high baroque. In spite of
such stimuli, Poussin remained loyal to the models
of Raphael and antiquity. Titian's paintings
became an additional inspiration in the early
1630s.

In 1630 Poussin married Anne-Marie Dughet;
her brothers Gaspard and Jean were his pupils. At
the insistence of King Louis XIII he traveled to
Paris in 1630 with his patron Paul Fréart de
Chantelou. There he was appointed Premier
Peintre in place of Simon Vouet; among other
court commissions, Poussin began decorating the
Grande Galerie in the Louvre. Because of in-
trigues with other artists he left Paris in 1642 and
returned to Rome, where he worked in relative
seclusion until he died on November 19, 1665.

66a. Nicolas Poussin
Ponte Mollè
Albertina Collection, Vienna

RIVER LANDSCAPE
Pen and brush, bistre ink and wash;
18.5 × 25.2 cm; inv. 11.445
The iron gall ink has bitten into the paper in
several places

Provenance: Crozat; P. J. Mariette, L.2097;
Charles Prince de Ligne, L.592; Duke Albert of
Saxe-Teschen, L.174

Bibliography: Bartsch 1794, no. 9; Friedländer
1931, p. 62; Friedländer-Blunt 1939, IV, G.4, V,
p. 124; Alb.Vienna 1964, no. 177; Knab 1971,
p. 378; Whitfield 1979, 10 ff.

The view is probably from a hill along the so-called Val di Pussino where it opens into the Tiber valley. In the distance one recognizes the familiar meandering of the Tiber river with its old towers and ruins, including the Tor di Quinto and, further away, the Castel Giubileo. In the background the valley is dominated by Monte Gennaro of the Sabine Hills and its foothills; Monti Tiburtini shows through at the right. A perfect play of light and shadow organizes the landscape into receding layers, reinforcing the horizontal forms with pen hatchings in contrast to the thrusting trees and the diagonal recession into depth of the river's S-bend. These movements are echoed in the clouds.[1]

The Val di Pussino extends westwards above the Milvine Bridge and is traversed by the winding Fontaniletto. At the end stand the towers and battlements of the Casale a Crescenza, a medieval Roman noble seat. Claude Lorrain often drew here and derived motifs for his landscape paintings from the area.[2] The similarity of Poussin's and Claude's painterly drawing styles and their conceptions of the Roman landscape's unforced monumentality should not, however, obscure their differences. In Poussin's hand, pen and brush unite in a more rigorous, organized rhythm and handling, which in the broad, patchy rendering of the clouds may be seen as prefiguring Cézanne, an artist who learned much from Poussin.

The Albertina sheet originally belonged to a sketchbook, whose drawings already bore attributions to Poussin, in P. Crozat's and P.J. Mariette's collections. The Albertina has another sheet from this group illustrating a view of the Tiber valley below the Ponte Molle, the famous bridge that Poussin drew from very close-up in a study which now belongs to the École des Beaux-Arts, Paris.[3]

In the fourth volume of W. Friedländer's and A. Blunt's corpus on Poussin drawings, J. Shearman attributed the drawings from the Crozat/Mariette sketchbook to Gaspard Dughet, Poussin's energetic pupil and brother-in-law. This attribution to Dughet is not convincing because the sheets in question are closer to early landscape drawings whose attribution to Poussin is secured by provenance and tradition.[4] In addition, the landscape passages in Poussin's compositional studies, executed at approximately the same time, for history paintings match the style of the present drawing and others in the aforementioned sketchbook. The Louvre's drawing of *Moses Strikes Water from the Rock*,[5] a study for the 1637 painting in Bridgewater House and a landscape drawing at Windsor showing Saint Mary of Egypt and the monk Zosimus, a sketch for an apparently unexecuted painting for an Anchorite monastery,[6] are comparable to the Albertina sheet. *E.K.*

66b. Nicolas Poussin
Mary of Egypt and the Monk Zosimus
By permission of Her Majesty Queen Elizabeth II

Notes

1. For discussion of the topography see: Antonio Nibbi, *Analisi storico topografico antiquaria della carta dei dintorni di Roma* (Rome, 1848); F. Noack 1910, p. 27 ff; Colombier 1960, p. 47 ff.
2. See the painting (L.V.107) in the Museum of Fine Arts, Budapest, with the Castell at the mouth of the valley; Roethlisberger 1961, p. 270 ff, fig. 188. The drawings L.V.188 (painting in the Metropolitan Museum; Washington/Paris 1982/83, no. 38) and Roethlisberger 1968 (nos. 672, 868, 870–871) depict La Crescenza and its immediate environs. See also Alb.Vienna 1967, no. 92.
3. See Friedländer-Blunt 1939, IV, G. 3 and 29, and 1–18, 22, 24, 25, 29, 31, 36, 37, et al.; T. Reff, "Cezanne and Poussin," *Journal of the Warburg and Courtauld Institutes* 28 (1960), p. 150 ff.
4. Friedländer-Blunt 1939, IV, nos. 270–279.
5. Friedländer-Blunt 1939, I, no. 23.
6. Friedländer-Blunt 1939, IV, no. 275 with further bibliography. The subject and composition of this Anchorite landscape largely corresponds to the landscape with St. Jerome in the Prado. See Blunt, Poussin Studies VIII. "Anchorite Subjects Commissioned by Philip IV," *Burlington Magazine* 101 (1959), p. 389 ff, nos. 172–182, especially 177. For discussion of style see Alb.Vienna 1964, p. 113 ff; Knab 1971; M. Chiarini, "Due mostre e un libro," *Paragone Arte* 187 (1965), p. 56 ff; Paris 1967, p. 154.

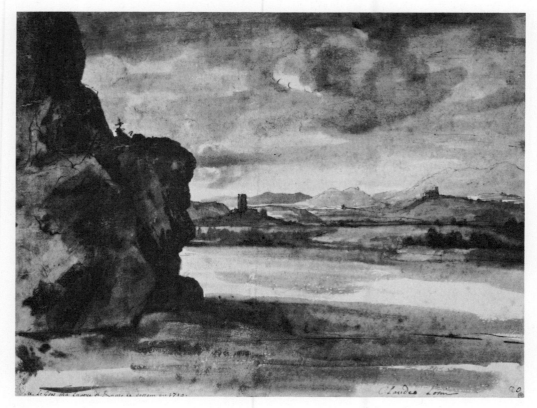

Claude Lorrain
Chamagne near Charmes 1600–1682
Rome

After the death of his parents in 1612, Lorrain (Claude Gellee, called Le Lorraine) was the pupil of his brother Jean Gellee, who made intarsia in Freiburg in Alsace, where he designed ornamental foliage and arabesques. In 1613 Lorrain moved to Rome and worked as an assistant first for Agostino Tassi, a versatile quadratur and landscape painter, in the Casino Montalto at Bagnaja, and then for two years (1619–22) in Naples for the landscape painter Gottfried Wals. In May 1625 he traveled home and took a position as assistant to Claude Deruet, Bellange's successor, in Nancy. He collaborated with Deruet on the frescoes of the local Carmelite church. Toward the end of 1626 he returned to Rome where he settled permanently.

His first dated drawing was done in 1627, his first dated painting in 1629, his first etching, *The Tempest*, in 1630. Joachim von Sandrart became his friend and companion on excursions to draw and paint landscapes; Nicolas Poussin and Pieter van Laer (Bamboccio) also participated in these excursions. In these years Claude also executed the partially destroyed landscape frescoes in the Crescenzi and Muti palaces. Claude was elected academician of the Accademia di San Luca in 1633, and in the same year took in Giovanni Domenico Desiderii, his assistant for twenty-four years. In 1637–39 Claude received commissions from Cardinal Bentivoglio, Pope Urban VIII, Philip IV of Spain and many other eminent personalities. To protect himself from forgers, Claude began making drawings of all his paintings. These drawings were kept in an album, which became known as the Liber Veritatis. At the suggestion of Baglione, he became a member of the Congregazione dei Virtuosi, a group whose tasks included tending Raphael's tomb in the Pantheon.

After a long life devoted to his work, Claude died on November 23, 1682. He was buried in the church of Santa Trinita de' Monti.

Already called "Raffaelle de Paesi" in his lifetime (Wildenstein Album), an epithet that refers also to his noble disposition, Claude's oeuvre marks the apex of the classical or ideal landscape painting, which depicted the Roman countryside, the arcadia of his age and the stretch of coast as far as Naples. As a painter Claude not only knew "how to break the harsh nature of colors" (Sandrart) but also how to render in his paintings and drawings the infinite expanse, harmony and grandeur of that landscape, its atmosphere, gentle melancholy and solemn rhythms. In this he found his own way between, on the one hand, the romantic and realist landscape concepts of his Netherlandish and German precursors and contemporaries and, on the other, the solemn rigor of the Carracci and Domenichino.

TIBER LANDSCAPE WITH ROCKY PROMONTORY
Pen and ink, brush and bistre wash, traces of black chalk; 19.9 × 26.7 cm; inv. 11.513; the iron gall ink has bitten into the paper in several places
Inscribed "Claudio Lorain" at right; the number "20" is also old and differs from Claude's handwriting, it is similar to Mariette's note "M.le Gros ma Envoye de Rome ce dessein en 1719" in lower left margin

Provenance: P. J. Mariette, L.1852; Moriz v. Fries, L.1904; Duke Albert of Saxe-Teschen, L.174

Bibliography: Basan 1777, p. 190, no. 1255; Pattison 1884, no. 271; Meder, Handzeichnung, fig. 234; Friedländer 1921, p. 190; Hind 1925; Christoffel 1941, p. 141; Vallery-Radot 1953, p. 195; Knab 1953, no. 28, p. 155; W. Hofmann, "Quelques Dessins français de l'Albertina," *La Revue des Arts* 2 (1955), p. 75; Benesch 1964, Meisterzeichnungen, no. XIX; Roethlisberger 1968, no. 279; Paris 1970, no. 140; Alb.Vienna 1950, no. 51; Paris 1967, no. 231.

Executed around 1640, the drawing shows the Tiber valley above Rome with Primaporta, Castel Proccoio and Marcigliana and the Tolfa mountains. In the background to the right Monte Soratte, praised by Horatius and so often drawn and painted by Claude in all its manifold appearances, is visible. One of Claude's major landscape studies, the effects of the drawing rely mainly on the application of wash, the many gradations of which depict both spatial depth and breadth as well as light and atmosphere. A few pen and brush strokes convincingly and simply achieve the transition from the foreground, with its stageset promontory, to the distance, which develops in horizontal layers in the manner of Claude's mature style. Seldom was baroque feeling for nature so happily fused with classical balance to capture the expression of a serious, elevated mood. This drawing is related in the freedom of its handling to the 1642 drawing[1] from the journey to Subiaco and to the 1643 landscape with shepherds drawing,[2] which shows a section of the Tiber valley a little further north from the view in the present drawing, though under somewhat brighter skies.[3] A. M. Hind and W. Hofmann noted that two further landscape studies in the British Museum are directly connected to the evolution and topography of the Albertina sheet: one a panorama from further downstream with bright evening sky and long shadows; the other, a very dynamic study of the motif from the Albertina drawing that focuses on the promontory on the bank with strong chiaroscuro and a kneeling hermit almost obscured by thick wash.[4] Boats lie at anchor on the water. W. Hofmann has surely correctly identified the praying hermit as St. Bruno, the founder of the Carthusian Order, who was beatified in 1623 and repeatedly depicted in solitary landscapes in the seventeenth century.[5] The grave and gloomy mood in both drawings reinforces this interpretation. One may thus observe how an idea for a composition and its theme originates in the artist's studies after nature. It must, however, be said that no painting of this subject by Claude is known today.[6]

The Albertina drawing, assigned by Marcel Roethlisberger to a supposed Campagna sketchbook,[7] is quite simply one of the great achievements of painterly drawing. The immediacy and

depth of the experience of nature and the grandiose melancholy (which Goethe would explain as the "effects of atmospheric conditions on the spirit") not only invite comparisons with the masterpieces of philosophical painting from the late Sung dynasty in China, but also, stay within the relevant period, with corresponding studies by Poussin and Rembrandt, not to mention other Netherlandish or Italian contemporaries such as Breenbergh, Asselijn, Jan Both or Pier Francesco Mola and Dughet. While the comparison with Poussin reveals a noticeably greater freedom and empathy with natural forms achieved at the expense of rigor, the comparison with Rembrandt shows the contrasts of light and shade to be more balanced, for all their inherent drama. Here, however, questions of aesthetic temperament and conviction are broached, questions that do not allow value judgments. *E.K.*

Notes
1. British Museum; Roethlisberger 1968, no. 583.
2. Petit Palais, Paris, inv. 967; Roethlisberger 1968, no. 542.
3. The panoramas of Tivoli and Velletri in the British Museum are related stylistically and probably date from the same years; Roethlisberger 1968, no. 430, 476.
4. Roethlisberger 1968, no. 278.
5. W. Hofmann refers, among others, to a painting by Pier Francesco Mola in a private collection in Rome published by R. Buscaroli, *La Pittura del Paesaggio in Italia* (Bologna: 1935), pl. LIV.
6. See Knab 1966, p. 122 ff, figs 22, 23; E. Knab, "Entwurf und Ausführung im Schaffen des Claude Lorrain," *Stil und Überlieferung in der Kunst des Abendlandes*, III in *Akten des 21. Internationalen Kongresses für Kunstgeschichte*, Bonn, 1964, (publ. Berlin 1965), p. 155 ff.
7. Roethlisberger 1968, p. 59 ff, nos. 276–413; opinions differ on the reconstruction of Claude's sketchbooks. See also London 1926, p. XIV; Knab 1960, p. 96 ff, 105 ff; Vienna 1964, nos. 73–75; Kitson 1961, p. 252 ff; Kitson 1963, p. 96 ff; Kitson 1978; Roethlisberger 1961, p. 277; Roethlisberger 1962.

67a. Claude Lorrain
Tiber Valley
Petit Palais, Paris

67b. Claude Lorrain
Tiber Valley
Courtesy of the Trustees of the British Museum, London

67c. Claude Lorrain
Tiber Bank
Courtesy of the Trustees of the British Museum, London

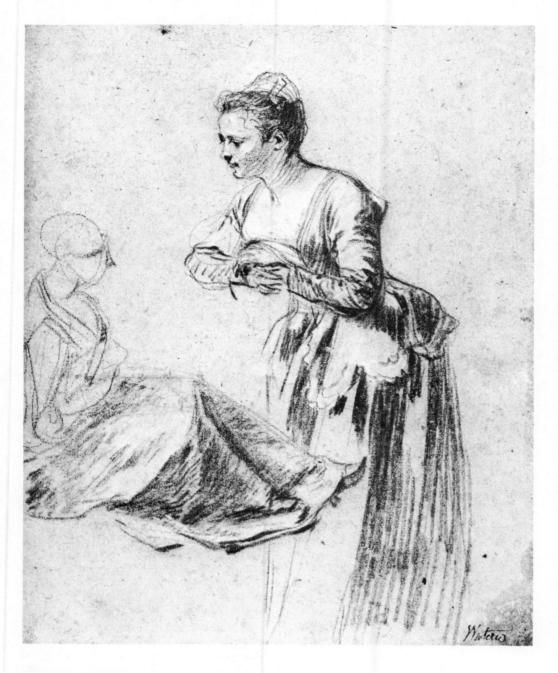

energetic red chalk hatching, reserved areas of white paper and delicately applied accents of black and white chalk), the artist focused on the study of the arms, the pose and movement of which are suggested by a sketchily intimated tangle of lines. The depiction of the face, an ideal type[2] shown in three-quarter profile, is achieved by a continuous contour line that creates the forehead, nose, mouth and upper neck; added white highlights lend emphasis to the forehead and cheekbones, while the shadows on the neck are rendered by parallel strokes of red chalk. The girl's gaze links her to a study of a second woman, who is seated and whose head and upper body are sketched in a few broad strokes. In this study Watteau concentrated mainly on the pose of the legs and the drapery covering them.

Watteau preferred to use red chalk combined with black and white chalks, a technique already employed in the seventeenth century by some French artists — such as Vouet, Lagneau or Coypel — and especially Rubens.

According to Gersaint,[3] Watteau valued his drawings more highly than his paintings because he believed he could achieve greater presence and naturalness in drawing.[4] His drawings were rarely produced in connection with specific works, but were usually studies from nature or after works by other artists. Watteau collected them in sketchbooks so that he could take motifs from this reservoir when needed and combine them into new pictorial compositions. Above all he sketched the poses of individual figures, at first only in red chalk, later *aux trois crayons*, often tightly squeezing several studies onto one sheet. In "Vie de Watteau," an address Comte de Caylus delivered to the Academy in 1748, he describes how such studies of the model were normally done: "Sa coutume était de dessiner ses études dans un livre relié, de façon qu'il avait toujours un grand nombre sous sa main. Il avait des habits galants, quelques-un de comiques, dont il revêtait les personnes de l'un ou de l'autre sexe selon qu'il en trouvait qui voulait bien se tenir et qu'il prenait dans les attitudes que la nature lui présentait. . . ."[5]

Because of the confidence of the stroke and the concentration on a concise, schematic line, which stands in contrast to the earlier detailed, decorative studies and may be compared to Gillot's drawings, this sketch should be dated to the artist's final years.

Ch.E.

1. 1822 Estate inventory, p. 836, "Étude d'une jeune fille se parant d'un bracelet."
2. K. T. Parker and J. Mathey, *Antoine Watteau, Catalogue complet de son oeuvre dessiné*, II (Paris, 1957), p. 305.
3. "Il trouvait plus d'agrément à dessiner qu'à peindre," quoted in: K. T. Parker, *The Drawings of Antoine Watteau* (London, 1931), p. 7.
4. "Je l'ai vu souvent se dépiter contre lui-même, de ce qu'il ne pouvait rendre en peinture l'esprit et la verité qu'il savait donner à sa crayon." K. T. Parker, *The Drawings of Antoine Watteau*, p. 7.
5. H. Adhémar, *Watteau, sa vie, son oeuvre* (Paris, 1950), p. 181.

Jean-Antoine Watteau
Valenciennes 1684–1721 Nogent-sur-Marne

Moved to Paris in 1702; c.1703 began training with the scene painter Claude Gillot; c.1707 entered the workshop of Claude Audran, conservator in the Luxembourg Palace, where Watteau studied Rubens' Medici cycle. 1709 unsuccessful attempt to win the Rome prize; 1717 admitted to the Academy as peintre des fêtes galantes with his painting *Embarquement pour Cythère*; 1719 traveled to London; and in 1721 moved to Nogent-sur-Marne, near Paris.

68

TWO STUDIES OF A YOUNG WOMAN
Red, white and black chalks on brownish paper; 26.9 × 21.4 cm; inv. 12.009
Inscribed "Wateau" in bistre ink at lower right

Provenance: Duke Albert of Saxe-Teschen; 1822 Estate inventory, p. 836; L.174

Bibliography: Schönbrunner-Meder, no. 200; G. Lafenestre, *Cinquante dessins de Watteau*, Paris, 1907, no. 5; Meder, Albertina-Facsimile 1922, no. 4; K. T. Parker and J. Mathey, *Antoine Watteau, Catalogue complet de son oeuvre dessiné*, II, Paris, 1957, p. 311, no. 560; Benesch 1964, Meisterzeichnungen, no. XX.

In the *Catalogue des Dessins de la Collection du feu S.A.R. le Duc de Saxe*, this drawing is listed as "Study of a young girl adorning herself."[1] It displays a powerful, assured handling of line; in spite of the sparing use of color, the effect is both painterly and graphic, with the rough-textured brownish paper mediating in the interplay between opposed coloristic values, thereby creating the impression of space and three-dimensionality. The figure of the standing girl is caught by Watteau in mid-movement; next to the rendering of the dress (its substance is created by broad,

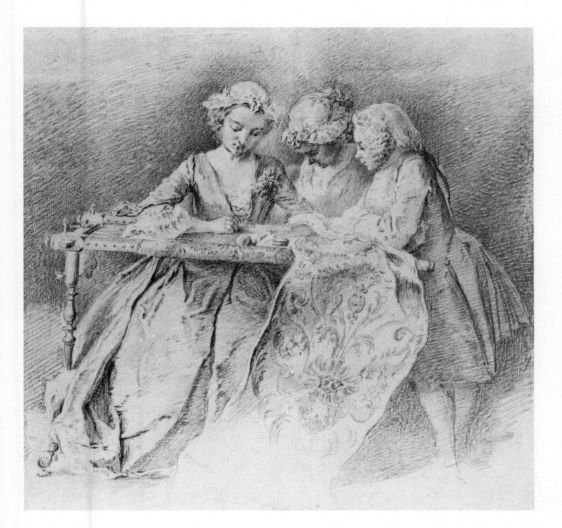

Jacques-André Portail
Brest 1695–1759 Versailles

Portrait painter and architectural draughtsman, flower painter and engraver. Active in Nantes and Paris, where he received a position in the office of the Comptroller General and Minister Orry de Vignory in 1735. In 1740 he became Garde des plans et tableaux de la couronne in Versailles, and from 1741 was entrusted with the organization of the annual Salon exhibitions in the Louvre. In 1746 he became a member of the Académie Royale as Peintre des fleurs.

THE EMBROIDERERS
Black and red chalk; 29.0 × 30.2 cm; inv. 12.099

Provenance: Duke Albert of Saxe-Teschen; 1822 Estate inventory, p. 849; L.174

Bibliography: Schönbrunner-Meder, no. 454; D. Sutton, *French Drawings of the Eighteenth Century*, London, 1949, no. LV; F. Boucher and P. Jaccottet, *Le Dessin français au XVIII^e siècle*, Lausanne, 1952, p. 149; Australia 1977, p. 110, no. 45.

Little is known of Portail's origins and oeuvre. He was one of Louis XV's most favored draughtsmen. This artist's landscape studies, figure drawings and genre scenes were executed mainly in red accented with other chalks. This technique, also used by Carmontelle and Liotard, allowed contrasts of warm and cold tones, thereby creating a delightful surface structure. In style and technique Portail's drawings are often compared to Watteau's.[1] While Watteau's figure studies usually capture the model in a particular movement[2] and thus often have a snapshot quality, Portail's works are closer to Chardin in their static calm. Portail also liked to group figures and engage them in some occupation around a piece of furniture such as a table. He further emphasized his treatment of "the human figure as still-life" by a neutral, uniform background.[3]

In this drawing, which shows a boy watching two girls embroidering, the majority of the surface is covered with an even network of thick hatching. Out of this, the artist develops the figures with a miniaturist's precision and love of detail, without rounding them out fully into three-dimensions. With the relatively uniform effect of the stroke, which equalizes the scene's spatial values without strong nuances, Portail achieves that ornamental, timeless grace of his images, whose stylized pictorial effect is a typical feature of French rococo painting. *Ch.E.*

Notes
1. Benesch 1964, Meisterzeichnungen, no. 215.
2. See Catalogue no. 68.
3. Benesch 1964, Meisterzeichnungen, no. 215.

THE AQUEDUCT NEAR ARCEUIL
Black and white chalks on blue paper;
30.7 × 44.5 cm; inv. 12.194
Inscribed "Vue d'Arceuil. François Boucher, du
Cabinet Boutin" in ink on verso at later date

Provenance: Duke Albert of Saxe-Teschen, L.174

Bibliography: Paris 1950, no. 143; A. Ananoff,
L'Oeuvre dessiné de François Boucher, I, Paris, 1966,
p. 157, no. 576; P. Jean-Richard, comp., *François
Boucher, gravures et dessins provenant du Cabinet des
Dessins et de la Collection Edmond de Rothschild, Musée
du Louvre*, Paris, 1971, pp. 64, 65, under no. 48.

The town of Arceuil lies south of Paris and acquired its name from the Roman aqueduct, the Arcus Juliani, which was rebuilt in 1613/14 by Salomon de Brosse. In the second half of the eighteenth century it belonged to the famous park of the Prince de Guise and was a favorite motif of numerous artists, including Charles Joseph Natoire, Jacques-André Portail and Jean-Baptiste Oudry.

Boucher leads the viewer's eye to the aqueduct from a narrow strip of land across which a wooden bridge points into the scene like a repoussoir element. A section of the aqueduct on both sides of the River Vanne can be seen between two thick clumps of trees. The sheet may be seen as an example of Boucher's studies after nature, which he recorded and recombined as models for his *paysages composés.*[1] A drawing, *Aqueduct at Arceuil*, by Portail reproduces the same landscape motif from the same vantage point, thus proving that our drawing is an actual study of a real view.[2] While Portail's drawing is sketchier and seems to be more of a quick outline, Boucher's work has a firmer composition and is closer to a finished painting by virtue of the painterly use of the drawing media. The blue paper, which gives an added painterly effect, the nuanced stumping and the differentiated strokes, from black shadows via lightly touched passages to delicate white areas of light, all combine to give striking expression to the atmospheric mood of this river landscape. One may conclude from the formal pictorial integration that this drawing was intended as the immediate model for Pierre-Quentin Chedel's etching *Le pont rustique.*[3] This etching, together with its pair *Le Pêcheur*,[4] was offered for sale by Chedel in the Mercure de France in April 1753,[5] which establishes an approximate date for the execution of the drawing. Boucher's preparatory drawing in chalk on blue paper of the same dimensions for the second engraving has also survived and is today in the Art Institute of Chicago.[6] It shows the same landscape but looking in the opposite direction from the aqueduct.

A spontaneous sketch[7] from nature on which the artificial elements like staffage figures have not yet been added obviously preceded this sheet. The Chicago drawing takes up immediately from this, adding the boy fishing and the dog, while strengthening the painterly elements. This drawing, one step beyond the Paris sketch, corresponds in style and composition to the Albertina sheet. We may therefore conclude that both were conceived as images for the subsequent etchings, giving a date of shortly before 1753. *Ch.E.*

François Boucher
Paris 1703–1770 Paris

Born the son of an embroidery designer, from whom he received his first training. Boucher probably apprenticed to François Lemoyne, c.1720, thereafter he trained in the workshop of the engraver Jean-François Cars and collaborated as an etcher on the extensive project of reproducing Watteau's drawings. In 1727 Boucher traveled to Italy, he returned to Paris in 1731 and was admitted to the Académie Royale as Peintre d'Histoire. In 1765 he became director of the academy and first court painter to Louis XV, alongside commissions for the court and the Parisian nobility, designs for the tapestry works at Beauvais and for theater sets.

70a. François Boucher
Landscape with Boy Fishing
Collection of the Art Institute of Chicago,
Chicago, Illinois

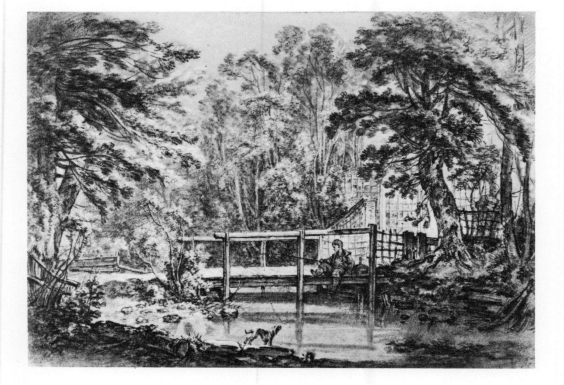

Notes

1. R. Shoolman Slatkin, comp., *François Boucher in North American Collections, 100 Drawings* (Washington, D.C.: National Gallery of Art, 1973/74), p. 73.
2. Jacques-André Portail, *Aqueduct at Arceuil*, pencil, pen and red chalk, 27.0 × 42.0 cm; collection of Frits Lugt, Institut Néerlandais, Paris, inv. 7643. Illustrated in *Le Dessin français dans les Collections Hollandaises* (Paris: Institut Néerlandais/Amsterdam: Rijksmuseum, Prentenkabinett, 1964), no. 69, pl. 53.
3. Pierre-Quentin Chedel, *Le Pont rustique*, etching; inscribed "Boucher del." lower left, "Chedel sc." lower right, title, lower center, 30.0 × 44.6 cm; Albertina Collection, Vienna, inv. F II, 43, p. 17. Illustrated in: P. Jean-Richard, *L'Oeuvre gravé de François Boucher dans la Collection Edmond de Rothschild, Inventaire Général des gravures*, I (Paris: École Française, 1978), p. 149, no. 489.
4. Pierre-Quentin Chedel, *Le Pêcheur*, etching, inscribed "Boucher del," lower left, "Chedel sc.," lower right, 29.8 × 44.5 cm; Albertina Collection, Vienna, inv. F II, 43, p. 16. Illustrated in P. Jean-Richard 1978, p. 147, no. 486.
5. P. Jean-Richards, *François Boucher* (1971), p. 65.
6. François Boucher, *Landscape with Boy Fishing*, black and white chalks on blue paper, 30.0 × 44.3 cm; Chicago Art Institute, The Joseph and Helen Regenstein Collection. Illustrated in R. Shoolman, *Francois Boucher in North American Collections* (Washington, D.C., 1973/74), p. 74, no. 57.
7. François Boucher, *Landscape near Arceuil*, black and white chalk on blue paper, 30.3 × 45.0 cm; Institut Néerlandais, Paris, inv. 1974-T41. Illustrated in: J. F. Méjanès, "A Spontaneous Feeling for Nature, French Eighteenth-Century Landscape Drawings," *Treasures from the Collection of Frits Lugt of the Institut Néerlandais* (Paris, 1976), p. 138, fig. 1.

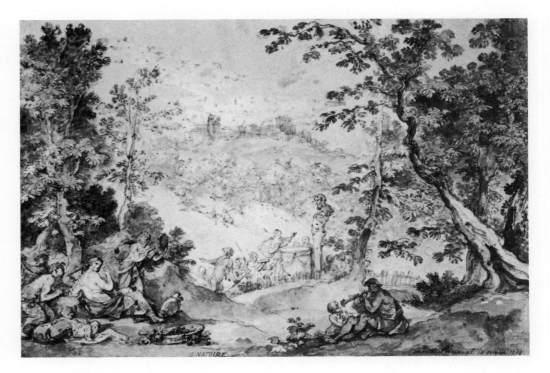

Charles-Joseph Natoire
Nîmes 1700–1777 Castel Gandolfo

Born the son of the architect and sculptor Florent Natoire. From 1717 he was a pupil of François and Louis Galloche; 1721 Natoire won Rome Prize; from 1723 to 1729 he attended the French Academy in Rome. When he returned to Paris, the artist was mainly active as a scene painter; 1731–35 he undertook the decoration of the La Chapelle-Godefroy château near Nogent-sur-Seine; 1734 he became a member of the Académie Royale; 1741 he created designs for Parisian Gobelin tapestries. In 1751 Natoire was named director of the French Academy in Rome. He resided in Castel Gandolfo from 1774 until his death.

71

ITALIAN LANDSCAPE IN AUTUMN
Black and red chalk, pen and bistre ink with gray and bistre wash, watercolor, heightened with white on bluish paper; 28.1 × 42.3 cm; inv. 12.079
Signed "G.Natoire" in ink at lower center; inscribed and dated "monte Porcio al 10 octobre 1763" at lower right

Provenance: Duke Albert of Saxe-Teschen, L.174

Bibliography: Benesch 1964, Meisterzeichnungen, no. XXI; Alb.Vienna 1978, no. 110.

Natoire's involvement with landscape painting began during his first stay in Rome (1723–29), where the French Academy, under its Director Vleughel, encouraged him to sketch the environs of Rome. After his return to Paris he achieved great success as a decorative painter in Versailles, Fontainebleau and elsewhere. Only after his appointment as director of the French Academy in Rome in 1751 did he devote himself to landscape drawing once again.

He was not interested in just recording a given view; he wanted to incorporate classical monuments, in the spirit of Panini and Piranesi. Influenced by the new interest in the Antique, which arose around the turn of the century, Natoire himself began to collect ancient frag-ments that he studied and included as props in his landscapes.[1] The majority of his landscape watercolors date from between 1755 and 1766; for the most part they are inscribed with details about location and date, whereby the indication of the month in addition to the season represented in the image seems to have been especially important to Natoire. Autumn and spring were his favorite times of year and he rendered their characteristic moods through changing light and differently colored vegetation. In order to achieve this painterly effect in his landscape drawings, Natoire developed a new technique: he would add brown or gray washes over the first sketch in black chalk, strengthened in pen or red chalk, and finish with watercolor. Whereas the early drawings have a thin, transparent layer of color, the later works are characterized by the use of thick pen strokes, emphasized white highlights and gouache instead of watercolor.[2] Apart from these mediums, the blue ground also intensifies the painterly effect of his compositionally integrated drawings.

The form of his compositions continues the tradition of Poussin, Claude and the Dutch Italianate artists of the seventeenth century: from a stagelike strip of foreground, which is usually enlivened with a mythological or pastoral scene, the viewer's eye is led towards the ideal landscape, concentrated in the background. Thus, the present drawing by Natoire is typical of his arcadian landscapes of the 1760s that use theatrical framing elements and genre scenes to transform actual landscapes into decorative, idealized views. In this sheet Monte Porzio is pushed into the distance by delicately applied washes and thin strokes, while the pastoral scene, presented on a strip of land framed by stylized groups of trees, is the main subject of the image. *Ch.E.*

Notes

1. *Charles-Joseph Natoire, peintures, dessins, estampes et tapisseries des collections publiques francaises* (Musée des Beaux-Arts, Troyes and traveling, 1977), p. 21, 22.
2. Cf. J. Claparede, *Les Dessins de Charles Natoire* (Montpellier, 1956).

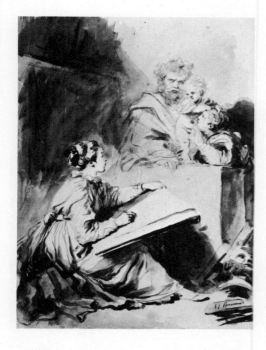

Jean-Honoré Fragonard
Grasse 1732–1806 Paris

Born the son of a glove manufacturer in Grasse.
Fragonard moved to Paris in 1738; apprenticed
for a short time with a Parisian notary c.1748; and
trained with the still-life painter Jean-Baptiste
Siméon Chardin (1750) and François Boucher.
From 1753 to 1755 he studied at the École Royale
des Elèves Protégés under Carl van Loo; 1755 to
1761, the French Academy in Rome, where he
met the painter Hubert Robert and his later
supporter Abbé de Saint-Non. In 1761 Fragonard
accompanied Saint-Non on a study trip to Naples
and then returned to Paris. In 1765 he became a
member of the Académie Royale de peinture;
1773/74 second voyage to Italy. In 1795 he and
Robert were members of the commission on the
national museum at the Louvre.

MARGUERITE GÉRARD SKETCHING
Brush and bistre wash over leadpoint
underdrawing; 45.1 × 33.8 cm; inv. 12.731
Signed "H. Fragonard" lower right

Provenance: Duke Albert of Saxe-Teschen, L.174

Bibliography: Schönbrunner-Meder, no. 749;
Meder, Albertina-Facsimile 1922, no. 26;
Benesch 1964, Meisterzeichnungen, no. 224;
A. Ananoff, *L'oeuvre dessiné de Jean-Honoré
Fragonard*, IV, Paris, 1970, no. 1965; Australia
1977, no. 47.

Fragonard's sister-in-law, Marguerite Gérard
(1761–1837), came to Paris in 1775 to help her
sister keep house. As a young girl she became her
brother-in-law's pupil, and eventually his assis-
tant. Fragonard portrayed or included her in his
genre scenes several times.[1]

In this drawing Fragonard uses a composition
based on a larger and a smaller, subordinate
triangle. The young artist, seen seated, is sketch-
ing a Holy Family. Moreover the composition,
itself, reflects that of a Holy Family. This is
supported by comparisons with Fragonard's
paintings, which show similarly idealized but
nevertheless everyday figures.[2]

This sheet by Fragonard is an excellent ex-
ample of the artistic possibilities of free-brush
drawing. The radiant effects of light and shadow
are fascinating, and the physical qualities of
various materials are accurately characterized. A
fine brush subtly records the attentive features of
the girl, while broad brushwork along her lower
arm and the hem of the skirt simultaneously
create contour and shadow. Powerful strokes of
the fully loaded brush, mainly in the shadowed
areas of the softly flowing draperies, alternate
with delicate, narrow traces, transparent washes
and reserved passages of white paper to produce
dynamic chiaroscuro fluctuations. Layered areas
of shadow that contrast with light surfaces give
the image its spatiality.

For all its artistic individuality, Fragonard's
virtuoso brushwork, based on the effects of light
and shade, is similar to some of Rembrandt's
works. However, while the linear structure is still
strongly felt in Rembrandt, painterly effects from
the bistre washes' varying density and rhythms
predominate with Fragonard. It is known that
Fragonard greatly admired Rembrandt and that
he acquired sixty-nine Rembrandt drawings at
the estate sale of Boucher's private collection on
February 18, 1771.[3] It is therefore also interesting
to note that Fragonard began using bistre wash
drawing in the '70s, bringing it to new heights.

Because of the technique and the character-
istically free brushwork, and because Marguerite
Gérard did not come to Paris until 1775, this sheet
may be dated to the late 1770s. *Ch.E.*

Notes
1. L. Réau, *Fragonard, sa vie et son oeuvre* (Brussels,
 1956), p. 107 ff.
2. J. H. Fragonard, *Rest on the Flight into Egypt*,
 Musée des Beaux-Arts, Troyes; oil on canvas,
 18.7 × 12.45 cm; probably painted in the
 1760s or 1770s. Illustrated in D. Sutton,
 comp., *Fragonard* (Tokyo/Kyoto, 1980), pl. 3.
3. E. Williams, comp., *Drawings by Fragonard in
 North American Collections* (National Gallery of
 Art, Washington, D.C., and Fogg Art
 Museum, Cambridge, Mass., 1979), p. 124.

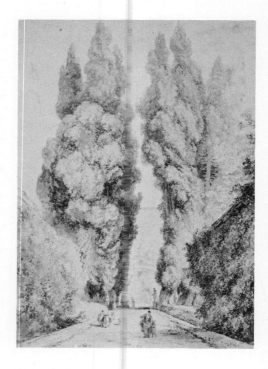

73

AVENUE OF CYPRESSES AT THE VILLA D'ESTE
Brush with bistre wash on leadpoint
underwriting; 46.5 × 34.3 cm; inv. 12.735
Signed "fragonard" lower right; inscribed in
another hand "Vue de la ville d'Este a Tivoli" at
upper left in pencil

Provenance: Duke Albert of Saxe-Teschen; 1822
Estate inventory, p. 514; L.174

Bibliography: Meder, Albertina-Facsimile 1922,
pl. 31; Paris 1950, no. 150; F. Daulte, comp.,
Fragonard, Musée des Beaux-Arts, Bern, 1954,
no. 53; A. Ananoff, *L'oeuvre dessiné de Jean-Honoré
Fragonard*, III, Paris, 1968, no. 1434.

The Villa d'Este in Tivoli, which was built in the
sixteenth century for Cardinal Ippolito d'Este
from the plans of Pirro Ligorio, was famous in the
eighteenth century for its terraced gardens criss-
crossed by geometrically ordered paths, steps,
bowers, grottoes, fountains and allées. In 1759
Fragonard met the theologian and patron of the
arts, Abbé de Saint-Non, who rented the Villa
d'Este and invited Fragonard and Hubert Robert
to be his guests in the summer of 1760. Together
they drew from the environs of Tivoli; between
1761 and 1763 Saint-Non made etchings from
these images, calling the work *Différantes vues
dessinées d'après nature dans les environs de Rome et de
Naples par Robert et Frago.*[1] In a letter to his brother
Saint-Non singled out Fragonard as a tireless
draughtsman: ". . . Fragonard est tout de feu, ses
dessins sont très nombreux. . . . Je trouve en eux
du sortilège."[2]

Of the studies from that time, the Musée des
Beaux-Arts in Besançon now owns a series of ten
red chalk drawings (Fragonard preferred red
chalk for his studies) of landscapes from the Villa
d'Este. A view of the grand cypress avenue[3]
identical in motif to the Albertina's drawing
is included in this series. The composition is domi-
nated by the severe perspective of the pathway
whose depth is both underscored by the side
walls, which run parallel and the continued aerial
perspective of the background. The two groups of
cypresses form the vertical counterpart and
thereby emphasize the strict axial division of the
composition. Because two compositional elements

of the motif are repeated in the two drawings, many scholars assumed that the Albertina's brush drawing was executed in the summer of 1760.[4] A detailed comparison of the two sheets, however, reveals that clear stylistic differences exist. While the red chalk drawing achieves its painterly effects with the help of tightly packed, sometimes rubbed chalk hatching and separate contour lines, the brush drawing uses bistre washes in several layers and differing densities. Fragonard then laid richly varied flecks of color, in an almost pointillist manner, over the washes to build up a flickering system for describing the vegetable nature of the thick treetops and hedges.

Fragonard's free brush drawings appear in 1773–74, during his second journey to Italy with the art lover Bergeret. In his letters Bergeret tells of an excursion to the park of the Villa d'Este.[5] A large number of Fragonard's most beautiful views of Roman gardens date from the spring of 1774.[6] Benesch has described their execution as "pointillist."[7] This could also describe the style of the Albertina's *Grand Cypress Avenue*; consequently a date of around 1774 may be applied to the Albertina sheet for Fragonard could have returned to Tivoli to try his hand at the same subject but in a new technique. *Ch.E.*

Notes

1. E. Williams, comp., *Drawings by Fragonard in North American Collections* (National Gallery of Art, Washington, D.C., and Fogg Art Museum, Cambridge, Mass. 1979), p. 20.
2. L. Guimbaud, *Saint-Non et Fragonard d'après des documents inédits.* (Paris, 1928), p. 98.
3. J. H. Fragonard, *The Grand Cypress Avenue of the Villa d'Este in Tivoli*, Musée des Beaux-Arts, Besançon; red chalk, 47.8 × 35.4 cm, inv. D.2.842. Illustrated in M. L. Cornillo, *Inventaire général des Dessins des Musées de Province, Collection Pierre-Adrian Pâris*, I (Besançon, 1957), no. 32.
4. Paris 1950, no. 150; *Fragonard* (Bern, 1954), no. 53; L. Réau, *Fragonard, sa vie et son oeuvre* (Brussels, 1956), p. 222; F. Fosca, *Les Dessins de Fragonard* (Lausanne, 1954), p. 53, no. 8.
5. J. Wilhelm, ed., *Bergeret de Grancourt, Voyage d'Italie, 1773–1774* (Paris, 1948), p. 96 ff.
6. Compare, for instance: J. H. Fragonard, *Roman Park Landscape with Fountain*, Albertina Collection, Vienna; brush with bistre, inscribed and dated "Rome 1774" lower right, 28.9 × 36.8 cm, inv. 12.736.
7. Benesch 1964, Meisterzeichnungen, p. 373.

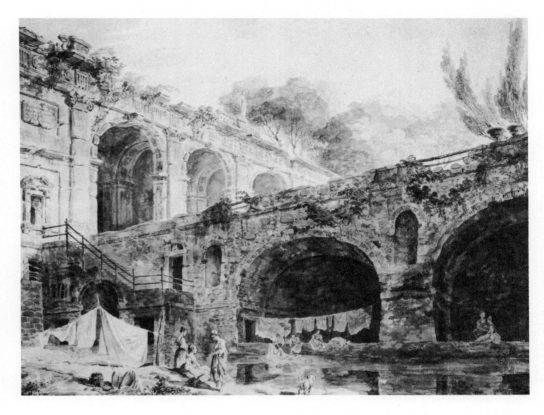

Hubert Robert
Paris 1733–1808 Paris

74

Son of Nicolas Robert, servant of the Ambassador of Lorraine to the French Court, Marquis de Stainville. Robert trained with the sculptor Michelangelo Slodtz; in 1754 he went to Rome in the entourage of the newly appointed French Ambassador (the son of Marquis de Stainville) and entered the French Academy in Rome, where Panini taught perspective and Natoire was director. From 1759 to 1762 Robert was a scholar at the academy; under the influence of Panini and Piranesi he turned to painting architecture. He traveled with his patron, the Abbé de Saint-Non, to Naples from April to June 1760 before joining Saint-Non and Jean-Honoré Fragonard at the Villa d'Este in Tivoli in July 1760. Robert returned to Paris in 1765, was elected to the Académie Royale as architectural painter in 1766, appointed Dessinateur des jardins du Roi (designs for the decoration of salons and French gardens such as Versailles, Ermenoville and Rambouillet) in 1788. Also designed the gardens and interior rooms of the chateau at Méréville in 1788. In 1795 became a member of the commission appointed to renovate the Louvre as a museum.

ROMAN RUINS AT THE VILLA MADAMA, WITH WASHERWOMAN

Pen and ink, brush and watercolor over black chalk underdrawing; 34.5 × 45.5 cm; inv. 12.431 Signed, dated and inscribed "Villam Madama Delineavit Romae, H. Roberti, 1760" at upper left

Provenance: Duke Albert of Saxe-Teschen; 1822 Estate inventory, p. 882; L.174

Bibliography: E. Hempel *Die Graphischen Künste*, 47 (1924), p. 9; *Hubert Robert, Musée de l'Orangerie*, Paris, 1933, p. 85, 86, no. 117; H. Burda, *Die Ruine in den Bildern Hubert Roberts*, Munich, 1967, p. 75.

This watercolor by Hubert Robert shows a section of the garden loggia at the Villa Madama on the Monte Mario, which was begun in 1518 by Giulio Romano from designs by Raphael on the model of antique Roman villas and finished by Antonio da Sangallo.

Robert is not concerned with a vedutelike depiction of the building, but rather with using the real architecture as a starting point for its artistic re-formation. Through the addition of ruined overgrown walls, this architecture is artificially transmogrified into a scene of picturesque ruins. Furthermore, the notion of *vanitas* is evoked by representing the decaying and the decayed.[1] At the time, texts on aesthetics, which recommended the depiction of idealized landscapes above all, remarked on the significance of ruins as pictorial themes, as they were "a painterly motif with the particular ability to fuse closely with the organic in nature better than any intact architecture."[2]

In Rome, Hubert Robert studied perspective with Gian Paolo Panini, from whom he appropriated the type of "genre scene with ruins" that brought him great fame in the second half of the eighteenth century. In 1766 he was elected to the Académie Royale under the rubric *peintre des ruines*.[3] In order to underline the opposition

between everyday life and the antique monument as a memorial of the past, Robert often placed a group of washerwomen in the foreground, staffage he sometimes copied exactly from Boucher.[4]

The Albertina drawing of the Villa Madama, dated 1760, from which François Janinet made a color engraving in 1778,[5] served as the model for an oil of the same motif now in the Hermitage in Leningrad.[6] The two works differ slightly — more figures have been added to the foreground and they have been arranged differently in the Hermitage oil; small changes have also been made to the trees. The Hermitage also has another painting by Robert,[7] in which Robert repeated the scene, but reduced the vegetation, altered architectural details, shortened the aqueduct and rearranged figures. For this painting there is also a preparatory watercolor,[8] which is more of a sketch than the Albertina sheet.

In the exhibited sheet of the Villa Madama, the strong light around the portico and the strip of land at left is achieved by a thin glazing of paint, which allows the white paper ground to shine through. The porous stonework of the aqueduct forms a dark barrier between the portico and the land; over a light brown ground a network of nuanced brown tones is laid down using the thin point of a brush, creating the effect of a ruined wall through the different color values. The deepest shadows in the niches are rendered with broad strokes of the brush and several overpaintings that leave the light forms of the washing and the figures untouched. The atmospheric effect in the sky is produced by a delicate application of paint in broad translucent planes. The treetops are worked up in several layers of dotted greens.

The influence of Robert's friend Fragonard, with whom he drew in the environs of Rome, may be seen in the virtuoso, loose brushwork. *Ch.E.*

Notes

1. H. Burda, *Die Ruine in den Bildern Hubert Roberts* (Munich, 1967), p. 52.
2. Ch. C. Hirschfeld, *Theorie der Gartenkunst*, III (Leipzig, 1779–1785), p. 115.
3. Cf. C. Gabillot, *Hubert Robert et son temps* (Paris, 1895), p. 92 ff; H. Burda, *Die Ruine*, p. 62.
4. J. Cailleux, "Hubert Robert a pris modèle sur Boucher," *Connaissance des arts* (1959), p. 100–107.
5. Albertina Collection, Vienna, inv. 1930/1767; R. Portalis, *Les graveurs du 18e Siècle*, II (Paris, 1881), no. 85.
6. Hermitage, Leningrad, oil on canvas, 52.0 × 69.5 cm, inv. 7593. Illustrated in: I. Nemilova, *La peinture française du 18e siècle* (Leningrad, Hermitage, 1982), no. 265.
7. Hermitage, Leningrad, oil on canvas, 95.0 × 133.0 cm, inv. 5649. Illustrated in: I. Nemilova, *La peinture française du 18e siècle*, no. 267.
8. Hermitage, Leningrad, pen with brown and black ink, and watercolor, 30.5 × 40.2 cm, inv. 14307. Illustrated in: Y. Kuznetsov, *Western European Drawings* (Leningrad, Hermitage, 1981), no. 89.

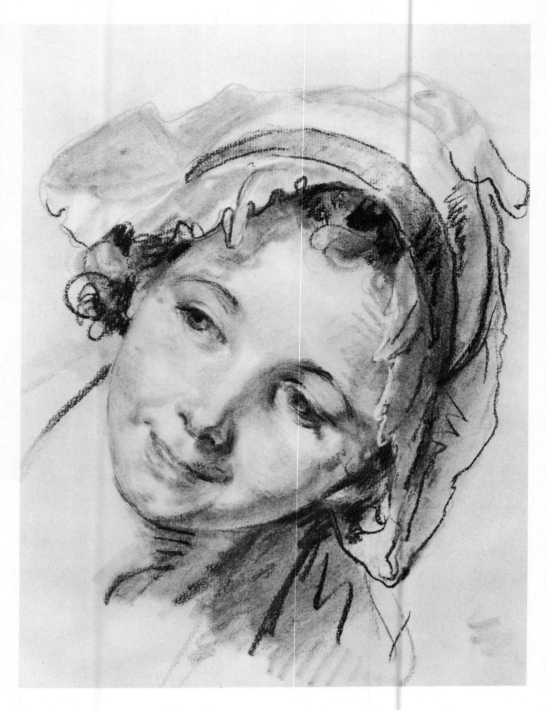

Jean-Baptiste Greuze
Tournus 1725–1805 Paris

75

Started his training in the studio of the portrait painter Charles Grandon in Lyon, c.1747; moved to Paris, c.1750, where he attended the drawing courses of the Académie Royale. Traveled to Italy in 1755–56; elected to the academy as a genre-painter in 1769; became a member of the Commune Générale des Arts, of which Jacques-Louis David was also a leading member in 1793.

HEAD OF A GIRL

White and black pastel chalks, charcoal, red chalk, areas of the ground rubbed with red chalk, 34.2 × 26.0 cm; inv. 12.771

Provenance: Duke Albert of Saxe-Teschen; 1822 Estate inventory, p. 918; L.174

Bibliography: Schönbrunner-Meder, no. 289; Meder, Albertina-Facsimile 1922, no. 21; J. Martin, *Catalogue raisonné de l'oeuvre peint et dessiné de Jean Baptiste Greuze*, Paris, 1908, p. 11, no. 136; Benesch 1964, Meisterzeichnungen, no. 220; Alb. Vienna 1978, p. 119, no. 112; A. Brookner, *Greuze, The Rise and Fall of an Eighteenth Century Phenomenon*, London, 1972, p. 98.

This sheet is a sketch for the oil painting *Le repas partagé*,[1] showing a young mother who smiles at her boy as he shares his supper with a little dog. Whereas the drawing radiates with the expressive spontaneity of its close-up, sheet-filling depiction of the girl's head (a freshness reinforced by the powerful and nuanced ductus), the oil in Leningrad portrays a scene that, in its idealization of everyday life and its charming presentation, answers to the fashionable taste of 1750. In his pictorial themes, which react against Fragonard and Boucher, Greuze attempted to do justice to contemporary notions of morality, religion and sentiment. His painting fulfills Diderot's injunction: "rendre la vertu aimable, le vice odieux."[2] The educational impulse is primary for Greuze; pathos and emotion characterize the majority of his works, which earned him praise as a "peintre de la morale, de la bienfaisance et des belles âmes."[3]

The painting *Le repas partagé* is in all likelihood the one that a disappointed Diderot described in 1765 as unclear and overloaded with unnecessary details.[4] The Albertina drawing, on the other hand, is reminiscent of Rubens' sketches in the scale and immediacy of the image and it shows that free and natural rendering which can always be found when Greuze turns away from the theatrical emotion of an entire composition and draws spontaneously from life. Modeling strokes, delicate rubbing and added white highlights create the three-dimensional face against the red-chalk background. The *trois crayons* manner, Watteau's favorite drawing technique, is here exploited by Greuze for all its possibilities: the interplay of lightly touched charcoal lines, rubbed passages, reserved areas of white paper and agitated, powerful chalk lines suggest the material of a crumpled cap, while the effect of hair and shadow is achieved by heavily applied chalk lines.

Apart from this study another sketch for the figure of the mother in *Le repas partagé* has survived.[5] It shows the entire figure sitting on a chair with limbs posed as in the painting. The Albertina drawing concentrates on portraying the angle of the head and the facial expression, while the Leningrad drawing, which only indicates the facial features schematically, is primarily concerned with capturing the whole figure. *Ch.E.*

Notes

1. Jean-Baptiste Greuze, *Le repas partagé*, oil on canvas, 66.5 × 56.0 cm, inv. 5727, Hermitage, Leningrad. Illustrated in: Brookner, *Greuze, The Rise and Fall of an Eighteenth Century Phenomenon* (London, 1972), no. 19. The painting was engraved by Pierre Maleuvre in 1772, 43.0 × 33.8 cm.

2. Quoted in: C. Mauclair, *Greuze et son temps* (Paris, 1926), p. 54.

3. Ibid., p. 71.

4. Denis Diderot, *Salons*, II, ed. J. Seznac and J. Adhémar, (Oxford, 1960), p. 149, no. 111, under the original title *L'enfant gâté*: ". . . Le sujet de ce tableau n'est pas clair. . . c'est ou l'enfant ou le chien gâté," p. 149; ". . . la mère, l'enfant, le chien et quelques utensiles auraient produit plus d'effet," p. 150.

5. Jean Baptiste Greuze, *Seated Woman*, Hermitage (Prints and Drawings Collection), Leningrad; black and white chalks with wash, 38.9 × 28.1 cm, inv. 14773. Illustrated in I. Novasselska, comp., *Jean Baptiste Greuze, Drawings from the Collection of the Hermitage* (Leningrad, 1977), no. 76.

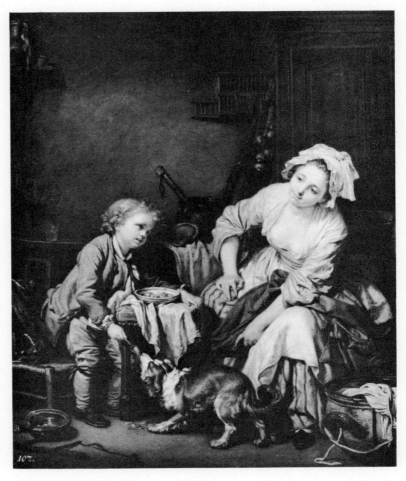

75a. Jean-Baptiste Greuze
Le repas partagé
Hermitage, Leningrad

75b. Jean-Baptiste Greuze
Sketch for *Le repas partagé*
Hermitage, Leningrad

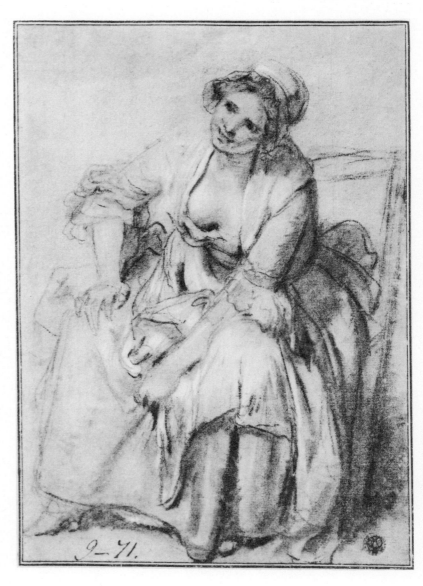

SELECTED BIBLIOGRAPHY

ALBERTINA CATALOGUES

Alb.Cat. I, 1926: Stix, A. and L. Fröhlich-Bum. *Beschreibender Katalog der Handzeichnungen der Albertina, Die Zeichnungen der venezianischen Schule*, I. Vienna: 1926.

Alb.Cat. II, 1928: Benesch, O. *Die Zeichnungen der Niederländischen Schulen des XV. und XVI. Jahrhunderts*, II. Vienna: 1928.

Alb.Cat. III, 1932: Stix, A. and L. Fröhlich-Bum. *Beschreibender Katalog der Handzeichnungen, Die Zeichnungen der toskanischen, umbrischen und römischen Schulen*, III. Vienna: 1932.

Alb.Cat. IV(V), 1933: Tietze, H., E. Tietze-Conrat, O. Benesch and K. Garzarolli-Thurnlackh. *Die Zeichnungen der Deutschen Schulen bis zum Beginn des Klassizismus*, IV(V). Vienna: 1933.

Alb.Cat. VI, 1941: Stix, A. and A. Spitzmüller. *Beschreibender Katalog der Handzeichnungen der Albertina, Die Schulen von Ferrara, Bologna, Parma und Modena, der Lombardei, Genuas, Neapels u. Siziliens* VI. Vienna: 1941.

Wickhoff 1891, ScV.: Wickhoff, F. *Scuola Veneziana*, part 1 of *Die italienischen Handzeichnungen der Albertina*. Jahrbuch der Kunsthistorischen Sammlungen des Allerhöchsten Kaiserhauses 12 (1891), p. CCXV ff.

Wickhoff 1892, ScR.: Wickhoff, F. *Die römische Schule*, part 2 of *Die italienischen Handzeichnungen der Albertina*. Jahrbuch der Kunsthistorischen Sammlungen des Allerhöchsten Kaiserhauses 13 (1892), p. III ff.

1822 Estate Inventory: *Catalogue des Dessins de la Collection de feu S.A.R. le Duc Albert de Saxe, passé en Fideicommis*. Vienna: 1822

EXHIBITION CATALOGUES

Amsterdam 1935: *Rembrandt Tentoonstelling*. Amsterdam: Rijksmuseum, 1935.

Amsterdam 1969: *Rembrandt 1669/1969*. Amsterdam: Rijksmuseum, 1969. Drawings catalogued by L. C. J. Frerichs and P. Schatborn.

Australia 1977: Koreny, F., comp. *Master Drawings from the Albertina, Vienna*. Sidney: Art Gallery of South Australia, and traveling, 1977.

Bologna 1956: *Mostra dei Carracci*. Bologna: 1956. Drawings catalogued by Denis Mahon.

Bologna 1962: Gnudi, Cesare, et al, comp. *L'Ideal Classico del Seicento in Italia e la Pittura del Paesaggio*. Bologna: 1962.

Chicago 1969: *Rembrandt after Three Hundred Years: An Exhibition of Rembrandt and His Followers*. Chicago: The Art Institute of Chicago, 1969. Drawings catalogued by E. Haverkamp-Begemann and A. M. Logan.

Des Moines 1975: Worthern, A. and S. Welsh Reed. *The Etchings of Jacques Bellange*. Traveling exhibition: Des Moines Art Center, Des Moines, 1975; Museum of Fine Arts, Boston, 1975; Metropolitan Museum of Art, New York, 1976.

Florence 1978: Bellosi, L., F. Bellini and G. Brunetti, comp. *I Disegni antichi degli Uffizi, I Tempi di Ghiberti*. Florence: Uffizi, 1978.

London 1926: Hind, A. M. *Catalogue of the Drawings of Claude Lorrain*. London: British Museum, 1926.

London 1948: *Old Master Drawings from the Albertina*. London: The Art Council of Great Britain, 1948.

London 1969: Kitson, M. and D. Howard, comp. *The Art of Claude Lorrain*. London: Heyward Gallery, 1969.

Milan 1959: Barelli, E. Spino, comp. *Disegni di Maestri lombardi del Primo Seicento*. Milan: Pinacoteca Ambrosiana, 1959.

Milan 1973: *Il Seicento Lombardo*, I–III. Milan: Pinacoteca Ambrosiana, 1973.

Moscow 1973: Knab, E. et al. *Meisterzeichnungen der Albertina*. Moscow: Puschkin-Museum, 1973.

Paris 1950: Adhémar, J., comp. *Cent cinquante chef-d'Ouevre de l'Albertina de Vienne*. Paris: Bibliothèque Nationale, 1950.

Paris 1960: Blunt, A. and Vorwort G. Bazin, comp. *Exposition Nicolas Poussin*. Paris: Louvre, 1960. Bibliography by G. Sterling.

Paris 1961: Bacou, R., comp. *Dessins de Carrache*. Paris: Louvre, 1961.

Paris 1967: Bacou, R., M. Serullaz, F. Viatte, et al, comp. *Le Cabinet d'un Grand Amateur, P. J. Mariette*. Paris: Louvre, 1967. Dedication by F. Lugt.

Paris 1975: Koschatzky, W., E. Knab and K. Oberhuber, comp., with assistance from F. Viatte. *Dessins Italiens de l'Albertina de Vienne*. Paris: Cabinet des dessins, Louvre, 1975.

Paris 1977: De Bruyn, S. P., et al, comp. *Le siècle de Rubens dans les collections publiques françaises*. Paris: Grand Palais, 1977/78.

Rome 1982: Thuillier, J., R. Taveneau, S. Guillaume, J. Leymarie, P. Arizzoli-Clementel, comp. *Claude Lorrain e i pittori lorenesi in Italia nel XVI secolo*. Rome: 1982.

Rotterdam-Amsterdam 1956: Regteren Altena, J. Q., et al, comp. *Rembrandt Tentoonstelling ter herdenking van de geboorte van Rembrandt op 15. Juli 1606, Tekeningen*. Rotterdam: Museum Boymans, 1956; Amsterdam: Rijksmuseum, 1956.

Stockholm 1956: *Rembrandt*. Stockholm: Nationalmuseum Stockholm, 1956.

Stockholm 1966: *Christina, Queen of Sweden*. Stockholm: Nationalmuseum Stockholm, 1966.

Venice 1961: Benesch, O. and K. Oberhuber, comp. *Disegni veneti dell' Albertina di Vienna*. Venice: Fondazione Giorgio Cini, 1961.

Venice 1981: Shaw, Byam, comp. *Disegni veneti della Collezione Frits Lugt, Fondazione Custodia, Parigi*. Venice: 1981.

Verona 1958: Maganato, L., comp. *Da Altichiero a Pisanello*. Verona: Musei Civici, Castelvecchio, 1958.

Washington/Paris 1982/83: Russel, H. D., comp. *Claude Gellée, dit le Lorrain*. Washington, D.C.: National Gallery of Art, 1982/Paris: Louvre, 1983.

Vienna 1871: *Düreraustellung des K. K. Österreichischen Museums für Kunst und Industrie*. Vienna: 1871.

Vienna 1962: Oberhammer, V., et al, comp. *Kunst um 1400, Ausstellung des Europarates*. Vienna: Kunsthistorisches Museum, 1962. Drawings and prints catalogued by O. Benesch and E. Mitsch.

Vienna 1977: *Peter Paul Rubens 1577–1640, Ausstellung zur 400. Wiederkehr seines Geburtstages*. Vienna: Kunsthistorisches Museum, 1977. Relevant entry by W. Prohaska.

EXHIBITION CATALOGUES, ALBERTINA COLLECTION

Alb.Vienna 1899/1900: *Die Zeichnungen Albrecht Dürers*. Vienna: Albertina Collection, 1899/1900.

Alb.Vienna 1936: Benesch, O., comp. *Die Holländische Landschaft im Zeitalter Rembrandts*. Vienna: Albertina Collection, 1936.

Alb.Vienna 1949: Benesch, O. and E. Knab, comp. *Die schönsten Meisterzeichnungen*. Vienna: Albertina Collection, 1949.

Alb.Vienna 1950: *Meisterwerke aus Frankreichs Museen*. Vienna: Albertina Collection, 1949.

Alb.Vienna 1956: Benesch, O., comp. *Rembrandt. Ausstellung im 350. Geburtsjahr des Meisters*. Vienna: Albertina Collection, 1956.

Alb.Vienna 1962: Keil, N., comp. *Meisterzeichnungen der Albertina, 16.–18. Jahrhundert*. Vienna: Albertina Collection, 1962.

Alb.Vienna 1963: Oberhuber, K., comp. *Parmigianino und sein Kreis*. Vienna: Albertina Collection, 1963.

Alb.Vienna 1964: Knab, E., comp. *Claude Lorrain und die Meister der römischen Landschaft im 17. Jahrhundert*. Vienna: Albertina Collection, 1964. Introduction by W. Koschatzky.

Alb.Vienna 1967: Keil, N., comp. *Meisterwerke der Albertina, Von Dürer bis Picasso*. Vienna: Albertina Collection, 1967.

Alb.Vienna 1968, IV: Oberhuber, K., comp. *Zwischen Renaissance und Barock, Das Zeitalter von Bruegel bis Bellange, Die Kunst der Graphik*, IV. Vienna: Albertina Collection, 1968.

Alb.Vienna 1968, V: Knab, E., comp. *J. Callot und sein Kreis, Die Kunst der Graphik*, V. Vienna: Albertina Collection, 1968. Contributions from K. Oberhuber.

Alb.Vienna 1969/70: Mitsch, E., comp. *Die Rembrandtzeichnungen der Albertina*. Vienna: Albertina Collection, 1969/70.

Alb.Vienna 1971, Meisterzeichnungen: Knab, E., comp. *Europäische Meisterzeichnungen aus dem Zeitalter Dürers*. Vienna: Albertina Collection, 1971.

Alb.Vienna 1971: Koschatzky, W. and A. Strobl, comp. *Die Dürerzeichnungen der Albertina*. Vienna: Albertina Collection, 1971.

Alb.Vienna 1975: Knab, E. and K. Oberhuber, comp. *Italienische Zeichnungen der Renaissance zum 500. Geburtsjahr Michelangelos*. Vienna: Albertina Collection, 1975.

Alb.Vienna 1977: Mitsch, E., comp. *Die Rubenszeichnungen der Albertina zum 400. Geburtstag*. Vienna: Albertina Collection, 1977.

Alb.Vienna 1978: Birke, V., et al, comp. *Das Dresdner Kupferstichkabinett und die Albertina, Meisterzeichnungen aus zwei alten Sammlungen*. Vienna: Albertina Collection, 1978.

Alb.Vienna 1979: Oberhuber, K. and E. Knab. *Italienische Zeichnungen der Renaissance zum 500. Geburtstag Michelangelos*. Vienna: Albertina Collection, 1979.

Alb.Vienna 1983: Mitsch, E., comp. *Raphael in der Albertina, Aus Anlaß des 500. Geburtstages des Künstlers*. Vienna: Albertina Collection, 1983.

AUTHORS

Anzelewsky 1971: Anzelewsky, F. *Albrecht Dürer, Das malerische Werk*. Berlin: 1971.

B.: Bartsch, A. *Le peintre-graveur, I–XXI*. Vienna: 1803–21.

Baldinucci 1681: Baldinucci, F. *Notize de' Professori del disegno da Cimabue in qua*, VI. Florence: 1681. Bibliography of Claude Lorrain.

Bartsch 1794: Bartsch, A. *Catalogue raisonné des desseins originaux des plus grands maîtres anciens et modernes qui faisoient partie du Cabinet de feu Le Prince Charles de Ligne*. Vienna: 1794.

Basan 1775: Basan, F. *Catalogue raisonné des differens objets de curiosités dans les Sciences et Arts, qui composoient le Cabinet de feu Mr. Mariette*. Paris: 1775.

Baudouin 1968: Baudouin, F. "Een jeugdwerk van Rubens, Adam en Eva, en de relatie Van Veen en Rubens." *Antwerpen, Tijdschrift der Stad Antwerpen* (July 1968), p. 3 ff.

Baudouin 1972: Baudouin, F. "Altars and Altarpieces before 1620." *Rubens before 1620*. Edited by J. R. Martin. Princeton, N.J.: 1972. p. 45 ff.

Baudouin, Rubens: Baudouin, F. *Rubens et son siècle*. Antwerp: 1972.

Bellori 1672: Bellori, G. P. *Le Vite de' Pittori, Scultori ed Architetti moderni*. Rome: 1672.

Benesch 1935: Benesch, O. *Rembrandt, Werk und Forschung*. Vienna: 1935.

Benesch 1944: Benesch, O. *The Art of the Renaissance in Northern Europe*. Cambridge, Mass.: 1944.

Benesch 1947: Benesch, O. *A Catalogue of Rembrandt's Selected Drawings*. London: 1947.

Benesch I–VI: Benesch, O. *The Drawings of Rembrandt*. London: 1954–1957. First complete edition in six volumes.

Benesch 1959: Benesch, O. "Zum zeichnerischen Oeuvre des jungen Van Dyck." *Karl M. Swoboda zum.* (January 28, 1959). Vienna: Wiesbaden, 1959. p. 35 ff.

Benesch 1960: Benesch, O. *Rembrandt as a Draughtsman*. London: 1960.

Benesch 1964, Meisterzeichnungen: Benesch, O. *Meisterzeichnungen der Albertina, Europäische Schulen von der Gotik bis zum Klassizismus*. Salzburg: 1964.

Berenson 1938: Berenson, B. *The Drawings of the Florentine Painters*. Chicago: 1938.

Bertolotti 1880: Bertolotti, A. *Artisti Belgi ed Vlandresi a Roma nei secoli XVI e XVII*. Florence: 1880.

Bertolotti 1886: Bertolotti, A. *Artisti francesi in Roma nei secoli XV, XVI, XVII*. Mantua: 1886.

Blum 1923: Blum, A. *Les Eaux-Fortes de Claude Gelée, dit Le Lorrain*. Paris: 1923.

Blunt 1945: Blunt, A. *The French Drawings at Windsor Castle, Oxford*. London: 1945.

Bousquet 1980: Bousquet, J. *Recherches sur le séjour des peintres français à Rome au XVIIe siècle*. Montpellier: 1980. Preface by J. Thuiller.

Boyer 1928: Boyer, F. "La succession de Claude Gelée, Le Lorrain." *Bulletin de la Société de l'Histoire de l'Art français* (1928), p. 152 ff.

Boyer 1931: Boyer, F. "Documents d'archives romaines et florentines sur le Valentin, Le Poussin et Le Lorrain." *Bulletin de la Société de l'Histoire de l'Art française* (1931), p. 233 ff.

Boyer 1933/34: Boyer, F. "Les années d'apprentissage de Claude Lorrain à Rome." *Etudes italiennes*. Paris: 1933/34, p. 308 ff.

Burchard 1913: Burchard, L. "Drei Zeichnungen in Dresdner Sammlungen." *Mitteilungen aus den sächsischen Kunstsammlungen*, IV. Dresden/Berlin: 1913. p. 52 ff.

Burchard-d'Hulst 1963: Burchard, L. and R.-A. d'Hulst. *Rubens Drawings*. Brussels: 1963.

Christoffel 1941: Christoffel, U. *Poussin und Lorrain*. Hanover: 1941.

Cocke 1969: Cocke, R. *The Drawings of Raphael*. London/New York/Sydney/Toronto: 1969.

Colloque Poussin: *Actes du Colloque Poussin*, I, II. Paris: 1960.

Colombier 1960: Du Colombier, P. "Poussin et Claude Lorrain." *Colloques Poussin I*. Paris: 1960. p. 41 ff.

Constable 1944: Constable, W. G. "The Early Work of Claude Lorrain. *Gazette des Beaux-Arts* 26 (1944), p. 305.

Crowe-Cavalcaselle 1883: Crowe, J. A. and G. B. Cavalcaselle. *Raphael, Sein Leben und seine Werke*. Leipzig: 1883.

Degenhart 1932: Degenhart, B. "Die Schüler des Lorenzo die Credi," *Münchner Jahrbuch der bildenden Kunst* 9 (1932), p. 95 ff.

Degenhart 1942: Degenhart, B. *Antonio Pisanello*. Vienna: 1942.

Degenhart-Schmitt 1968: Degenhart, B. and A. Schmitt. *Corpus der italienischen Handzeichnungen 1300–1450*, I–IV. Berlin: 1968.

Delen 1944: Delen, A. J. J. *P. P. Rubens, een Keuze van 26 Tekeningen*. Antwerp: 1944.

Demonts 1923: Demonts, L. *Les Dessins de Claude Gellée, dit Le Lorrain*. Paris: 1923.

Dollmayr 1895: Dollmayr, H. "Raffaels Werkstätte," *Jahrbuch der Kunsthistorischen Sammlungen des Allerhöchsten Kaiserhauses* 16 (1895), p. 231 ff.

Dussler 1959: Dussler, L. *Die Zeichnungen des Michelangelo, Kritischer Katalog*. Berlin: 1959.

Dussler 1966: Dussler, L. *Raffael, Kritisches Verzeichnis der Gemälde, Wandbilder und Bildteppiche, Bruckmanns Beiträge zur Kunstwissenschaft*. Munich: 1966.

Dussler 1971: Dussler, L. *Raphael, A Critical Catalogue of His Pictures, Wallpaintings and Tapestries*. London/New York: 1971.

Ephrussi 1882: Ephrussi, Ch. *Albert Dürer et ses dessins*. Paris: 1882.

Evers 1943: Evers, H. G. *Rubens und sein Werk, Neue Forschungen*. Brussels: 1943.

Félibien 1666–68: A. Félibien Sieur des Avaux. *Entretiens sur les vies et les ouvrages des plus excellens Peintres, anciens et modernes.* Paris: 1666/88.

Fenyö 1960: Fenyö, I. "Dessins inconnus des Carracci." *Bulletin du Musée National Hongrois des Beaux-Arts* 17 (1960).

Fenyö 1965: Fenyö, I. *Norditalienische Handzeichnungen aus dem Museum der Bildenden Künste in Budapest.* Budapest: 1965.

Fenyö 1967: Fenyö, I. "Drawings by Annibale Carracci in Budapest." *Master Drawings* 5, no. 3 (1967), p. 255 ff.

Fischel 1898: Fischel, O. *Raphaels Zeichnungen, Versuch einer Kritik der bisher veröffentlichten Blätter.* Strassburg: 1898.

Fischel I–VIII: Fischel, O. *Raphaels Zeichnungen, I–VIII.* Berlin: 1913–41.

Fischel 1948: Fischel, O. *Raphael.* London: 1948.

Fischel-Oberhuber, 1972, IX: Fischel, O. and K. Oberhuber. *Raphaels Zeichnungen, Abteilung IX, Entwürfe zu Werken Raphaels und seiner Schule im Vatikan 1511/12 bis 1520.* Berlin: 1972.

Flechsig 1931, II: Flechsig, E. *Albrecht Dürer, Sein Leben und seine künstlerische Entwicklung,* II. Berlin: 1931.

Forlani-Tempesti 1969: Forlani-Tempesti, A. "The Drawings." *The Complete Work of Raphael.* New York: 1969. p. 303 ff. Edited by M. Salmi.

Forlani-Tempesti 1983: Forlani-Tempesti, A. *Raffaello, Disegni.* Florence: 1983.

Freedberg 1961: Freedberg, S. J. *Paintings of the High Renaissance in Rome and Florence.* Cambridge, Mass.: 1961.

Friedländer 1921: Friedländer, W. *Claude Lorrain.* Berlin: 1921.

Friedländer 1931: Friedländer, W. "Zeichnungen Poussins in der Albertina." *Belvedere* (1931), p. 56 ff.

Friedländer 1965: Friedländer, W. *Nicolas Poussin.* Paris: 1965.

Friedländer-Blunt 1939: Friedländer, W. and A. Blunt. *The Drawings of Nicolas Poussin,* I–V. London: 1939.

Fuessli 1801: Fuessli, H. R. "Übersicht der Sammlung von Kupferstichen und Zeichnungen Sr. Königl. Hoheit des Herrn Herzog Albrechts von Sachsen-Teschen." *Annalen der Bildenden Künste für die Österreichischen Staaten* I (1801), p. 203 ff.

Gerson 1969: Gerson, H. *Rembrandt Gemälde, Gesamtwerk.* 1969.

Glück 1921: Glück, G. *Rubens Zeichnungen der Wiener Albertina in zwölf Faksimiledrucken,* XXVIII. Munich: 1921. Marées Gesellschaft.

Glück 1933: Glück, G. *Rubens, Van Dyck und ihr Kreis, herausgegeben von L. Burchard und R. Eigenberger.* Vienna: 1933.

Glück-Haberditzl 1928: Glück, G. and F. M. Haberditzl. *Die Handzeichnungen von Peter Paul Rubens.* Berlin: 1928.

Graul 1906: Graul, R. *Rembrandt.* Leipzig: 1906.

Grautoff 1914: Grautoff, O. *Nicolas Poussin.* Munich: 1914.

Grimm 1872: Grimm, H. *Das Leben Raphaels von Urbino, Italiänischer Text von Vasari.* Übersetzung und Commentar, part I. Berlin: 1872.

Grimm 1886: Grimm, H. *Das Leben Raphaels. II. Ausgabe des ersten Bandes und Abschluß in einem Bande.* Berlin: 1886.

H.: Hind, A. M. *Early Italian Engraving,* I–VII. London: 1938–48.

Haak 1969: Haak, B. *Rembrandt, Sein Leben, sein Werk, seine Zeit.* Cologne: 1969.

Haberditzl 1912: Haberditzl, F. M. "Über einige Handzeichnungen von Rubens in der Albertina." *Die Graphischen Künste* 35 (1912), p. I ff.

Hartt 1944: Hartt, F. "Raphael and Giulio Romano." *The Art Bulletin* 26 (1944), p. 67 ff.

Hartt 1958: Hartt, F. *Giulio Romano.* New Haven, Conn.: 1958.

Hartt 1971: Hartt, F. *The Drawings of Michelangelo.* London: 1971.

HdG.: Hofstede de Groot, C. *Die Handzeichnungen Rembrandts. Versuch eines beschreibenden und kritischen Kataloges.* Haarlem: 1906.

Held 1959: Held, J. S. *Rubens, Selected Drawings.* London: 1959.

Held 1980: Held, J. S. *The Oil Sketches of Peter Paul Rubens, A Critical Catalogue,* I, II. Princeton, N.J.: 1980.

Heller 1831: Heller, J. *Das Leben und die Werke Albrecht Dürers,* I, II. Bamberg/Leipzig: 1831.

Hind 1925: Hind, A. M. *The Drawings of Claude Lorrain.* London: 1925.

Hofmann 1955: Hofmann, W. "Quelques dessins français de l'Albertina." *La Revue des Arts* 2 (1955), p. 75 ff.

Hollstein: Hollstein, F. W. H. *Dutch and Flemish Etchings Engravings and Woodcuts,* I. Amsterdam: 1949 ff.

Hollstein: Hollstein, F. W. H. *German Engravings, Etchings and Woodcuts, ca.1400–1700.* Amsterdam: 1954 ff.

Hoogewerff 1942: Hoogewerff, G. J. "Nederlandsche Kunstenaats te Rome." *Studien van het Nederl. Historische Instituut te Rome,* III. s'Gravenhage: 1942.

Hoogewerff 1952: Hoogewerff, G. J. *De Bentvueghels.* s'Gravenhage: 1952.

Hoogewerff 1953: Hoogewerff, G. J. *Via Margutta, centro di vita artistica.* Rome: 1953.

Hourticq: Hourticq, L. "Claude Lorrain et Jacques Callot." *Mélanges Bertaux.* Paris: 1924. p. 150 ff.

Joannides 1983: Joannides, P. *The Drawings of Raphael.* Oxford: 1983.

Kaplan 1974: Kaplan, A. M. "Dürer's 'Raphael' Drawing Reconsidered." *The Art Bulletin* 56 (1974), p. 50 ff.

Kitson 1961: Kitson, M. "Claude's Books of Drawings from Nature." *Burlington Magazine* 103 (1961), p. 252 ff.

Kitson 1963: Kitson, M. "The Place of Drawings in the Art of Claude Lorrain." *Acts of the Twentieth International Congress of the History of Art,* III. Princeton N. J.: 1963. p. 96 ff.

Kitson 1978: Kitson, M. *Claude Lorrain: Liber Veritatis.* London: 1978.

Kitson-Roethlisberger 1959: Kitson, M. and M. Roethlisberger. "Claude Lorrain and the Liber Veritatis." *Burlington Magazine* 101 (1959), p. 14 ff.

Knab 1953: Knab, E. "Die Zeichnungen Claude Lorrains in der Albertina." *Alte und Neue Kunst* (1953), p. 121.

Knab 1956: Knab, E. "Der heutige Bestand an Zeichnungen Claude Lorrains im Boymans Museum." *Bulletin Museum Boymans van Beuningen* 7 (1956), p. 103 ff.

Knab 1960: Knab, E. "Die Anfänge des Claude Lorrain." *Jahrbuch der Kunsthistorischen Sammlungen in Wien* 56 (1960), p. 63 ff.

Knab 1963: Knab, E. "Stylistic Problems of Claude's Draftsmanship." *Acts of the Twentieth International Congress of the History of Arts,* III. Princeton N. J.: 1963. p. 113 ff.

Knab 1967: Knab, E. "Über Bernini, Poussin, LeBrun." *Albertina Studien* 1967/68. p. 3 ff.

Knab 1969: Knab, E. "Ein Gemälde von Claude Lorrain im Museum Boymans van Beuningen." *Bulletin Museum Boymans van Beuningen* 20 (1969), p. 94 ff.

Knab 1969, Genio: Knab, E. "De Genio Loci." *Miscellanea J. Q. van Regteren Altena.* Amsterdam: 1969. p. 133 ff.

Knab 1971: Knab, E. "Observations about Claude, Angelico, Dughet and Poussin." *Master Drawings* 9 (1971), p. 367 ff.

Knab-Mitsch-Oberhuber 1983: Knab, E., E. Mitsch and K. Oberhuber. *Raphael, Die Zeichnungen.* Stuttgart: 1983.

Koopmann 1890: Koopmann, W. *Raffael-Studien mit besonderer Berücksichtigung der Handzeichnungen des Meisters.* Marburg: 1890. First edition.

Koopmann 1895: Koopmann, W. *Raffael-Studien mit besonderer Berücksichtigung der Handzeichnungen des Meisters (second edition) Handzeichnungen aus Raffaels römischer Zeit.* Marburg: 1895.

Koopmann 1897: Koopmann, W. *Raffaels Handzeichnungen in der Auffassung von W. Koopmann.* Marburg: 1897.

Koschatzky-Oberhuber-Knab 1971: Koschatzky, W., K. Oberhuber and E. Knab. *I Grandi Disegni Italiani dell' Albertina.* Milan: 1971.

Koschatzky-Strobl 1971: *Die Dürer Zeichnungen der Albertina.* Salzburg: 1971.

Kuznetsov 1974: Kuznetsov, J. I. *Zeichnungen von P. P. Rubens.* Moscow: 1974. In Russian.

Lauts 1943: Lauts, J. *Domenico Ghirlandaio.* Vienna: 1943.

Lavallée 1930: Lavallée, P. *Le Dessin français du XIIè au XVIè siècle.* Paris: 1930.

Lavallée 1948: Lavallée, P. *Le Dessin français.* Paris: 1948.

Lippmann 1905: Lippmann, F. *Zeichnungen Albrecht Dürers in der Albertina zu Wien in Nachbildungen unter Leitung v. J. Schönbrunner.* Berlin: 1905. Edited by J. Meder.

Lübke 1878/79: Lübke, W. *Geschichte der Italienischen Malerei vom vierten bis ins sechzehnte Jahrhundert.* Stuttgart s.d. (1878/79).

L.: Lugt, F. *Les Marques et Collections de Dessins et d'Estampes.* First edition, Amsterdam, 1921; second edition, The Hague, 1956; supplement, The Hague, 1956.

Mahon 1947: Mahon, D. *Studies in Seicento Art and Theory, Studies of the Warburg Institute,* 16. London: 1947.

Mahon 1962: Mahon, D. "Poussiniana." *Gazette des Beaux-Arts* 60 (1962), p. I ff.

Marabottini 1969: Marabottini, A. "Raphael's Collaborators." in: *The Complete Work of Raphael.* New York: 1969. p. 199 ff. Edited by M. Salmi.

Mariette 1741: Mariette, P. J. *Description sommaire des dessins des grands maîtres du Cabinet de feu M. Crozat.* Paris: 1741.

Mariette 1857–60: Mariette, P. J. "Abcedario." Edition by Ph. Chenevières und A. de Montaiglon, in: *Archives de l'Art français,* 1857–1860.

Martin 1969: Martin, J. R. *Rubens, The Antwerp Altarpieces.* London: 1969.

Meder 1922: Meder, J. *Handzeichnungen alter Meister aus der Albertina und aus Privatbesitz.* Vienna: 1922.

Meder, Albertina-Facsimile 1922: Meder, J. *Albertina-Facsimile, Handzeichnungen französischer Meister des XVI–XVIII Jahrhunderts.* Vienna: 1922.

Meder, Albertina-Facsimile 1923: Meder, J. *Albertina-Facsimile, Handzeichnungen vlämischer und holländischer Meister des XV–XVIII Jahrhunderts.* Vienna: 1923.

Meder 1923: Meder, J. *Albertina Facsimile, Handzeichnungen italienischer Meister des XV–XVIII Jahrhunderts*. Vienna: 1923.

Meder, Handzeichnung: Meder, J. *Die Handzeichnung*. First edition, Vienna, 1919; second improved edition, Vienna, 1923.

Mongan-Sachs 1946: Mongan, A. and P. J. Sachs. *Great Drawings in the Fogg Museum of Art*, I–III. Cambridge, Mass.: 1946.

Morelli 1891/92: Morelli, G. "Handzeichnungen italienischer Meister in photographischen Aufnahmen von Braun und Co. in Dornach, kritisch gesichtet von Giovanni Morelli (Lermolieff). Mitgeteilt von E. Habich." *Kunstchronik* 3 (1891/92).

Neumann 1919: Neumann, C. *Rembrandts Handzeichnungen*. Munich: 1919.

Noack 1910: Noack, F. *Die römische Campagna*. Rome: 1910.

Oberhuber 1962: Oberhuber, K. "Die Fresken der Stanza dell'Incendio im Werk Raffaels." *Jahrbuch der Kunsthistorischen Sammlungen in Wien* 22 (1962), p. 23 ff.

Oldenbourg: Oldenbourg, R. *Peter Paul Rubens, Des Meisters Gemälde, Klassiker der Kunst*, V. Berlin/Leipzig. Fourth revised edition.

Oertel 1942: Oertel, R. *Fra Filippo Lippi*. Vienna: 1942.

Panofsky 1948, I, II: Panofsky, E. *Albrecht Dürer*, I, II. Princeton, N.J.: 1948.

Pascoli 1730: Pascoli, L. *Vite de' Pittori, Scultori ed Architetti moderni*. Rome: 1730. Facsimile edition, Rome, 1935.

Passavant 1860: Passavant, J. D. *Raphael d'Urbin et son père Giovanni Santi*. Paris: 1860.

Pattison 1884: Pattison, M. *Claude Lorrain, sa vie et son oeuvre*. Paris: 1884.

Pope-Hennessy 1970: Pope-Hennessy, J. *Raphael, The Wrightsman Lectures*. London: 1970.

Popham-Pouncy 1950: Popham, A. D. and P. Pouncy. *Italian Drawings in the Department of Prints and Drawings in the British Museum, The Fourteenth and Fifteenth Centuries* I, II. London: 1950.

Pugliatti 1977: Pugliatti, T. and A. Tassi. *Tra conformismo e libertà*. Rome: 1977.

R.-D.: Robert-Dumesnil, A. P. F. *Le Peintre-Graveur français*. Paris: 1835–71.

Regteren Altena 1964: Regteren Altena, J. Q. van. *Verewigte Stadt*. Stockholm: 1964.

Regteren Altena 1966: Regteren Altena, J. Q. van. *Les Dessins Italiens de la Reine Christina de Suède, Analecta Regenensia*, II. Stockholm: 1966.

Roethlisberger 1961: Roethlisberger, M. *Claude Lorrain, The Paintings*, I, II. New Haven, Conn.: 1961. Second edition, New York, 1981.

Roethlisberger 1962: Roethlisberger, M. *Claude Lorrain, L'Album Wildenstein*. Paris: 1962.

Roethlisberger 1968: Roethlisberger, M. *Claude Lorrain, The Drawings*, I, II. Los Angeles: University of California, Berkeley, 1968.

Roethlisberger 1979: Roethlisberger, M. "Additional Works by Goffredo Wals and Claude Lorrain," *Burlington Magazine* 121 (1979), p. 20 ff.

Roli 1969: Roli, R. *I Disegni italiani del Seicento*. Treviso: 1966.

Rooses 1886–92, I–V: Rooses, M. *L'Oeuvre de P. P. Rubens*, I–V. Antwerp: 1886–92.

Rosenauer 1965: Rosenauer, A. *Studien zur stilistischen Entwicklung von Domenico Ghirlandaios Frühwerk*. Vienna: 1965.

Rosenauer 1969: Rosenauer, A. "Zum Stil der frühen Werke Domenico Ghirlandaios," *Wiener Jahrbuch für Kunstgeschichte* 22 (1969), p. 59 ff.

Rosenauer 1972: Rosenauer, A. "Ein nicht zur Ausführung gelangter Entwurf Domenico Ghirlandaios für die Capella Sassetti," *Wiener Jahrbuch für Kunstgeschichte* 25 (1972), p. 187 ff.

Rosenberg 1948: Rosenberg, J. *Rembrandt*. Cambridge, Mass.: 1948.

Rosenberg 1964: Rosenberg, J. *Rembrandt, Life and Work*. London: 1964. Revised edition.

Ruland 1876: Ruland, C., comp. *The Works of Raphael Santi da Urbino as Represented in the Raphael Collection in the Royal Library at Windsor Castle*. 1876. Formed by H.R.H. the Prince Consort 1853–1861 and completed by Her Majesty Queen Victoria.

Sandrart-Pelzer 1925: Pelzer, A. R., ed. *Joachim Sandrart, Teutsche Academie der Edlen Bau-Bild und Mahlerey-Künste*. Nuremberg/Frankfurt, 1675; Munich, 1925.

Schatborn 1977: Schatborn, P. "Beesten mae't leven." *De Kronick van het Rembrandthuis* 29 (1977) p. 20 ff.

Scheidig 1962: Scheidig, W. *Rembrandt als Zeichner*. Leipzig: 1962.

Schlosser-Magrino 1924: Schlosser-Magrino, J. *Die Kunstliteratur*. Vienna: 1924.

Schönbrunner-Meder: Schönbrunner, J. and J. Meder, eds. *Handzeichnungen alter Meister aus der Albertina und anderen Sammlungen*. Vienna: 1896–1908.

Seilern 1955: Seilern, A. *Flemish Paintings and Drawings at 56 Princes Gate, London SW7*. London: 1955.

Shearman 1959: Shearman, J. "Rezension von Hartt 1958." *Burlington Magazine* 101 (1959), p. 456 ff.

Shearman 1964: Shearman, J. "Die Loggia der Psyche in der Villa Farnesina und die Probleme der letzten Phase von Raffaels graphischem Stil." *Jahrbuch der Kunsthistorischen Sammlungen in Wien* 60 (1964), 59 ff.

Shearman 1965: Shearman, J. "Raphael's Unexecuted Projects for the Stanze." *Festschrift für Walter Friedländer zum 90. Geburtstag*. Berlin: 1965.

Siblik 1974: Siblik, J. *Raffael Zeichnungen*. Vienna: 1974.

Slatkes 1980: Slatkes, L. J. "Rembrandt's Elephant." *Simiolus, Netherlandish Quarterly for the History of Art* 2, no. 1 (1980), p. 7 ff.

Springer 1883: Springer, A. *Raffael und Michelangelo*. Leipzig: 1883. Second improved edition.

Stix 1925: Stix, A. *Handzeichnungen der Albertina*, New Series, II, *Italienische Meister des 14.–16. Jahrhunderts*. Vienna: 1925.

Strauss 1974, I–VI: Strauss, W. L. *The Complete Drawings of A. Dürer*, I–VI. New York: 1974.

Sumowski 1957/58: Sumowski, W. *Nachträge zum Rembrandtjahr 1956*, *Wissenschaftliche Zeitschrift der Humboldt-Universität zu Berlin* 7 (1957/58), p. 223–78.

Sumowski 1961: Sumowski, W. *Bemerkungen zu Otto Benesch's Corpus der Rembrandt-Zeichnungen*, II. Bad Pyrmont: 1961.

Swoboda 1978: Swoboda, K. M. *Die Spätgotik*. Vienna: 1978.

Swoboda 1979: Swoboda, K. M. *Die Frührenaissance*. Vienna: 1979.

Swoboda 1979, Renaissance: Swoboda, K. M. *Die Renaissance*. Vienna: 1979.

Thausing 1876, I: Thausing, M. v. *Dürer, Geschichte seines Lebens und seiner Kunst*, I. Leipzig: 1876.

Thausing 1884, II: Thausing, M. v. *Dürer, Geschichte seines Lebens und seiner Kunst*, II. Leipzig: 1884.

Thode 1903–13: Thode, H. *Michelangelo, Kritische Untersuchungen über seine Werke*, III. Berlin: 1908–13. (Zeichnungen, Kartons, Gemälde.)

Tietze 1928: Tietze, H. and E. Tietze-Conrat. *Der junge Dürer*. Augsburg: 1928.

Tietze 1937/38, I–II: Tietze, H. and E. Tietze-Conrat. *Kritisches Verzeichnis der Werke Albrecht Dürers*, I. Basel/Leipzig, 1937; Basel/Leipzig, 1938.

Tolnay, 1947–60: Tolnay, Ch. de. *Michelangelo*, I–V. Princeton, N.J.: 1947–60.

Ueberwasser 1948: Ueberwasser, W. *Handzeichnungen europäischer Meister des XIV bis XVIII Jahrhunderts aus der Albertina*. Bern: 1948.

Vallery-Radot 1953: Vallery-Radot, J. *Le Dessin français au XVIIè Siècle*. Lausanne: 1953.

Van de Velde 1975: Velde, C. van de. "Rubens Hemelvaart van Maria in de Kathedraal te Antwerpen." *Jaarboek van het Koninklijk Museum voor Schone Kunsten*. Antwerp: 1975, p. 245 ff.

Van Marle 1923–38: Marle, R. van. *The Development of the Italian Schools of Painting*, I–XVIII. The Hague: 1923–38. XII/XIII.

Vasari 1550: Vasari, G. *Le Vite de' più eccellenti Architetti, Pittori et Scultori Italiani da Cimabue, insino a tempi nostri . . .*, I, II. Florence, 1550 (1568); Edited by G. Milanesi, Florence, 1878–80.

Venturi 1927: Venturi, A. *Choix de Cinquante Dessins de Raffaello Santi*. (Dessins et Peintures des Maîtres anciens publiés par la Maison Braun & Cie, Première Série, Quatrième Volume). Paris/London: 1927.

Vlieghe 1972: Vlieghe, H. *Saints I u. II, Corpus Rubenianum Ludwig Burchard VIII*. Brussels: 1972/73.

Voß 1924: Voß, H. *Die Malerei des Barock in Rom*. Berlin: 1924.

Waagen 1867: Waagen, G. F. *Die vornehmsten Kunstdenkmäler in Wien*, II. Vienna: 1867.

Walch 1971: Walch, N. *Die Radierungen des Jacques Bellange*. Munich: 1971.

Weixlgärtner 1927: Weixlgärtner, A. *Alberto Dürer*, Festschrift für Julius Schlosser zum 60. Geburtstage. Zurich/Vienna: 1927.

Weizsäcker 1930/31: Weizsäcker, H. "Die Anfänge des Claude Lorrain in ihrem Zusammenhang mit der römischen Landschaft." *Zeitschrift für bildende Kunst* 64 (1930/31), p. 25 ff.

Whitfield 1979: Whitfield C. "Poussin's Early Landscapes." *Burlington Magazine* 121 (1979), p. 10 ff.

Wickhoff 1891, 1892: Albertina Catalogues.

Wilde 1953: Wilde, J. *Italian Drawings in the Department of Prints and Drawings in the British Museum, Michelangelo and His Studio*. London: 1953.

Wilde-Popham 1949: Popham, A. E. and J. Wilde. *The Italian Drawings of the XV and XVI Centuries in the Collection of His Majesty The King at Windsor Castle*. London: 1949.

Winkler, I, II, III, IV: Winkler, F. *Die Zeichnungen Albrecht Dürers*, I–IV. Berlin: 1936–39.

Wittkower 1952: Wittkower, R. *The Drawings of the Carracci at Windsor Castle*. London: 1952.